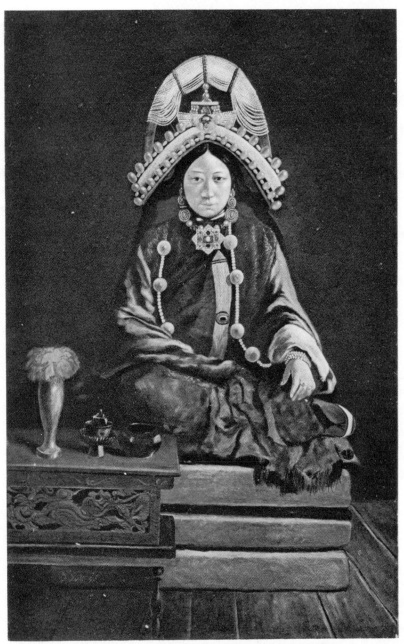

THE MAHARANI OF SIKKIM (NORTHEASTERN HINDUSTAN)

She wears two gold rings, one set with a turquoise, the other with coral. The peculiar crown of gold, turquoise and coral is that adopted for the queens of Sikkim. From the necklace of amber beads hangs a *gau*, or charm box, set with rubies, lapis-lazuli, and turquoise.

Oil painting by Damodar Dutt, a Bengali artist

Dr. Berthold Laufer's "Notes on Turquoise in the East," Chicago, 1913

RINGS
FOR THE FINGER

FROM THE EARLIEST KNOWN TIMES TO THE PRESENT,
WITH FULL DESCRIPTIONS OF THE ORIGIN, EARLY
MAKING, MATERIALS, THE ARCHÆOLOGY, HISTORY,
FOR AFFECTION, FOR LOVE, FOR ENGAGEMENT,
FOR WEDDING, COMMEMORATIVE, MOURNING, ETC.

BY

GEORGE FREDERICK KUNZ
Ph.D., Sc.D., A.M.

WITH 290 ILLUSTRATIONS

DOVER PUBLICATIONS, INC.
NEW YORK

To

PETER COOPER

AND TO

HIS DESCENDANTS

WHO HAVE SO GENEROUSLY AND DEVOTEDLY
CARRIED OUT HIS TRADITIONS, AND DEVELOPED
THEM AS OCCASION DEMANDED,

AND TO

THE COOPER UNION OF ARTS AND SCIENCES

IN THE LABORATORIES, LECTURE ROOMS AND
LIBRARY OF WHICH THE AUTHOR SPENT
USEFUL, PROFITABLE EVENING HOURS FOR
SEVERAL YEARS, AT A TIME WHEN THERE
WERE NO OTHER OPPORTUNITIES OF A SIMILAR
NATURE IN THE CITY OF NEW YORK — THIS
VOLUME IS AFFECTIONATELY DEDICATED

This Dover edition, first published in 1973, is an unabridged republication of the work originally published by the J. B. Lippincott Company in 1917. The frontispiece and illustrations facing pages 31 and 152 were in color in the original edition and are here reproduced in black and white. This edition is published by special arrangement wth the J. B. Lippincott Company, East Washington Square, Philadelphia, Pennsylvania 19105.

International Standard Book Number: 0-486-22226-8
Library of Congress Catalog Card Number: 78-172181

Manufactured in the United States of America
Dover Publications, Inc.
180 Varick Street
New York, N.Y. 10014

FOREWORD

THE present volume aims to offer in attractive and convenient form everything that is of importance and interest in regard to finger-rings, from the fabled ring of Prometheus down to the latest productions of the goldsmiths and jewellers of our day.

The subject offers a striking illustration of the wonderful diversity of form, decoration and usage, that the skill and fancy of man have been able to realize in the case of the little circlet constituting a ring. To make this clearer to the reader, a division in accordance with the general history and the special uses of rings has seemed more effective than any attempt to separate all the material along geographical or chronological lines.

One of the earliest uses to which rings were put was for the impression of an engraved design or device upon letters or documents, as the sign-manual of the wearer. From the time of the ancient Egyptians, this use prevailed in various parts of the world and many of the most striking rings of this type are described and figured here. Allied to these, and in some cases identical with them, are the rings given as marks of official dignity and rank.

A most important class are the rings bestowed upon and worn by the higher ecclesiastics. Papal rings, among which the most noted is the " Fisherman's Ring," rings for cardinals and for bishops, and also occasionally in former times, for abbots, were and are still regarded with special reverence in the Roman and Greek churches. The usage of wearing rings of this type dates far back in the history of Christianity. Many examples of these

rings are given, as also of others bearing Christian emblems, and of those worn by nuns, and by widows who had vowed never to re-wed.

Closely connected with these religious rings, are the betrothal and wedding rings. Here it has seemed best to group together the available data, since the line of demarcation between engagement and wedding rings, though clearly enough marked to-day, is not easy to draw in regard to earlier times. A very full selection of mottoes has been added, some of which might still be used; the greater number, however, belong to a past age, upon the sentiments of which they cast interesting side lights.

Rings as charms and talismans form a class apart. Often the peculiar form of the circlet was conceived to have a symbolic virtue, but more frequently the talismanic quality depended upon some curious engraved device, upon the stones set in the rings, or upon a mystic or religious inscription. Rings of healing were talismans valued for their special power to cure disease; the " cramp rings," dated in legend back to the time of Edward the Confessor, were notable in this series.

The rings of famous men and women will always be prized as mementos, and in the various chapters of this book a large number of them will be found, both rings of the mighty dead and those of distinguished living persons; among these latter we are happy to be able to produce an illustration of the inscription of President Wilson's ring from an impression of his seal courteously made by his own hand. It shows his name engraved in Pitmanic shorthand.

Our American Indians have also made their contribution to the art of ring-making, occasionally in the earlier centuries, and more especially in more recent times. Notably the Navajos of New Mexico have

exhibited a considerable degree of skill in this direction. Much new information on this subject will be found in the present work.

How rings are made by our jewellers of to-day, more especially by the accurate and varied mechanical methods now employed for their production, is concisely treated in a supplementary chapter. While machine-made rings can scarcely be expected to equal those executed by the hand of the true artist-goldsmith, those now, produced are nevertheless objects of beauty and adornment.

A ring is a symbol to which great interest is attached from the cradle to the grave. Frequently, a natal stone, or a ring set with a natal stone, is given to a child at its birth. When the child is baptized it receives the talismanic gem of the guardian angel. At confirmation the gem of the week is given. At graduation from school or college, a class ring is bestowed. Finally, on the announcement of an engagement, a ring set with any one of the choicer precious stones is selected for the fiancée. Thus each important epoch in early life has its appropriate memento, which will recall the memory of it in after years.

As very full indications as to the literature have been given in the footnotes, it has not seemed necessary to append the numerous titles in the form of a bibliography.

The author's thanks are due to the following persons, who have courteously imparted much valuable information:

Hon. Peter T. Barlow; Miss Ada M. Barr; W. Gedney Beatty; Theodoor de Boog, Museum of the American Indian; Dr. Stewart Culin, Brooklyn Institute; Robert W. De Forrest; Mrs. Alexander W. Drake; Dr. Gustavus A. Eisen; Prof. Richard Gottheil, Colum-

bia University; Dr. L. P. Gratacap, Curator, Dept. of Mineralogy, American Museum of Natural History; Right Rev. David H. Greer, Bishop of New York; Mrs. Isabel Hapgood; Prof. A. V. Williams Jackson, Columbia University; William H. Jones; Minor C. Keith; Dr. F. A. Lucas, Director, American Museum of Natural History; B. Mazza; Edward T. Newell, President, American Numismatic Society; Prof. John Dyneley Prince, Columbia University; Mrs. Annie R. Schley; Dr. George C. Stone; J. Alden Weir, President, National Academy of Design; Dr. Clark Wissler, Curator, Dept. of Anthropology, American Museum of Natural History; Theodore M. Woodland; Walter C. Wyman, and also the late William M. Chase; Dr. Charles S. Braddock, Jr.; Prof. Friedrich Hirth, Columbia University; Sidney P. Noe, Librarian, and Howland Wood, Curator, American Numismatic Society; Rev. Dr. John P. Peters and Rev. Father William J. Stewart, all of New York City.

Prof. Cyrus Adler, Dropsie College, Philadelphia; Dr. Hector Alliot, South Western Museum, Los Angeles, Cal.; Dr. F. H. Barrow, Director, Golden Gate Museum, Los Angeles, Cal.; Prof. Hiram Bingham, Yale University; Frank S. Daggett, Director, Museum of History, Science and Art, Los Angeles, Cal.; Dr. Joseph K. Dixon, Secretary, National American Indian Memorial Asso., Philadelphia; Dr. Arthur Fairbanks, Director, Museum of Fine Arts, Boston, Mass.; Franciscan Fathers, St. Michael's Mission, Arizona; Prof. L. C. Glenn, Vanderbilt University, Nashville, Tennessee; Dr. F. W. Hodge, Ethnologist-in-charge, Smithsonian Institution, Washington, D. C.; Prof. W. H. Holmes, Head Curator, Dept. of Anthropology, United States National Museum, Washington, D. C.; Dr. Wal-

ter Hough, Acting Head Curator, Dept. of Anthropology, United States National Museum, Washington, D. C.; Prof. Morris Jastrow, Jr., University of Pennsylvania; Dr. Berthold Laufer, Curator of Anthropology, Field Museum of Natural History, Chicago; Waldo Lincoln, American Antiquarian Society, Worcester, Mass.; Prof. George Grant McCurdy, Curator of Anthropology, Peabody Museum of Natural History, Yale University; Dr. William C. Mills, Curator and Librarian, Chicago Archæological and Historical Soc.; Edward S. Morse, Director, Peabody Museum, Salem, Mass.; Dr. Warren K. Moorehead, Curator, Dept. American Archæology, Phillips Academy, Andover, Mass.; Ostby & Barton Co., Providence, R. I.; Admiral Robert E. Peary, Washington, D. C.; Dr. R. Rathbun, United States National Museum, Washington, D. C.; William Riker, Newark, N. J.; Oliver A. Roberts, Librarian, Masonic Temple, Boston, Mass.; Prof. Austin T. Rogers, Leland Stanford Jr. University, Stanford University, Cal.; Dr. F. J. V. Skiff, Director, Field Museum of Natural History, Chicago; Prof. Friedrich Starr, University of Chicago; Rev. John Baer Stoudt, Northampton, Pa.; Ex-President William H. Taft, New Haven, Conn.; J. P. Tumulty, Secretary to President Wilson, Washington, D. C.; the late Dr. William Hayes Ward, Assyriologist, South Berwick, Mass.

W. W. Blake, Mexico City; A. W. Feavearyear, London, England; R. Friedländer & Sohn, Berlin; Prabha Karavongu, Siamese Legation, Washington, D. C.; Mrs. Isabel Moore, Azores; M. Georges Pelissier, Paris, France; Dr. William Flinders Petrie, Egyptologist, Hampstead, England; Sir Charles Hercules Read, Curator, Dept. British and Mediæval Antiquities and

Ethnography, British Museum; Dr. Leonard Spencer, Curator, Mineralogical Dept., British Museum (Natural History) ; C. J. S. Thompson, Curator, Wellcome Historical Medical Museum, London, England; Sir Herbert Tree, London, England; Dr. T. Wada, Tokio, Japan; Herr Leopold Weininger, Vienna, and also Dr. Albert Figdor, Vienna, and U. S. Consul W. Bardel, St. Michael, Azores.

The illustrations of rings in the British Museum are mostly from one or the other of the two exceedingly comprehensive catalogues of rings published by this museum: " Finger Rings, Greek, Etruscan and Roman," by F. H. Marshall, and " Finger Rings, Early Christian, Byzantine, Teutonic, Mediæval, and Later," by O. M. Dalton. In each volume the section devoted to a special description of each ring is preceded by a most scholarly and enlightening introductory essay.

G. F. K.

New York City,
November, 1916

[1] Signet of the author, reading George F. Kunz, New York. Engraved upon a dark red sard, in Teheran, Persia, in 1895.

CONTENTS

ILLUSTRATIONS

SPECIAL PLATES

RINGS

I

THE ORIGIN, PURPOSES AND METHODS OF RING WEARING

THE ORIGIN OF THE RING

THE origin of the ring is somewhat obscure, although there is good reason to believe that it is a modification of the cylindrical seal which was first worn attached to the neck or to the arm and was eventually reduced in size so that it could be worn on the finger. Signet rings were used in Egypt from a very remote period, and we read in Gen. xli, 42, that the Pharaoh of Joseph's time bestowed a ring upon the patriarch as a mark of authority. From Egypt the custom of wearing rings was transmitted to the Greek world, and also to the Etruscans, from whom the usage was derived by the Romans. The Greek rings were made of various materials, such as gold, silver, iron, ivory, and amber.

In his Natural History, Pliny relates the Greek fable of the origin of the ring. For his impious daring in stealing fire from heaven for mortal man, Prometheus had been doomed by Jupiter to be chained for 30,000 years to a rock in the Caucasus, while a vulture fed upon his liver. Before long, however, Jupiter relented and liberated Prometheus; nevertheless, in order to avoid a violation of the original judgment, it was ordained that the Titan should wear a link of his chain

on one of his fingers as a ring, and in this ring was set a fragment of the rock to which he had been chained, so that he might be still regarded as bound to the Caucasian rock.

Another origin ascribed to the ring is the knot. A knotted cord or a piece of wire twisted into a knot was a favorite charm in primitive times. Frequently this was used to cast a spell over a person, so as to deprive him of the use of one of his limbs or one of his faculties; at other times, the power of the charm was directed against the evil spirit which was supposed to cause disease or lameness, and in this case the charm had curative power. It has been conjectured that the magic virtues attributed to rings originated in this way, the ring being regarded as a simplified form of a knot; indeed, not infrequently rings were and are made in the form of knots.[1] This symbol undoubtedly signified the binding or attaching of the spell to its object, and the same idea is present in the true-lovers' knot.

Many rings of the Bronze Age were found in the course of excavations conducted in 1901 by M. Henri de Morgan in the valley of Agha Evlar, stretching back from Kerghan on the Caspian Sea, in the region known as the " Persian Talyche." Here several sepulchral dolmens were discovered which yielded a considerable number of ornamental objects of metal and stone, as well as beads of vitreous paste. There was no trace of inscriptions to aid in dating these " Scythian " finds, but they are considered to belong to the second millennium before Christ. The bronze rings are of several different types, some of them showing from three to five spirals; in other cases the ends

[1] Fossey, " La magie assyrienne," Paris, 1902, p. 83.

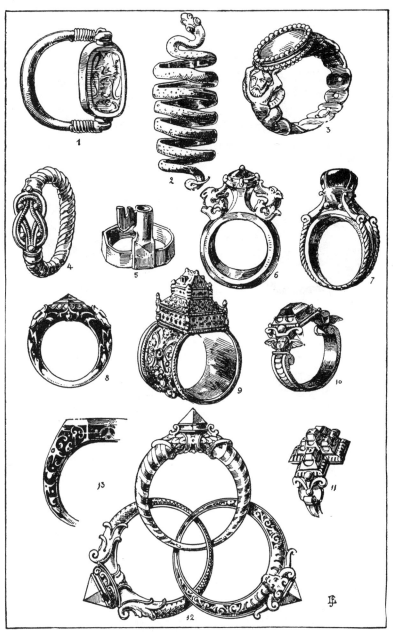

EVOLUTION OF THE FINGER RING

1, Egyptian seal ring. 2, Greek snake ring, found at Kertch in the Crimea. 3, antique **Roman ring** (Berlin Antiquarium). 4, Romano-Etruscan ring. 5, Roman key ring. 6, Gothic ring with stone set on raised bezel. 7, Gothic ring with cabochon-cut stone. 8, Renaissance ring with enamel decoration. 9, Hebrew wedding ring. 10, Renaissance ring. 11, Renaissance ring. 12, coat of arms of the Medici, three interlinked stones, each set with a natural pointed diamond crystal

Large serpentine ring with many coils.
Græco-Roman, Fourth Century B.C. to
Second Century A.D.
British Museum

Græco-Roman silver ring, set with
an oval engraved sardonyx. Second
Century A.D.
British Museum

Greek gold ring with eye-shaped bezel.
From Tarsus; Third Century A.D.
British Museum

Hellenistic bronze ring. Bezel set with a
convex pale green paste. Remains of gilding
on ring
British Museum

Greek silver ring. Engraved de-
sign beneath a sunk border; draped
figure of a girl holding out a dove
British Museum

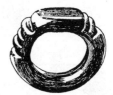

Roman ring of opaque dark glass.
Fourth Century A.D.
British Museum

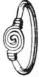

Mycenæan gold rings. 1, from
Ialysos, Rhodes; given to the British
Museum in 1870 by John Ruskin;
2, from excavation at Enkomi, 1896
British Museum

are overlapping, or else brought together as closely as possible.[2]

Although it would scarcely be safe to assume that finger-rings were never worn by the ancient Assyrians, still the almost total absence of representations of them, even on female figures, renders it safe to say that this must have been only very rarely the case. Possibly the persistence in Assyria and Babylonia of the cylindrical form of seal may account for this, in part at least, for the signet ring in many places was evolved from the cylinder-seal. Moreover, the absence of small intaglios in the period earlier than 500 B.C. would have deprived a ring of its almost essential setting. The plates in Layard's great work on Assyrian remains, as well as those published by Flandrin and Coste, also offer strong negative evidence, although Dr. William Hayes Ward states that he would have expected finger-rings might have come from Egypt by the way of Syria. At a later period, under Greek influence, rings were not uncommon.[3] In the immense cemeteries at Warka and elsewhere numerous iron rings have been found, many of them toe-rings, as well as some made of shell, but the date of these burials is not easily determined, and they are probably, in most instances, not of much earlier date than the eighth or even the sixth century before Christ.

A proof that genuine antiques can still be picked up in our day in the East is given by Doctor Ward, who said that he bought in Bagdad a lovely gold ring set with a cameo on which was inscribed in Greek char-

[2] Délégation en Perse, Mémoires publiés sous la direction de M. J. de Morgan, vol. viii, " Recherches archéologiques," 3d ser., Paris, 1905, pp. 321, 322 ; figured on p. 320.

[3] Communicated by the late Dr. William Hayes Ward.

acters "Protarchus made it." When, on visiting London, he told this to Doctor Murray, of the British Museum, the latter gave full expression to his scepticism, saying, "There are plenty of those signed things." But when the gem itself was shown him, he exclaimed, "This is jolly genuine," and he had it photographed for his book.[4]

A very interesting find was made in 1893, during the excavations conducted under the auspices of the University of Pennsylvania at Nippur. In the northwestern part of the mound, as many as 730 inscribed tablets were unearthed, which had been carefully stored in a chamber measuring eighteen by nine feet. These tablets, when deciphered, proved that the chamber was the record room of the sons of a certain Murashu, Bêlhâtin and Bêl-nadin-shumu, whose activity seems to have been analogous to that of our counsellors-at-law. Many of the tablets bear records concerning the members of the family personally, but in other cases their services appear to have been claimed in various legal difficulties. One of the most curious of these ancient documents is a contract dated the eighth of the month of Elul, in the year 429 B.C. (thirty-fifth year of Artaxerxes I of Persia), in which Bêl-ah-iddina, Bêlshumu, and Hatin give the following guarantee to Bêl-nadin-shumu, son of Murashu:

As concerns the gold ring set with an emerald, we guarantee that in twenty years the emerald will not fall out of the gold ring. If the emerald should fall out of the gold ring before the end of twenty years, Bêl-ah-iddina, Bêlshumu, and Hâtin shall pay unto Bêl-nadin-shumu an indemnity of ten mana of silver.

The record bears the names of seven witnesses and

[4] Communicated by the late Dr. William Hayes Ward.

that of the scribe, and is signed with the thumb-nail marks of those who guaranteed the jewel, " instead of their seals." [5]

It seems that we have here the names of the members of a firm of jewellers doing business in Nippur, in the fifth century before Christ, and evidently they were quite confident that the work they sold was well and solidly done, for the indemnity represented a sum equivalent to about $400 in our money. This must have been the estimated value of the emerald. As the stone was probably not very large, this particular gem must have been highly valued at that time, a fact due, in all likelihood, to the special talismanic virtues attributed to it.

Several gold rings of Egyptian workmanship, excavated in tombs at Enkomi, Cyprus, date back to the time of the Middle Empire in Egypt. One in pale gold, now in the British Museum, has a flat oval bezel, inscribed " Maāt, the golden one of the two lands." This belongs to the period from the XIX to the XXI Dynasty (or approximately from 1350 to 1000 B.C.). A ring found on the surface of the ground is of electrum and very massive, and is engraved with a draped figure seated on a throne, to whom approaches another figure clothed with a lion's skin and wearing on the head a disk and horns; a lion walking is in the exergue, and the sun's disk is above the two figures. This is believed to belong to the late XVIII Dynasty, toward 1400 B.C. A thin, rounded hoop of pale gold, the ends of which are twisted round each other, and a rounded hoop of yellow gold engraved with four uræi, are two other ex-

[5] Hilprecht and Clay, " Business Documents of Murashû Sons of Nippur ": The Babylonian expedition of the University of Pennsylvania, Series A: Cuneiform texts, vol. ix, Philadelphia, 1898, p. 30.

amples in the British Museum of the rings from Enkomi. A massive silver ring from the same place has a large oval bezel with the following names and titles inscribed in Egyptian hieroglyphics: Rā-Heru-Khuti, Rā-Kheperu Nefer, Meri-Rā, Ptah-neb-nut-maāt.[6] The Cypriot gold ornaments which these rings help to date are considered to be essentially contemporary with those from the tombs in the lower town of Mycenæ, the period being approximately 1300–1100 B.C., possibly some years earlier or later.

A beautifully worked, perforated gold ring, set with a scarab of carnelian, was found in Cyprus and is now in the Konstantinidis Collection at Nicosia. The workmanship as well as the style of the setting indicates that it was produced in the sixth century B.C. Engraved on the carnelian is a fabulous monster, somewhat resembling a chimæra, half lion, half boar.[7] Another ring of the same period from Marion-Arsinoë, Cyprus, has a silver hoop, and is set with a flat scaraboid, engraved with a female figure kneeling.

One of the largest Mycenæan rings shows a goddess seated near a tree, and worshippers approaching to do her homage. Others offer various devices: an altar with worshippers; a griffin and a seated divinity; a pair of sphinxes; griffins, bulls' heads, etc., in heraldic order-

[6] F. H. Marshall, " Catalogue of Finger Rings, Greek, Etruscan and Roman, in the . . . British Museum," London, 1907, pp. 1, 2, 997 (see pl. xx) ; also the same author's Catalogue of the Jewellery Greek, Etruscan and Roman, in the . . . British Museum, London, 1911, p. xvii.

[7] Max Ohnefalsch-Richter, " Kypros, the Bible, and Homer," London, 1893, vcl. i, p. 367, and vol. ii, plate xxxii, fig. 32.

ing.[8] Here we have early Greek art transforming and adapting Oriental forms of metal engraving, to be succeeded, more than five centuries later, by the great gem-engravings of the palmy days of the art of Ionia and Greece.

Among the Cyprian rings of the Mycenæan period, about 1000 B.C., in the British Museum, is a double gold ring which had been evidently inlaid with some vitreous substance, all but faint traces of which have now disappeared. This was found in a site near Famagusta, Cyprus, that has been satisfactorily identified with the spot where the Greeks under Teucer are said to have established a settlement on their return from the siege of Troy. Other gold rings discovered here at the same time, in 1896, have plain hoops, with a small cylindrical ornament strung on the hoop, to serve in place of a bezel with setting. Still another of these rings has, on one side, an extension squared off at the corners, making a long and narrow flat surface on the outside of the hoop; along its edge runs a beaded ornamentation.[9]

The oldest Greek ring bearing an inscription is one believed to belong to the late Mycenæan period. The gold hoop has engraved upon it the Cypriot syllables Le-na-ko, possibly meaning the name Lenagoras. It was found with other ornaments in a grave near Lanarka, Cyprus.[10] The similarity of the name Lanarka with the

[8] Strena Helbigena, 73; Journal of Hellenic Studies, vol. xxi, p. 155, fig. 33; p. 159, fig. 39; Schliemann Mycenæ and Tiryns, pp. 354, 360.

[9] See F. H. Marshall, *op. cit.*, p. 3; rings from Enkomi, Cyprus.

[10] Pauly's Real Encyclopädie der Altertumswissenschaft, vol. ix, pt. i, col. 827; Stuttgart, 1914; Marshall, Catalogue of the Finger Rings, Greek, Etruscan, and Roman, in the British Museum, London, 1907, No. 574.

phonetic value of the inscribed signs might perhaps suggest that a place name rather than a person's name is signified. That in ancient times several cities had their special signets is proved by a Greek inscription as to the cities of Smyrna, Magnesia, and Sipylum.[11]

Pliny already remarked the fact that nowhere in the Homeric poems is any mention made of rings or of seals. This is the more singular that we have so much positive evidence in Cretan and Mycenæan remains that rings were known to a part of the Greek world for a long time prior to the composition of the Iliad and Odyssey. Probably due allowance must be made for the individual preference of the poet, or school of poets, to whom we owe these masterpieces of ancient literature. In our own day, the present writer in his researches has often been disappointed to find nothing concerning precious stones or jewels in a given work treating of a subject that would invite their mention, the obvious reason being that the author cared little or nothing for such things, and hence passed over, unnoticed, all data regarding them. Nevertheless, the metal-worker's art evidently appealed strongly to the author (or authors) of the Homeric epics, as is shown in many places, notably in the long description of the representations on the elaborately wrought shield made by Vulcan for Achilles (Il., xviii, 478–608).

Certainly the traditions of Homeric times, recorded by later Greek writers, tell of several rings worn by Homeric personages. A ring of Ulysses, engraved with a dolphin by order of the wily hero, in memory of the rescue of his son Telemachus by one of the creatures of the deep, is mentioned by Plutarch ("De solertia

[11] Corpus inscriptionum Græcarum, 3137, i, 87 sq.

anim.")．Moreover, Helen of Troy is stated to have worn on one of her fingers a ring bearing the figure of an "enormous fish," and, finally, the great Greek painter Polygnotus, a contemporary of Pericles (495–429 B.C.), in a painting showing the descent of Ulysses into Hades, represented the youthful Phocus as wearing a ring, set with an engraved gem, on one of the fingers of his left hand.[12] This painting was highly reputed in ancient times, and had been dedicated to Apollo in the shrine at Delphi by the Cnidians.

The significance of the ring in the fourth century before Christ, as an ensign of office in Athens, is brought out by a passage in the "Knights" of the comic poet Aristophanes, where the people, as an expression of their discontent with the administration of Kleon, demand that he surrender the ring with which he has been invested, as a proof that he is no longer entrusted with the office of treasurer.[13]

A clever use of a ring is reported to have been made by Ismenias of Thebes, when he was sent by the Bœotians as an envoy to the Persian King. Before he was brought into the royal presence he was instructed by the master of ceremonies that he must prostrate himself before the sovereign. This act was strongly repugnant to his Greek consciousness, both as a debasement of his individual dignity, and as an act of divine homage offered to a mortal. To escape from the dilemma, the envoy, as he approached the throne, took off his ring and succeeded in dropping it without attracting too much attention; whereupon he stooped and picked it up. The Greek onlookers understood the meaning of his action, while

[12] Le Brun-Dalbanne, "Les Pierres gravées du trésor de la cathédrale de Troyes," Paris, 1880, p. 32.

[13] Aristophanes, "Knights," Act II, sc. 4.

the Persians believed that he had satisfactorily con-
formed to the court ceremonial. His little ruse was
rewarded by a favorable reception of his requests by
the Persian King, who had long been offended by the
obstinate refusal of the Greeks to render him the homage
he regarded as his due.[14]

The iron ring of the Romans, accounted for in
popular fancy by the tale of the rock and link ring of
Prometheus, probably came to the Romans from the
Etruscans, who appear to have owed the fashion to the
Greeks, and Pliny notes in his "Naturalis Historia,"
written about 75 A.D., that even then the Lacedæmonians,
with true Spartan sobriety, still wore iron rings.[15]
Roman tradition carried back the introduction of such
rings to the age of Numa Pompilius, about 700 B.C., and
there is evidence that, at a later time at least, they were
regarded as symbols of victory when worn on the hand
of a successful general, a late instance being the wearing
of an iron ring by Marius at his triumph for the victory
over Jugurtha in 107 B.C.[16]

The progressive changes in the Roman regulations
and customs governing the wearing of rings and the
material of which they should be made have been stated
in a concise and convenient form by M. Deloche, and
his conclusions are of considerable value, based as they
are upon a very careful study of the classic sources and
their best interpreters in the past.[17]

[14] Æliani, "Varia historia," Lib. I, cap. xxi.

[15] Lib. xxxiii, cap. iv.

[16] *Ibid., loc. cit.*

[17] M. Deloche, "Le port des anneaux dans l'antiquité
romaine, et dans les premiers siècles du moyen âge "; extrait des
Mémoires de l'Académie des Inscriptions et Belles Lettres, vol.
xxxv, Paris, 1896, pp. 4, 5.

The iron ring, the only one originally, was at first regarded as a mark of individual honor, awarded by the sovereign or in his name. From the earliest times of the Roman Republic, a senator sent on an embassy received a gold ring, all other senators being restricted to iron ones. Soon, however, senators of noble birth, and, later on, all senators without distinction, enjoyed the right of wearing gold rings. In the third century B.C. this privilege was then extended to the knights, and in the last years of the Republic, as well as under the emperors, many other classes of citizens were made partakers of the privilege, so that before long even some freedmen and certain of those pursuing the least reputable vocations were permitted the enjoyment of a distinction once so jealously guarded.

Toward the latter part of the third century A.D. all Roman soldiers could lawfully wear gold rings, although in the late Republican and earlier Imperial periods this right was accorded only to the military tribunes. Thus, finally, all class distinctions in this respect were done away with. Every freeborn man could wear a gold ring, freedmen, with a few exceptions, were confined to silver rings, and the iron ring became the badge of slavery.

After the battle of Cannæ (August 2, 216 B.C.), in which the Romans were totally defeated by Hannibal, the Carthaginian leader ordered that the gold rings should be taken from the hands of the dead Romans and heaped up in the vestibule of his quarters. Enough were collected to fill a bushel basket (some authorities say three bushel baskets), and they were sent to Carthage, not as valuable spoils of war, but as proof of the great slaughter among the Roman patricians and knights, for at this time none beneath the rank of knights, and only those of highest standing among them, those

provided with steeds by the State (*equo publico*), had been given the right to wear gold rings.[18]

On days of national mourning the gold rings were laid aside as a mark of sorrow and respect, and iron rings were substituted. This was the case after the defeat at Cannæ in 216 B.C. and on the funeral day of Augustus Cæsar in 15 A.D. This usage is noted in one of the poet Juvenal's satires.[19] Occasionally, as a mark of disapprobation, senators would remove their gold rings at a public sitting, as, for instance, when, in 305 B.C., the appointment as edile of Cneius Flavius, son of the freedman Annius, was announced in the Senate.

In Rome suppliants took off their rings as a mark of humility, or a sign of sadness. When the censors C. Claudius Pulcher and Titus Sempronius Gracchus were cited by the tribune Rutilius as guilty of a crime against the State, Claudius was condemned by eight of the twelve centuries of Knights. At this, many of the principal personages of the Senate, taking off their gold rings in the presence of the assembled citizens, put on mourning garments, and raised supplications in favor of the accused persons.[20]

Another instance of this usage with suppliants is shown in a recital of Valerius Maximus, wherein he relates that when, about 55 B.C., Aulus Gabinius was violently accused by the tribune Memmius, and there seemed to be little hope that he would escape punishment, his son Sisenna cast himself as a suppliant at the feet of Memmius, tearing off his ring at the same time. This mark of humiliation finally induced Memmius and

[18] Titi Livii, " Ab urbe condita," lib. xxiii, cap. xii.

[19] Sat. iii, lines 153–156.

[20] Titi Livii, "Ab urbe condita," lib. xlii, cap. xvi.

his fellow-tribune Lælius to withdraw the accusation, and set Gabinius at liberty.[21]

The wearing of a gold ring, because it was a sign of patrician and later of free birth, had such a high value in the eyes of the Romans that some freedmen used the subterfuge of wearing a gold ring with a dark coating, so that it would appear to be of iron. Thus, although they neither had the gratification nor incurred the perils of wearing a symbol confined to the freeborn, they had the intimate personal satisfaction of knowing that it was really on the hand.[21a]

From the rather scant evidence that has come down to us, it appears that Roman women were not subjected to as strict regulations in the wearing of rings of precious metal as were the men. The wives of simple plebeians who were in good circumstances seem as generally and freely to have worn them as the wives and daughters of senators or knights, or other patrician women. Pliny writes of the women wearing gold on every finger.[22]

In Rome, as early as the first century, at a time when the right of wearing gold rings was, as has been shown, very strictly limited, it occasionally happened that a famous actor was accorded this privilege by the special favor of some influential admirer of his art. Sulla granted this right to Roscius, and some years later, in 43 B.C., the Roman quæstor in Spain bestowed a gold ring upon Herennius Gallus in the ancient city of Gades, the modern Cadiz. This gave him the right to occupy a seat in one of the first fourteen rows at the theatre, the part reserved for the knights. This special privilege

[21] Valerii Maximi, " Factorum et dictorum memorabilium libri IX," lib. viii, cap. i.

[21a] See Plinii, " Naturalis Historia," lib. xxxiii, cap. xxiii.

[22] " Naturalis Historia," lib. xxxiii, cap. xi.

was accorded to the actor by the Lex Roscia of 67 B.C., conferring the ring upon Roscius.[23]

Although the Christian women of the early Christian centuries were taught to avoid all superfluous adornments, the wearing of a gold ring was permitted to them. This was not, however, to be considered as an ornament, but was simply for use in sealing up the household goods entrusted to a wife's care. Nevertheless, while noting this use, Clemens Alexandrinus (ca. 150–ca. 217 A.D.) adds that, if both servants and masters were properly instructed in their respective duties and obligations, there would be no need for such precautions.[24]

The dignity conferred by the right to wear a gold ring is even noticed in the Epistle of James, where we read (ii, 2–4):

For if there come unto your assembly a man with a gold ring, in goodly apparel, and there come in also a poor man in vile raiment, and ye have respect to him that weareth the gay clothing, and say unto him, Sit thou here in a good place; and say to the poor, Stand thou there, or sit here under my footstool; are ye not then partial in yourselves, and are become judges of evil thoughts?

While this apostle here, as elsewhere in his epistle, warmly espouses the cause of the poor, the prominence he gives to the gold ring as a mark of the rich man, and a passport to the place of honor in the congregation, is a full acknowledgment of the impression it created upon strangers, just as the ribbon of an order is taken as a

[23] F. H. Marshall, " Catalogue of the Finger Rings, Greek, Etruscan and Roman, in the . . . British Museum, London, 1907, p. xix, citing Macrobius, Saturnalia III, 14, 13, and Cicero, Ad. Fam. X, 32, 2.

[24] Clementis Alexandrini, " Pædagogus," lib. iii, cap. ii.

proof of dignity or station in monarchial countries to-day, and even to a certain extent in republican France.

The custom of bestowing birthday rings (*anuli natalitii*) was frequently observed in imperial Rome, and a rich and influential personage, with many friends and clients, would receive a large number of these rings on the anniversary day of his birth. As a rule, a setting of white sardonyx seems to have been most favored, to judge from a line in the first of the Satires of the Latin poet Persius (34–62 A.D.).

The famous decree of Justinian, promulgated in 539 (Novella 78 of the Digest), conferring upon freedmen the right of wearing gold rings, runs as follows: [25]

If a master, on freeing his slave, has declared him to be a Roman citizen (and he is not allowed to do otherwise), let it be known that, according to the present law, he who shall have received his liberty shall have the right to gold rings and to regeneration, and shall not need to solicit the right of the prince, or to take any other steps to secure it. It will be his as a consequence of his liberation, in virtue of the present law, which goes into effect from this day.

This decree shows that, as is proved by other texts, freedmen were sometimes accorded the privilege of wearing gold rings by special permission of the ruler or State, but all who could not obtain such special permission were punishable if they ventured to wear a gold ring, just as in countries where State orders are recognized and protected the wearing of such an order or of its ribbon by unauthorized persons is punishable in some way. The " right of regeneration " is more peculiar, as this refers to a legal fiction, by which it was assumed that some one of the ancestors of the freedman had been

[25] Beck, " Corpus juris civilis," vol. ii, pp. 406, 407.

free-born; hence, the quality of free-birth was only re-
vived, not created, in the case of the descendant. This
is, after all, not so unreasonable as it may seem to be,
for the slaves, being generally prisoners of war, or else
the descendants of citizens who had in some way lost
their citizenship, could truly claim, in a majority of
instances, that they came of free-born stock.

The image of Mars on a ring-stone was greatly
favored by Roman soldiers. A good example of this
style of ring is to be seen at the National Hungarian
Museum in Budapest. The gem, a carnelian, is en-
graved with a figure of the god, with helmet and spear;
his left hand rests on a shield bearing the Medusa's head.
The hoop is of silver. This ring was found in Bosnia
and was donated to the museum in 1820.[26]

An old Roman inscription mentions a guild of ring-
makers (*conlegium anularium*),[27] and the denomination
anularius even appears as a proper name of the engraver
of a signet ring.[28] Near the Forum was a flight of steps
designated *scalæ anulariæ*,[29] indicating either that ring
engravers or vendors were to be found there, or that they
had their shops or workshops in the neighborhood.

Treating of the dictatorial conduct of the Procurator
Verres, Cicero, in his violent, we might almost say viru-
lent arraignment of him, were it not so well deserved,
says that when Verres wished to have a ring made for
himself he ordered that a goldsmith should be summoned
to the Forum, publicly weighed out the gold for him,

[26] Cimeliotheca Musei Nationalis Hungarici, sive catalogus
historico-criticus antiquitatum, raritatum, et pretiosorum—eius
instituti," Budæ, 1825, p. 136.

[27] Corpus inscriptionum Latinarum, vol. i, No. 1107.

[28] *Ibid.*, vol. xi, No. 1235.

[29] Suetonii: " Vita Augusti," 72.

Spanish silver coins reached them. The Navajos are believed to have acquired their knowledge of jewellery-making from the Pueblo Indians who were the first to undertake it. Prior to this there was massive work in copper probably due to influences from the North. The Spanish derivation of the silver-working is proven by the old Spanish methods used; the bellows is Spanish-Moorish. No reference either to the making or the use of jewellery before recent times by the Navajos is believed to exist. As an indication of the source of the silver used, the Hopi name of this metal is *shiba,* the literal meaning of the word being " a little round, white cake," an apt designation of a silver coin. In the total absence of archæological evidence as to the Navajos, Dr. Walter Hough is decidedly of the opinion that silver work among the tribe is of comparatively recent date. A few of the Navajo finger-rings in the National Museum in Washington are at least old enough to show considerable signs of wear.[41]

Among the women of the Pueblo Indians the wearing of a great number of rings on the hand is an indication of aristocratic birth. This is illustrated in the accompanying plate, showing a ring on every finger of both hands; they are of silver, set with turquoise. Rings of this type are also shown in the portrait of a Navajo maiden, a daughter of Chee Dodge, dressed in the costume of the wife of a Navajo chief.[42]

As the Navajo silversmiths dwelt in small huts or temporary shelters which they might move away from

[41] Communicated by Walter Hough, Acting Head Curator, Dept. of Anthropology, United States National Museum, Washington, D. C.

[42] Communicated by Joseph K. Dixon, Secretary of the National American Indian Memorial Association.

One of the best of these Indian ring-makers is Koch-Ne-Bi-Ki Bitsilly, called Charley for short. He finds regular employment in the Grand Canyon shop at Albuquerque, N. M., for several months in each year, devoting the remainder of his time to the care of his sheep and other property. He is pronounced to be above the average in intelligence, energy and initiative. Other silversmiths are: Asidi Yashe, Charlie Hogan, Charlie Largo, Malapai, Bigay and Hastin Nez.

Of the stones used for ring-settings, garnets are never employed except at the special request of a trader; rarely, roughly-cut peridots are set in rings. Turquoise from New Mexico, is the favorite stone, although a little Persian turquoise is occasionally brought in by the traders and set in Navajo rings. In early times the turquoise supply came from the deposits near Cerrillos, now known as the Tiffany Mine,[40a] which furnished the material for all the turquoise ornaments in the ruins at Chaco Canyon and elsewhere. In the manufacture of rings these silversmiths frequently make a number at the same time, first fashioning all the hoops, and then adding the design to the hoops, after which the cups for the settings are added to the series. An industrious worker will be able to finish up as many as a dozen rings on this plan in three days, whereas, when special care is to be exercised in making a single ring, a whole day's work will be required. From four to five thousand rings are made annually in New Mexico and Arizona.

As metal working was unknown to the Navajos, as well as to the other Indians of the Southwest before the advent of the white man, it seems most probable that silver jewellery was not made by these Indians until

[40a] Not named after Charles L. Tiffany.

usually well formed, the projection at the upper part having a form suggestive of a finished bezel, thus rendering the ring a harmonious and attractive adornment for the hand. This interesting specimen was brought to light in 1898, with a few other shell rings. An Indian copper finger ring was unearthed, in the same year, in a grave forming part of a cemetery at the mouth of the Wabash River, southern Indiana. More recently, in 1912, what is believed to have been a stone ring was taken by Doctor Moorehead from the Red Paint Indian cemetery at Orland, Maine.[40]

The proficiency of the Navajo and Pueblo Indians of New Mexico as silversmiths is shown by the fact that there are from fifty to seventy-five Indians regularly occupied in this way at present, while several hundred others are more or less familiar with the art and work occasionally. The average pay is so much by the ounce, fifty cents for bracelets, conchos, etc., and seventy-five cents for rings, plus twenty-five cents for each and every setting. It has been estimated that a Navajo silversmith, if he find steady work, may earn as much as $125 a month. This, however, is rarely the case, as they are not fond of overwork, and when they have earned a little sum in ten or fifteen days, they will lay off until it is spent and they are again forced to resume their tasks. Of the more industrious, who might be willing to work uninterruptedly, many are quite prosperous, owning flocks of sheep or other live stock, or else farm land, which must be attended to in preference to the jewellery industry.

[40] Warren K. Moorehead, "A Narration of Exploration in New Mexico, Arizona, Indiana, etc.," Andover, Mass., 1906, p. 89, fig. 45.

among the remains of fifteen Indians found in this particular mound were those of a child.[37] A few stone rings, presumably for wear on the finger, have been met with in Indian graves in the Scioto Valley, Ohio, in Kentucky, in Tennessee and also in Arizona, New Mexico and California. An ornamental stone ring from Kentucky was evidently a finger-ring, as are also some others of the stone rings.[38]

A shell ring from the adobe ruins near Phœnix, Arizona, in the Salado Valley, shows the skill of the primitive Indians of this region in ring-making. Art in shell is pronounced by Dr. Warren K. Moorehead to be characteristic of the early Indian peoples of this valley, the shell material, which is found in great profusion in the ruins and in the desert, having come here either because of trade relations with the Indians of the sea-coast, or as a result of frequent journeys by some of the Salado peoples to the distant salt water. The discovery of shell frogs in the so-called " City of the Dead " in this valley, by Prof. Frank H. Cushing, some thirty years ago, was at first received with considerable incredulity, but since then several have been unearthed by successive explorers. Shell and bone implements with turquoise inlays occur both in Arizona and New Mexico.[39] The shell ring we have just noted, is un-

[37] Warren K. Moorehead, " Primitive Men in Ohio," New York, 1892, p. 148; see plate xxvi, p. 152.

[38] Warren K. Moorehead, " Stone Age in North America," Boston and New York, 1910, vol. i, p. 440, fig. 385, ring in Collection of B. H. Young, Louisville, Kentucky.

[39] See the writer's " Magic of Jewels and Charms," Philadelphia and London, 1915, pp. 352, 353; colored plate opp. p. 352.

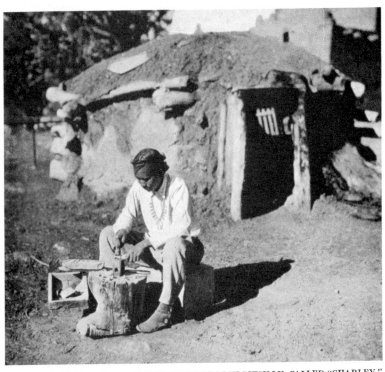

NAVAJO SILVERSMITH OF ARIZONA, KOCH-NE-BI-KI-BITSILLY, CALLED "CHARLEY,"
MAKING RINGS AT GRAND CANYON, ARIZONA

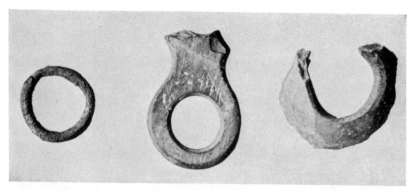

Ancient Indian rings. 1, copper finger ring. From a grave in cemetery at mouth of the Wabash, Southern Indiana, 1898. 2, stone ring (?). From Red Paint Cemetery, Orland, Maine. Explored by W. K. Moorehead in 1912. 3, shell ring, broken. From adobe ruin, Mesa, Arizona, 1898. All full size
Courtesy of Mr. Warren K. Moorehead

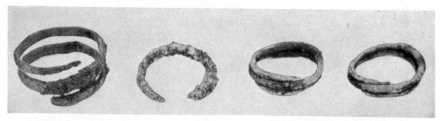

Ancient Indian metal finger rings. 1, spiral ring from middle finger of a skeleton. Hamilton Co., Ohio. 2, broken ring taken from floor of Adana Mound, Ohio. 3 and 4, rings from middle finger of skeleton found in the Adana Mound, Ohio Natural size

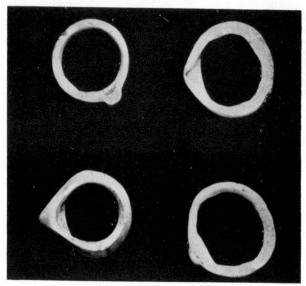

Four thin shell rings from the Indian adobe ruins near Phoenix, Arizona, explored in 1898
Courtesy of Mr. Warren K. Moorehead

mous superiority conferred on them by their fire-arms.
Even the few specimens which were actually brought to
Charles V seem to have disappeared, and were probably
melted down for use as bullion.[35]

Of the silversmiths' methods a little can be learned
from a study of Aztec paintings. Thus we are able to
know that they used the crucible, the muffle and the blow-
pipe. The statement is made by Torquemada and by
Clavigo that they possessed the now lost art of casting
objects half of gold and half of silver. Some fine ex-
amples of Aztec work in gold and silver are to be seen
in the marvelous collections of the Museo Nacional in
Mexico City, and among them are several finger-rings.
One of these comes from Teotihuacan; its broad hoop is
decorated with the head of one of the Aztec gods, wearing
an elaborate and curiously complicated head-dress.
Other gold rings are of a peculiar type, the inner half
of the hoop being only about two-fifths as high as the
outer and very broad half, so that the finger could be
closed without inconvenience.[36]

So few finger-rings of the Indian aborigines, who
once inhabited the present territory of the United States,
have been brought to light, that some authorities have
been disposed to deny the existence of any relics of
this kind. Among the rare discoveries may be noted a
copper ring found in one of the Indian mounds near
Chillicothe, Ross County, Ohio. This ring has been
made by bending a short copper rod until the ends over-
lapped and then pounding them as closely together as
possible. It is only large enough for a child's finger, and

[35] W. W. Blake, " The Antiquities of Mexico," New York,
1891, p. 74, figure.

[36] *Ibid.*, p. 73, figures.

continent, as in the instance above noted, rings have been found in burials believed to be pre-Columbian.

To the very few pre-Columbian rings found in Indian mounds, belong four from Ohio, now in the collection of the Ohio State Archæological and Historical Society, Columbus, Ohio. One of the rings was unearthed twenty years ago from a mound in Hamilton County; it is of spiral form and was on the middle finger of the left hand of a skeleton. The three others came from the Adana Mound, two of them being spiral-rings, both found on the middle finger of a skeleton's left hand; the third is not a complete circle, and was picked up at the base of the mound. The spiral-rings are very finely and delicately fashioned.[34]

The Aztecs of ancient Mexico executed many ornamental objects of gold, silver, copper and tin, and worked in iron and lead as well. Specimens of this silversmiths' work were sent by Fernan Cortés to Emperor Charles V, and their artistic quality elicited the admiration of the Spanish jewellers. These seem to have been only a small portion of the rich booty gathered by the Spanish Conquistador, the metal worth of which he estimated at 100,000 ducats ($250,000), or even more, according to the statement in a letter addressed to his sovereign. The greater part of this treasure is believed to have been lost during the " *Noche Triste,*" the " Night of Sorrows," when the Spanish conquerors were surprised and attacked in Mexico City by the native warriors, and were forced to seek safety, after suffering considerable losses in a retreat from the narrow, city streets into the open country, where they could better utilize the enor-

[34] Communicated by Dr. William C. Mills, Curator and Librarian of the Museum.

mains here also yielded a ring made out of a cone-shell, with incised decoration. The exceptionally fine specimen noted above almost certainly had a religious or talismanic character, and it may have been thought to protect the wearer from storms and thunderbolts.

The skill with which the shells were utilized for rings as well as for other objects of adornment must have been the result of many generations of experiment and training, springing from that inherent artistic sense so often manifest in the Indians of the pueblos in contrast to the Indians of the plains. Often the circular form was already present in the shell, and this was utilized by dividing a part of the cone into sections, thus giving rings of varying diameter. The material was then smoothed and polished, and either left plain or decorated with an incised pattern, into the outlines of which appropriate coloring matter was introduced. In other cases, when the shell material did not offer a natural circlet, a disk was cut out, and a large perforation produced the rough circlet, to be worked up later into a finished ring.

The attainable evidence in regard to the wearing of rings by the aborigines of North and South America is, in the main, negative. This is the case with the Pacific coast Indians, as well as with the Chiriqui graves and other ancient remains in the present United States of Colombia.[33] Indeed, so far as can be ascertained, the wearing of rings is essentially an Oriental fashion and was brought to the ancient peoples of Europe from the East. Still, here and there on the North American

[33] Communications from Prof. George Grant McCurdy, Curator, Anthropological Section of Peabody Museum of Natural History, Yale University, and from Dr. Frank S. Daggett, Director, Museum of History, Science and Art, Los Angeles, Cal.

and commanded the man to set his bench down in the Forum and to make the ring in the presence of all.[30]

Tacitus states in his Germania that the most valiant of the Cattæ, wore " like a fetter " an iron ring, which was a mark of infamy among the Germans. Only when a warrior had killed an enemy had he the right to divest himself of this ring. Whether this was a tribal usage, or only the sign of an obligation voluntarily assumed, must be left to conjecture. It is supposed to evidence that the slaves of the Germans wore iron rings, and that thus such rings were looked upon as badges of slavery.[31]

Finger-rings are exceedingly rare among the remains of the prehistoric American peoples, although a few have been found in the Pueblo ruins of Arizona and New Mexico. These are usually cut out of shell. Some of them are skilfully cut from Pectunculus shells, and others from " cone-shells " (*Conus*). Of the former kind a number were unearthed at Chaves Pass, Arizona.[32] Many of the rings were incised with an ornamental design; one of the most beautiful of these was decorated with red figures representing clouds and lightning. This ring, large enough to fit an adult's finger, was found, together with bones of a human hand, in one of the pre-Columbian graves, at Casa Grande, Arizona. The re-

[30] Cicero, " In Verrem," iv, 25, 26.

[31] Deloche, " Le port des anneaux dans l'antiquité romaine, et dans les premiers siècles du moyen âge," Paris, 1896, pp. 46, 47; extrait des Mémoires de l'Académie des Inscriptions et Belles Lettres, vol. xxxv, part ii.

[32] Jesse Walter Fewkes, " Two Summers' Work in Pueblo Ruins," Bureau of American Ethnology, vol. xxii, pt. i, p. 91. Also the same writer's " Casa Grande, Arizona," Bureau of American Ethnology, vol. xxviii, pp. 143, 144; rings figured on pl. lxxv, fig. *A*, and in text cut, fig. 49.

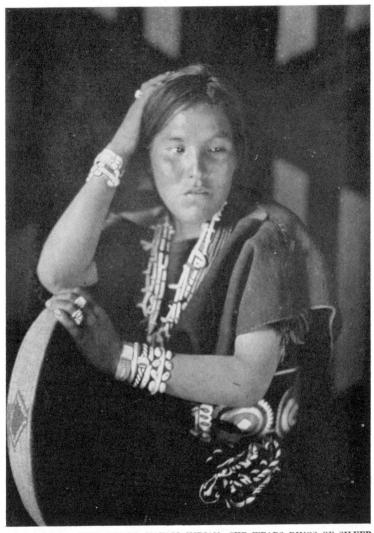

DAUGHTER OF CHEE DODGE, NAVAJO INDIAN. SHE WEARS RINGS OF SILVER
SET WITH TURQUOISE

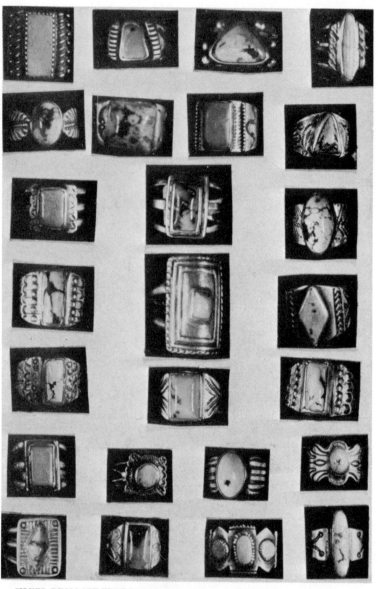

SILVER RINGS SET WITH TURQUOISE MINED IN ARIZONA AND NEW MEXICO,
MADE BY THE NAVAJO INDIANS, GRAND CANYON, ARIZONA. 1916

at short notice, they were forced to build low forges directly on the ground, obliging them to crouch down while working.[43] In this respect the Pueblo artisans had a considerable advantage, since their spacious dwellings made it possible for them to set their forges solidly in a frame high enough to enable them to do their work standing. A considerable number of tools and appliances are in the workshop of the Navajo silversmith; most of them, however, of rude fabrication and not well adapted for fine and accurate work. He deserves the more credit for the quality of work he is able to produce. The following is a pretty full list of the outfit in such a workshop: Forge, bellows, anvil, crucibles, molds, tongs, scissors, pliers, files, awls, cold chisels, matrix and die for moulding buttons, wooden stake, basin, charcoal, tools and materials for soldering (blow-pipe, braid of cotton rags soaked in grease, wire, and borax), materials for polish (sand-paper, emery-paper, powdered sandstone, sand, ashes, and solid stone), and materials for whitening (a native mineral substance—almogen, salt and water).[44]

It has been noted that the Navajos had not acquired the art of making an air chamber of the mouth in operating the blow-pipe, but blew with undistended cheeks, the result being an intermittent flame. The latter is furnished by burning a thick braid of cotton rags soaked in mutton suet or some other similar kind of grease. For the polishing work, the emery paper is sparingly used

[43] The details in this and the following paragraphs are taken from Washington Matthews, " Navajo Silversmiths," in the Second Annual Report of the Bureau of American Ethnology, 1880–1881, Washington, 1881, pp. 171–178.

[44] Op. cit., between pp. 174 and 175, plate showing silversmith's shop set up near Fort Wingate.

because of its cost. After all the preliminary polishing has been done with sandstone, sand or ashes, the finishing is done with emery-paper. For the blanching of the silver the hydrous sulphate of ammonia, termed almogen, is used, the silver being bathed in a solution of this, with the addition of a little salt. The blow-pipe is usually made by beating out a piece of thick brass wire into a long flat strip, which is then bent into the requisite form.

Two of the best of these silversmiths were engaged to work for a short time near Fort Wingate. As has been noted, their forges are commonly set very low down, and the position of the workers was evidently an uncomfortable one. Nevertheless, they showed a great degree of persistence, working sometimes as many as from twelve to even fifteen hours in a day. When paid by the piece, artisans could earn about two dollars a day on an average. The method of chasing was excessively primitive. While one worker held the object firmly on an anvil, the other applied to it part of the shank of a file that had previously been rounded, and struck this with smart taps of a hammer. Finer figures were engraved with the sharpened part of a file, to which a peculiar zigzag, forward motion was imparted by the hand. One fault that could be charged against these silversmiths was a lack of economy as to the precious material they used, no care being taken to gather up and utilize the amount lost in filing and polishing, as well as by oxidation in the forge, so that the net loss was estimated at fourteen per cent.

While the art of the work produced can scarcely be termed finished, when judged by very high standards, still the silver ornaments executed by the Navajos possess at least the charm inherent in individual work, as contrasted with the more harmonious and finished produc-

tions of merely mechanical art, where thousands of objects of a given type of design are turned out annually in a highly-organized silversmithing establishment. With these Indians we have the " personal note " that is too often missed in the ornaments of our day. This Navajo industry has received much encouragement from the managers of the Santa Fè Railroad, and from its agencies. Although the art among the Navajos is generally believed to have been introduced by Spanish influence, the fact that before the Spanish Conquest the native Mexicans were able to work metals with considerable skill would make it not improbable that it spread to the New Mexico tribes, and perhaps from them to the ancestors of the Navajos of to-day. The Navajo Indians belong to the Athapascan race and emigrated from the northwestern coast. Copper had been worked into ornaments from of old by Indians of the same stock in Alaska, and some remains indicate that this was the case, in rare instances, with the Navajos.

The superiority of the Navajos of a later time to the Pueblos as silversmiths, may, perhaps, result from their already acquired knowledge of copper-working. As the Navajo men had not the occupation of farming, as had the Pueblos, silversmithing gained favor among them as a fad, as a means of relieving the tedium of idleness. There is rarely any tendency to transmit this art directly from father to son, individual preferences being the chief factors. Indeed there is so little of the caste spirit among the Navajos that the occupation of the father counts for but little in determining that of the son. This is largely dependent upon the fact that descent is principally traced through the mother. Exogamy, marrying outside the clan, is the orthodox code of the Navajos, a man being expected to avoid taking a wife from the clan to

which his mother belonged,—a wise precaution for them.

As an early description of the lack of silversmiths' instruments of precision among the Navajos in planning and executing their work, Mr. Matthews says of conditions as he observed them thirty-five years ago:

" The smiths whom I have seen working had no dividers, square, measure, or any instrument of precision. As before stated, I have seen scissors used as compasses, but as a rule they find approximate centres with the eye and cut all shapes and engrave all figures by the unaided guidance of this unreliable organ. Often they cut out their designs in paper first and from them mark off patterns on the metal. Even in the matter of cutting patterns they do not seem to know the simple device of doubling the paper in order to secure lateral conformity."

As the Navajos have no silver mines in their country, they depend largely for their material upon Mexican silver dollars worth about 48 cents in United States money. These are melted and then molded, or else cut and hammered into the desired forms. Sometimes, United States half or quarter dollars are used in this way, although such silver costs more than twice as much, because of its worth as currency. Before silver was freely used, copper and brass were bought at the trading posts and favored as materials; a supply of these metals being often secured by melting down parts of the kettles or pans furnished to the Indians by the United States Government, or else bought from white settlers. Some old Navajo silversmiths assert that the art of working silver was introduced from Mexico about sixty years ago, toward the middle of the last century. About this time a Mexican silversmith named Cassilio came to the Navajo country and taught his art to a Navajo black-

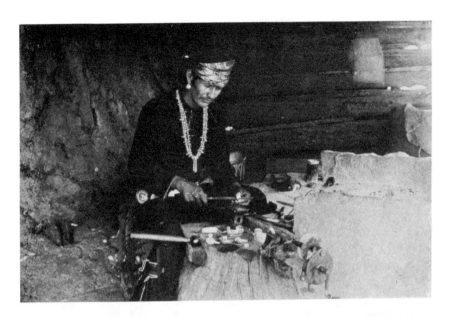

NAVAJO SILVERSMITHS OF NEW MEXICO, ENGAGED IN MAKING SILVER RINGS
1, Tsozi Bigay; 2, Atziddy Yaski

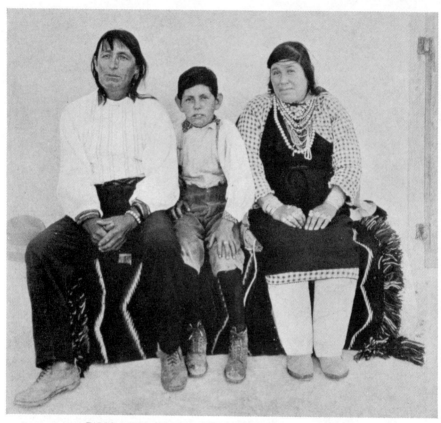

PABLO ABEITA, PUEBLO INDIAN, WITH HIS SON AND WIFE
The latter wears turquoise and silver rings on every finger of each hand
Courtesy of Dr. Joseph Kossuth Dixon

smith called by his people Atsidi Sani, or the "Old Smith." Cassilio is said to have been still living about 1872. An artisan considered to be one of the best, if not the very best of the Navajo silversmiths of our day, who is called Beshlagai Ilini Altsosigi or the "Slender Silversmith," originally learned his art from Mexicans. The fact that Lieut. James H. Simpson, who explored the heart of the Navajo country in 1849, has nothing to say about silversmithing, although he details very fully the various arts and industries of the Navajos, goes far to prove the truth of the statement that Navajo silversmithing dates from a later time.[44a]

Borax is now generally used for soldering, but before it was brought to their country, the Navajo silversmiths are said to have mined a certain substance for this use, probably a kind of native alum. Rock salt, an easily attainable material, called in the Navajo tongue *tse dokozh* (saline rock), was used for whitening tarnished or oxidized silver. For this purpose the salt was dissolved in boiling water, into which the silver articles were thrown and left for a time. In place of the sandstone, sand and ashes originally used, the silversmiths are now able to employ sandpaper or emery paper bought at the stores. Of the tools employed we have already treated at some length. The details in this and the preceding paragraph have been derived from the very interesting and valuable "Ethnologic Dictionary of the Navaho Language," published in 1910 by the Franciscan Fathers, at St. Michaels, Arizona.[45] Here

[44a] "An Ethnologic Dictionary of the Navaho Language," published by the Franciscan Fathers, Saint Michaels, Arizona, 1910, p. 271.

[45] This is a well-printed octavo of 536 pages, with a most comprehensive index.

the nouns and verbs denoting action are grouped in the only really logical way, under the respective industries and trades, or other forms of human activity. As some of the foremost writers on the origin of language have urged that its beginnings are to be sought in the various rhythmic exclamations of a body of workers, at first uttered automatically and later used consciously as calls to work, or to favor a coördination of efforts, no better classification of the vocabulary of a primitive race can be employed.

The various forms and qualities of silver rings found full expression in the Navajo language, a proof of the importance accorded to this branch of silversmithing among them. The word for ring being *yostsá,* we have the following designations: [46]

> yostsá deshzházh, a worn down ring
> yostsá geéldo, a broken ring
> yostsá énidi, a new ring
> yostsá quastqí, an old ring
> yostsá ntqél, a broad ring
> yostsá altsósi, a slender ring
> yostsá ntsa, a large ring
> yostsá altsisi, a small ring
> yostsá náilgai, a polished ring
> yostsá yijí, a blackened, oxidized ring
> yostsá do-bikeeshchíni, a plain ring
> yostsá bikeeshchíni, a ring with a design
> yostsá alkésgiz, a twisted ring
> yostsá bitsá, a ribbed ring
> yostsá biná, the setting of a ring
> yostsá tséso biná, a ring with a glass setting
> yostsá dotlízhi biná, a ring with a turquoise setting
> yostsá tlish beélya, a snake-shaped ring

[46] *Op. cit.,* pp. 283, 284.

Feb. 13th, '16

My dear Dr. Kunz;

Replying to your inquiry, I can recall no instance of an Eskimo of the Whale Sound region wearing a ring.

On one of my earlier expeditions I took an assortment

of weight rings along
in addition to needles
thimbles, beads, soap,
etc, for the women
of the tribe

I found they had
no attraction. Women
would accept them
as _gifts_ & hang
them up in their
tents or houses, but
would not accept

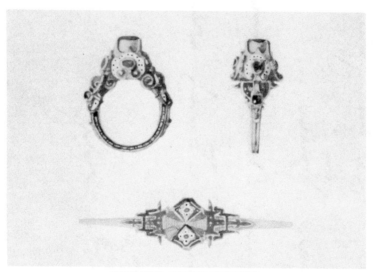

GOLD RING, RICHLY ENAMELED

The hoop has white, red and black enameling, and is studded with little emeralds and rubies. The high bezel is set with an emerald and with a small ruby on each of the four sides. Second half of Sixteenth Century

Albert Figdor Collection, Vienna

GOLD RING, WITH HEAD IN FORM OF A ROSE KNOT

The setting consists of a diamond in a silver bezel, and three rubies in gold bezels; between the rubies are three enameled playing cards. The hoop is of openwork interspersed with two playing cards and two ovals in enamel; a section of reddish gold indicates an enlargement of this ring. Eighteenth Century

Albert Figdor Collection, Vienna

This plate is discussed on pp. 89-90.

Rings are not in favor with the Eskimos, who do not appear to make or wear any. Indeed, Admiral Peary found it impossible to dispose of a lot of rings he had taken with him on one of his Arctic trips in the belief that they would be attractive to the Eskimos, and good objects of barter.[47] Perhaps in the intense Arctic cold even the slightest pressure on the finger may have been avoided, lest it should impede circulation and increase the danger of having the fingers frost-bitten.

The Mendæans of Mesopotamia are the silversmiths of this region, and they exhibit much skill in their work. The greatest demand is for cigarette cases and for signet rings and seals, although they make a variety of other small ornamental objects. Their methods of work are quite characteristic. In the case of the smaller objects, such as rings, etc., they hammer them out from a heated silver bar. When the general form has been attained, they work up the surface with a steel file or pencil, which has a triangular point; with it the desired design is laboriously engraved. This process being completed, a black metallic powder, made into a paste, is rubbed over the entire surface, naturally accumulating more or less, according to the greater or lesser depths of the cuttings; the object is then placed in a charcoal forge and fired. After it has remained therein long enough, it is removed and the superfluous powder is rubbed or worked off. The completed ring or other ornament then offers most beautiful contrasts between the bright silver and the lustrous black inlay. The Mendæans are sometimes called "Christians of St. John," because of their great veneration for John the Baptist.

[47] Communicated by Admiral Peary in a letter to the author, February 13, 1916.

However, they in no sense deserve the name of Christians, their peculiar, eclectic doctrine being a mixture of ancient and Christian Gnosticism, with certain elements of the old Persian religion. They have quite a literature, dating back to the early centuries of our era, and written in an Aramaic dialect similar to that of the Talmud.

THE PURPOSES OF RING WEARING

The wearing of rings as ornaments for the hand requires no explanation in view of the innate love of adornment shown from the very earliest periods of human history. However, apart from this merely ornamental use, rings were applied to many special uses and were worn for many definite purposes, some of which are so important as to merit extended notice in separate chapters; others again are less far-reaching and less significant, and certain of these will be explained and illustrated here.

We are not apt to think the wearing of many rings especially in accord with the profession of philosophy, and yet Ælian tells us that a chief cause of the dissension between Plato (427–347 B.C.) and his pupil, Aristotle (384–322 B.C.), arose from the blame bestowed by Plato upon the greatest of ancient philosophers—" the master of those who know," as Dante calls him—because Aristotle adorned his hand with many rings.[48] Could this have been done with a view to impressing his students and philosophers with greater respect than they might always have been disposed to accord to his intellectual greatness alone? The externals of luxurious adornment made, perhaps, a more direct appeal than the mere power

[48] C. W. King, "Antique Gems," London, 1860, p. 281; citing Ælian, iii, 19.

1, Late Roman ring; 2, gold ring set with an engraved red carnelian.
Found in 1846 near Amiens, France

1, ring of gilt copper set with a ruby; 2, ring set with irregularly-
shaped sapphire
Londesborough Collection

1, Roman ring, perhaps a signet; elliptical hoop with projecting shoulders;
2, hexagonal ring set with engraved stone bearing figure of Hygeia, the
Goddess of Health

Ring that was perhaps given by a Roman lady to a
successful charioteer. Bust of donor on summit of ring

All from Fairholt's "Rambles of an Artist"

1, spiral ring with heads of Isis and Serapis
2, Etruscan gold ring
British Museum
Fairholt's "Rambles of an Artist"

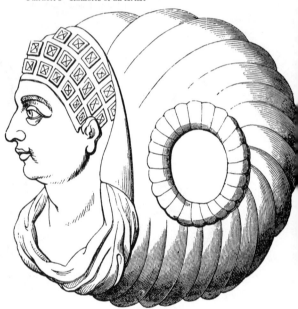

Silver ring with ten projections
(decade ring); that for the Creed (the
bezel) has the design of the Cross.
Impression
British Museum

Immense ring with female head incorrectly said to be that of Plotina,
wife of Trajan
Montfaucon, "L'Antiquité expliquée," Paris, 1719

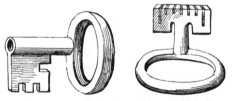

Ancient Roman Key Rings
Fairholt's "Rambles of an Artist"

of logical exposition could do, and such an eminently practical thinker as Aristotle was may not have been blind to these considerations.

A gold ring figured by Gorius is thought by him to have been a gift from an ardent Roman sportswoman to a victorious charioteer, to whose skill she may perhaps have been indebted for some material gain, since wagering in chariot races was as common in Roman times as betting on horse races in our own day. This ring is engraved with a woman's head and two heads of reined horses; the name of the donor, Pomphonica,[49] and the words *amor* and *hospes,* are engraved on the circlet. " Love the Host," as these words may be read, makes a slightly enigmatic inscription. Indeed, it may well be that some fair Roman had the ring made as a memento for her own use and wear. Another conjecture is that it was a man's ring executed as a memento of what was dearest to him, his lady-love and his chariot horses. It was in the Cabinet of the Tuscan grand duke Francis of Lorraine, later Emperor of Germany and husband of Maria Theresa.[50]

A Latin inscription, from Granada, Spain, mentions a ring, set with a jasper, that was placed by a son upon the statue of his mother. The value of the ring is given as 7000 sestertii, indicating that the stone was engraved; the design probably had a symbolic significance, as in the case of most of the votive rings.[51]

[49] Frederick William Fairholt, " Rambles of an Archæologist," London, 1871, p. 86, with figure of ring.

[50] J. P. Mariette, " Traité des pierres gravées," Paris, 1750 vol. i, p. 18.

[51] See Marshall, " Catalogue of the finger rings, Greek, Etruscan, and Roman, in the departments of antiquities, British Museum, London, 1907, p. xxvi, note.

Martial, in one of his epigrams (V.12) says that there was nothing surprising in the feats performed by certain athletes, when Stella could carry ten maidens upon one of his fingers. In a very interesting study on this subject, C. W. King endeavors to prove that the lines refer to a remarkable ring whereon ten precious stones must have been associated in some way with dedicated to Minerva and the Nine Muses. In another epigram (V.11) Martial writes of Stella turning sardonyxes, emeralds, diamonds, and jaspers around one of his finger-joints, and King conjectures that the Ten Maidens were represented by the opal, sapphire (hyacinth), spinel, Oriental topaz, almandine garnet, and pearl, in addition to the four stones enumerated above. Should this conjecture be well-founded these different stones were set at regular intervals, these stones being Minerva and the Muses, although we have no direct proof of this.

This ring of the Ten Maidens suggests the decade or rosary rings, of which so many specimens exist. Usually there were ten bosses or knobs, as the name indicates, but occasionally there were eleven, for counting ten Aves and a Pater. The earliest date Mr. Waterton is inclined to assign to rings of this type is the fourteenth century.[52] A so-called decade ring with twelve bosses is described in the catalogue of the Londesborough Collection.[53] Here the central knob is a tooth, opposite this is a piece of labradorite, while on either side are set two amethysts, a chrysoprase and an emerald, two jacinths, two turquoises, and two pearls. The twelfth knob stood for the creed. Sometimes, where there are eleven projections, ten paternosters and the creed were

[52] Archæological Journal, London, 1863, vol. xx, p. 75.
[53] London, 1853, p. 6.

to be recited. A good example of a decade ring is one of silver in the British Museum. The ten projections for the paternosters are very marked and the eleventh, for the creed, which forms the bezel, has the form of a crucifix, the cross resting on three steps. This rises to a considerable relative height above the hoop. Such a ring could scarcely be worn with comfort, its liturgical use evidently being the paramount idea of the maker.[54]

The gold and silver chaplet rings, with a cross and ten beads or bosses in relief upon the hoop, were frequently used by the Knights of Malta, in the eighteenth century; indeed this type of ring is said to have been invented by them. Their use as substitutes for the less convenient chaplet was spreading, until in 1836 the matter was referred by Pope Gregory XVI to the tribunal of penitentiaries. Its decision, transmitted by the Cardinal Penitentiary Castracane, as to the question " whether the gold or silver rings, surrounded by ten bosses, which are used by some pious persons for the recitation of the Rosary of the Blessed Virgin, can be blessed with the appropriate indulgences," was in the negative.[55]

The ring-money used by the ancient Gauls and Britons illustrates the employment of what might be ornamental objects as currency. An exceptionally fine specimen made of nearly pure gold was recently found by a farmer while he was ploughing a field near Wood-

[54] O. M. Dalton, " Franks Bequest, Catalogue of the Finger Rings, Early Christian, Byzantine, Teutonic, Mediæval and Later " (British Museum), London, 1912, p. 122, No. 792, pl. xi.

[55] X. Barbier de Montault, " Le costume et les usages ecclésiastiques selon la tradition romaine," Paris, 1897, vol. i, pp. 176, 177.

stock, Oxfordshire, England. Of course many or most of these rings were not worn but merely used as money.

A legal use of a sapphire ring to bind a bargain is recorded in a deed of gift, from about 1200 A.D., by a certain John Long to William Prohume, clerk, of land and houses in St. Martin's Street, Exeter, at a rent of 6s 8d, which sum was to be donated to St. John's Hospital in Exeter. The grantor acknowledges the receipt of 45 marks and of a gold ring set with a sapphire as the price of this lease on very favorable terms.[56]

Precious stones set in rings sometimes served to hide a " talisman " of a peculiar kind, namely, a dose of death-dealing poison, kept as a last resort to free the wearer of the ring from disgrace or from a worse death. So we are told that when Marcus Crassus stripped the Capitoline Temple of its treasures of gold, the faithful guardian broke between his teeth the stone set in his ring, swallowed the poison hidden beneath it, and immediately expired.[57] The great Hannibal, also, had recourse to the poison contained in his ring, when he was on the point of being given up to his bitter enemies, the Romans. Of this ring the satirist Juvenal wrote as follows: " *Cannarum vindex et tanti sanguinis ultor Anulus,*" or " That ring, the avenger of those who fell at Cannæ, and of so much blood that had been shed." Another great man, the peerless orator Demosthenes, is said to have carried with him a similar ring. In a Rabbinical commentary on Deuteronomy occurs the following curious passage:

Hast thou then no ring? Suck it out and thou wilt die.

[56] Historical Manuscripts Commission, Report of MSS. in various collections, vol. iv, Dublin, 1907, p. 59.

[57] Plinii, Hist. Nat., lib. xxxiii, cap. xxv.

This has been explained as referring to a hollow ring filled with liquid poison.[58]

Some ancient gold rings were made hollow, so that they could be filled with mastic or brimstone, or an aromatic material. In the old " Oneirocriticon," or " Dream Book " of Artemidorus, to see a ring of this kind in a dream portended treachery or deceit, as they enclosed something hidden from view, while a ring solidly wrought by the hammer was exactly what it purported to be.[59]

The poison-rings of the Borgias are not fabulous, for some of them still exist, one bearing the date 1503 and the motto of Cæsar Borgia in Old French, " *Fays ce que doys avien que pourra* " (Do your duty, happen what may). Beneath the bezel of this ring there is a sliding panel and when this is displaced there appears a small space where the poison was kept. Such rings simply afforded a ready supply of poison at need, but another type constituted a death-dealing weapon. It is curious to note how in a ring of this latter type the Renaissance goldsmith has combined an artistic idea with the nefarious quality of the jewel. The bezel is wrought into the shape of a lion, and the hollow claws of the animal admit the passage of a subtle poison concealed in a small reservoir back of the bezel. By a mechanical device the poison was pressed out of the cavity through the lion's claws, and it is conjectured that the death-wound could have been inflicted by turning the bezel of the ring inward, so that a hearty grasp would produce a few slight punctures in the enemy's hand.[60]

[58] Neuhebräisches und Chaldäisches Wörterbuch," by Jacob Levy, Leipzig, 1879, vol. ii, p. 139, s. v. tabba'ath.

[59] Artemidorus, " Oneirocritica," ii, 5.

[60] Davenport, " Jewelry," Chicago, 1908, pp. 127, 128.

While these Borgia rings represent an extreme of diabolical ingenuity, the perfumed rings, the use of which has been revived to a certain extent of late, constitute a refinement of civilization. This ring is generally made of plain gold with a small elastic ball and valve at the back. This is squeezed flat and the ring is immersed in a perfumed liquid; when the pressure is removed the scent is drawn into the ring by suction. An ingenious adjustment renders it possible for the wearer to discharge a jet or spray of perfume by the exercise of a very trifling pressure. Not only perfumes but disinfectants also are sometimes used, and rings charged in this way may be said to represent antidotes of the dreaded poison rings, not perhaps in a literal sense, but at least in the sense of being curative rings.

A poison ring of Venetian workmanship has a richly engraved hoop, the setting consisting of a pointed diamond on either side of which are two cabochon-cut rubies. On touching a spring at the side of the bezel holding the diamond, the upper half, in which the stone is set, springs open, revealing a space beneath in which a small quantity of poison could be concealed, enough in the case of the more active poisons to furnish a lethal dose, either for an enemy or for the wearer of the ring himself in case of need.[61]

The son of the great Egmont was involved more or less directly in an unsuccessful plot to poison the Prince of Orange in 1582. It was asserted that the crime was committed at the would-be assassin's own table, by means of a drug concealed in a ring. This story appeared to

[61] Frederick William Fairholt, "Rambles of an Artist," London, n. d. (1865?), p. 144, fig. 177.

be confirmed by the alleged finding in Egmont's lodgings of a hollow ring filled with poison.[61a]

A writer on poison mysteries describes a possible poison ring in the great British Museum collection. The bezel has a repository covered by a thin-cut onyx on which is engraved the head of a horned faun.[61b] However, in the British Museum Catalogue of Rings by O. M. Dalton, the statement is made that there are no authentic poison rings in the Museum, and that "the mere possession of a locket-bezel does not suffice to lend romance to a ring perhaps intended to contain a harmless perfume.[61c]

A golden ring-dial in the British Museum collection is a flat band around the middle of which runs a channel in which another, movable ring, fits closely. The month-names are engraved on the band, six above the channel and six below it. The movable ring has a small hole with a star on one side, and a hand with index and second fingers extended on the other. Inside, the numbers of the hours from 4 A.M. to 8 P.M. are engraved in two lines, the hour of noon being beyond them at the point opposite to the ring which suspends the dial. In using a dial-ring the aperture in the movable ring was brought in a line with the month in which the observation was

[61a] John Lathrop Motley, " The Rise of the Dutch Republic," New York, 1856, Vol. iii, pp. 558, 559, citing a curious Dutch pamphlet published at Leyden in 1582 and consisting of two letters, one from Bruges, dated July 25, 1582, the other written two days later from Antwerp.

[61b] C. J. S. Thompson, " Poison Romance and Poison Mysteries, London, n.d., 2d. ed., p. 123.

[61c] O. M. Dalton, " Catalogue of the Finger-rings, Early Christian, Byzantine, Teutonic, Mediæval, and Later [British Museum]," London, 1912, p. lv.

taken; this being done the figure on the inside upon which the sun's ray would fall would give the approximate time of day.[62]

Shakespeare provides Touchstone with a dial ring in "As You Like It" (Act II, sc. 7) where Jaques says:

> " Good morrow fool," quoth I. " No, Sir, quoth he,
> Call me not fool, till heaven hath sent me fortune."
> And then he drew a dial from his poke,
> And looking on it with lack-lustre eye,
> Says, very wisely, " It is ten o'clock."

A watch-ring of the eighteenth century is in the Franks Bequest Collection of the British Museum. The oval watch in the bezel is framed with pearls, on the back of the ring are the initials A.R. As the bezel measures but nine-tenths of an inch in length, this tiny watch exemplifies the skill of the watch-makers of the time. The entire ring weighs but 175 grains.[63]

The custom of leaving memorial rings for the friends of the departed had its origin in the bestowal of more substantial bequests. In fact, these rings stand in somewhat the same relation to such bequests as does the wedding ring to the gifts the husband was expected to make to his wife when he wedded her. In both cases this has been lost sight of, and the intrinsic value of the objects being slight, only the sentimental value is considered.

[62] O. M. Dalton, " Catalogue of the Finger Rings, Early Christian, Byzantine, Mediæval and Later," bequeathed by Sir Augustus Wollaston Franks (British Museum), London, 1912, p. 243, No. 1698, pl. xxiii.

[63] O. M. Dalton, " Franks Bequest, Catalogue of the Finger Rings, Early Christian, Byzantine, Teutonic, Mediæval and Later " (British Museum), London, 1912, p. 245, No. 1708, pl. xxiii.

An early instance of the bequest of rings is offered in the case of Richard II (1366–1400), who, by his testament, left a gold ring to each of the nine executors, five of whom were bishops and four great nobles.[64] In the seventeenth century one who held, and still holds sway in another realm, that of literature, conformed to this usage, for in Shakespeare's will, dated March 25, 1616, rings were bequeathed to Hamlett Sadler, William Reynoldes, Anthony Nash and John Nash, his fellow townsmen, as well as to three actors, Burbage, Heming and Condell, who had the privilege of " creating " parts in the greatest dramas ever written. The sum of 26s 8d is appropriated for each of these rings, about $6.50 of our money.

As the fashion became more prevalent, the number of rings provided for in the wills of well-known persons must have constituted quite a charge upon their estates. The quaint and delightful Pepys, that close observer and great gossip who knew all the prominent people of the London of his day, left directions on his death, in 1703, for the distribution of 123 memorial rings among his friends. One of the most important events in English history is believed to have given such a great vogue to this usage.

The death of Charles I on the scaffold, January 30, 1649—his martyrdom as the royalists called it—created an ineffaceable impression upon the minds and hearts of those who had taken the king's side in the struggle with the parliamentary party. To commemorate this

[64] " Memorial Rings, Charles the Second to William the Fourth, in the Possession of Frederick Arthur Crisp," privately printed (London). The data in this and succeeding paragraphs treating of memorial rings, are (unless otherwise noted) derived from this valuable and interesting work.

sad event and to obey the last injunction of the unfortunate monarch, " remember," a great number of memorial rings were made, bearing the name and often the portrait of Charles, and these were worn by the royalists. It appears that this seemed to make the bestowal of memorial rings a more general custom than before, as from this time an increased number of such rings appear.

The types of these rings varied considerably in the course of centuries. Those of the sixteenth century were made of plain gold, or of gold enamelled with representations of a skeleton, spade and pick, hour-glass, or similar emblems of death; the inscription was engraved, usually on the inside of the ring; occasionally the bezel was rounded into the form of a skull. In the period succeeding the death of Queen Anne (1714), and extending to about 1774, the fashion gradually changed, and the inscriptions, instead of being engraved, were in raised letters, thrown into greater relief by the application of white and black enamel. This style is said to have been brought from France, and the earliest specimens are presumed to have been executed by French workmen; an example of this type of ring, dating from 1717, is in the Crisp Collection. In one such ring the inscription is enamelled *within* the hoop. An exceptionally fine specimen of the rings of this period is that in memory of Richard Pett, who died February 23, 1765, aged 76 years.[65] This bears an amethyst and four rose diamonds in an openwork setting. Another innovation during this period is the employment of white enamel in the case of rings in memory of young maidens; the earliest example dates from 1726 and was given as a memento of the death, at fifteen years, of Dorothy Tenison, daughter of the Bishop of Ossory. In their search for novelty the goldsmiths sometimes had resort

[65] Crisp Collection, No. 334, p. 115.

to rather grewsome decorations, and the bezel of some rings has the form of a coffin, within which lies a skeleton, carefully done in enamel.

The last quarter of the eighteenth century supplies us with some of the most elaborately designed memorial rings. In many of these the bezel shows various emblematic figures formed of gold wire, seed pearls, ivory and enamel; one ring of this type has the inscription: " Heaven has in store what thou hast lost." However, hair soon became the favorite material. At first, a lock of hair from the head of the deceased person was enclosed in the bezel, no attempt being made to form any pattern; but soon the hair was spread out over the surface and arranged in the form of a tree; later on, these rings show us an urn placed beneath the tree, and still later we have in addition a male or female figure in an attitude of grief, all these being formed entirely of hair.

A unique ring in the Crisp Collection [66] is a memento of the death of seven children, the eldest not over nine years, who perished in a fire in Leadenhall Street, London. This gold and ivory ring bears a design showing seven cherubs' heads surrounding the words: "To eternal bliss." At the back of the bezel is inscribed: "Translated 18 January 1782."

As a rule there is little variety in the inscriptions upon memorial rings. *"Memento mori,"* and " Not lost but gone before " are most frequent. On the ring of Princess Amelia, the favorite daughter of George III, who died November 2, 1810, are the words " Remember me." [67] There is a touching story regarding this ring. On her death-bed the princess ordered that it should be

[66] No. 632, p. 197.
[67] Crisp Collection, No. 981, p. 317.

made and had a lock of her hair enclosed in it. As she lay dying she put the ring on her father's finger with the words of the inscription. The loss of this dearly beloved daughter appears to have finally determined the madness of the unhappy king, for he never recovered his reason after the event.

Another interesting ring is that dedicated to the memory of the rather notorious Lord Lovat, who was beheaded in London, April 9, 1747, for alleged complicity in the Jacobite rising of 1745. This is set with a crystal, beneath which is some hair between two rose diamonds, and bears Lovat's last words, the famous line of Horace, " *Dulce et decorum est pro patria mori.*" [68]

The extravagance and tastelessness shown in many of the more elaborate forms of the memorial ring, have had the natural result of causing a reversion to the severe simplicity of the earlier types, and a plain, but massive gold ring, with the words, " To the memory of ————" became the usual type.

Seven Nelson memorial rings were shown at the Royal Naval Exhibition at Chelsea in 1891; two of these contained some of the hero's hair, and one belonged to those distributed among Nelson's captains and other officers after his death. Of the two rings enclosing hair, one set with a diamond was loaned by Messrs. Lambert & Co. and the other by Admiral Sir Arthur Farquhar, K.C.B.[69] A fine specimen of a Nelson ring is in the British Museum. The broad, flat hoop expands at the shoulders, and in a raised oblong bezel are figured a viscount's coronet and a ducal coronet with N beneath

[68] No. 165, p. 69.

[69] Notes and Queries, 11th ser., No. 311, December 11, 1915. p. 469.

1, memorial ring of Charles I, concealed portrait beneath a table-cut diamond. 2, memorial ring with two skeletons supporting a sarcophagus. When the lid is raised a minute skeleton is seen within

Fairholt's "Rambles of an Artist"

1, design for a memorial ring from the "Recueil des Ouvrages d'Orfevrerie" by Gilles l'Egaré; early part of reign of Louis XIV. 2, English memorial ring converted into a memorial of Charles I by the following inscription inside the hoop: "C. R., Jan. 30, 1649, Martyr." 3, memorial ring, early part of Eighteenth Century

Fairholt's "Rambles of an Artist"

Gold memorial ring of Capt. Robert Jackson, died October 29, 1726, aged fifty-six years

British Museum

Cameo portrait of Louis XII of
France, cut in a pale ruby. On the
gold plate at the back of the bezel is
the inscription: Loys XII^me Roy de
France deceda 1 Janvier, 1515. Latter
part of Fifteenth or beginning of Six-
teenth Century. Double linear size

C. D. Fortnum's "Antique Gems
and Jewels in Her Majesty's Collec-
tion at Windsor Castle"

Nelson memorial ring. Gold ring
with two initial letters: N, beneath
a viscount's coronet, referring to the
title Viscount Nelson of the Nile; and
B, beneath a ducal coronet, for the
title Duke of Bronte

British Museum

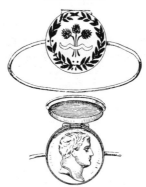

Napoleon memorial ring of gold,
said to be one of six given those con-
cerned in his escape from Elba in 1815.
Portrait concealed beneath hinged lid

British Museum

the former and B beneath the latter, indicating his titles
Viscount Nelson of the Nile and Duke of Bronté. Below
the letters is the name Trafalgar and on the exterior of
the hoop appears Nelson's motto *"Palmam qui meruit
ferat"* (Let him bear the palm who merits it).

There is historic record of two memorial rings, one
set with an emerald and the other with a sapphire, the
gifts of two unhappy royal personages made shortly
before death. The first of these rings was bestowed
upon the great French preacher Bossuet by the Stuart
princess Henrietta Anne, who, on her death-bed, directed
that after she had gone to rest there should be given to
Bossuet " the emerald ring she had ordered to be made
for him." Of the second ring, that set with a sapphire,
we learn that shortly before her execution in 1587, the
unfortunate Mary of Scotland took it from her finger
and sent it to her faithful follower, Lord John Hamilton,
in whose family it has since then been passed down from
generation to generation as a priceless heirloom.[70]

Several memorial or mourning rings are among the
treasures of the Figdor Collection in Vienna. One of
these is of massive silver and has the Old French inscrip-
tion: *"dort couat,"* (rest in peace) ; it was found at Huy,
near Statte, Belgium, and represents work of the fif-
teenth century. Another is of enamelled gold, and is
evidently for a woman's wear. The inscription is: " R.
C. Not lost but gone before," in gilt letters on a white
enamel ground. This is an English ring of about 1800.
A German ring of the eighteenth century has its head
formed in the shape of a coffin, on which are skull and
cross-bones; on its sides is the inscription: " Hir ist

[70] A. E. Cropper, " Some Notes On Three Classes or Types
of Rings," in The Connoisseur, London, vol. xix, p. 184, Sep-
tember to December, 1907.

Ruhe," (Here is rest). When the lid is lifted, a heart is disclosed in the coffin.[71]

Memento mori rings, bearing a death's head, were sometimes left as legacies. Such was the " golde ringe with a deathe's head " bequeathed by Thomasin Heath to her sister in 1596, " for a remembrance of my good will." Shakespeare wrote in his Love's Labour's Lost (Act V, sc. 2) of " a Death's face in a ring," where poor, pedantic Holofernes' countenance is made the subject of mockery. A rather unaccountable circumstance is that such rings are asserted to have been worn, toward the end of the sixteenth century, by professional " ladies light o' love," if we can safely generalize from a passage in Marston's " Dutch Courtezan." [72]

The ruthless executions carried out after the suppression of the last Jacobite revolt in 1745, are memorialized in a ring of the period. This is of gold, the inscriptions being defined by a white enamel background. On the panel-shaped bezel are the letters B. D. L. K., the initials of the Jacobite lords, Balmerino, Kilmarnock (exec. Aug. 18, 1746), Deruentwater (exec. Dec. 8, 1746), and Lovat (exec. April 9, 1747), and the dates 8, DEC. 9, AP. 18, AU; in the middle is an axe and the date 1746. The initials of seventeen of these lords' followers, executed on Kensington Common in the same year, are marked on the hoop of the ring.[73]

[71] Communicated by L. Weininger, of Vienna.

[72] O. M. Dalton, " Catalogue of the Finger Rings, Early Christian, Byzantine, Teutonic, Mediæval and Later," bequeathed by Sir Augustus Wollaston Franks, K.C.B. (British Museum, London, 1912, p. xxxiii, footnote.

[73] O. M. Dalton, " Franks Bequest, Catalogue of the Finger Rings, Early Christian, Byzantine, Teutonic, Mediæval, and Later [British Museum]," London, 1912, p. 204, No. 1417.

In the possession of Waldo Lincoln, of Worcester, Mass., is a memorial ring consisting of a narrow plain gold band. There is faintly discernible on this a winged head, apparently a skull, similar to the heads of this type sometimes to be seen sculptured on old gravestones. Around the inner side of the band runs the following inscription: "Hoble I. Winslow Esqr., ob. 14 Decr. 1738 Æ 68." [74] This refers to Isaac Winslow, a son of the noted Josiah Winslow (1629–1680), governor of Plymouth Colony from 1673 until his death, and who was the first native-born governor in New England. It was during his term of office that the severe contest with the Indians, known as King Philip's War, was fought out successfully.

A mourning ring with a strangely materialistic motto is that executed by order of the Beefsteak Club to commemorate the demise of John Thornhill, Esq., on September 23, 1757, according to the inscription in white enamel on the hoop. The bezel is flat and of oval form, enamelled in pale blue and white; in the centre is shown a gridiron and around this is the legend: " Beef and Liberty." [75] The Beefsteak Club, formed early in the eighteenth century, was Tory in politics, an opponent of the Kit-Cat Club, whose members were devoted to the success of the Whigs.

Rings as memorials of the dead suggest the mention of a memorial ring of another kind, one destined to favor the revival of a defunct government. When Napoleon I was exiled to Elba after the overthrow of his empire

[74] Communicated by Waldo Lincoln, the owner of the ring.

[75] O. M. Dalton: " Franks Bequest, Catalogue of the Finger Rings, Early Christian, Byzantine, Teutonic, Mediæval and Later [British Museum]," London, 1912, p. 232, No. 1628.

and the restoration of the Bourbons, many of his faithful followers clung to the hope that he would return and re-establish his rule in France. In order to aid in keeping this hope alive, a number of rings were made which could be worn with impunity, but which could also serve when desired as proofs of the wearers' attachment to the Napoleonic cause. One of these is described as a gold ring on which a minute gold and enamel coffin was set; on pressing a spring at the side of the ring a section of the circlet sprang up and revealed a tiny figure of Napoleon executed in enamel.[76]

At the English Bar, the usage long existed that certain chosen barristers should be given the title and superior rank of serjeants. In important cases, a serjeant was usually retained as principal manager and chief representative at the trial, and generally made the statement of the case in court, while one or more ordinary barristers got up the evidence and aided in the examination of witnesses; no serjeants have been appointed since 1868. As with almost all the stages of an English law-student's and barrister's progress, heavy expenses had to be born by the new serjeant, as he was expected not only to give a splendid dinner, or rather a series of dinners lasting for a week, to all who were closely or distantly related to his preferment, but to bestow a gold ring upon each one of the numerous guests, these " serjeant rings " varying in elegance and value according to the rank of the recipient.

So strictly was this purely traditional custom construed that a close watch was kept to prevent any cheapening of the quality or intrinsic value of these obligatory rings. As it had been laid down by a leading authority

[76] Szendrei, " Catalogue de la collection de bagues de Mme. de Tarnóczy," Paris, 1889, pp. 142, 143.

that the ring to be given to a chief justice, or " chief baron," must have the weight of twenty shillings' worth of gold, a formal protest was made on one occasion, when rings weighing a tenth less than this had been bestowed, not, as Lord Chief Justice Kelynge told the newly appointed serjeants, because of the money value, but " that it might not be drawn into a precedent." [77] The average cost of one of these bestowals of rings has been estimated at about £40 ($200).

The first definite notice of the bestowal of serjeants' rings comes from the later years of Elizabeth's reign, although the usage is believed to date back at least as far as the time of Henry VI (1422–1461). The Latin motto on a ring of Sir John Fineux, called in 1485, is " *Suæ quisque fortunæ faber,*" or " Every man is the artizan of his own fortune." The mottoes engraved on these rings have varied from reign to reign. One of Elizabeth's time bears *"Lex regis præsidium"* (The Law is the stronghold of the King) ; under Charles II the motto was *"Adest Carolus magnus"* (Charles the Great is with us). Much more dignified and telling is the motto in James II's reign, *"Deus, lex, rex"* (God, the Law, the King), implying that God is the source of the law, and that the law is above kings. As to the heavy tax sometimes imposed upon a new barrister's pecuniary resources, it is stated that on one occasion 1409 rings were given at an expense of £773 ($3865). The usage, though maintained to a considerable extent, became somewhat less oppressive toward the end of the eighteenth century, but even in 1856 rings were given, some of them bearing the motto *"Cedant arma togæ"* (Arms

[77] Charles Edwards, " The History and Poetry of Finger-Rings," New York, 1855, pp. 86–90.

will give place to the Gown) in allusion to the approaching peace with Russia after the Crimean War.[78]

About 1830, when popular feeling was roused to the highest pitch by the agitation for the repeal of the Corn Laws, many rings were set with the following stones, the initial letters forming the word " repeal ":

> Ruby
> Emerald
> Pearl
> Emerald
> Amethyst
> Lapis lazuli

An Irishman, who owned such a ring, noted one day that the lapis lazuli had fallen out, and took the ring to a jeweller in Cork, to have the missing stone replaced. When the work was completed, the owner, seeing that the jeweller had set a topaz in place of a lapis lazuli, protested against the substitution; but the jeweller induced him to accept the ring as it was, by the witty explanation that it now read " repeat," and that if the agitation were often enough repeated, the repeal would come of itself.[79]

METHODS OF WEARING

A striking illustration of the large number of rings that some of the noblewomen of ancient Egypt wore on their fingers is given by the crossed hands of the wooden image on a mummy case in the British Museum.

[78] Hon. R. C. Neville (4th baron Braybrooke), " The Romance of the Ring, or the History and Antiquity of Finger Rings," Saffron Walden, 1856, pp. 25, 26.

[79] Londesborough Collection: Catalogue of a collection of ancient and mediæval rings and personal ornaments, London. 1853, p. 7. Privately printed.

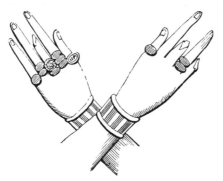

Crossed hands of the figure of a woman upon a mummy case
in the British Museum
Fairholt's "Rambles of an Artist"

Hands from portrait of a woman. School of Cranach
British Museum

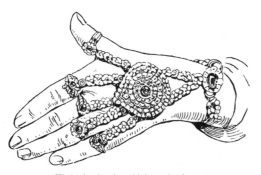

Hindu ring jewel combining a ring for each
finger and for the thumb, a large ornament
for the back of the hand, and a bracelet
Barth, "Das Geschmeide"

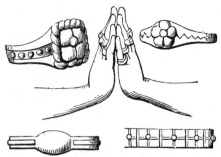

Hands from effigy of Sir Humphrey Stafford's wife in
Bromsgrove Church, Staffordshire, England. Rings on
every finger except on little finger of right hand. Four of
these rings are figured, the full size of the originals
Fairholt's "Rambles of an Artist"

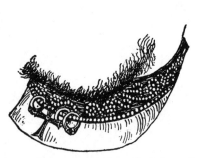

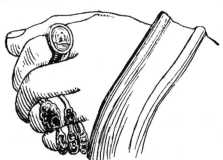

Three rings strung on a necklace. Detail of portrait
of John Constans of Saxony
British Museum

Right hand from portrait of Benedict von Hertenstein by
Holbein; seal on index finger
Metropolitan Museum of Art, New York

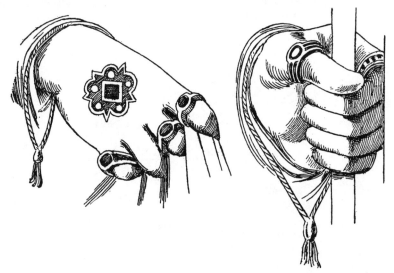

Hands from Botticini's "St. Jerome with St. Damasius and other Saints"
National Gallery, London

The left hand is given a decided preference in this respect over the right, there being no less than nine rings on the former against but three on the latter. These left-hand rings comprise one thumb-ring (the signet), three for the index, two for the middle finger, two for the " ring-finger," and one for the little finger. The thumb of the right hand bears a ring and two are on the middle finger.

In the tomb of a king of the Chersonesus, discovered at Nicopolis in the Crimea, two rings were on the king's hand and ten on that of the queen. The style of workmanship indicated that these rings were productions of the Greek art of the fourth century B.C.,[80] a period when in the Greek world rings were usually worn more sparingly, in contrast with the fashion that prevailed during the latter part of the first Christian century in Rome.

The fine Egyptian collection of the Metropolitan Museum of Art in New York City offers an illustration of Egyptian ring wearing at the beginning of our era. This appears in the mummy-case of Artemidora, daughter of Harpocradorus, who died in her twenty-seventh year. The wooden case figures the form of the deceased woman. The index, fourth and little fingers of the left hand, each bear a ring; the fingers of the right hand have been broken off. The hands are of stucco and the rings are gilded.

In the Golden Age of Greek gem-engraving, from about 480 B.C. to 400 B.C., the scarab, never used by the Greeks of Asia Minor, came into general disuse in the Greek world, and a type of ring-stone appeared, destined to become very popular. In these the engraving was often done on the convex side of a scaraboid form, the convexity having been much flattened out, while with

[80] Compte rendu de la Commission Arch. de St. Pétersbourg, 1864, p. 182.

the true scarab the flat underside bore the engraved
design or characters. Occasionally ring-stones had been
originally pierced for suspension. The flattened scara-
boid marked a transition to the flat ring-stones; but
few, if any, examples of these antedate the beginning
of the fourth century B.C.

One of the theories given by Macrobius to explain
the wearing of rings on the fourth finger, attributes this
usage to the desire to guard the precious setting of the
ring from injury. He states that rings were first worn,
not for ornament, but for use as signets, and in the
beginning were made exclusively of metal. However,
with the increase of wealth and luxury, precious stones
were engraved and set in the metal ring, and it became
necessary to place such a ring on the best-protected
finger. The thumbs were most constantly used; the
index was too exposed; the third finger was too long,
and the little finger too small, while the right hand was
much more frequently used than the left hand. Hence
the choice fell upon the fourth finger of the left hand
as the best fitted to receive a precious ring.[81] Pliny
declares that while at first, in the Roman world, the
ring was worn on the fourth finger, as was shown in
the statues of the old kings Numa Pompilius and Servius
Tullius, it was later on shifted to the index and finally
to the little finger,[82] this being in accord with our modern
custom, for men's seal-rings especially.

Isidore of Seville, in his brief chapters on rings, cites
the words spoken by Gracchus against Mænius, before
the Roman Senate, as a proof that the wearing of many
rings was then considered to be unworthy of a man.

[81] Macrobii, " Saturnalia," Lipsiæ, 1868, p. 446, lib. vii,
cap. 13.

[82] " Historia Naturalis," liber xxxiii, 24.

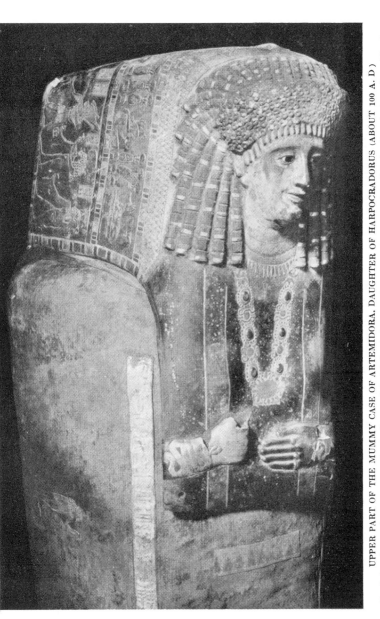

UPPER PART OF THE MUMMY CASE OF ARTEMIDORA, DAUGHTER OF HARPOCRADORUS (ABOUT 100 A. D.)

She died at the age of twenty-seven On the fingers of the left hand there are three rings; the fingers of the right hand are broken off. The rings (which are gilded) as well as the hands themselves are modeled in relief in stucco

Metropolitan Museum of Art, New York City. Gift of J. Pierpont Morgan, Esq.

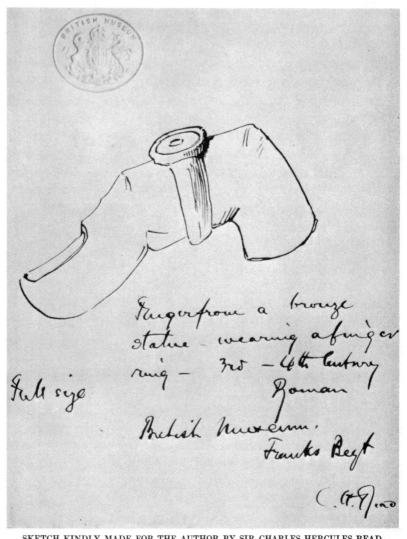

SKETCH KINDLY MADE FOR THE AUTHOR BY SIR CHARLES HERCULES READ
Curator of the Department of British and Medieval Antiquities and Ethnography in the British Museum,
with his autograph description

The speaker calls upon his hearers to " look upon the left hand of this man to whose authority we bow, but who with a woman's vanity, is adorned like a woman." The Bishop of Seville also adduces the declaration of Crassus who, as an explanation for his wearing two rings, although an old man, said that he did so in the belief that they would further increase his already immense wealth.[83] Hence he must have thought them endowed with some magic power.

One explanation of the greater supply of ancient gems of the period subsequent to the Augustan Age, as compared with those of an earlier date, has been found in the increasing popularity of ring-wearing. Horace (65–8 B.C.) already considers three rings on the hand as marking the limit of fashionable wear, but Martial (ab. 40–104 A.D.), writing a century later, tells of a Roman dandy who wore six rings on each finger. As an instance of the multiplication of seal-rings, Pliny states[84] that the signet proper had to be placed for safe-keeping in a special receptacle, which was then stamped with the impression of *another* seal, lest some improper use should be made of the signet, the equivalent of an individual signature.[85]

When the usage of wearing rings set with plain or engraved precious stones became general in Rome, special caskets were made—many of them of ivory—to contain the rings and other small jewels. The name *dactyliotheca,* " ring-treasury," was given to such a

[83] Sancti Isidori Hispalensis Episcopi, " Opera Omnis," vol. iv, col. 702, Etymologiæ, lib. xix, cap. 33, vol. lxxxii of Migne's Patrologia Latina, Paris, 1850.

[84] " Historia Naturalis," lib. xxxiii, cap. 6.

[85] Duffield Osborne, " Engraved Gems," New York, 1912, p. 107.

casket. The first Roman to own one was Emilius Scaurus, son-in-law of Sylla (138–78 B.C.), who lived in the early part of the first century before Christ, but for a long time his example was not followed by the Romans, the next *dactyliotheca* to be seen in Rome being that dedicated by Pompey to the Capitol in 61 B.C., out of the spoils of Mithridates the Great, who owned the most famous gem collection of his time.[86] In the first century A.D. these ring-caskets came into general use, and were regarded as indispensable parts of a rich man's luxury. This is brought out in one of Martial's epigrams when, after saying that Charmius wore six rings on each finger and kept them on at night and even when he took his bath, he proceeds: "You ask why he does so? Because he has no *dactyliotheca*."[87] This evidently implies that he lacked one of the elements of Roman " good form " in the fashionable world.

The Latin epigrammatist whose brief, caustic poems are a mine of information regarding the customs and costumes of the Romans in the Imperial age, wrote the following couplet, probably designed for an inscription upon a *dactyliotheca,* or ring-case: [88]

" Often does the heavy ring slip off the anointed fingers; but if you confide your jewel to me, it will be safe."

In the large ring collections of royal treasuries or of wealthy nobles in mediæval times, the rings with precious-stone settings were often classified according to the particular stones, and then those of each of these classes were strung on one or more small sticks or wands

[86] Plinii, " Naturalis Historia," lib. xxxvii, cap. 11.

[87] Martialis, " Epigrammata," xi, 59.

[88] Martial, Bk. XIV, No. cxxiii; from " Martial translated into English prose," London, George Bell & Sons, 1897.

(*bacula*). Among King John's (1167–1216) jewels in
the Tower of London, an inventory of 1205 lists several
such *baculæ,* one with 26 diamonds, two with 40 and 47
emeralds, respectively, another shorter one with 7
" good " topazes and still another with 9 turquoises.[89]
Jewellers also, were wont to keep their rings strung on
such small rods, an example of this being shown in a
portrait depicting a jeweller, painted by an unknown
German artist of the sixteenth or seventeenth century.

With other royal collections of rings the classified
set rings were kept already in ancient times in *dactylio-
thecæ,* or ring-caskets, the term *dactyliotheca* coming to
be used later more broadly as an equivalent for " ring
collection " or even " gem collection." In 1272 the
Crown Jewels of Henry III of England included a
number of these ring boxes, four of them for 106 ruby,
or balas-ruby rings, two for 38 emerald rings, one for 20
sapphire rings, and another for 11 topaz rings and one
set with a peridot.[90]

The following description of a jade (nephrite) ring-
box of seventeenth-century Indian workmanship, in the
Heber R. Bishop Collection, is given in one of the great
folios treating of these wonderful jades.[91]

A small covered box of three compartments in the form
of three compressed plums (or similar fruit) held together by
the twigs and leaves of a leafy branch which projects to form
a handle, and hollowed out to form a receptacle for finger-rings,
studs or the like. The box proper is decorated underneath with
leaves carved in slight relief, and is flanged on the edges to
receive the three upper segments of the fruit which forms the

[89] Hardy, " Rotuli litterarum patentium in tursi Londinensi
asseverati," London, 1835, vol. i, pt. i, p. 55.

[90] Rymer, " Fœdera," London, 1727, vol. i, pp. 878, 879.

[91]*Op. cit.,* vol. ii, pp. 249, 250, No. 760, illustration.

cover and are similarly decorated on top with plum blossoms and held together by a twig, a leaf, and an upright bud which serves as a handle. The whole is very daintily cut and polished, and is so thin and of such translucency that print in contact with it can easily be read through it. The mineral is remarkably pure and resembles a pale transparent horn.

While the Greeks and Romans did not usually wear rings on the middle finger, the Gauls and Britons adorned it in this way. In the sixteenth century it was customary to assign rings as follows, according to the quality of the wearer:[92]

To the thumb for doctors.
To the index finger for merchants.
To the middle finger for fools.
To the annular finger for students.
To the auricular finger for lovers.

There is a curious Hindu superstition to the effect that anyone who wears a ring on the middle finger will probably be attacked and bitten by a scorpion. For this reason the Hindus are said to avoid wearing any rings on this finger, although the others are laden with them, each finger-joint having its special adornment.[93] In the Græco-Roman world also there was a prejudice against decorating the middle finger with a ring.

Regarding the liberality with which the Greeks and Romans of the second century of our era used ring adornments for their fingers, the great Greek humorist Lucian gives testimony. In his writing entitled " The Cock," he makes a character relate a dream in which the dreamer thought that a rich man had just died and had left him

[92] Schaumi, " De annulis," Francofurti, 1620, cap. ix.
[93] Col. T. C. Hendley, " Indian Jewellery," London, 1909, p. 79. Journal of Indian Art and Industry.

his fortune. Thereupon, in his dream, he saw himself arrayed in splendid raiment and wearing *sixteen* rings on his fingers.[94]

Of the affectations practiced in ring wearing by some *nouveau-riches* foreigners in Roman times, Juvenal says: When one sees an Egyptian plebeian, not long before a slave in Canopus, carelessly throwing back over his shoulder a mantle of Tyrian purple, and seeking to cool his perspiring fingers by wearing summer-rings of openwork gold, as he cannot bear the weight of gemmed rings, how can one fail to write it down in a satire?[95]

Indeed, to judge from the weight and size of some of the rings that have been preserved from ancient times, this practice was not quite so foolish as it may seem, for in the moist heat of the dog-day in Rome such heavy rings may well have been a burden. With the Roman ladies rings bearing images of the animals worshipped by the Egyptians came into fashion in Imperial times, favored no doubt by the enthusiastic worship of Isis and Serapis. Such rings are said to have been worn almost exclusively by women up to the reign of Vespasian, when men began to wear them also.[96]

In ancient Rome it was not unusual for the admirer of a philosopher or a poet to wear his portrait engraved on a ring-stone. One of the elegies of Ovid[97] (b. 43 B.C.), written during his banishment from Rome, by order of Augustus, alludes feelingly to this custom. The poem is addressed to a faithful friend, who wears the poet's portrait in his ring, and Ovid says: " In casting

[94] Luciani, " Opera Omnia," Paris, 1615, p. 712.
[95] Juvenal Sat. I, ll, 26–30.
[96] Schaumi, " De annulis," Francofurti, 1620, cap. iv.
[97] Tristia, Lib. i, el. vii.

your eye upon this, perhaps you sometimes say, ' how far away is poor Ovid now! ' " He died in exile in 18 A.D.

So huge were the proportions of the Roman emperor Maximinus (d. 238 A.D.), who rose from the ranks to the imperial dignity, that he is said to have used his wife's bracelet for a thumb-ring.[97a] The great size of some of the Roman rings to be seen in collections indicates that they could only have been worn on the thumb.

One of the fingers of a bronze statue in the British Museum, a Roman work of the third or fourth century, A.D., has a ring on its second joint. We are fortunate enough to be able to reproduce here a full-size drawing of this, courteously made for the present book by Sir Charles Hercules Read, Curator of the Department of British and Mediæval Antiquities and Ethnography in the Museum.

In a letter to M. Deloche, the German archæologist Lindenschmit states that in only one instance was he able to ascertain definitely on which finger the rings of the early mediæval period were worn. This concerned a female skeleton, exceptionally well preserved, owing to favorable conditions of sepulture; on the fourth finger of the right hand there was a bronze ring. This sepulchre was found at Obermorlen, in Hessen-Darmstadt. Researches in France have furnished confirmation of this. In the Merovingian cemetery of Yeulle (dept. Pas-de-Calais) a woman's ring was found on the right hand of the skeleton, as was also the case with two rings in the Visigothic and Merovingian cemetery at Herpes (dept. Charente), and this proved to be the case with

[97a] Julii Capitolini, " Maximini duo," cap. vi; Scriptores hist. August., vol. ii, p. 7.

almost all the early medieval rings found in this region. On the contrary, M. Albert Béquet, Curator of the Archæological Museum of Namur, and the French archæologist, M. L. Pilloy, report the discovery of rings placed upon the left hand. As a possible explanation of these contradictory results, the opinion has been advanced that the rings on the right hand were wedding rings, and those on the left, rings worn for ornament, as there is good evidence that at an early period among the Gauls the betrothal ring was put on the right hand, not on the left.[98]

The portrait by Coello of Maria of Austria, daughter of Charles V of Germany, shows on the fourth finger of the left hand a ring set with a large table-cut stone, which may be a ruby, or else a rather dark-hued spinel. The right hand is gloved, the parts of the glove covering the index and fourth fingers having slits so as to give space for the rings on those fingers. There is an elaborate girdle of table-cut stones, a richly worked cross with three pendent pear-shaped pearls is suspended from a gauze scarf about the neck, splendid pearl earrings hang from the ears, and the coiffure is surmounted by a head ornament set with precious stones and pearls.

In a three-quarter length portrait of Henry VIII, painted by Hans Holbein in 1540, when the king was in his forty-sixth year, he is represented wearing three rings on his hands, two of these, set with square-cut stones, are on the index fingers of the right and left hand, respectively. The third and smaller ring, also set with a square-cut stone, is on the little finger of the king's left hand. There is an intentional harmony in the jewelling, for

[98] Deloche, " Le port des anneaux dans l'antiquité et dans les premiers siècles du moyen âge," pp. 61–63.

stones of the same form, alternating with pearls, adorn the collar suspended from Henry's neck and serve also as decoration for the sleeve-guards. This portrait is in the Reale Galleria d'Arte Antica, Rome.

Princess Mary, daughter of Henry VIII and Catherine of Aragon, and afterwards Queen of England (1553–1558), is portrayed in a painting in the University Galleries, Oxford, by an unknown artist, as wearing, in addition to many fine pearls both round and pear-shaped, three rings, one on the index, another on the middle finger, and the third on the fourth finger of the left hand. That on the middle finger is set with a pearl, and the ring-adornment of this finger is quite worthy of note because of the comparative rarity of this setting.

A large pear-shaped pearl, figured on a portrait of "Bloody Mary," was given to her by Philip of Spain, who afterward took it back to Spain with him. It later came into the possession of Jerome Bonaparte, who gave it to Queen Hortense. She gave it to the young prince, who later became Napoleon III, and he, in turn, disposed of it to the Duke of Abercorn, in whose possession it now remains. Allison V. Armour, Esq., to whom it was shown in Ireland by the Duke, at the time of an expected visit from King Edward, told the author it was very interesting to note that it had apparently preserved all its original lustre.

The adornment with a ring of the second phalanx of the right-hand middle finger, appears in the fine portrait, said to be that of Mary Stuart, in the Prado Gallery, Madrid; the little finger of the same hand shows a stone-set ring, worn as usual. Over the elaborately embroidered bodice hangs a neck-ornament, at the different sections of which are groups of three pearls, and

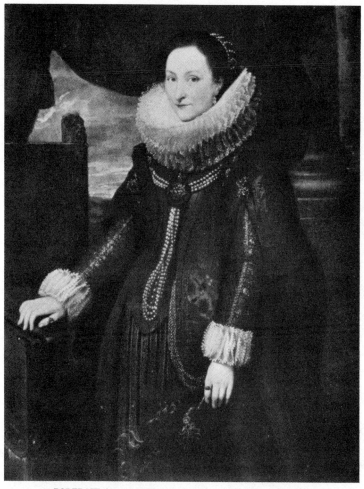

PORTRAIT OF A LADY, BY ANTON VAN DYKE (1599–1641)
The thumb ring on the right hand, and the ring on the index of the left hand, are both set with square-cut stones, the last-named probably a ruby
Metropolitan Museum of Art, New York. Marquand Gift, 1888

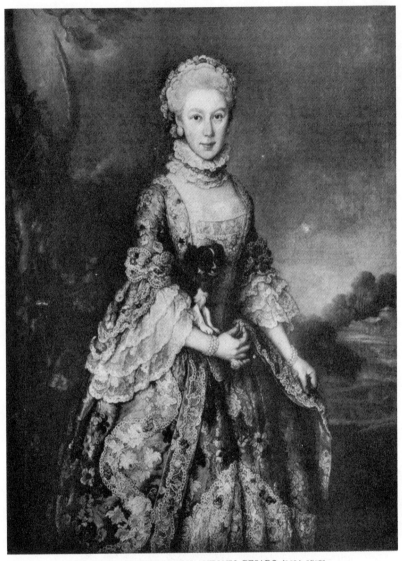

PRINCESS HATZFELD, BY ANTONIO PESARO (1684–1757)
Large pearl cluster on little finger of right hand
Cathclina Lambert Collection sold at American Art Galleries, New York, February, 1916

there are pearl earrings in the ears, as well as groups of pearls in the head-ornament. The portrait is listed as a production of the French School, but is of doubtful authenticity as a likeness of the unhappy queen.

The Italian fashion of ring-wearing in the sixteenth century is illustrated by the portrait of a noblewoman by Lorenzo Lotto, in the Galleria Carrara at Bergamo, Italy. On the right hand are two rings, on the fourth and little finger respectively; the left hand bears three, one on the index, apparently set with an engraved gem, and two on the fourth finger, the larger of which seems to have as setting a pointed diamond, while the smaller one, possibly bearing a little facetted diamond, is on the second phalanx of the finger, a fashion sometimes followed instead of wearing the two rings together, one directly over the other, on the third phalanx.

A fine example of a pearl-cluster ring is to be seen in the portrait of Princess Hatzfeldt by the artist Antonio Pesaro (1684–1757). The ring, worn on the little finger, has a large centre-pearl surrounded by five smaller ones, the whole constituting a rather inconveniently large jewel, although unquestionably a very beautiful one. It appears to be the only ring worn by the fair princess when posing for her portrait.

Finger rings were sometimes worn suspended from the neck, usually strung on a chain. This custom is testified to by several old portraits, among them by one of the Elector John Constans of Saxony, in the Collection of Prince George of Saxony, Dresden, and also in several of Lucas Cranach's portraits. In one of the latter, depicting an elderly and hard-featured Dutch lady, eight rings are to be seen strung on a chain or band below the collar. As the sitter's hands are adorned with five rings, her object may rather have been to display all her choicest rings, than to wear them as amulets, although

this superstitious use is generally believed to be the true
explanation of wearing finger-rings suspended from the
neck. Sometimes a single ring was hung from the neck
on a long string, and rings were occasionally worn
attached to a hat or cap, as shown in the portrait of
Bernhard IV, Margrave of Baden (1474-1536,), by
Hans Baldung Grien, in the Pinakothek, Munich.[100]

The painting of hands adorned with one or more
rings, was not favored by several of the portraitists of
the seventeenth century. Few if any rings, for example,
can be found on the delicately shaped hands of any of
Sir Peter Lyly's beauties, hands undoubtedly lacking in
individuality and conforming to a preconceived type.
Vandyke's usage in this respect varied, probably, with
the taste of the respective sitters, although the frequent
absence of rings might lead to the inference that he did
not favor them in portraits. The great masters of the
sixteenth century certainly gave no evidence of any such
prejudice, their realism and their fondness for rich orna-
ment and color causing them to adorn the hands of their
subjects, both men and women, with valuable and finely
wrought rings. With eighteenth century painters, the
tendency to discard rings was very pronounced, as in-
dicated by their sparing appearance in portraits of this
period.

It may be interesting to note the distribution of the
rings in seventeen portraits of the Blakeslee Collection,
disposed of in New York City, March, 1916, and
representing a kind of average for the period from the

[100] O. M. Dalton, " Catalogue of the Finger Rings, Early
Christian, Byzantine, Teutonic, Mediæval and Later, bequeathed
by Sir Augustus Wollaston Franks, K.C.B. (British Museum),"
London, 1912, pp. xxv, xxvii, 1, figs. 6, 15.

latter part of the sixteenth century to the beginning of
the nineteenth century:

Right Hand	Left Hand
Index finger, 7	Index finger, 4
Middle finger, 1	Middle finger, 0
Fourth finger, 7	Fourth finger, 7
Little finger, 1	Little finger, 6

Thus the index and fourth fingers of the right hand
and the fourth and little fingers of the left hand are
almost equally favored.

An oil-portrait of the Mahârânî of Sikkim, painted
in 1908 by Damodar Dutt, a Bengali artist, shows this
queen decked out with all her favorite jewel adornments;
among them are two gold rings, one set with a turquoise
and the other with a coral, on the middle and fourth
fingers of the left hand (see Frontispiece). The right
hand is concealed in a fold of her mantle, but had there
been any rings on it, it would probably have been dis-
played, to judge from the variety of the ornaments she
was pleased to wear at the sittings. She is a full-blooded
Tibetan princess, was born in 1864, and became the
second wife of the King of Sikkim in 1882, so that she
was forty-four years old when the portrait was painted.
At this time she and her husband had been held in cap-
tivity by the British since 1893. The singular crown is
the one adopted by the queens of Sikkim. It is com-
posed of broad bandeaux of pearl, turquoise and coral;
the gold earrings are inlaid with turquoise in concentric
rings; the necklace has large amber balls, and suspended
from it is a *gau* or charm-box, set with rubies, lapis lazuli
and turquoise; on the wrist is a triple bracelet of corals.[101]

[101] Berthold Laufer, " Notes on Turquoise in the East,"
Field Museum of Natural History, Pub. 169, Anthrop. Ser.,
vol. xiii, No. 1, plate 1; Chicago, July, 1913.

In the opinion of J. Alden Wier, President of the Academy of Design, New York City, rings can scarcely be regarded as in any sense important accessories of a good portrait, as this does not depend upon the elaboration of such detail. With Popes and Doges, and with some of the higher ecclesiastics, however, rings are significant as insignia of office, and are therefore depicted as marks of individuality.[102]

A fifteenth century example of a thumb ring was found in England at Saxon's Lode, a little south of Upton. The material was of silver, either considerably alloyed, or else plated with a baser metal. In seventeenth century times in England the wearing of such rings was favored by many of the richer, or more prominent citizens, so that they served to differentiate the wearer from those less well-to-do, although he might not have the right to a crest or coat-of-arms. A character in one of the Lord Mayor's shows given in the reign of Charles II (1664), is described as " habited like a grave citizen,—gold girdle and gloves hung thereon, rings on his fingers, and a seal ring on his thumb," like Falstaff's alderman.[104]

Even native African potentates could boast of fine jewelled rings in the seventeenth century. When an embassy of Hollanders came to visit the christianized King of the Congo in 1642, and were ushered into his presence, they found him vested in a coat and drawers of gold-cloth, and adorned with three heavy gold chains. On his right thumb was " a very large Granate or Ruby

[102] Communicated by J. Alden Weir, N.A., in letter of March 15, 1916.

[104] Journal of Archæology, vol. iii, p. 268.

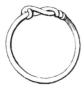
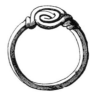

Two wire rings from a tumulus near Canterbury, Kent, England, one with
a bezel effect
Fairholt's "Rambles of an Artist"

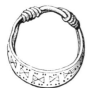
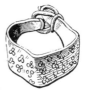

Two Anglo-Saxon rings found near Preston, Lancashire, England, in 1840
Fairholt's "Rambles of an Artist"

Silver thumb ring found at Saxon's
Lode, England. Fifteenth Century
Archæologia, vol. iii, p. 268

Silver-gilt ring, with broad, flat
hoop, and rectangular bezel set with
a carbuncle
British Museum

Ring of mixed metal set with engraved stone showing a monkey looking into a mirror
Fairholt's "Rambles of an Artist"

1, thumb-ring; two cockatrices engraved in relief on agate.
2, ring set with Gnostic gem
Fairholt's "Rambles of an Artist"

Two gold rings. 1, with high cir-
cular bezel; Frankish (?); Sixth or
Seventh Century; 2, with pyramidal
bezel; Lombardic (?); Seventh Century
British Museum

Agate ring with a Runic inscription
Late Saxon
British Museum

Massive gold ring with two bezels, one engraved with circular design of interlacing
curves, the other with three interlaced triangles. Late Saxon
British Museum

Ring, and on his left hand two great Emeralds." [105] The
red stone was almost certainly a large cabochon-cut
garnet, and it is very doubtful that the green stones were
genuine emeralds.

Under the strict discipline of the Catholic rulers of
Poland the wearing of rings was for a long time for-
bidden to the Jews. This restriction was removed in the
reign of Sigismund Augustus (1506–1548), but the
permissive decree required that a Jewish ring must bear
the distinguishing inscription " Sabbation," or " Jeru-
salem." The Jews themselves sometimes enacted rigid
sumptuary laws as to rings, for instance in Bologna,
where a convocation of rabbis decided that men should
be confined to one ring, while women were not to be
allowed to wear more than three.[106] At a later period a
Frankfort convocation decreed that no young girl should
be permitted to wear a ring. Not improbably the
natural fondness of the Hebrew women for rich jewels,
a fondness already emphasized by the prophet Isaiah
(chap. iii, vs. 16–26) in the case of the Daughters of
Jerusalem in the eighth century B.C., may have led to an
excessive use of fine rings. Indeed any strict sumptuary
regulation always implies the existence of an undue de-
gree of luxury in the usages that are subjected to legal
restraint.

A unique collection of ring stones may be seen in the
American Museum of Natural History, New York.
These are oval, domed stones, about one inch long, and
are all cut so as to fit a single setting. They were gath-
ered together by an old gentleman in the seventeenth
century, so that without changing the gold ring to which

[105] John Ogilby, Africa, London, 1671, p. 559.

[106] Vogelstein and Rieger, " Geschichte der Juden in Rom,"
vol. i, p. 337.

he was accustomed, he could vary the color of the precious stones, thus bringing them into harmony with that of the waistcoat he was wearing. As there are two hundred and forty of these specially-cut stones, the waistcoats must have represented the whole gamut of colors and shades. A few of the stones are capped with a different gem. This collection was presented to the Museum in January, 1873, by the late Samuel P. Avery, Esq.

There is also in the Museum a remarkable collection of rings begun in the eighteenth century by a Viennese imperial and royal jeweller named Türk, and continued by his grandson up to 1860. It was later acquired by J. Pierpont Morgan, Esq. The settings of the seventy rings comprise a variety of colored diamonds, as well as emeralds, sapphires, and a number of uncommon stones.

II

FORMS OF RINGS AND MATERIALS OF WHICH THEY ARE MADE

AMONG ancient gold rings, one of Egyptian workmanship is especially noteworthy for its size and weight as well as for its design. It is ½ inch in its largest diameter, and bears an oblong plinth, which turns on a pivot; it measures 6/10 inch at its greatest, and 4/10 inch at its least breadth. On one of the four faces is the name of the successor of Amenhotep III, Amenhotep IV (Akhenaten), who lived about 1400 B.C.; on another is figured a lion, with the inscription "lord of strength"; the two remaining sides show a scorpion and a crocodile respectively. The weight of this massive ring is stated to be about five ounces and its intrinsic gold value nearly a hundred dollars.[1]

Some remarkably fine finger-rings were among the ornaments found by Ferlini, an Italian physician, when he unearthed the treasure of one of the queens of Meroë. These rings are now in the Berlin Royal Museum. Some of them are plain hoops to which movable plates are attached; others are signet rings. In a few specimens of the first-named class the plate is so large as to extend over three figures, the inconvenience to which this could give rise being partly obviated by joints in the plate, so that the fingers might be moved with greater facility. We hardly think that a design of this type is ever likely to become popular in our times.

[1] Sir John Gardner Wilkinson, "Manners and Customs of the Ancient Egyptians," vol. iii, p. 373.

Scarabs strung on wire so as to be worn on the finger were found at Dahshur by De Morgan. These belonged to the Twelfth Dynasty, to the time from Usertasen III to Amenemhat III (ab. 2660–2578 B.C.). Stronger wire was used at a later time, the ends being thrust into perforations on the sides of the scarabs. In all these cases the scarab and the circlet, more or less well formed, were separate parts loosely put together. It was not until the Golden Age of the ancient Egyptian civilization that complete metal rings were made, in which both circlet and chaton formed one piece. Rings of the Egyptian type, although strongly modified by Ionic or Phœnician art, were introduced into Etruria at a very early period, and probably thence into Latium.[2] At an even earlier date, at least 1200 B.C., scarab rings were worn in Cyprus, several examples having been found in sepulchres there, the scarab being made of porcelain strung on a gold-wire hoop.

The ancient rings in the British Museum offer examples of nearly all the different types favored in early times.[3] Some, from the Mycenæan period, exhibit a long shield-shaped bezel, convex above and concave beneath, across the direction of the hoop; others have a flat band decorated with plaited or twisted wire on which is set a bezel holding a paste. Phœnician rings of the period from 700 to 500 B.C. present a variety of forms, some being swivel rings, the extremities of the rounded hoops passing into beads, in which are inserted the pivots

[2] F. H. Marshall, Catalogue of the Finger Rings Greek, Etruscan and Roman, in the Departments of Antiquities, British Museum, p. 50, Nos. 278–281; pl. vii, No. 281.

[3] See F. H. Marshall, "Catalogue of the Finger Rings, Greek, Etruscan, and Roman, in the Departments of Antiquities, British Museum," London, 1907, pp. xxxvii–xlix.

of a scarab-setting; another type has elliptical hoops, either plain or ornamental, the scarab being in a filigree-decorated bezel; in still another, the lower part of the hoop is twisted into a loop, so that the ring can be worn suspended; there are also some plain, flat or rounded hoops, sometimes with the ends overlapping.

The Greek and Hellenistic periods, from the sixth to the second century B.C., furnish a large variety of forms, some copied or adapted from earlier ones and then independently developed. A rounded hoop tapering upward, with ornamental extremities, occasionally appears in fine examples, the ends of the hoop representing the lions' masks; the bezels are frequently of oval shape, and the shoulders of the hoop are often nearly straight; in another type while the outside of the hoop is rounded, the inside is facetted; sometimes there is a high convex bezel, bevelled underneath. There are still a few swivel rings with scaraboids. In the Hellenistic period appear massive gold rings with square-cut shoulders and raised oval settings, in which a convex stone is placed. Still another type is an expanding hoop formed of two overlapping ribbons and with a convex bezel.

Etruscan rings assume various characteristic and peculiar forms, many of which are found among the Roman rings of a later period, indicating the derivation from the Etruscans of ring-wearing among the Romans. One of these in the British Museum has a broad hoop ending in convex shields, a scarab being pivoted in the terminals; in others, the hoop is hollow, terminating in cylindrical ornaments, between these a scarab revolves on a wire swivel. A peculiar example has a grooved hoop, the ends being convex disks, in which is pivoted a scarab. One of these Etruscan rings has a very large convex oval bezel, around the slope of which run a series of embossed figures.

As an example of Roman art found in Egypt, we have a spiral ring of serpent form, either extremity terminating in a bust, of Isis and Serapis respectively. The conjecture has been made that this ring, and others of the type, may have been intended to figure the reigning emperor and empress of Rome under the types of Isis and of Serapis, the latter a Græco-Egyptian divinity as worshipped in Alexandria and in the Roman world, though having a distinctly Egyptian form in the national pantheon as Asar-Hapi, or Osiris-Apis. The rings of the type described have the advantage of being easily adapted to a finger of any size, since pressure at both extremities would enlarge the girth of the single spiral.[4]

In his Etymologiæ, Isidore of Seville defines three of the types of rings worn in ancient times, the *ungulus,* the *Samothracius* and the *thynnius.*[5] The *ungulus* was set with a gem and owed its designation to the fancy that the stone was as closely attached to the gold of the ring as a human nail (*ungulus*) was to the flesh of the finger. The Samothracian ring was of gold, but had an iron setting. Lucretius in the sixth book of his great philosophic and scientific poem, " De Natura Rerum," in speaking of the magnet to which he attributes negative and positive powers, of repulsion and of attraction, relates that when, in an experiment, Samothracian rings were placed in a brazen dish beneath which a piece of magnetic iron was moved to and fro, he had seen the rings leap up, as though to flee from an enemy. The third type of ring was the *thynnius,* the name indicating, according to Isidore, that it was made in Bithynia, called

[4] Figured in Caylus, " Receuil d'antiquités," vol. ii, p. 310.

[5] Sancti Isidori Hispalensis Episcopi, " Opera Omnia," vol. iv, col. 702, Etymologiæ, lib. xix, cap. 32; vol. lxxxii of Migne's Patrologia Latina, Paris, 1850.

at an earlier time, Thynna. Horace writes, in one of his odes, of rings " chased by a Thynnian graver."

Of the key-shaped rings, several specimens of which have been preserved from Roman times, it has been suggested that the key projection was intended to serve as a guard for an exceptionally long finger-nail, similar to the finger-guards the Chinese wear for a like purpose. The fact that many of these key-rings are evidently too large to have been worn on the finger, makes it not improbable that the ring form was arbitrarily chosen, and that they may have been carried suspended from a girdle. Some of them, however, might have fitted on a very stout thumb, and a few of the rings of this type do not exceed the ordinary finger-ring in diameter.[6]

One of the large and unwieldly Roman rings, or at least a ring made on this model, bears a bust said to be that of Plotina, the wife of Trajan. This was in the collection of Monsignor Piccolomini. The extraordinarily elaborate coiffure shows three rows of facetted gems, and this alone may be considered to testify against the antiquity of the ring. Still, even as a production of the Renaissance period, the fact that it at least figures an ancient form makes it an object of interest and of a certain archæological value.[7]

It was in the late Republican, and especially in the Imperial age in Rome, that the greatest variety of ring forms were produced, originally influenced by the earlier Etruscan art, and later largely by the extraordinary

[6] C. D. E. Fortnum, "Additional Notes on Finger Rings and on Some Engraved Gems of the Early Christian Period," Archæological Journal.

[7] Dom Bernard de Montfaucon, " L'Antiquité expliqué," Paris, 1724, Suppl., vol. viii, p. 40; pl. xiv, opp. p. 43, two views, side and front.

eclectic art of Alexandria, where the combination of Egyptian, Oriental and Greek elements brought forth many peculiar forms, some of which are noted elsewhere. A Romano-Egyptian ring has a flat hoop, subangular on the outside, the large circular bezel being engraved with three figures of divinities. Then there are the composite rings, sometimes having as many as four hoops, joined together at the back of the bezel. A striking type is the penannular ring in the form of a coiled serpent, or else having at each extremity the head of a serpent. In another form the bezel is lozenge-shaped.

There are also massive rings with an elliptical hoop and thick projecting shoulders, the setting being depressed; sometimes the shoulders slope sharply up to the bezel, forming a decided angle on the hoop. Hoops polygonal on the outside and circular within also occur. Some twin rings were made adapted to fit on two fingers of the hand; in one of these are three cup settings holding garnets, one on the top of each hoop and one between the hoops. In some instances the hoops of these twin rings were not closely joined to each other, but connected by a short gold chain, so that the rings could either be worn on a single finger, or on two fingers.

Many of the hoops of the later Roman rings were elaborately decorated, either in openwork, with spirals in wire, or with beads on the shoulders; this latter type is, however, more probably of Merovingian times. A Roman polygonal hoop, with a high-set bezel, has on the side of this loops for carrying a string of pearls suspended from the ring. In one of the rings specially designed for insetting with engraved gems, the hoop, rounded on the outer side, has shoulders ending in curling leaves. A curious specimen is a plain hoop broad-

Gold ring with plain hoop on which is freely looped a little mouse wrought in gold and white enamel. It slips around the hoop. About 1600

Albert Figdor Collection, Vienna

Gold ring of Venetian workmanship. The ends of the hoop form monsters' heads, supporting a bezel formed like the petal of a flower. XIV Cent.

British Museum

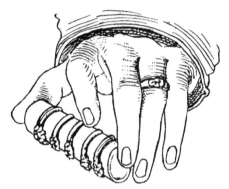

HAND OF A JEWELER, HOLDING A *BACULA* WITH FIVE RINGS
British Museum

Gold ring set with an amethyst Found at Lorsch, Grand Duchy of Hesse-Darmstadt, and hence called the "Lorscher Ring." German; end of Tenth or beginning of Eleventh Century.

Grossherzoglich - Hessisches Museum, Darmstadt

Silver ring having projecting bezel in form of a spur with revolving rowel. Italian (?), Fourteenth or Fifteenth Century

British Museum

"Regard ring," with seven hoops. The initials of the six stones spell the word "regard"

British Museum

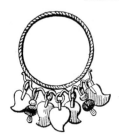

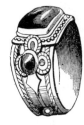

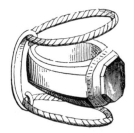

Rings of modern Egyptian type. 1, woman's ring; hoop of twisted gold, 2, man's ring made by silversmith of Mecca, with stone setting; 3, cast silver ring; stone setting; with guards

Fairholt's "Rambles of an Artist"

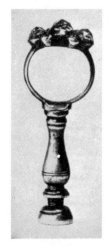

Pipe stopper ring. A silver ring on which are set three Indian, rose-cut zircons. This ring was placed on the finger and the tobacco in the bowl of the pipe was pressed down with it. French; about 1750. A similar ring was figured by Hogarth in one of his illustrations

Field Museum, Chicago

ening in an oval bezel; in this has been inserted an intaglio
head in sard, the shape of the stone following the exact
outline of the head, without any margin.

A Burgundian ring of a form that M. Deloche be-
lieves to be unique, has an open hoop. At one extremity
is a nail-shaped attachment which can be passed through
the other extremity, thus closing the ring. A bronze
ring, also Burgundian, of a rare or unique type has at
the bezel a high, oblong projection. Both these rings
are of the Merovingian period which closed in 752 A.D.[8]

In no period were a greater number of ring forms
produced than in the Middle Ages. The major part of
these mediæval rings were made as insignia of office or
rank, for sealing official documents, or for ceremonial
use. One of the earliest is that known as the Lorscher
Ring.[9] It is considered to belong to the end of the tenth,
or the beginning of the eleventh century, and to be a
product of German workmanship under the influence of
the Byzantine art of the Merovingian period. The
artistic and finely executed design of the bezel is especi-
ally worthy of admiration. The stone set therein is a
light-colored amethyst cut *en cabochon* and without foil.
This ring is now in the Grossherzoglich-Hessisches
Museum in Darmstadt.

The Besborough Collection of Gems, shown in June,
1861, by the Archæological Institute of London, was
interesting for the high artistic excellence of the rings
in which many of the gems were set. A number of them
rank among the finest examples of Renaissance work in
this direction. One, set with a sard in which a head of
Lucilla has been engraved, shows, carved in flat relief

[8] M. Deloche: "Étude historique et archéologique sur les
anneaux sigillaires," Paris, 1900, pp. 225, 226, figs.

[9] Friedrich Henkel, "Der Lorscher Ring," Trier, 1896.

on the gold hoop, two nude figures bearing in their hands torches, the design continuing completely around the hoop; about the figures are doves and flowers. This beautiful specimen of goldsmiths' work belongs to the first half of the sixteenth century. The pose of the small figures has been wonderfully adapted to the curve of the ring.[10]

To a special class has been given the name " iconographic rings," this designates those bearing, either on the bezel or the sides, images of the Virgin and Child or of the saints. These rings, which date from a period running from 1390 to about 1520, are peculiar to England and Scotland. The material is either gold or silver, those of the latter metal showing much ruder workmanship than was devoted to the gold rings.[11]

What must have been regarded in its time as an exceptionally ornate ring is listed in an inventory of 1416. It is described as a gold ring having a helmet and a shield made of a sapphire, the shield bearing the arms of "Monseigneur." As supports of the shield were an emerald bear and a swan made of a white chalcedony.[12]

An ornate though tasteless type of Italian rings were those called " giardinetti," showing flower baskets, jardinieres, or nosegays, the flowers being figured by precious stones and pearls, with stems and leaves of gold. As the aim was purely decorative, the stones and pearls

[10] C. W. King, " Notices of Glyptic Archæology exhibited by the Archæological Institute in June, 1861," London (Report from Archæological Journal), p. 12.

[11] " Catalogue of the Special Exhibition of Works of Art at the South Kensington Museum, June, 1862," section 32, " Rings," by Edmund Waterton, p. 622.

[12] De Laborde, " Notice des émaux du Musée du Louvre," 2d Part, " Documents et Glossaire," p. 131, s. v. Anel.

were usually small and inexpensive ones. Very few such rings have been made in recent times, but from the sixteenth to the eighteenth century they were much favored and a number of fine specimens have been preserved from that period.[13]

A ring-setting consisting of a turquoise surrounded by small diamonds appears to have been favored in England in the seventeenth century, for Samuel Pepys in his " Diary," under date of February 18, 1668, writes that he had been shown a " ring of a Turkey-stone, set with little sparks of diamonds."

A " Trinity Ring," that is a ring consisting of three intertwined circlets, was shown in February, 1857, to the Society of Antiquaries in London by Mr. Octavius Morgan. This specimen, carved, or turned out of a circular band of ivory, was believed to be one of three executed by the German ivory carver, Stephan Zick (1639–1715), who is said to have been the first to make a ring of this type out of ivory, although they may have been made of gold—no exceptionally difficult task— before Zick executed his ivory rings.[14] This ring, or one similar to it, is now in the British Museum, Franks Bequest.

While the rings of the Louis Quinze period were generally of delicate and beautiful form, the tendency to exaggeration in fashions that characterized the succeeding Louis Seize period found expression in rings of disproportionate size. At the same time both the number of rings in a fine lady's jewel casket, and the number she would wear at the same time upon her hand, greatly increased over what was customary in the pre-

[13] Cyril Davenport, " Jewellery," Chicago, 1908, p. 118.

[14] William Jones, " Finger-Ring Lore," London, 1877, pp. 487, 488.

ceding reign. Thus Bachaumont, in his "Mémoires Secrets," states that at the sale of Mlle. de Beauvoisin's jewels, which took place November 22, 1784, there were 200 rings rivalling one another in magnificence. Another French author of this time, M. Mercier, wrote in 1782 " when one takes the hand of a pretty woman, one only has the sensation of holding a quantity of rings and angular stones, and it would be necessary first to strip these off the hand before we could perceive its form and delicacy."

The enthusiasm of the early days of the Revolution brought into vogue rings set with a little fragment of the stone-work of the recently demolished Bastille; at the same time wedding-rings were enamelled in red, white and blue, the new Republican colors. At the outset the young royalists, as a protest, wore rings of tortoise-shell, with the motto, Domine salvum fac regem, " God save the King."

A type of ring that became popular during the darkest days of the French Revolution, the period of the dreadful Reign of Terror, was that of a large silver hoop with a plain gold bezel on which was graven the head of some one of the leading spirits of the time, such as Marat, De Chalier, or De Lepelletier St.-Fargeau.

There are several significant French proverbs regarding rings, of which we may here note the following: "Ne mets pas ton doigt en anneau trop étroit" (Do not put your finger in too small a ring) ; "Anneau en main, honneur vain" (A ring on the finger is an empty honor) ; "Bague d'amie porte envie" (The ring of a lady friend arouses envy).

Portrait rings were very popular at the time of the French Revolution, as they afforded an opportunity for the expression of the ardent devotion to particular per-

sonalities characteristic of that troublous period. Many Washington rings and Robespierre rings were to be seen, bearing the enamelled portrait of the respective hero, but the most popular were the Franklin rings, for Franklin's personal influence, born of his sterling qualities of insight and common sense, and perhaps strengthened by the contrast of his cool-headedness with the feverish excitement of the Paris of that time, was wide and far-reaching.

Hindu tradition tells of the wearing of rings in India in very ancient times. The earliest forms used by the Brahmans in their forest life, were woven of *kusa*-grass (*Saccharum spontaneum*), and even in our time rings of this kind are worn by those assisting at a religious ceremony, as otherwise the water offered to gods or to the spirits of ancestors will not be accepted. As to metal rings, Hindu law assigns those of gold to the index finger and silver rings to the fourth finger.

A story related in the Hindu epic " Mahabharata " alludes to a trick or magic practice with rings, denominated *ishika*. A ring was thrown into a deep well and then recovered in some mysterious way after it had seemed to be irrevocably lost. The " Mahabharata " in its present form may date from about 500 A.D. The other great Hindu epic, the Ramayana of Valmiki, written perhaps as early as 500 B.C. even mentions engraved rings. When Sita, wife of Rama, the hero of the poem, is abducted by Rávana, the ten-headed Cinghalese giant, Rama sends a monkey called Hanumán to seek for her, giving him a seal ring as a token. As soon as the monkey succeeds in finding Sita, he approaches her holding out the ring and saying, " Gracious Lady, I am the messenger of Ráma. Look, here is his ring engraved with his name."

In Sanskrit books the following types and kinds of rings are mentioned: [15]

Dwi-hirak (double diamond).—Rings with a diamond on either side and a sapphire in the centre.

Vajra (diamond, thunderbolt).—A triangular finger ornament, with a diamond in the centre and other stones on the sides.

Ravimandal.—A ring with diamonds on the sides and other stones in the middle.

Nandyávarrta.—A four-sided finger ornament studded with precious stones.

Nava-ratna or *Navagraha.*—A ring on which the nine most precious stones have been set. The nine precious stones in Sanskrit are called: *Hirak, Nánikya, Baiduryya, Muktá, Gomed, Bidrum* or *Prabál, Marakata, Pushpa-rág,* and *Indranil;* or the Diamond, Ruby, Cat's-eye, Pearl, Zircon, Coral, Emerald, Topaz, and Sapphire.

Bajra-beshtak.—Ring of which the upper circumference is set with diamonds.

Trihirak (triple diamond).—Ring with two small diamonds on the sides and a big one in the centre.

Sukti-mudriká.—Ring made like the hood of a cobra snake, with diamonds and precious stones on the upper surface.

Mudrá or *Anguli-mudrá.*—Ring with name engraved upon it.

These are some of the principal names for finger rings in modern India:

Angushtri.—A ring set with stones, called also *Mundri* or *Anguthi.*

Chhallá.—The *chhallá* is a quite plain hoop or whole hoop ring (with or without stones), being gold or silver, but the same all round. Worn also on the toes.

Angushtárá or *Anguthá.*—A big ring with a broad face, worn on the great toe.

Khari panjángla.—A set of finger rings of ordinary shape.

Sháhálami or *Khári.*—A ring of long oval shape.

[15] T. N. Mukharji, "Art Manufactures of India," Calcutta, 1888, pp. 105–107.

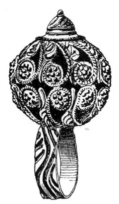

Oriental gold ring, large globular
bezel with leaves and flowers in open-
work. Said to have belonged to Chief
Samory

British Museum

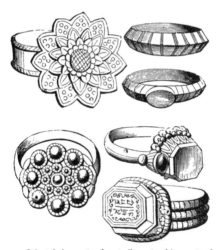

Oriental rings. 1, of cast silver; 2, of brass; 3, of
silver; 4–6, Moorish rings: 4, set with turquoise and
rubies; 5, with octagonal bloodstone and turquoise;
6, signet-ring bearing name of owner on a carnelian

Fairholt's "Rambles of an Artist"

1, ring with pendent garnets; 2, silver ring. East Indian. The
loose-hung silver drops jingle as the hand moves
Fairholt's "Rambles of an Artist"

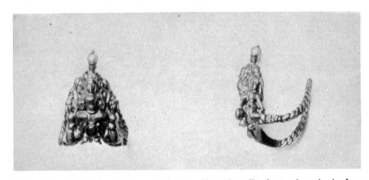

Elaborate East Indian ring, with figure of Buddha. Hoop of peculiar shape to keep the ring from
falling off the finger
Courtesy of Miss Helen Bainbridge

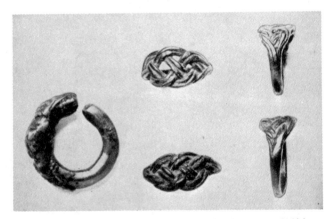

Rings made by Siamese Bonza, or Priest, from metal lying about among the idols at
Ongchor, Old Cambodia, in 1871
Courtesy of Mr. Walter C. Wyman

Birhamgand.—A broad ring.

In Bombay, the local designations for finger rings are: *Angthi, Salle, Mohorechi Angthi* and *Khadyachya angthya;* toe-rings are named: *Ranajodvi, Jodvi, Phule, Gend,* and *Masolia.*[16]

Rings, necklaces, armlets and *Sirpech* (or tiaras) are made at Bikánir, and exquisitely light and fine rings of gold and silver are produced at Jhánsi in the Gwalior territory. An unusual form of ring ornamentation appears in a silver ring of Indian workmanship, dated in the fourteenth or fifteenth century. This has a projecting bezel in the form of a spur, with a revolving swivel. A ring of similar design, believed to be Venetian, now in the Ashmolean Museum, Oxford, was brought from Chalis.[17]

The rings made by the Hindu goldsmiths are in many cases very elaborately chased and ornamented, in the ornate style characteristic of Indian jewellery. The women of the Deccan almost universally wear rings; they are usually of gold, a silver ring being looked upon as showing meanness on the part of the wearer. There does not appear to be any preference of one finger over the other for decoration with rings. One of the most attractive types is a closely-fitting ring to which is affixed a little mirror, about the size of a silver quarter-dollar; this may be mounted either in gold or silver, and undoubtedly Hindu female vanity finds this thumb mirror of some practical use. With its rich ornamentation a ring of this kind is in itself a pretty jewel, but would

[16] T. N. Mukharji, "Art Manufactures of India," pp. 124–128, Calcutta, 1888.

[17] O. M. Dalton, " Franks Bequest, Catalogue of the Finger Rings, Early Christian, Byzantine, Teutonic, Mediæval, and Later [British Museum]," London, 1912, p. 247, fig.

hardly suit Occidental taste on account of its size and the inconvenience of wearing it. A rather singular fact is that mirror-rings are sometimes worn on the great toe, where they would seem to be quite useless; but it has been suggested that as the Hindu women of the better class commonly have their feet nearly or quite bare when in their apartments, and have acquired the power to move and use their feet much more freely than is the case with Occidentals, a toe mirror might possibly be of some slight utility; still, it seems probable that they are purely ornamental and came into fashion in imitation of the thumb-mirrors. Many varieties of toe-rings are made, a special type being that for wear on the middle toe.[18]

A ring of an unusual form is worn on the great toe of the left foot by some Hindu married women, as a distinguishing mark of the married state. Men frequently wear a ring on the big toe for curative purposes, or to augment their masculine vigor. These toe-rings of the men are not generally closed circles, but open hoops, so that they can be easily removed when this is desirable.[19]

The art of the Persian goldsmith in the fifteenth century is displayed in a ring belonging to one of the splendid collections of the Metropolitan Museum of Art, in New York. It is of massive form with an immense bezel, richly decorated in openwork; the hoop is also elaborately chased. The flat surface of the bezel is adorned with a design in keeping with the ornamentation of its sides and of the hoop. For a large and massive ring

[18] Col. T. H. Hendley, " Indian Jewellery," Journal of Indian Art and Industry, vol. xii, pp. 4, 5; 1907–1909. Figs. on plates 6, 7, 8, 15, 18.

[19] *Ibid.*, p. 103.

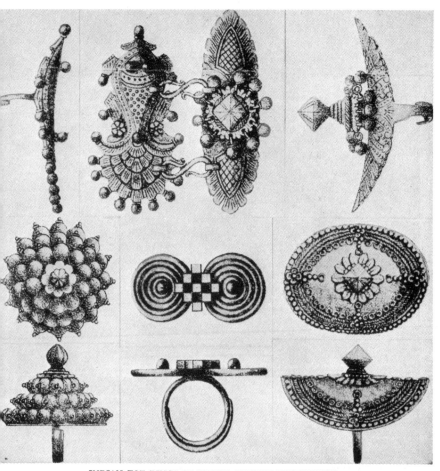

INDIAN TOE RINGS OF SILVER, MADRAS PRESIDENCY
three views of ring worn on second and third toes of the left foot; the conventional fish is an emblem of Siva
2, 3, 4, other toe rings
Journal of Indian Art and Industry, vol. v, 1894

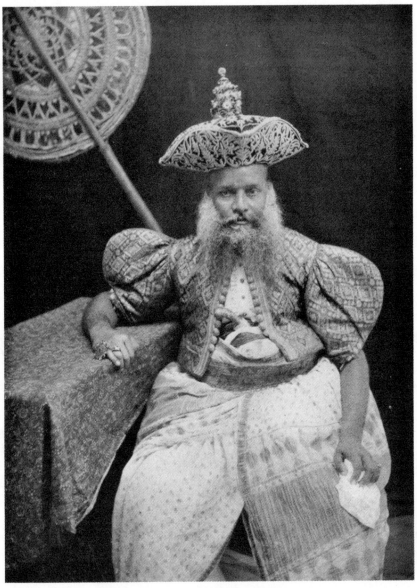

RICH CINGHALESE MERCHANT, IN GALA DRESS

The immense, round ring on the little finger of his right hand is a favorite adornment in Ceylon; smaller rings are on the fourth finger of right hand, and on the little finger of left hand

this one is remarkably well-proportioned and harmonious in design.

A good specimen of the rings worn on state occasions by East Indian princes was sold in February, 1913, at the American Art Galleries. It is of gold, but bears no precious stones; the circlet is ornamented with white enamelled crocodiles, and also with a minute enamelled figure, within a temple and incased in glass; the bezel of this ring is decorated in blue, green and red enamel.

While the simpler Chinese rings as a general rule are unset, usually consisting merely of a plain silver band on which are engraved designs of various objects, or else coated with ornaments in enamel, the rings of the Tibetans display a considerable variety of settings, turquoise, coral, agate, mother-of-pearl, mica and similar stones being used. Few or none of the true precious stones are to be found in the rings of these countries. The Field Museum of Natural History in Chicago has a large number of specimens some of which are figured in the accompanying plate.[20]

A collection of some two dozen rings of artistic Siamese workmanship were sent to the Chicago Exhibition of 1893, in charge of Prince Surrya, later Siamese ambassador to France. These rings were of nearly pure gold, and were ornamented with designs in red, green, and white enamel, representing animals, fish, and other forms, but never human figures. They were believed to be of considerable age and historic value; indeed, they were so highly prized that they were not publicly exhibited but were kept locked up in a safe, and only rarely displayed to some especially favored visitor. After the

[20] Communicated by Dr. Berthold Laufer, Curator of Anthropology, Field Museum of Natural History, Chicago.

close of the Exhibition they were safely returned to Siam.

An American traveller in Cambodia, in 1871, succeeded in having a few rings made for him by a native Buddhist *bonza,* the material being old metal found lying about among the idols of a temple at Ongchor. The work of the priest gives evidence of a considerable degree of skill in design, doubtless derived from examination and study of native and Indian types of rings. The type having an intertwined bezel prevails; one massive ring is penannular.[21] An elaborate Burmese ring has the hoop in the form of a serpent, whose open mouth displays the death-dealing fangs. Along the body runs a continuous band of rubies placed in oval settings. The rest of the surface is adorned with green, red and white enamel—mouth, nose, tail and scales being brought out in this way. Of two red stones which originally marked the serpent's eyes, one has fallen out; on either side of the head is a small sapphire. This fine ring is in the British Museum.[22]

While fifty years ago in Japan the women of the better classes did not favor the wearing of finger-rings, it was not infrequently the case that kitchenmaids and housemaids would wear silver or brass rings. They are believed to have been influenced by the example of Dutch women in Nagasaki.[23] At the present day American and European influence is very slow in making itself felt in the direction of ring-wearing.

[21] Communicated by Mr. F. W. Partridge, through Mr. Walter C. Wyman.

[22] O. M. Dalton, " Franks Bequest: Catalogue of the Finger Rings, Early Christian, Byzantine, Teutonic, Mediæval and Later [British Museum]," London, 1912, p. 336, No. 2422, Pl. xxx.

[23] Communicated by Dr. T. Wada, of Tokio.

In the large oval bezel of a fine Syrian ring is set a paste representing a topaz. The shoulders expand to form the bezel. This ring, the lower half of which has been broken off, shows an exceptionally fine patina; it was of large size and must have been a striking ornament on the wearer's hand. As the broad oval extends across the hoop, not at right angles with it, it must have interfered slightly with a free use of the fingers near the one on which the ring was worn.

In the Philippine Islands a type of ring that is made by the natives has a number of spiral twists, from five to as many as a dozen coils appearing in these rings. The serpentine form is accentuated by a pattern of dots or cross-marking, with sometimes the indication of a conventional flower design. While rather clumsy for wear, these rings still possess a certain artistic quality. Fine examples are in the Ethnological Department of the American Museum of Natural History, New York City.

The ancient city of refuge, Machu Picchu, probably built by the Incas nearly 2000 years ago on a Peruvian mountain top, was uncovered by the National Geographic Society—Yale University Peruvian Expedition of 1912, of which Dr. Hiram Bingham was the director. Among the many interesting relics found on this unique site were some silver rings, one being of the twisted type, with the ends free, so as to suit the size of any finger, while another has been welded or hammered into a closed circlet. While it is impossible to date these rings with any approach to exactness, they are undoubtedly examples of the art of native Peruvian silversmiths prior to the Spanish Conquest.[24]

Rings in great variety are worn in the Congo region

[24] Hiram Bingham, " The Story of Machu Picchu," in The National Geographic Magazine, February, 1915, pp. 172–217.

and in every part of Bantu and Negro Africa. There
are heavy rings and light ones, simple hoops and spirals,
and they are worn on neck, arm, leg, finger and toe. They
are made of brass, copper, ivory, iron, elephant foot-pad,
and several other materials. At Akkra, and in Liberia,
there is quite a manufacture of gold rings, and, to a lesser
extent, of silver rings also.[25]

An example of the exceptionally large rings some-
times made to commemorate special occasions, rather
than for possible wear, is one donated to President Pierce
by some Californian admirers in 1852. This somewhat
ambitious production scarcely answers the requirements
of a high standard of art, but its decoration offers a great
variety of appropriate designs illustrating life in the Far
West in the middle of the past century. The ring is of
solid gold and weighs something over a pound, thus
having a mere metal value of about $250. On square
surfaces cut on the circlet are a series of designs intended
to present an epitome of California's early history; the
native animals in a wild state, the Indian warrior armed
with bow and arrow, and a native mountaineer; then
comes a Californian, riding a horse at full speed and
casting his lasso; to him succeeds the miner with pick and
shovel. The bezel is engraved with the arms of Cali-
fornia; it is hinged and when opened reveals a kind of
box having nine compartments divided by golden bars.
In each compartment is a characteristic specimen of
one of the principal ores found in California. Inside
the circlet has been engraved the inscription: " Presented
to Franklin Pierce, the Fourteenth President of the
United States." [26] What may be called a presidential

[25] Communicated by Prof. Frederick Starr, of the Uni-
versity of Chicago.

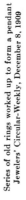

Series of old rings worked up to form a pendant
Jewelers' Circular-Weekly, December 8, 1909

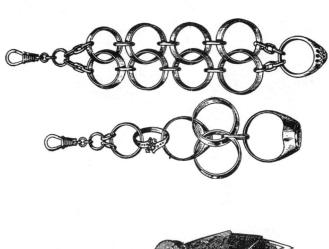

Ring given to President Franklin Pierce in 1852 by citizens of California
"Gleason's Pictorial Magazine," December 25, 1852

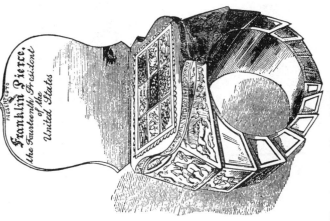

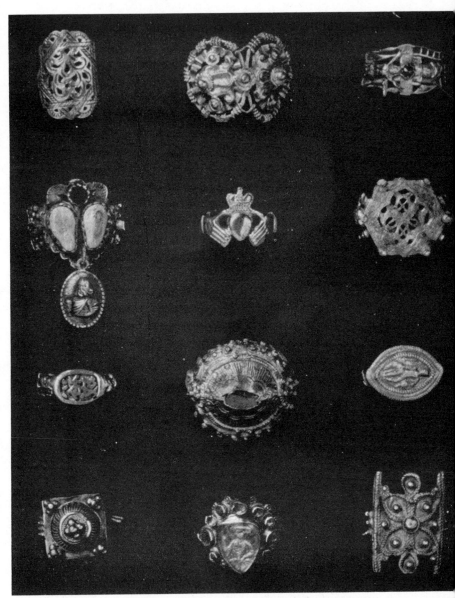

RINGS FROM THE ALEXANDER W. DRAKE COLLECTION, SOLD AT THE AMERICAN ART GALLER
IN MARCH, 1913

1, silver ring of East Indian workmanship. 2, massive Tartar finger ring of fine gold. 3, copy in silver of the betro ring of Martin Luther, a gift of Richard Watson Gilder. 4, finger ring with precious stone setting and two irregularly-sha pearls. Pendant shows the bust of a bearded man in armor. 5, gold betrothal ring. Two hands holding a crowned he Type used by Galway fisherman from the Thirteenth Century and called a "Claddugh Ring." 6, open-work gold ring. 7, Chinese gold ring—oval with Chinese characters, on either side a chiseled bat. 8, Moorish finger ring of fine gold. Large sh with characteristic ornamentation. 9, gold ring with intaglio of a shepherd and goat cut on a light sard. 10, square gold with bead groups in centre and at corners, the central part in raised openwork. 11, gold ring. French. Heart-shaped beze with Watteau figure in repousse, under crystal, and surrounded with bits of green and white crystal between small flower gold. 12, silver finger ring. Two hoops linked together by true-lovers' knot.

ring is that depicted in the effigy of Abigail Power
Fillmore, wife of President Fillmore (1850–1853), a
quaint wax figure in the Wives of Presidents series,
shown in the United States National Museum, Wash-
ington D. C. In this she is shown wearing a handker-
chief ring.

An unusually large ring was worn by the well-known
theatrical manager, Sheridan Shook. It was set with
an amethyst an inch long by three-quarters of an inch
broad and half an inch deep, and weighing two and a
half ounces. The letter S was engraved in the stone and
inlaid with small diamonds. This immense ring with its
massive gold setting can hardly be termed a great work
of art, but it is unique in its way and was greatly valued
by its owner, who only ceased to wear it when ill-health
and weakness made it too much of a burden.

The extensive and remarkable collections of the late
Alexander Wilson Drake, which were disposed of at the
American Art Galleries in New York, March 10th to
17th, 1913, comprised a fine collection of finger rings,
illustrating a large variety of forms and periods. There
were in all nearly 800 examples, set and unset. There
were betrothal rings, memorials rings, gimmal rings,
puzzle rings, rings of Roman, French, German, Italian,
Spanish, Russian, Irish, Scandinavian, English and
American workmanship, and many Oriental rings, Sas-
sanian, Indian, Japanese, Chinese, Hebrew, Gypsy and
Moorish, one of the latter being a gold circlet with
the twelve signs of the zodiac engraved in high relief
around it.

[26] Charles Edwards, " The History and Poetry of Finger-
Rings," New York, 1885, pp. 42–44; quoting from Gleason's
Pictorial Newspaper, December 25, 1852.

The personality of the collector added greatly to the charm of this collection for all who had known him. As art editor of the *Century Magazine,* and in a thousand other ways, no one had labored more enthusiastically and successfully in the cause of art encouragement and art education, and his death constituted a real loss for the progress of art in America.

The valuable and carefully chosen collection of gem stones set in rings, which was made by the late Sir Arthur Herbert Church (1834–1915), has been presented by his widow, Lady Church, to the trustees of the British Museum and is shown in the Natural History building.[27]

Corundum	12	Opal (precious, fire, black	
Spinel	17	and milk)	10
Chrysoberyl	8	Zircon	45
Quartz (amethyst, tiger-		Phenacite	5
eye, chrysoprase)	3	Enstalite	1
Peridot	1	Moonstone	2
Spodumene	1	Garnet	19
Labradorite	1	Topaz	8
Beryl	4	Cordierite	2
Andalusite	1	Sphene	1
Tourmaline	20	Turquoise	1

Only three of the rings are set with more than a single stone.

Of the 18 examples in the British Museum collection of the interesting class of rings cut out of a single stone, The collection comprises 169 specimens, 45 of them zircons, fully illustrating the wide range of color to be found in this gem-stone; two of them are of a beautiful sky-blue. The following list gives the number of rings for each mineral species:

[27] Communicated by Dr. Leonard J. Spencer, Curator of the Department of Mineralogy, British Museum (Nat. Hist.).

several belonged to the collection of Sir Hans Sloane in 1753, five of them being archers' thumb-rings, of agate, carnelian, mocha-stone, or jasper. A green jasper ring of this type is thus entered in the Sloane Manuscript catalogue: " A thumb piece for defending it from being hurt by the bowstring, from Turkey."

A remarkable, though decidedly eccentric ring of the *art nouveau* style of René Lalique shows in the long, irregularly oval bezel, a full-length, nude female figure cut in very high relief out of a bluish rock-crystal; set at one side about the middle of the figure is a round pearl, apparently of immense proportions as compared with those of the human body.[28]

Not only are there the watch-bracelets which have been so extensively worn of late years, but minute ornamental watches have been set in finger-rings, where they can be consulted with even greater ease than when worn on the wrist. The watch-face is surrounded by a bordering of small jewels. Apart from their practical value, the " watch-rings " are pretty and dainty objects in themselves, and lend a new element of variety to the long list of ring forms.[29]

There is in the collection of the Imperial Kunstgewerbe Museum, Vienna, an exceptionally fine example of the watch-ring, made by Johann Putz, of Augsburg, in the seventeenth century. It has a detachable cover, cut from an emerald, on which the Austrian double-eagle has been engraved. In the same collection are two sun-dial rings; one, made in the seventeenth century, has a lid figuring a hedge-hog, studded

[28] Figured in *Journal der Goldschmiede Kunst*, 30 Jahrg., No. 27, Leipzig, July 3, 1909, p. 220.

[29] See also p. 353 of the present work.

with black diamond lozenges; the other, a sixteenth century ring, bears a Greek inscription to the effect that "time removes all things and brings forgetfulness;" the sun-dial is on the inner side of this ring, which is of silver gilt. There is also a gold astrolabe ring, which when closed looks like an ordinary one; but when the connected circles are opened up, the ring constitutes a veritable astrolabe.[30]

A gold "sphere-ring" in the British Museum collection has an outer hoop in two parts, working like a gimmal, and three interior hoops which are almost concealed when the ring is closed. The exterior hoop is chased; on the inner surfaces, concealed from view when the ring is closed, appears in sections the following inscription in black enamel: Verbo Dei celi firmati sunt. Dixit et creata sunt, ipse mandavit et creata sunt. (The heavens are founded in the word of God. He spoke and they were created; he commanded and they were created.) After "firmati sunt," is the date 1555. The three interior hoops bear, enameled in black, the signs of the zodiac, stars, and other astral figures. This ring is of German workmanship.[31]

In the collection of works of art bequeathed to the British Museum in 1898 by Baron Ferdinand Rothschild, and designated as the Waddesdon Bequest, there are several characteristic rings. Of these perhaps the most notable is a large finger ring of gold, enameled and set with jewels, a sixteenth century example of German workmanship. The bezel is in the form of a clasped book; on

[30] Communicated by L. Weininger, of Vienna.

[31] O. M. Dalton, "Catalogue of Finger Rings, Early Christian, Byzantine, Teutonic, Mediæval and Later [British Museum]," London, 1912, p. 243, No. 1700, Plate xxiii.

the cover is a skull, about which are four stones, sapphire, ruby, emerald, and diamond, and two toads and snakes in enamel. When the book cover is thrown back there appears a loose plate of gold, on which is enameled a recumbent figure with skull and hour-glass; on the under side of the cover is inscribed in black enamel (in capitals): SIVE VIVIMUS, SIVE MORIMUR, DOMINI SUMUS. COMMENDA DOMINO VIAM TUAM, ET SPERA IN EUM ET IPSE FACIET (Whether we live or whether we die we are the Lord's. Commit thy way unto the Lord and trust in Him, and He shall bring it to pass). This combines the text, Romans xiv, 8 with Psalm xxxvii, 5. On the shoulders of the ring are two groups in enamel, the Fall and the Expulsion from Eden.[32]

Sixteenth century ring-making, so rich in its variety of eccentric types, evolved whistle-rings, one of which is in the British Museum. This is of bronze gilt; the large oval bezel is engraved with a shield of arms; the hoop is slender at the back. The shoulders are engraved with strap-work, one of them having a tubular whistle.[33]

An enameled gold ring of striking and original design is owned by Dr. Albert Figdor, Vienna. The bezel has a lid on which is enameled a head wearing a half-mask; the eyes are of small lozenge-shaped diamonds, and there is a bordering of seventeen rubies. On lifting

[32] Sir Charles Hercules Read, "The Waddesdon Bequest: Catalogue of the Works of Art Bequeathed to the British Museum by Baron Ferdinand Rothschild, M.P.," 1898; London, 1902, p. 94.

[33] O. M. Dalton, "Catalogue of the Finger Rings, Early Christian, Byzantine, Teutonic, Mediæval, and Later [British Museum]," London, 1912, p. 87, No. 571, fig.

the lid there appears beneath an oval surface, on which is enameled a heart with the motto: " Pour vous seule " (For you alone). The inner side of the lid is hollowed out so as to serve as a receptacle for hair. The hoop, of a ribbon-like form, bears the significant inscription: " Sous le masque la vérité " (Beneath the mask is truth). This ring, which belonged to the famous Viennese trage-dienne, Charlotte Wolter, is of French workmanship and dates from about 1800. A whimsical gold ring in the collection has a plain hoop, to which the figure of a little mouse, wrought in gold, is looped by the tail so that it slips around the circlet. Another gold ring of singular design is one having a diamond in a silver setting about which are three rubies in gold settings; between the rubies are three playing cards in enamel. The hoop is of open-work with two playing cards and two ovals; a section of reddish gold that has been added to it, indicates that the ring was enlarged at some time from its original size.[34]

A decoration of a somewhat unusual type appears in a ring to be seen in the Cleveland Museum of Art, the gift of Mr. and Mrs. J. Homer Wade. It has for its adornment a minute landscape painting, in place of a precious stone or seal decoration.[35] This might be a suggestion to those who may wish to bear with them a pretty reminder of their favorite country home, or else of some scene that is associated with exceptionally happy memories.

A symbolic ring recently designed and executed in New York artfully combines a number of significant

[34] Communicated by L. Weininger, of Vienna; see p. 31.

[35] The Cleveland Museum of Art, Catalogue of the Inaugural Exhibition, June 6 to September 20, 1916, Cleveland, 1916, p. 68, No. 109.

elements, each of which has a distinct bearing upon the history, the fortunes, or the taste of the prospective wearer. At the head of the ring is set his birth-stone, the sard, about which are engraved his family crest and motto, and the initials of his name. On the shank are two relief representations, one of a lion, " the king of beasts," typifying royal descent, the other showing the wearer's patron saint, Michael; at the left of this figure is set an emerald as the talismanic gem. Surmounting the head of the ring are a series of light gothic arches, indicating the religious character of this jewel. On the smooth inner side of the head is engraved a mystic design, consisting of a double triangle, interlaced to form a six-pointed star, and enclosed by a circle; within the triangles appears in blue emerald the " mystic number " 15, that of the wearer, blue being his astral color; the triangles symbolize the inseparability of the Holy Trinity, and the circle typifies Eternity, this word being engraved above, as well as the date of the wearer's birth, and a legend commemorating the gift of the ring. It is made of fine gold, so that it may the better denote absolute purity.

In one type of serpent ring, one of the ends is inserted loose into the mouth of the serpent's head terminating the other end, so that by a little careful bending, the trifling difference in the diameter of the hoop necessary to adjust it perfectly to a finger can be easily attained. This form already appears among ancient rings.[36]

Two finely wrought serpent rings are shown on

[36] Frederick William Fairholt, " Rambles of an Artist," London, n. d., p. 77, fig. 88. A later edition of this book, dated 1871, bears the title, " Rambles of an Archæologist."

the Plate.[36a] In one of these (No. 2), with three coils, the erect head of the snake with distended jaws is vividly portrayed, making the ring a work of art indeed, but arousing an instinctive repulsion in the beholder. The other serpent ring constitutes a simple circlet, the head of the snake overlapping the tail. As an example of artistic workmanship it fully equals the larger ring, and may be considered better adapted for the adornment of the hand, since the serpent nature is not so aggressively presented.

Rings of a quite unique type, that owes its origin to the great war and to French skill and taste in adapting the most unpromising means to an artistic end, are those made by French soldiers out of aluminum fuses taken from the bombs which their German foes have so liberally rained upon them. At the outset the disks were first worked with scissors to make rude rings for men's big fingers. Later on the well-furnished tool-box of the machine-gun squad was called into requisition. This early primitive type was soon abandoned, and in order to make rings of the proper dimensions the metal from the German shells was fused and run into ingots; the crucible was frequently one of the new iron helmets, which was set on a wood fire that was kept going by a bellows improvised from a bayonet sheath. However, the soldiers finally became so reckless in their search for material that it was found necessary to put a stop to this, after several had been shot by the enemy.

The first models for the rings were made of wood or soft limestone. At a more advanced stage, round bars were made, which were cut into sections by means of the jagged edge of an old trench-spade. The smoothing off

[36a] From the collection of W. Gedney Beatty, New York City.

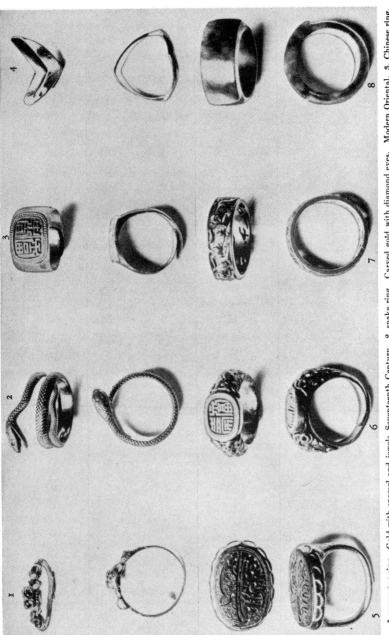

1, mourning ring. Gold with enamel and jewels, Seventeenth Century. 2, snake ring. 3, Chinese ring. Native gold with seal reading, "Riches and public honors." Nineteenth Century. 4, wish-bone ring. 5, Persian ring. Gold and silver, set with a carnelian having seal characters of owner's name. Metal engraved inside. Eighteenth Century. 6, Chinese ring. Native gold with seal reading, "Long life and riches." Overlapping back. 7, animal ring. Eighteenth Century. Carved gold in two colors with continuous procession of tigers. Modern French. 8, Chinese ring. Of greenish jadeite in one piece. Eighteenth Century

Carved gold with diamond eyes. Modern Oriental. Overlapping back. Copy of an African one in gold.

Rings from the Collection of W. Gedney Beatty

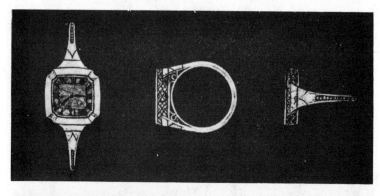

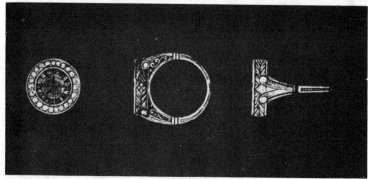

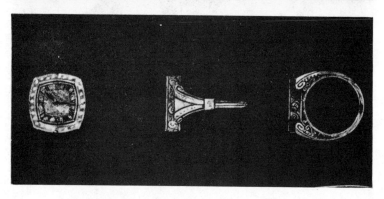

THREE TYPES OF WATCH RING
Front, side and end views

was done with a knife, and for making the ring apertures a pick was commonly used. They were then polished with a piece of hard wood, moistened from time to time to soften it.

This still primitive form failed to satisfy the amateur ring-makers, and soon some of them began to engrave their rings with the point of a pocket-knife, and others, more ambitious, encrusted them with small pieces of copper, either mortised or rivetted in. Although many of the rings were undoubtedly the work of entirely un-practiced hands, of course in any of the great modern national armies men of all trades and professions are represented, and hence the really fine examples of these war-time rings have been the work of those familiar with the jewellers' art. So eagerly did some of the soldiers pursue this avocation, that when their aluminum threat-ened to give out, they would look impatiently for a bom-bardment to get a new supply.[37]

The " add-a-link " ring is made up of a series of small links which all snap one in the other. The pur-chaser buys one with the number of links requisite to fit the finger exactly. If he wishes to have a stone in it he buys a link with a stone inserted therein. A plain link is snapped out of the ring and the link with the stone is snapped in. Sometimes these rings are made up of a variety of stones and then again with only one stone. It is possible in this way for the purchaser to obtain, at a moderate cost, a variety of settings, changeable at will. Moreover, a ring of this type can be enlarged as the finger grows larger.

Among a number of ring-types designed for the practical convenience of the owner and only worn tem-

[37] " Les bagues des tranchées," *L'Illustration*, July 3, 1915, p. 20, with cuts showing soldiers at work and specimens of their rings.

porarily to serve a particular purpose, we may note the cigarette ring, provided with a straight sliding rod the end of which clasps the middle of a cigarette, so that when a whiff has been taken, the hand may be freely used without laying aside or dropping the cigarette. Another smokers' ring is one provided with a projection for stopping a pipe, rendering it possible for the ardent pipe-smoker to keep his pipe-bowl well filled and well packed without soiling the tips of his fingers. These pipe-stopping rings are sometimes of rich materials, in one instance the stopper was of a beautiful white zircon, finely contrasting with the rich yellow gold of the ring proper. Rings of this kind were very much in vogue in the eighteenth century, and one appears on the hand of a gentleman in one of Hogarth's engravings.

The name " swivel ring " is applied when the head of the ring is loose, and is loosely secured by a bar to the band or circlet, so that the ring will swing around. This type is frequently used in scarab rings, or where there is a double intaglio, a double miniature, or other double object, or where the ring is what is known as a concealed seal ring, the outside part being a gold ornament or a stone.

One of the " surprise rings " in which a hinged outer section of the hoop can be made to detach itself, on a spring being pressed, so that a concealed surface appears, shows on its hidden surface a number of magical signs and the names of the angels or spirits Ashmodel, Nachiel, Zamiel, and others. Wearing a ring of this kind, the adept could reveal his belief in the magic arts to others of his sect or fraternity, thus bearing about with him a secret passport admitting him to their confidence.[38]

[38] Frederick William Fairholt, " Rambles of an Artist," London, 1880, p. 141, fig. 171.

A pretty way of utilizing old and cherished rings for the production of an attractive ornament is to link them together so as to form a chatelaine. By this means a large number of family memorial rings, either those of more or less remote ancestors or of persons whom the owner has known and loved, may be combined in a single beautiful chain. This can be done in several ways. After opening the rings at the joint, they are strung one below the other, the monotony of the effect being varied by one or more double rings, the terminal of the chain being a seal-ring with the bezel downward. Another method is to have a series of double rings, each one of which is joined to the member of the pair immediately below, by means of a small ring made for this purpose; here again the terminal will be either a seal-ring, or one set with a large precious stone. Such ornaments are not only things of beauty in themselves, but unique in the memories they serve to perpetuate in the hearts of the wearers.

THE MATERIALS OF RINGS

Ring whittling or carving is a favorite occupation of sailors and young boys. Many interesting rings have been carved by them out of peach pits, flexible ivory, cocoanut shells, gutta percha, walrus ivory, boxwood, whale's teeth and many other substances. These are frequently incised with the initials of the wearer or the one to whom the ring is to be presented. Then again, pins are cut off and the upper part driven into the hoop, in such a way that the head of the pin appears as a beading; often metallic points are added. Other rings are carved with hearts, folded hands and other symbols of sentiment.

As a ring is necessary in marriage it has occasionally happened when no precious metal was available in hasty

marriages, or out of economy, that a curtain ring, taken from the church curtain, has been used.

Memory rings, of threads wound around the finger, have often been employed. Sometimes these are made of cord or yarn, and each ring is supposed to represent one object to be remembered, and to be purchased, or delivered at the final place of destination. The writer distinctly remembers seeing an old man nearly 90 years of age, wearing a waistcoat older than himself, and with at least twenty strings of different colors and variety on his fingers. He trudged a distance of six miles to the nearest village and had been instructed not to return until he had purchased or obtained the object meant by each string. This memorizing by cords or strands has been practised by many primitive peoples who had not developed any system of writing, a well-known instance being the wampum records of some of our North American Indian tribes.

To the famous episode of the descent of the life-goddess Ishtar to the infernal regions, forming part of the great Babylonian poem known as the " Gilgamesh Epic," have been appended a few lines suggesting an idea distantly resembling that in the Greek myth of Orpheus and Eurydice. A mourner who seeks to release a loved one from the Realm of Death, is told to address himself to Tammuz (=Adonis). A festival garment is to be put on the god's statue to induce him " to play on the flute of lapis-lazuli," with a ring of porphyry. This divine music was believed to arouse the dead and call them to inhale the fragrance of the incense offering prepared for them.[40] The " porphyry ring " for play-

[40] Morris Jastrow, Jr., " The Civilization of Babylonia and Assyria," Philadelphia and London, 1915, pp. 459, 460.

ing the musical instrument might seem to indicate that it was some form of lyre, on which the ring could be used as a kind of plectrum, rather than a flute or other wind-instrument.

Rings made entirely of a precious stone substance were not uncommon in the time of Rameses III (1202–1170 B.C.) and later Egyptian sovereigns, but there is no evidence of their having been made at a more remote period. The prejudice against burying rings with the dead does not seem to have affected the Egyptians, for in a number of cases rings have been found on the fingers of mummies.[41]

The sardonyx was a favorite stone with the Romans of the Imperial Age, as is proved by the frequent allusions to it by the poets of this time. Of a celebrated player on the lyre, Juvenal (50–130 A.D.) says that as his hand passed over the strings the whole instrument was lighted up by the sheen of his many sardonyx rings.[44] Such a ring was regarded as a most appropriate birthday gift.[45] Another passage relates that the advocate Paulus, in order to render his address before the court more impressive, wore upon his hand a fine onyx ring which he had borrowed from a friend especially for this occasion.[46] Indeed, so highly was the stone prized that it was called the first of gems (*gemma princeps sardonychus*) and ivory caskets were regarded as fit receptacles for sardonyxes.[47] The value of rings set with

[41] Sir J. Gardner Wilkinson, "Manners and Customs of the Ancient Egyptians," revised by Samuel Birch, New York, 1879, vol. ii, p. 340, note by Birch.

[44] Juvenal, sat. vi, l, 382.

[45] Persius, sat. i, 1, 16.

[46] Juvenal, sat. vii, ll, 143, 144.

[47] *Idem*, sat. xiii, ll, 138, 139.

them is shown by the fact that in Hadrian's (76–138 A.D.) time, they were expressly associated with the gems of greatest value, such being strictly differentiated from those worth but four gold pieces each.[48]

Several rings of the Later Roman period in the British Museum are set with small diamonds. Of these the following are believed to represent original settings:[49]

No. 779. Plain solid hoop with sides cut flat. It is set with a small pointed diamond. Castellani Coll., 1872.

No. 785. Thin rounded hoop, slightly expanding upwards. Pointed diamond in raised oblong setting. From Tartûs. Franks Bequest, 1897.

No. 787. Angular hoop, projecting sharply below the shoulders, which are in the form of hollow leaves within a triangular frame. The bezel is square and contains an octahedral diamond; the sides are open and form a kind of wave pattern. Castellani Coll., 1872. 3rd century, A.D.

No. 788. Type akin to last. On either shoulder is an openwork triangle. The bezel is square and contains an octahedral diamond; on either side of the bezel is a small openwork triangle.

No. 789. Type akin to last. The lower part of the hoop has a groove running along its middle; either shoulder is cut away in a slight curve. The bezel is square, with a triangular space left open in each side and with a round opening below. It contains a diamond of octahedral form. Franks Bequest, 1897.

No. 790. Type akin to last. The hoop is rounded without; the curved excision of the shoulders is more pronounced. Two double pyramid-shaped (octahedral) diamonds are set in the bezel. A triangle is cut out of either shoulder, and two smaller

[48] Ulpian, L., 6 *sqq.*, De bon. damnat.

[49] F. H. Marshall, " Catalogue of the Finger Rings, Greek, Etruscan and Roman, in the Departments of Antiquities, British Museum," London, 1907, pp. 127–129, pl. xx, 778, 785, 790 and text figures 106, 107 on p. 129.

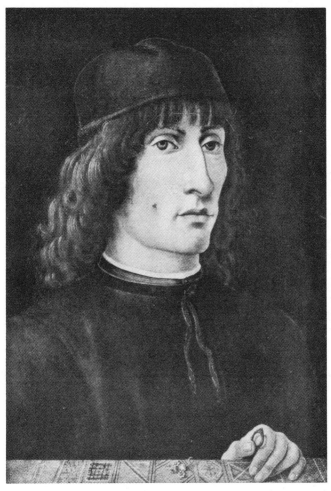

PORTRAIT OF AN UNKNOWN MAN IN THE COSTUME OF THE FIFTEENTH
CENTURY, BY ANTONIO DEL POLLAIOLO

He holds between the thumb and index of his left hand a ring set with a naturally pointed
diamond crystal

Galleria Corsini, Florence

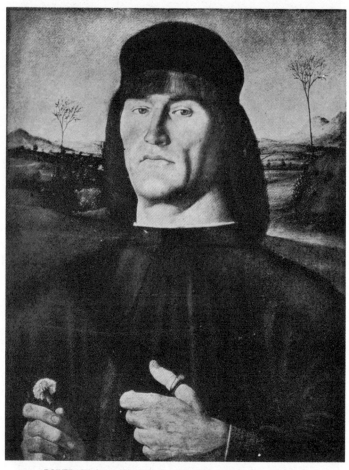

PORTRAIT OF A VENETIAN SENATOR, BY A. DA SOLARIO
Seal ring on thumb of left hand
National Gallery, London

triangles on either side of the bezel. Underneath the stone are two lozenge-shaped openings. Franks Bequest, 1897.

In all these cases the diamond is a small natural crystal of octahedral form suggesting the " diamond, a point of a stone," of which the astronomer Manilius wrote in the first century, and, perhaps, the diamond in Berenice's ring mentioned in the same period by the satirist Juvenal. Another ring in the British Museum, however, is set with two *facetted* diamonds, as well as with two other stones (No. 778 of catalogue, Plate xx, same number). Here the diamonds have unquestionably been set at a time long posterior to the making of the ring, which is believed to belong, approximately, to the same period as the others we have listed. The diamonds were probably inserted to replace two of the original stones that had fallen out of their settings.

Sir Charles Hercules Read pronounces the instances of diamond settings in ancient rings to be exceeding rare. He states that the examples above noted are the only ones of which he knows, and considers that they belong to the third or fourth century of our era.[50]

The famous Marlborough collection of gems includes a thumb ring entirely of sapphire. To give this stone ring the necessary resisting power, it has been lined with a thick hoop of gold. The engraving it bears, a head of the Elder Faustina, the wife of Antoninus Pius (86–161 A.D.), is believed to replace an original Arabic inscription that fitted this ring for use as a seal.[51]

Rings entirely of precious-stone material, or " hololith " rings, have been found at Mycenæ, one of jasper

[50] From a personal letter to the writer, dated February 21, 1916.

[51] C. W. King, "Antique Gems and Rings," London, 1872, p. 373.

and another of rock-crystal, and a carnelian ring was dis-
covered in a tomb in southern Russia. Each of these
bears an engraved design. Two carnelian rings are in
the British Museum.

Chalcedony rings, that is, rings entirely formed of
this stone, while quite rare, are represented by a few
specimens. We describe elsewhere the so-called be-
trothal ring of the Virgin at Perugia,[52] and the British
Museum has a large example of a chalcedony ring, with
the hoop rounded on the outer side, and a raised bezel
that has been roughly cut so as to indicate a human head,
some scratches marking the hair. The work is late
Roman and the inscription shows that it was made for
some adherent of the Gnostic sect.[53]

A large ring, entirely of rock crystal, shows on the
oval flattened surface of the upper part a curious com-
bination of the " Tau Cross," with superposed
" chrisma," and with a serpent twined about it, recalling
the brazen serpent of Moses, the view of which restored
health to the diseased; the Greek letters, *alpha* and
omega, " the beginning and the end," complete this in-
terlacing of Old and New Testament emblems; the
doves facing the cross are the faithful to whom the Cross
of Christ brings salvation.[54] Another entire crystal ring
bears on its flat face a design of somewhat similar im-
port, with, however, the curious difference that the lower

[52] See pp. 222, 258–261 of present work, and plate opposite
p. 316 of the writer's, " The Curious Lore of Precious Stones,"
Philadelphia and London, 1913.

[53] F. H. Marshall, Catalogue of the Finger Rings, Greek,
Etruscan, and Roman, in the Departments of Antiquities,
British Museum, London, 1907, p. 110, No. 654, pl. xvii.

[54] Bosio, " Roma Sotteranea," Romæ, 1672, vol. i, p. 211.

end of the cross is supported on a little Cupid, on either side of which figure is a dove.[55]

The jewels of the Mogul emperors were the most splendid in the world, but few have survived intact to our time, as nearly all were broken up by the spoilers of the Mogul Empire. However, one of the few that have been preserved for us is a most interesting illustration of the type of ring favored in that age and region. This is one made for Jehangir Shah, the father of Shah Jehan, for whom was erected the wonderful Taj Mahal at Agra, a memorial of his dearly beloved wife, Mumtaz Mahal, who died in 1629. It is about $1\frac{1}{4}$ inches in diameter and is cut out of a solid emerald of exceptional purity and beauty of color; from the ring proper depend two fine emerald drops, while set in two collets are rose diamonds with ruby bordering. Jehangir's name is engraved on the hoop. This ring was probably carried off by Nadir Shah at the looting of Delhi in 1739, and after remaining in the Persian treasury for a few years found its way, with other gems and jewels plundered from the Moguls, into the hands of the Afghan chiefs. One of these, the unfortunate Shah Shujah, in the course of his wanderings after he had been blinded and deprived of his throne by a brother, finally sought and found refuge under the protection of the British East India Company, and as a token of gratitude, or as a slight *quid pro quo,* he gave this historic ring to the company. After having been acquired by Lord Auckland, it passed into the hands of the Hon. Miss Eden. This is probably the very finest specimen of the rare type of hololith rings,

[55] Gorlæi, " Dactyliotheca," 1672, vol. i, p. 211; cited in " Dictionnaire d'Archéologie Chrétienne et de Liturgie," Paris, 1907, vol. ii, col. 2194, figures.

or rings entirely consisting of a single precious-stone material.[56]

For those who believed in the magic virtues of precious stones, a ring of this kind would possess much greater efficacy than would a metal ring set with the stone, as in the former case the substance when worn would always be in direct contact with the skin of the wearer. Jehangir also owned an entire ruby ring given him by Shaikh Farid-i-Bukhari, and valued at 25,000 rupees (about $12,500). In modern times, the Burmese ambassador to the court of Persia is said to have brought with him, as a gift to the Shah, a ring cut out of a solid ruby of the finest color.[57]

One of the most remarkable archers' rings was engraved out of a single piece of emerald. It is an example of the type which is narrow at one end, tapering to a broad edge at the other. It is of a beautiful green emerald and very handsomely engraved. This ring was probably made for the Mogul Emperor Shah Jehan, about 1650. It was part of Nadir Shah's share of the booty from the sack of Delhi in 1739, and this Persian adventurer had the following inscription engraved upon it in Persian characters: " For a bow for the King of Kings, Nadir, Lord of the Conjunction, at the subjugation of India, from the Jewel-house [at Delhi] it was selected 1152 [1739 A.D.]". The luckless Shah Shuja, gave it to Runjit Singh, the Lion of the Panjab, in 1813, when he

[56] King, " Natural History of Precious Stones," London, 1870, p. 297.

[57] Blochmann, "Ain-i-Akbari," Calcutta, 1871, p. 414 and Wills, " The Land of the Lion and the Sun," London, 1883, p. 376; cited in Ball, "A Description of Two Large Spinel Rubies," Dublin, 1894, p. 390; reprint from Proc. of the Roy. Ir. Soc., 3d ser., vol. iii, No. 2.

took refuge at the latter's court at Lahore. At the end of the second Sikh war in 1849 it was found with the regalia in the royal treasury of Lahore. This splendid ring once owned by Lord Dalhousie, was sold at Edinburgh in 1898; it came into the possession of W. H. Broun, Esq., and is now one of the gems of a private collection in Philadelphia.[58]

In past times the Shahs of Persia have passed ordinances restricting the exportation of turquoise. Regarding this precious stone as peculiarly Persian and for the furthering of Persian goldsmiths, it was enacted that no unset turquoises should be exported; as a rule the settings were in rings, these being easily transported, since a great number of them could be strung together. Sometimes a prospective purchaser was permitted to test the quality of a string of turquoise rings by wearing a bunch of them for a while under his arm-pit, to see whether the stones would change color. Although some failed to endure this rather severe test, many withstood it successfully.

The entire circlet of certain of the finest turquoise rings was of pierced gold enriched with rose diamonds; other, less valuable turquoises have been set in fine gold rings, carved or plain, and those of the next lower value, in ornamented silver. The cheaper sort ranged in price all the way from one cent to a few dollars, and were often set in rings made of tin, or of tinned iron, the hoop costing but two cents. The stones were always cut

[58] T. H. Hendley, " Indian Jewellery," *Journal of Indian Art and Industry*, vol. xii, 1907–1909, p. 166; pl. 141. Gul-Begum, " The History of Humâyûn," translated by Annette S. Beveridge, London, 1902, p. 121, note; Orient Trans. Fund, n. s., vol. i.

irregularly *en cabochon,* the form being frequently quite
pleasing; if the turquoise were thin the back was coated
with pitch to bring out the color, and on the surface was
engraved some short formula from the Koran, such as
"Allah be praised!" or "Allah is great!" Occasionally
the Shah's portrait was the subject.

In the Roman world entire rings of yellow amber
were sometimes formed, and in a few instances figures
or heads have been engraved in relief upon the chaton.
Their execution need not have presented any greater
difficulty than did the carving of the many small amber
figures which have come down to us from ancient times.
A carved amber ring in the Franks Bequest of the British
Museum is beautifully formed with full-relief figures of
Venus and of Cupid on either side. It is cut out of a
single piece of amber, and is considered to be the finest
example extant of Roman carving in that material,[59] but
unfortunately is considerably damaged.

Pliny declares that in his time amber ornaments were
almost exclusively for women's wear; indeed, a few years
later, Artemidorus, in his "Oneirocritica," an interpreta-
tion of dreams, after saying that amber and ivory rings
were only appropriate for women, proceeds to assert
that this was true of all kinds of rings.[60] There are but
a very few ivory rings in the British Museum, although
the collection includes several bone rings, probably for
wear on the thumb. The relief-carving of masks has

[59] Hodder M. Westropp, "A Manual of Precious Stones
and Antique Gems," London, 1874, p. 120. No. 1627 of
British Museum Catalogue of the Finger Rings, Greek, Etrus-
can and Roman, in the Dept. of Antiquities, by F. H. Marshall,
London, 1907.

[60] Oneirocritica, lib. ii, cap. 5.

been thought to make it likely that they were actors' rings.[61]

Not only have entire emerald and ruby rings been formed, but even the intractable diamond has lately been cut in this form. An entire diamond ring, the work of the diamond-cutter Antoine, of Antwerp, was shown in the exposition held in Antwerp in 1894.[62] Another such ring has since been executed by Bart Brouwer of Amsterdam. In this latter ring the facets are all triangular.

The unrivalled Heber R. Bishop Collection of Jades, now in the Metropolitan Museum of Art, New York City, contains an ancient thumb-ring (*pan chih*), entirely of jade, from the time of the Han Dynasty (206 B.C.–220 A.D.). Its major and minor diameters are 1.16 inches and 1.03 inches, respectively, and it weighs .809 ounce. The material is the nephrite variety of jade, the color being clouded gray with very dark brown veinings. The rings of this type were worn on the thumb of the left hand to protect it from injury by the bowstring after the discharge of the arrow. The dark veining results from the filling of the fissures in the material with some brownish-black substance; it is an excellent example of the amphibolic alteration of jadeite, which is shown by chemical analysis to be present here to the amount of 4.15 per cent. (No. 330 of the collection).

A recent type of archer's thumb ring in this collection, of the Ch'ien-Lung period (1736–1795 A.D.), is of

[61] F. H. Marshall, " Catalogue of the Finger Rings, Greek, Etruscan, and Roman, in the Departments of Antiquities, British Museum," London, 1907, p. xxxvii; see plate xxiv, Nos. 1621, 1624.

[62] Figured in Leviticus, " Geillustreerde encyclopedie der diamantnijverheid," Haarlem, 1907, p. 229.

cylindrical form, the thick solid side bevelled inward at the base so as to adjust the ring to the hand; the convex top slopes downward from the middle. This is of a beautiful light emerald-green jadeite, clouded here and there with shades of greenish gray. It has diameters of 1.06 inches and 1.25 inches, and weighs about 1 $^2/_3$ ounces. The specific gravity and hardness are those of the jadeite variety of jade, a silicate of aluminum, while nephrite is a silicate of magnesium (No. 508).

The Bishop Collection also contains two archers' rings of the original type, with a wide flange on the lower side. These are entirely of carnelian, and are representative of the kind really used by archers. The greater part of the thumb-rings, many of them called more or less loosely " archers' rings," were never designed for any such special use, but constitute a modification of the original form to suit them for habitual wear. Indeed, in many cases the more ornate were rather used as pretty toys to handle, as Orientals are fond of handling gems or small jewels, than for wear. Of course the gradual disuse of archery in military operations contributed greatly to the change of fashion.

In this collection may be seen a finger-ring (chih-huan) of white jade (nephrite) set with jewels. Its shape resembles that of an archer's ring and it is decorated with floral designs, the effect enhanced by sixty precious stones, comprising twenty-four rubies, thirty-two emeralds and four diamonds. This ring is of Indian workmanship, those made in China scarcely ever having any precious-stone adornment. In the floral ornamentation a row of rubies and emeralds cut *en cabochon* are outlined in gold so as to represent flowers, while in the field are four conventionalized upright sprays, each composed of three flowers, the upper one a facetted diamond,

while the lateral pair are facetted emeralds. On the upper rim an undulating floral scroll has stem and leaves of gold, and flowers set alternately with rubies and emeralds.[63]

At the time a Corean embassy visited the United States in 1883, one of its leading members was Min Yonk Ik, a princely personage, closely related to the queen of the country, who brought with him two thumbrings, which he wore, alternately, on his right hand thumb. In the case of one of these rings the Corean must have been imposed upon by the seller, for he supposed it to be jade, while the present writer's examination of it showed that the material was merely serpentine. Its outside diameter was 34 mm. ($1^1/_3$ in.), the inside diameter being 22 mm. (about $\frac{7}{8}$ in.), the length, or height, was 28.5 mm. ($1\frac{1}{8}$ in.). This ring was described by the writer in 1884, in *Science;* in the succeeding year he had occasion to correct a statement that it was an archer's ring.[64] The Corean women commonly wear two rings, always exactly similar in every respect. As a rule they are perfectly plain, of oval form, the material being gold, silver, amber or coral. The coral was usually imported from China.

The Chinese ambassador, Wu Ting Fang, wore a jade ring in which was a thick plate of gold to reduce the size. Some of the more beautiful are of the pale green jade, known by the Chinese as *fei ts'ui,* or "king-

[63] " The Heber R. Bishop Collection of Jades," New York, vol. ii, p. 259, illustration.

[64] Science, vol. iv, No. 82, pp. 172, 173, with cut of the ring; vol. iv, No. 85, pp. 270, 271, communication by Edward S. Morse on the subject; vol. vi, No. 126, July 3, 1885, reply of George F. Kunz, citing letter of Lieut. G. C. Foulke, U.S.N., of U. S. Legation at Seoul, Corea.

fisher-plumes." Many of these rings are exceedingly costly; when made of some piece of jade possessing very exceptional qualities of color and surface, a thumb-ring may cost as much as $10,000, or even $15,000. Incidentally, it should be noted that Wu Ting Fang is an excellent judge of precious stones.

Archers' rings are made by Chinese and Manchus, Turks and Persians, who release the arrow according to Asiatic style, the bowstring being held by the bent thumb. In China they eventually became the insignia of military rank, and were of jade, or a glass imitation of jade; the latter are the kind usually to be found in curio shops. The Japanese did not use them, the archers wearing a glove with a horn thumb-piece. This type of glove was, however, not used by the Japanese swordsmen, as the stiff thumb-piece would have hindered the free use of the hand.[65]

An engraved finger ring entirely of milk-white jade is in the Berlin Mineralogical Museum, and in the collection of Dr. David Wiser, of Zurich, there is a jade ring-setting on which is engraved a scorpion. This image was believed to lend to the object so engraved a talismanic virtue. A slab of jade in the Freiburg Museum bears the carefully engraved figure of a scorpion and is considered to be an amulet. The source of this specimen and the place and time in which it was engraved have not been accurately acertained.[65a]

The Pueblo Bonito ruins in New Mexico have furnished us with a fragment of a jet ring. The portion remaining of this ring shows that it must have had a

[65] Communicated by Stewart Culin, Brooklyn Institute.

[65a] Heinrich Fischer, " Nephrit und Jadeit," Stuttgart, 1880, pp. 39, 334, fig. 52 on page 39.

diameter of about 2.3 centimetres, the width of the band being 1.4 centimetres. Apparently some accident befell the original ring, causing part of the brittle material to chip off, for in the section that has been preserved a piece of jet, as wide as the band and 9 millimetres across, has been inlaid in the body of the ring. This was cut away to a depth of a millimetre, and the concave-convex inlay was then glued on.[66]

The gold-plating of bronze rings dates back to the Mycenæan period, and Ionic silver rings with gold plating were made in the sixth century B.C.; Cypriote bronze rings of about the third century B.C. have also been found. Where, as in many cases, mere gilding has been resorted to, only traces of this may remain after the lapse of centuries.[67] We note elsewhere the gold-plated iron rings worn by some Roman slaves to evade the penalty imposed upon those who illegally wore gold rings.

Glass rings are frequently made at Murano and other places in Italy of the so-called " gold stone," aventurine, or Venice gold stone. They are very inexpensive and are generally worn by children or young girls. Mosaic rings are those in which the upper part of the ring contains either a Byzantine mosaic made up of colored glass or other material, or a Florentine mosaic, in which shell, marble and other materials are set in slate or marble settings.

Bohemian garnet rings are generally made of facetted, rose cut, or cabochon cut garnets, set usually in 8 to 14

[66] George H. Pepper, " The Exploration of a Burial Room in Pueblo Bonito, New Mexico," Putnam Anniversary Volume, New York, 1909, p. 244, fig. 7.

[67] F. H. Marshall, " Catalogue of the Finger Rings, Greek, Etruscan and Roman, in the . . . British Museum," London, 1907, p. xxxii.

carat gold. They are made in Prague and other cities
in Bohemia, the garnet material, of the pyrope variety,
coming largely from the mines at Meronitz, Bohemia.

Among the cheap materials that have been used on
occasion for making rings, are horseshoe nails, which
may perhaps be supposed to possess some of the wonder-
ful talismanic power accorded by popular fancy to the
horseshoe. The nails are more or less skilfully twisted
into a ring form, and are at least as durable as other
forms of iron rings.

An extraordinary material combination for the sub-
stance of rings, is that of dynamite and pewter. At
present when the war-fever has seized upon almost all
civilized peoples, we might accord to the dynamite in this
composition a symbolic martial meaning. What risk
there might be of the painful results of war befalling
the wearer of a dynamite ring through its detonating
unexpectedly because of some powerful shock, is per-
haps too slight to deter those who are in eager pursuit of
novelties.

The pale alloy of gold, known as electrum,[68] was
favored for ring-making in Oriental Greece, and is
termed " white gold " in ancient inventories. Thus in
an inventory of the temple treasures of Eleusis, made in
332 B.C., there is mention of " two plain gold rings of

[68] A natural or artificial mixture of gold and silver found
native at Vorospotak, Transylvania, and elsewhere, mentioned
by Herodotus. The electros, ἤλεκτρος, of Homer and Strabo;
Pliny, xxxiii, 23; although this word was most frequently used
to designate amber. Varying in specific gravity from 15.5 to
12.5. The ratio of gold to silver is 1:1. Specific gravity of
gold, 19.33; silver, pure, 10.5; correspond to 35.3 per cent.
of silver, gold 64.7 per cent. Pliny states that when the propor-
tion of silver to gold is 1:4 (20 per cent.), it is called electra.

white gold." [69] Some Ionic rings of the fifth century,
B.C. from Cyprus are also of this metallic composition.
Of gold rings set with stones, a Parthenon inventory of
422 B.C. lists one with an onyx, perhaps a scaraboid, and
in a Delos inventory of 279 B.C., there is one with an
anthrax, probably a garnet. The variation of the phras-
ing in these two mentions, the former naming an onyx
having a ring of gold, while the latter speaks of a " gold
ring having a garnet," might be taken to indicate that
the onyx was a large object compared with the hoop,
and the garnet a relatively small one.[70]

In the masterpiece of ancient Greek romantic prose
literature, the Æthiopica of Heliodorus (fl. ab. 400 A.D.),
perhaps Heliodorus Bishop of Tricca, the writer de-
scribes a splendid ring given by Kalasiris to Nausikles.
This was one of the royal jewels of the King of Ethiopia.
The hoop was of electrum, and in the bezel was set a
beautiful amethyst engraved with a design showing a
shepherd pasturing his flock.[71] Heliodorus especially
dwells upon the fact that this was an Ethiopian (prob-
ably an Indian) amethyst, this variety far surpassing
those from Iberia (the Spanish Peninsula) and Britain.
In the very successful rendering of this Greek passage
by Rev. C. W. King, the contrast between the former
and the latter is thus gracefully expressed:[72]

[69] Corpus Inscriptionum Atticarum, ii (5), 767 b, 1, 19.

[70] J. H. Marshall, " Catalogue of the Finger Rings, Greek,
Etruscan and Roman, in the . . . British Museum," London,
1907, p. xxxi.

[71] " Heliodorou Aithiopikôn, biblia deka," Parisiois, 1804,
pt. i, pp. 190–192.

[72] C. W. King, " The Natural History of Precious Stones
and Gems," London, 1865, p. 64.

For the latter blushes with a feeble hue, and is like a rose just unfolding its leaves from out of the bud, and beginning to be tinged with red by the sunbeams. But in the Ethiopian Amethyst, out of its depth flames forth like a torch a pure and as it were Spring-like beauty; and if you turn it about as you hold it, it shoots out a golden lustre, not dazzling the sight by its fierceness, but resplendent with cheerfulness. Moreover, a more genuine nature is inherent in it than is possessed by any brought from the West, for it does not belie its appellation, but proves in reality to the wearer an antidote against intoxication, preserving him sober in the midst of drinking-bouts.

In his " Rape of the Lock," Pope writes of Belinda's golden hair-bodkin, that the metal had originally been worked up into rings and then into a gold buckle, thus the gold was

> The same, his ancient personage to deck
> Her great-great-grandsire wore about his neck
> In three seal-rings, which, after melted down,
> Formed one huge buckle for his widow's gown.

Besides the precious metals many other materials were used in ancient times for rings. Thus a few leaden rings have been preserved, a number of them having been unearthed in a tomb at Beneventum. The casting has been roughly done, without finishing touches. It has been suggested that in view of the rarity of leaden rings, the large number found in this tomb may be taken to indicate that the deceased had been a manufacturer of rings of this kind. From Tanagra comes a leaden ring of great size; as it is too large for wear, it might be regarded as a votive offering to a shrine or temple. Glass rings were also used at times for this purpose by the poorer classes, an example of such a ring being listed among the possessions of the temple of Asklepios at Athens as early as the fourth century B.C. The manu-

facture of glass rings was quite extensively carried on in Alexandria. In one case the bezel had been adorned with a painting of a woman's head, over which was placed a translucent glass plate. This was found at the Rosetta Gate, Alexandria.[73]

An ivory ring of Roman times, later provided with a band of silver, is noted in the descriptive catalogue of the Royal Museum at Budapest. It is of oval form and artistically engraved with the seated figure of a military leader clothed with a mantle, the left hand extended as though delivering a speech; in his right hand he holds a spear. Behind him is a trophy, and before him stands a Roman soldier fully armed. Engraved ivory rings from Greek or Roman times are rare, just as are engraved amber rings. The trophy emblem denotes that this ring commemorated some triumph, or victory.[74]

A " St. Martin's ring " had become, in the seventeenth century, a name for a brummagem ring, as is shown among other examples by the following satirical passage from a book entitled " Whimsies, or a new Cast of Characters," published in London in 1631: " St. Martin's Rings and counterfeit bracelets are commodities of infinite consequence; they will passe current at a may-pole, and purchase favor from their May Marian." A rare tract called " The Captain's Commonwealth " (1617) says that kindness was not like alchemy or a St. Martin's ring, " that are faire to the eye and have a rich outside; but if a man should breake

[73] F. H. Marshall, " Catalogue of the Finger Rings, Greek, Etruscan, and Roman, in the Departments of Antiquities, British Museum," London, 1907, pp. xxxv, xxxvi.

[74] " Cimeliotheca Musei Nationalis Hungarici sive catalogus historico-criticus antiquitatum raritatum et pretiosorum eius instituti," Budæ, 1825, p. 136.

them asunders, and looke into them, they are nothing but brasse and copper." The makers, or vendors of these rings lived within the precincts of the collegiate church St. Martin's-le-Grand, and had long enjoyed a certain immunity from prosecution under the laws prohibiting the manufacture of ornaments made in imitation of genuine gold or silver ones. The gilding or silvering of brooches or rings made of copper or latten, is prohibited by an ordinance of Henry IV (1404), and another of Edward IV (in 1464), which, while pronouncing it to be unlawful to import rings of gilded copper or latten, expressly declared that the act should not be construed as meaning anything prejudicial to one Robert Styllington, clerk, dean of the King's free chapel of " St. Martin le Graund de Londres " or to any person or persons dwelling within this sanctuary or precincts, or who might in after time dwell there, or more especially in St. Martin's Lane.[75]

Rings set with precious stones, other than turquoises and pearls, can be safely cleaned with warm water, white soap and a trifle of ammonia. The wash should be applied with a soft old tooth-brush, so as to cleanse the spaces between the filling and the stone-setting. A little polishing off with a soft chamois will thoroughly restore the brilliancy of the stone. Turquoise or pearl rings, however, need more careful treatment and the above directions do not apply in their case.

[75] Francis Cohen, " St. Martin's rings," Archæologia, vol. xviii, pt. i, London, 1815, pp. 55, 56.

III

SIGNET RINGS

IF we pass over the scene between Judah and his daughter-in-law Tamar, related in Gen. xxxvii, 12–26, where the patriarch leaves his signet (not necessarily a signet *ring*) his bracelets and his staff, as pledges for a promised gift, the earliest Hebrew notice of a ring is in Genesis xli, 42, where we read that in return for the interpretation of his dream and for the valuable counsel as to laying up a stock of grain in Egypt to forestall a coming famine, the Pharaoh of the time " took off his ring from his hand, and put it upon Joseph's hand." This might refer to a period about 1600 B.C., or possibly somewhat earlier, always providing the tradition be accepted as in a certain sense exact. Centuries later, in the Desert, when the Lord commanded offerings for the Tabernacle, the Ark of the Covenant, and for the ephod and breastplate, among the gifts proffered are enumerated " bracelets, earrings, and rings " (Exodus, xxxv, 22). The Book of Daniel, written not earlier than the sixth century before Christ, and more probably, in its present form, a work of the second century B.C., relating the imprisonment of Daniel in the lions' den, states that when at the reluctant command of King Darius he was shut up therein, " a stone was brought, and laid upon the mouth of the den; and the king sealed it with his own signet, and with the signet of his lords " (Dan. vi, 17). Still, these might have been of the well-known Babylonian type of " rolling seals " and not rings.

The Book of Esther, however, of later date than
Daniel, makes definite mention of the signet ring of the
Persian monarch called Ahasuerus (Artaxerxes) in the
Biblical text, and while the recital can scarcely be ac-
cepted as historical in any sense, the details of custom
and adornment are probably quite trustworthy. On
investing Haman with a great authority, Ahasuerus
" took his ring from his hand and gave it unto Haman,"
whereupon the latter summoned the king's scribes and
had them write letters to the provincial governors—in-
structing the latter to kill all the Jews in the kingdom
on the thirteenth day of the month Adar; each of these
letters was " sealed with the king's ring." Before this
dire disaster could be consummated, the royal favor was
gently swayed in an opposite direction by the grace
and charm of Esther, the Hebrew favorite of the sov-
ereign, and the wicked Haman was hanged on the tall
gallows he had set up for Mordecai, Esther's guardian,
on whom the ring stript from Haman's hand was
bestowed. In spite of the somewhat confused recital,
one point is always strongly brought out, that the im-
pression of the royal signet imparted to letters or docu-
ments the quality of royal ordinances.

In Persia the power and authority attributed to the
ring of the sovereign is noted by the Persian poet Unsuri
(fl. 1000 A.D.), and in the legends of that land the famous
though fabulous hero-king, Jemshid, is said to have had
a magic ring of wondrous power. Among the Persians,
as in many other Oriental countries, the signet-ring was
long considered to be a symbol of authority.[1]

[1] Communicated by Prof. A. V. Williams Jackson, of Col-
umbia University, who cites G. B. Browne's " Literary History
of Persia " (London and New York, 1906), vol. ii, p. 123,
note 3, and Louisa Stuart Costello, " Rose Garden of Persia,"
London, 1887, p. 33.

The gold ring of Queen Hâtshepset (about 1500 B.C.), consort of Thothmes II, whose prenomen, Maât-ka-Ra, signifies " flesh and blood of Amen Ra," is set with a lapis lazuli scarab inscribed with the above words.[2] Another ring with lapis lazuli setting is that of Thothmes III, whose titles, Beautiful God, Conqueror of All Lands, Men-kheper-Ra, are inscribed on one side of the rectangular stone above a design representing a man-headed lion in the act of crushing a prostrate foe with his paw.[3] A steatite scarab, set in a gold ring, bears the name of Ptah-mes, a high priest of Memphis.[4] Another steatite ring-scarab is inscribed with the name and title of Shashank I, the Shishak of the Bible, who reigned about 966 B.C.[5]

The gold signet ring of Aah-hotep I, queen of Seqenenra III (1610–1597 B.C.) of the XVII Dynasty, was found with a wealth of other jewels at Draa-abul-Nega, the northern and most ancient part of the Theban necropolis. This queen had an unusually long and eventful life. The records clearly indicate that she must have been one hundred years old, or very nearly that age, at the time of her death, and while her youth was passed at the end of the period of the oppressive rule of the foreign Hyksos kings, she lived to witness the glorious revival of native Egyptian rule under her husband, son and grandson. This ring is now in the Louvre Museum.[6]

[2] British Museum, Fourth Egyptian Room, No. 201 (Table Case J).

[3] British Museum, Fourth Egyptian Room, No. 202.

[4] British Museum, Fourth Egyptian Room, No. 204.

[5] British Museum, Fourth Egyptian Room, No. 217.

[6] W. M. Flinders Petrie, "A History of Egypt During the XVII and XVIII Dynasties," London, 1904, pp. 9, 10.

An interesting Egyptian signet bears the cartouche of Khufu, the second ruler of the IV Dynasty (ab. 3969–3908), the Cheops of the Greeks (Manetho's Suphis), in whose reign the greatest of the pyramids was built. The worship of Khufu continued to a late period of Egyptian history, and this signet belonged to a Ra-nefer-ab, priest or keeper of the pyramid under the XXVI Dynasty, 664–525 B.C.[7] The ring is of fine gold, and weighs nearly ¾ ounce; it was found at Ghizeh by Colonel Vyse, in a tomb known as Campbell's Tomb, and was acquired in Egypt by Dr. Abbott, who gathered together a choice collection of Egyptian antiquities during a residence of twenty years in Egypt. In 1860, this collection was given to the New York Historical Society through the liberality of citizens of New York.[8]

The rings of the Minoan and Mycenæan periods from about 1700 B.C. to 1000 B.C. offer a great variety of engraved designs, some in relief and others in intaglio, but all destined it seems for use as signets. Undoubtedly these rings derive in the last instance from Egyptian influence, their especial characteristics, however, are early Greek, but rarely Egyptian, as in the case of a bronze ring with a sphinx in relief found in the necropolis of Zafer Papoura near Knossos in Crete.

Many of the Mycenæan engraved rings were evidently not intended to be used for sealing, as the intaglio is frequently very shallow, and as the proper position of the parts of the body would not be rightly shown in an impression. Hence these rings must have been designed simply for wear as ornaments. The hoop is often

[7] W. M. Flinders Petrie, "A History of Egypt from the Earliest Times to the XVI Dynasty," New York, 1895, p. 42.

[8] New York Historical Society, "Catalogue of Egyptian Antiquities," New York, 1915, p. 63; No. 1046, figs. 1, 2 and 3.

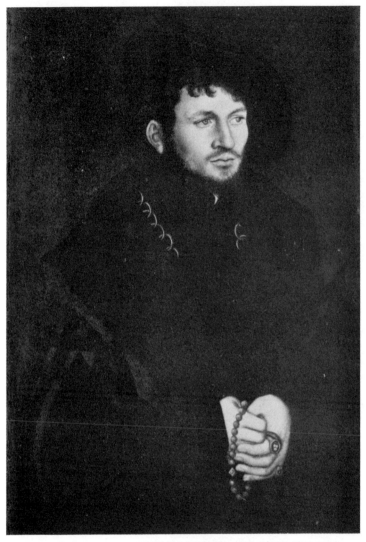

PORTRAIT OF A MAN, BY LUCAS CRANACH THE ELDER (1472–1553)
Seal ring on index of left hand with plain ring beneath it; ring with precious stone setting on little
finger of the same hand

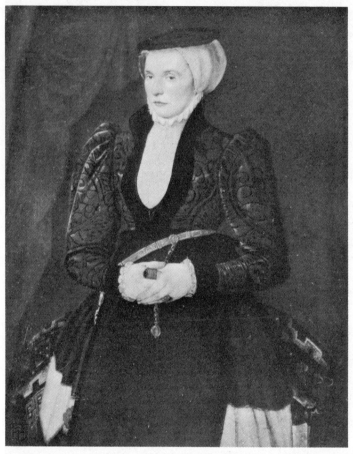

PORTRAIT OF KATHARINA AEDER, WIFE OF MELCHOW HANLOCHER,
BY HANS BOCK THE ELDER
Gem and serpent ring on right forefinger, and three rings on left fourth finger
Art Gallery at Basel, Switzerland

astonishingly small, so much so that it will not pass down
onto the third finger-joint of an average man's hand,
and would only fit the very slender finger of a woman.[9]

Some remarkably fine rings are in the Cesnola Col-
lection of Cypriote Antiquities in the Metropolitan
Museum of Art, New York. Among them two serpen-
tine rings of gold are well worth noting. In one of these
the coil has six turns which are brazed together; at either
end is a ram's head. The other ring shows a serpent
of two full coils, with erect head and curved neck and tail;
scales are marked at the ends. The bands of the ring are
smooth and plain.[10] Many of the rings are of the swivel
type and are set with artistically engraved scarabs. In
one of these the scarab is of green plasma, translucent
but somewhat clouded; the cutting is well executed. The
bottom shows two wrestlers, each entirely nude with the
exception of a short ribbed apron about the loins. Be-
hind each is an erect uræus (the serpent emblem of
Egyptian divinities and kings), with wings like those of
the goddess Mut, extended in protection. Between the
wrestlers, on the ground, is an object resembling a
wolf's head. The bow and collet of this signet are of
gold. The plasma scarab in another of these swivel
rings has been pronounced to be a perfect example of
this form. The stone is a pure green and the scarab
has been decorated with two seated, winged andro-
sphinxes (with man's head and lion's body), the paws
raised before the sacred tree between them; the symbol

[9] Adolph Furtwängler, " Die Antiken Gemmen," Leipzig and
Berlin, 1900, vol. iii, p. 31.

[10] A descriptive atlas of the Cesnola Collection of Cypriote
Antiquities in the Metropolitan Museum of Art, New York,
by Louis P. di Cesnola, vol. iii, pt. i, New York, 1903, pl. xxiv,
Nos. 12 and 13.

of lordship, *neb,* is placed below. The hoop is a plain, thin wire.[11]

Two massive ivory rings were found in the course of excavations at Salamis, on the island of Cyprus. One was set with an oval disk of green glass, and was of the type used for sealing amphoræ of wine. The other bears the head of a woman in bas-relief; this is probably a cameo of Arsinoë.[12]

The story of the ring of Polycrates, tyrant of Samos (d. 522 B.C.), is related by Herodotus [13] (b. 484 B.C.), who, writing less than a century after the death of Polycrates, may probably give us the main facts with reasonable accuracy. According to this account, Polycrates had formed an alliance with Amasis, King of Egypt, and the latter began to fear that the unbroken good fortune of the Samian ruler would arouse the jealousy of the gods; he therefore counselled Polycrates to throw away his most prized treasure. This was a splendid emerald, set in a gold ring, and engraved by Theodorus of Samos, the supreme master of the art of gem engraving in that age. Acceding to the request of Amasis, Polycrates sailed out to sea on one of his ships and cast the precious ring into the waters. However, the gods refused the gift, for not long afterward the tyrant's chief cook brought him back the ring, which had just been found in cutting up a fish. News of this occurrence was sent to Amasis, who immediately broke off the alliance, since he believed that the gods were implacable, and would visit Polycrates with downfall and destruc-

[11] *Ibid.,* pl. xxv, figs. 10 and 12.

[12] Alexander Palma di Cesnola, " Salaminia (Cyprus), The History, Treasures and Antiquities of Salamis in the Island of Cyprus," London, 1884, p. 73, figs. 7 and 13 on pl. vii.

[13] Lib. iii, caps. 40–43.

tion. This, indeed, proved to be the case, as a few years later the tyrant was inveigled into the power of Orœtes, a Persian satrap, and was put to death by crucifixion.

The design engraved upon this ring was a lyre, if we can trust the statement to this effect made centuries later by Clemens Alexandrinus.[14] Strange to say Pliny, who relates the story quite fully, asserts that in the Temple of Concord there was shown the supposed gem of the famous ring of Polycrates. This was an unengraved sardonyx, set in a golden cornucopia, and had been dedicated to the temple by Augustus. Pliny is careful to write " if we may believe," in reporting this almost certainly spurious treasure of the Temple of Concord. Probably the attribution was nothing more than an invention of the custodians to enlist the interest of visitors.

A corroboration to a certain extent of the tradition that the seal of Polycrates was cut on an emerald is given by the existence of a small engraved emerald of about this period, found in Cyprus, and evidently of Phœnician workmanship. It bears the figure of a sovereign holding a sceptre in one hand and an axe in the other; on his head is a high tiara and the arrangement of hair and beard, as well as the dress and other details, are of Ægypto-Syrian type. This gem formed part of the Tyszkiewicz Collection.[15]

In a recently published work, M. Salomon Reinach, of the National Museum at St. Germain-en-Laye, an archæologist of the highest repute, makes a curious conjecture in regard to the real significance of the story

[14] Pædagogus, lib. iii, cap. ii.

[15] Adolf Furtwängler, " Die Antiken Gemmen," Berlin, 1900, vol. ii, p. 273, vol. iii, p. 81; see vol. i, plate lxi, No. 11.

related by Herodotus regarding this signet. M. Reinach holds that when Polycrates sailed out to sea to cast away his ring, he was engaged in the performance of a ceremony similar to that performed annually by the Doges of Venice, when they wedded the Adriatic by casting a ring into its waters. Polycrates, as a "thalassocrat," or ruler of the sea, celebrated in this way his mastery over this element, and M. Reinach believes that this act, told as an isolated happening by Herodotus, was really a ceremony repeated each year. The conjecture is an ingenious one, although it may not be generally accepted.[16]

The signet of the Persian sovereign, Xerxes, is said to have borne the nude figure of a woman with disheveled hair.[17] This depicted Anahita, the Persian goddess of fertilization and also of war, a divinity closely resembling the Assyrian Ishtar in her attributes and functions. According to other ancient authorities, however, the design was either a portrait of Xerxes himself, that of Cyrus the Great, or else a representation of the horse whose neighing legend states to have been received as an omen determining the choice of Darius Hystaspes, father of Xerxes, as King of Persia.

In Græco-Roman times, a certain Eurates is represented to be the owner of a ring set with an engraved signet bearing the head of the Pythian Apollo, and to have boasted that the ring literally " spoke " to him. Of course, the satirist Lucian, who tells this tale, only offers it as a specimen of the lies told by Eurates, still the

[16] Reinach, " Cultes, Mythes et Religions," Paris, 1906, vol. ii, p. 214.

[17] Duffield Osborne, " Gem Engraving," New York, 1912, p. 287.

recital indicates that such fables were credited in the second century of our era.[18]

Another superstitious use of signet rings was to throw a number of them into a heap and pull out one at random, the design engraved on the signet being interpreted as a favorable or unfavorable omen, which foretold the outcome of any contemplated action. An instance of this appears in Plutarch's life of Timoleon (d. 337 B.C.), the Greek general who freed Syracuse from the tyrant Dionysius. In one of his campaigns the enemy had taken up a strong position behind a river, which the troops of Timoleon were forced to ford. A noble rivalry sprang up among the officers as to who should be the first to enter the river, and Timoleon, fearing that confusion would result from the dispute, decided to settle the question by lot. Therefore he took from each of the officers his signet ring, cast them into his own cloak, shook them together, and drew out one, which fortunately bore the figure of a trophy. This was hailed as a good omen, the quarrel was forgotten, and the stream was forded so impetuously, and the attack was so vigorous that the enemy was overwhelmed.[19]

After his Persian conquests, in 331 B.C., Alexander the Great sealed the letters he sent to Europe with his old seal, while for those sent to functionaries in his new Asiatic domains he used the seal of Darius III, Codomannus (reigned 336–330 B.C.), whose daughter Statira he afterwards wedded. Quintus Curtius regards this as emblematic of the idea that a single mind was not wide

[18] Luciani, " Opera," vol. iii, Lipsiæ, 1881, pp. 119, 120. Philopseudes, 37.

[19] Plutarchi, " Vitæ," vol. ii, Lipsiæ, 1879, p. 32. Timoleon, 31.

enough to embrace two such destinies,[20] but the true
reason was undoubtedly that the Asiatic officials were
already familiar with the Persian sovereign's seal and
were accustomed to render it due obedience.

The emblem of the anchor used by the Seleucidæ,
the dynasty founded in Syria by Seleucus Nicator, one
of Alexander's generals, is said to have originated in a
strange dream of Laodicea, mother of Seleucus and wife
of Antiochus. One night she dreamt that she was visited
by the God Apollo, and that he bestowed upon her a ring
set with a stone on which an anchor was engraved. This
was to be given to the son she was to bear. As such a
ring was found in the room the next morning, the dream
seemed to be thoroughly corroborated, and, moreover,
when Seleucus was born, he had on his thigh the birth-
mark of an anchor. Subsequent to Alexander's death
in 323 B.C., Seleucus founded, in 312 B.C. the kingdom
of Syria, which was transmitted to a long series of his
descendants, each of whom in turn is said to have borne
a similar birthmark.[21]

In the Hellenistic period (ca. 300 B.C.–ca. 100 B.C.)
signet rings entirely of metal largely gave place to those
in which the seal was engraved on a stone set in a metal
ring. Chalcedony continued to be freely used for this
purpose, but the employment of the choicer and harder
precious stones from India, transparent and brilliant,
and of deeper coloring, characterizes this period. In the
front rank is the jacinth, unknown in earlier times, with
its wonderful ruddy hues. This is the favorite stone of
the time. Usually the gem is given a strongly convex

[20] " De rebus gestis Alexandri Magni, regis Macedoniæ,"
lib. vi, No. 6.

[21] Justini, " Historiarum phillipicarum libri XLIV," lib. xv,
cap. 4.

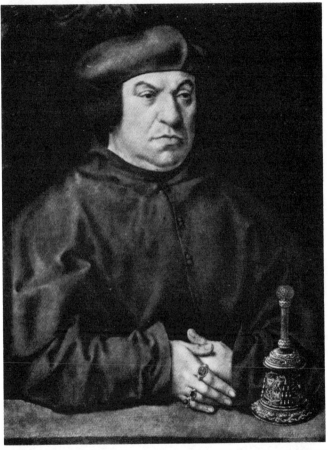

CARDINAL OF BRANDENBURG, BY THE MASTER OF THE DEATH OF
MARY
Seal ring on index of right hand; rings set with precious stones on fourth and little fingers
of the same hand
Reale Galleria Nazionale, Rome

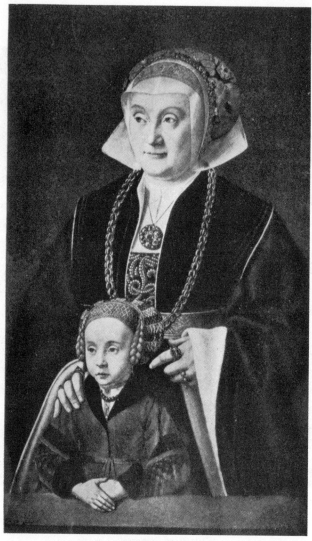

PORTRAIT OF A MOTHER AND HER DAUGHTER,
BY BARTHOLOMEW BRUYN
Three rings on right hand, one with a pointed diamond; also three rings on left hand,
two on index finger; the one on the fourth finger set with two pearls
Imperial Hermitage, Petrograd

form in order to bring out better the play of color. Scarcely less favored than the jacinths were the garnets, also cut in a convex shape; in many cases the under side was cut slightly concave to enhance the effect. Evidently, however, garnets were less prized than jacinths, for the engravings on the former are almost without exception much inferior to those on the latter. Sometimes, in this period, unengraved garnets, cut convex, are used for ring adornment. Another precious stone that makes its first appearance in the Hellenistic epoch is the beryl, which, because of its costliness, is more rarely met with than those we have already mentioned. It is only used for the very finest work, as is also the case with the topaz. The amethyst, which had almost gone out of fashion in the preceding periods, was now restored to favor, principally because of its beautiful color; like the other stones, it was cut convex. Rock crystal was still used, as were also carnelian and sardonyx.[22]

That cruel persecutor of the Jews, Antiochus IV, Epiphanes (175–164 B.C.), on his death-bed, confided to his most trusted councillor, Philip, the signet ring from his finger, that it might be held in trust for his son, a child but nine years old, until the latter should come of age and exercise the royal authority. In the meanwhile, the grant of the signet was equivalent to the bestowal of the regency upon Philip, as he had the power to affix the royal seal upon all edicts or ordinances. The son did not, however, live to receive the ring, as he only survived his father two years, although he was a nominal successor under the title, Antiochus V, Eupator.[23]

[22] Adolf Furtwängler, " Die antiken Gemmen," Leipzig and Berlin, 1900, vol. iii, p. 150.

[23] " Le Cabinet de la Bibliothèque de Sainte Geneviève," by the Rev. Father Claude du Molinet, Paris, 1692, p. 29.

Two Greek epigrams in the Anthology, on engraved amethysts in signet rings, express the prevailing superstition regarding the sobering effect of this precious stone; these have been very well Englished by Rev. C. W. King.[24] One, by Antipater, concerns a signet of Cleopatra and runs in King's version as follows:

> A Mœnad wild, on amethyst I stand,
> The engraving truly of a skilful hand;
> A subject foreign to the sober stone,
> But Cleopatra claims it for her own;
> And hallow'd by her touch, the nymph so free
> Must quit her drunken mood, and sober be.

That this was really a ring-stone is proved by the Greek words " on the queen's hand," which King has not literally translated. The image was that of Methe, goddess of intoxication. The other epigram is shorter but to the same point:

> On wineless gem, I, toper Bacchus, reign;
> Learn, stone, to drink, or teach me to abstain.

That admiration of a work of art on the part of an unscrupulous official is sometimes fraught with danger for the rightful ownership of the object, was illustrated in the case of a seal ring belonging to a Roman citizen of Agrigentum in Sicily. The arch-pilferer Verres, Roman governor of the island from 73 to 71 B.C., being on one occasion struck by the beauty of a seal impression on a letter just handed to his interpreter Vitellius, asked whence the letter came and who was the sender. The information was of course quickly given, and there-

[24] " The Natural History, Ancient and Modern, of Precious Stones and Gems," London, 1865, pp. 60, 61; Anthology ix, 752; ix, 748.

upon Verres, then in Syracuse, dictated a letter to his representative in Agrigentum, requiring that the seal ring should be forwarded to Syracuse without delay, and the owner, a certain Lucius Titius, was forced to give it up to the unscrupulous Roman governor.[25] The injustice of this act must have been felt all the more keenly that the special and peculiar design on a seal was then regarded as something closely linked with the personality of the owner.

A strong appeal to the memories aroused by a signet bearing the effigy of a renowned ancestor, was made by Cicero in one of his orations against Catilina. He declared that when he submitted to Publius Lentulus Sura, who was involved in the great Catilinian conspiracy, an incriminating letter believed to be his, asking him whether he did not acknowledge the seal with which it was stamped, Lentulus nodded assent. Thereupon Cicero addressed him in these words: " In effect the seal is well known, it is the image of your ancestor, whose sole love was for his country and his fellow-citizens. Mute as it is, this image should have sufficed to hold you aloof from such a crime." [26]

When, after the decisive battle of Pharsala, Julius Cæsar came to Egypt in pursuit of his defeated adversary, Pompey, he learned that the latter had been treacherously assassinated by the Egyptians, who hoped thereby to gain favor with the conqueror. As proof of Pompey's death, his head was brought to Cæsar, who turned away in aversion from the messenger of death. At the same time, Pompey's signet ring was given to

[25] M. Tullii Ciceronis, " In Verrem, lib. iv," Oratio nona, cap. 26.

[26] Ciceronis, " In Catilinam," iii, cap. v.

the victor, on receiving which tears rose to his eyes,[27] for no memento could be more potent than such a ring. Cæsar's manifestation of grief was absolutely free from hypocrisy for he was " of a noble generous nature," and had long had the most friendly relations with Pompey, to whom he gave his daughter Julia in marriage, until the inevitable rivalry for the control of Rome brought them into enmity. The death of Julia is said to have contributed not a little to the termination of the friendship between Cæsar and Pompey.

St. Ambrose answering the self-posed query, whether anyone having an image of a tyrant was liable to punishment, asserts that he remembered to have read that certain persons who wore rings bearing the effigies of Brutus and Cassius, the assassins of Cæsar, had been condemned to capital punishment.[28] Of course, the wearing of such a ring would imply not only an admiration of the person figured, but also devotion to his cause.

The imprint of a proprietor's seal was frequently made upon his trees, and served to establish his ownership, so that strangers could have no excuse for cutting them down, or in case of fruit trees, for plucking the fruit. The degree of confidence reposed in the seal impression is strikingly illustrated by the account that when Pompey learned that some of his soldiers were committing atrocities on the march, he ordered that all their swords should be sealed, and no one should remove the impression without having obtained permission to do so.[29]

[27] Georgii Longi, " De annulis signatoriis antiquorum," Francofurti et Lipsiæ, 1709, p. 24, citing Plutarch's life of Pompey.

[28] Ibid., p. 40.

[29] Ibid., p. 115.

The symbols used as mint-marks on ancient coins are often reproductions of the seals of the chief magistrate of the city or district, or else of the mint-master. Among these may be noted such types as: a locust, a calf's head, a dancing Satyr, a young male head, a culex (gnat), etc.[30] A ring as a mint-mark on early English coins is a clear indication that such coins were struck in one of the ecclesiastical mints. On a penny of Stephen's reign (1135–1154), from the Archbishop of York's mint, this mint-mark has been made by converting the left leaf of the fleur-de-lys surmounting the sceptre into a small annulet. The ring-mark appears on the coins of York from the earliest times, and is assumed to have been especially favored for the English Primate's mint in reference to the Ring of St. Peter, or the Fisherman's Ring. A penny, probably coined after the installation of Archbishop William in 1141, appears to be one of the earliest of this type. The reverse gives Ulf as the name of the coiner or moneyer.[31]

While none of the signet rings of Roman emperors, or even of Romans prominent in the social or political life of the centuries immediately preceding and succeeding the beginning of the Christian Era, have been preserved, it is possible to learn from literary sources the devices engraved on many of them. Scipio Africanus, the conqueror of Hannibal, had his father's portrait engraved on his signet, and his son followed the father's example in this respect. The idea seems to be an ex-

[30] Edward T. Newell, " Historia numorum," Oxford, 1911, p. 159.

[31] W. J. Andrew, "A Remarkable Hoard of Silver Pennies and Halfpennies of the Reign of Stephen, found at Sheldon, Derbyshire, in 1867," in *The British Numismatic Journal*, 1st ser., vol. vii (1911), pp. 52, 56; see pl. ii, fig. 27.

cellent one, as both family honor and filial love could thus find expression. The gifted, but dissolute Sylla, in the first design he had cut upon his signet, sought to perpetuate the memory of his victory over Jugurtha in 107 B.C., the Mauritanian king Bocchus being depicted in the act of surrendering Jugurtha. Later on Sylla used a signet with three trophies, and finally selected one with a portrait of Alexander the Great. For Lucullus, the great gourmet and master of all the arts of Roman luxury, the head of Ptolemy, King of Egypt, seemed the design best fitted for his signet.

The two great rivals, Pompey and Cæsar, chose widely divergent symbols. The former wore a signet engraved with a lion bearing a sword, while on Cæsar's ring was cut an armed Venus, the Venus Victrix, from whom the gens Julia claimed descent, and for whose statue Cæsar is said to have brought pearls from Britain to be set on the statue's breastplate. The first choice made by Augustus was a sphinx, in symbolical allusion to his taciturnity; later in his reign he wore a signet with Alexander the Great's head engraved thereon, and finally, moved perhaps by the flatteries of his adulators, he substituted his own image for that of the great Macedonian. The famous literary patron of the Augustan Age, Mæcenas (d. 8 A.D.), who was at the same time a very able statesman, chose the singular emblem of a frog. That the blood-thirsty Nero should select a design figuring a martyrdom seems very appropriate, and in the flaying of Marsyas by Apollo cut on his ring, he undoubtedly identified himself with the sun god and leader of the muses who took vengeance upon his would-be rival in the musical art. For Nero was a most devoted amateur of the arts as he understood them, and had sung—in a strained, high-pitched voice it is said—in the

theatres of Greece, earning applause enough from the wily Greeks we may be sure. Actuated by jealousy, he is said to have had the singer Menedemus whipped, and to have warmly applauded his "melodious" cries of agony, evidently rejoicing in having forced him to " sing another song."

Galba (3–69 B.C.), Nero's immediate successor, is said to have used successively three signets, the first depicting a dog bending its head beneath the prow of a ship; this was followed by a ring showing a Victory with a trophy, and lastly came one bearing the effigies of his ancestors. As his reign of less than a year seems too short for us to suppose that all these changes were made in that time, perhaps only the last-mentioned ring was the one he used as emperor. Commodus (161–192 A.D.), the unworthy son of the philosopher-emperor, Marcus Aurelius, had the figure of an Amazon engraved for his signet, this choice having been made, so it is said, because of the pleasure he took in seeing his mistress Martia dressed in this way.

Augustus Cæsar reposed such unlimited confidence in his son-in-law, Agrippa, and in his friend and finance minister, Mæcenas, that he was in the habit of confiding his letters to them for correction, and gave them permission to send off the corrected letters, bearing the stamp of his signet which he had deposited in their charge, without submitting them again to him. Similar trust was reposed by Vespasian in Mutianus.[32]

The seal was stamped on a linen band passed around the closed tablets on the inside surfaces of which the letter had been written. The impression, made when

[32] P. J. Mariette, " Traité des pierre gravées," Paris, 1750, vol. i, pp. 23, 24.

the ends of the band were joined, was either upon wax, soft viscous earth, or even on a mixture of chalk; this was commonly moistened with saliva before the signet was used, so that the engraved stone might not adhere to the imprint and could be easily taken off. The bearer of such a letter fully realized his responsibility for its delivery with unbroken seal, and generally took pains to have this duly recognized by the person to whom it was addressed.[33] The personal seal was also impressed, both in Roman times and later, upon all documents private or public. In the case of private documents the strictly guarded individuality of the seal really afforded a very considerable guarantee of the genuineness of a document. A survival of this is the common little red seal attached now-a-days to legal documents, necessary to their validity it is true, but giving no possible confirmation of the signature. This latter was in fact represented by the design of the old signets.

The " Dream Book " of Artemidorus relates as an especially direful vision, that of one who dreamed his signet ring had dropped from his finger, and that the engraved stone set therein had broken into many fragments, the result of this being that he could transact no business for forty-five days,[34] presumably until he could have a new signet engraved. For the impression of the individual signet was indispensable to give validity to any order or agreement.

The Jewish historian Josephus cites, as an example of absent-mindedness, that when the Roman senator Cneius Sentius Saturninus arose in the senate and pro-

[33] P. J. Mariette, " Traité des pierre gravées," Paris, 1750, vol. i, p. 20.

[34] Georgii Longi, " De anulis signatoriis antiquorum," p. 25; Artemidori, " Oneirocriticon," lib. v, cap. 32, i, 709.

Two gold rings, with onyx gems. Roman. 1, engraved with seated figure of Ceres; 2, design of dove bringing back the olive branch to the Ark

Gorlæus, Dactyliotheca, Delphis Bat., 1601

Two brass rings. Roman. 1, set with an inscribed agate, 2, key-ring, set with an engraved onyx

Gorlæus, Dactyliotheca, Delphis Bat., 1601

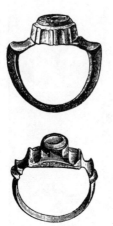

Two bronze rings excavated at the
Borough Field, Chesterford, Essex,
1848. Late Roman.

British Museum

Bone ring with grotesque mask
carved on bezel. Found near the
ampitheatre at Lyons, France. Roman.

British Museum

Roman gold rings of the Fourth Century A.D 1, set with plasma bead; 2, double ring, set with garnets; 3, gold ho
composed of **a** plain band on either side of a wavy band; set with a convex plasma; 4. set with convex almandine intag

British Museum

Ornamental gold ring from Wiston,
Sussex England, set with a dark
amethyst

British Museum

Silver ring. On bezel engraved
design of a bird approaching a fallen
stag. About Fifth Century A.D.

British Museum

nounced a fiery harangue on the death of Caligula, urging the senators to regain their former liberties of which they had been robbed, he quite forgot that he wore on his hand a ring set with a stone on which the head of the detested tyrant was cut. His fellow senator, Trebellius Maximus, remarking it, however, snatched it from his finger, and the stone was crushed to pieces.[35]

How common in ancient Rome was the use of a signet ring to seal up the provision rooms in a household, is shown by a passage in the " Casina " of the comic poet Plautus, written about 200 B.C., where Cleopatra on leaving her home to visit a neighbor, directs her slaves to seal these rooms and bring her ring back to her.[36]

Of the betrothal ring, Clemens Alexandrinus says that it was not given as an ornament, but for sealing objects in the conjugal domicile. As the husband's signet ring was often used in a similar way, it was quite customary to bequeath it to a wife or a daughter. An example of this appears in the case of Emperor Aurelian (214–275 A.D.) who left his seal ring to his wife and daughter jointly, the Latin historian adding that in so doing he was acting " just like a private citizen." [37]

A curious subject was chosen for his signet-ring by a native of Intercatia in Spain. His father had been killed in a single combat by the Roman leader Scipio Æmilius, and it was this scene that the son had engraved upon his ring. When Stilo Preconinus related this fact in Rome he laughingly demanded of his hearers what they supposed the Spaniard would have done if his father

[35] Josephus, " History of the Jews," book xix, chap. 2.

[36] Act II, sc. i, ver. 58.

[37] Vopisci, " Divus Aurelianus," in Scriptores hist. August., vol. ii, p. 184.

[38] Abbé Barrand, " Des bagues à toutes les époques," Paris, 1864, p. 177; reprint from *Bulletin Monumental*, vol. xxx.

had killed Scipio instead of being killed by him.[38]

In the Roman world the custom of removing the rings in case of death is noted by Pliny, who says that they were taken from the fingers of those in the comatose state of the dying; the rings were often replaced after death.[39] An instance in point is noted by Suetonius, who reports that when Tiberius became unconscious, and was believed to be about to die, his seal ring was slipped from his finger, but on regaining consciousness the emperor demanded that it should be replaced.[40] To have a ring drop from the finger was regarded as a bad omen, and when an accident of this kind happened to Emperor Hadrian, he is said to have exclaimed: " This is a sign of death." The ring which fell from his finger bore a gem engraved with his own image.

The elegy of Propertius (49–15? B.C.) on the " Shade of Cynthia," gives proof that a valuable ring was often left on the hand of the corpse when it was burned on the funeral pyre. The Latin verses describing the apparition may be thus rendered in prose:[41]

" She still had the same eyes and hair as when on the funeral couch; but her garments had been burned away. The flame had destroyed the beryl which used to grace her finger, and the infernal stream had discolored her lips."

The sense of intimate connection between a valued ring and the wearer, finds expression in Shakespeare's lines (Cymbeline Act I, sc. 5):

My ring I hold dear as my finger; 'tis part of it.

And if we go back 2200 years to a far distant quarter of the globe we meet with the same feeling of intimate

[39] Plinii, " Naturalis Historia," lib. xxxiii.

[40] Suetonii, " Vita Cæsarum," Tiberius.

[41] Lib. iv, No. vii.

connection in the inspired words of the Hebrew prophet Jeremiah (xxii, 24):

As I live, saith the Lord, though Coniah the son of Jehoiakim King of Judah were the signet upon my right hand, yet would I pluck thee hence.

The prophet Haggai (chap. ii, verse 23) uses the designation signet to indicate a specially chosen instrument, in the following words:

In that day, saith the Lord of hosts, will I take thee, O Zerubbabel, my servant, the son of Shealtiel, saith the Lord, and will make thee as a signet: for I have chosen thee, saith the Lord of hosts.

The Freemasons have adopted the signet of Zerubbabel as one of the symbols of the Royal Arch, the seventh masonic degree.[42]

The monogram of Christ appears on a signet made for a Christian lady of Roman times, Ælia Valeria. Of this sacred symbol St. John Chrysostom wrote that the Christians of his time always inscribed it at the beginning of their letters, and he gives as a reason for this that wherever the name of God appeared there was nothing but happiness. Undoubtedly the shape of the Greek X (Ch), forming part of this monogram, suggested a form of the cross, and gave an added significance to the monogram, especially in view of Chrysostom's statement that the Christians of his time painted or engraved a cross on their houses and made the sign of the cross over their foreheads and their hearts.[43]

[42] Albert G. Mackey, "The Book of the Chapter: or Monitorial Instructions in the Degrees of Mark, Past and Most Excellent Master and the Royal Arch," New York, 1858, p. 128.

[43] "Le Cabinet de la Bibliothèque de Sainte Geneviève," by the Rev. Father Claude du Molinet, Paris, 1692, p. 3, pl. 8, fig. 5, impression of seal; the letters are rather irregularly disposed.

Clemens Alexandrinus in the second century tells us that men were required to wear the seal ring on the little finger, as worn in this way it would interfere least with the use of the hand, and would be best protected from injury and loss.[44] While, however, fashion must have dictated to a great extent the finger on which a seal ring was to be worn, we should bear in mind that any particular custom in this matter was not constant, and that individual preferences must often have determined the finger chosen to bear the seal ring. This diversity is attested by the differing statements of the old writers, as well as by the rare examples offered by ancient statues and paintings.

One of the rare ivory rings in the British Museum is a signet the bezel of which bears an engraved design of Christ on the Cross, with the Virgin and St. John on either side. The legend is the motto of Constantine the Great: In hoc signo vinces. The hoop of this ring, which was found in Suffolk, has been restored at the back. The figures are very rudely engraved for a production of the sixteenth century.[45]

It appears to have been an ancient usage in some parts of the Christian world to use two signet rings in connection with the baptismal ceremonies. One of these was employed to seal up the font, or else the baptistry, while the other was used to affix a seal upon the profession of faith made by the neophyte, this profession being later entered on a public register. Some of the ecclesiastical writers saw the origin of the first-named ring in the text (Cant. iv, 12):

[44] Clementis Alexandrini, " Pædagogus," lib. iii, cap. ii.

[45] O. M. Dalton, " Franks Bequest, Catalogue of Finger Rings, Early Christian, Byzantine, Teutonic, Mediæval and Later (British Museum)," London, 1912, p. 120, No. 778.

Bronze signet-ring, Byzantine, two views
and impression. The abbreviated Greek in-
scription reads: "May the Lord help his
servant Stephan"

British Museum

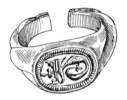

Bronze signet ring. European.
Fifteenth Century

British Museum

Silver ring, broken at the back.
Bezel bears letter "T" crowned.
Fifteenth Century

British Museum

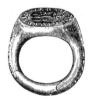

Ivory signet ring, with impression.
On the carved bezel, the Crucifixion,
between the Virgin and St. John;
legend: "*In hoc signo vinces*," motto
of the Emperor Constantine

British Museum

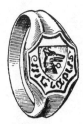
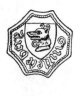

Bronze signet. The octagonal bezel is engraved with a greyhound's head, and a rather obscure inscription. Ring and impression of signet. Fifteenth Century

British Museum

Gold signet ring, engraved with a lion rampant; beneath, a star. Ring and impression.
Sixteenth Century

British Museum

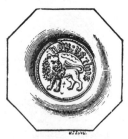

Massive gold ring; bezel engraved with a lion passant regardant, and the legend: "Now is thus." English, late Fifteenth Century. Ring and impression of signet

British Museum

A garden enclosed is my sister, my spouse; a spring shut up, a fountain sealed.[46]

A recognition that at the beginning of the sixth century A.D. bishops were in possession of signet rings is offered by a circular letter addressed by Clovis I, in 511 A.D., after his victory over the Visigoths at Vouglé, to the bishops of the many cities that came under his domination as the fruits of this success. He informs the bishops that he will free all prisoners, either clerical or lay, for whom this favor shall be asked in letters " sealed with your ring." This, however, only confirms the other testimony to the effect that the bishops had signets, but does not suffice to establish the existence at this time of rings given to them at their consecration as symbols of their office.[47]

The French kings of the Merovingian age stamped upon their royal documents the design engraved on their signet rings, the accompanying formula being frequently as follows: " By the impress of our ring we corroborate (*roborari fecimus*)"; slightly different forms appear sometimes. The following list gives, with the dates, a number of seal impressions that have been found on such documents:[48]

[46] SS. Zenonis et Optati, " Opera omnia," in Migne's Patrologia Latina, vol. xi, Paris, 1845; S. Optati, "De schismate Donatistiarum," lib. i, cap. 10, note.

[47] Philippi Labbæi and Cossarti, " Sacrosancta concilia," vol. iv, col. 1403.

[48] Deloche, " Le port des anneaux dans l'antiquité romaine, et dans les premiers siècles du moyen âge," Paris, 1896, pp. 108, 109; from Mémoires de l'Académie des Inscriptions et Belles Lettres, vol. xxxv.

Childebert I, 528 A.D.
Sigebert I, 545, A.D.
Chilperic I, 583 A.D.
Dagobert I, 629, 631–632, 635 A.D.
Childeric II, 664 A.D.
Thierry III, 673 A.D.
Dagobert II, 675 A.D.
Charles Martel (mayor of the palace), 724 A.D.
Pepin le Bref (mayor of the palace), 748 and 751 A.D.
Pepin le Bref, king, 755 and 768 A.D.

In the Carolingian period, Charlemagne and his successors continued the use of the same formulas.

The possession of signet rings by well-born women, although not usual in Roman times, became quite common in the early Middle Ages, under the influence of the Germanic peoples, which accorded to woman a much more important station than did the Romans or Gallo-Romans. Among the relics of the Merovingian period that have been preserved to our day, is the ring of Berteildis, one of the wives of Dagobert I (602?–638).[49] It is of silver and is inscribed with the name of the queen and the monogram of the word *regina*.[50] A document from the time of Childeric II, dated in 637, shows impressions of two queenly signets, one that of Emnechildis, wife of Sigebert II, King of Austrasia and guardian of Childeric, and the other belonging to Blichildis, Childeric's wife.

In the tomb of the Frankish king Childeric I (458–481 A.D.), accidentally discovered at Tournai in 1653,

[49] M. Deloche in Revue archéologique, 3d Series, 1886, vol. ii, p. 141 and 1893, vol. i, p. 269.

[50] See also the same writer's " Étude historique et archéologique sur les anneaux sigillaires," Paris, 1900, p. 203, fig. This ring was found at Laon, dept. Aisne.

in an ancient cemetery of the parish church of St. Brica, were found a number of valuable relics of this sovereign, among them his signet ring. After having been taken to Vienna by Archduke Leopold Wilhelm, then governor of the Low Countries, the treasure came, after his death, into the Imperial Cabinet there. In 1665 the Archbishop of Mayence secured from Emperor Leopold I permission to offer it to Louis XIV. In July of this year the precious objects were transmitted to the French king and were deposited in the Cabinet de Médailles, recently constituted in the Louvre. Shortly afterward, they were transferred to the Bibliothèque du Roi, and were safely preserved in this institution, under its changing names, until 1831, when the ring and other of the Childeric relics, as well as a number of other historic objects, were stolen from the library. The ring was never recovered. Fortunately there exists a very exact description and a figuration of the ring in an account of the treasure published in 1655, at Antwerp, by Jean Jacques Chifflet, first physician of the Archduke.[51] The ring, which is of massive gold, bears a large oval bezel on which is engraved the bust, full face. The sovereign is beardless, with long hair parted in the middle and hanging down to his shoulders. The bust is garbed in Roman style; on the tunic may be seen a decorative plaque. The king's right hand holds a lance which rests on his shoulder, as may be observed in the imperial medals of Constantine II, Theodosius II, and their successors. The legend, in the genitive case, *Childerici Regis,* presupposes the

[51] "Anastasis Childerici I Francorum regis, sive Thesaurus sepulchralis Tornaci Nerviorum effossus et commentario illustratus," Antverpis, ex officina Plantaniana Balthazaris Moreti, 1655. This is a quarto of 367 pages, with 27 plates and copperplate engravings.

word *signum* or *sigillum*, as the ring was unquestionably a signet. M. Deloche considers it probable that it was made on the occasion of Childeric's marriage with Basnia, Queen of Thuringia, who had abandoned her native land and her husband to wed the Frankish sovereign. Clovis I (481–511) was the offspring of this union. Although the original has been lost there has fortunately been preserved an imprint from it on the margin of a manuscript in the Bibliothèque de Sainte Geneviève; of the entire ring there is the carefully executed drawing made for Chifflet's work.[52]

In many cases the Carolingian monarchs rendered their signets, set with antique gems, significant of their own personality by having their names engraved around the setting. In this way Carloman (741–747) utilized an antique gem showing a female bust with hair tied in a knot, while Charlemagne's choice was a gem engraved with the head of Marcus Aurelius; at a later time he substituted for this one bearing the head of the Alexandrian god Serapis. It is noteworthy that there is a great likeness between the portraits of Antoninus Pius and the type chosen for Serapis. Louis I, le Debonnaire (814–840), selected a portrait of Antoninus Pius, and his son, Lothaire, Roman emperor, 840–855 A.D., a gem with Caracalla's head, the choice being no inappropriate one in view of Lothaire's weak and treacherous character. Rev. C. W. King conjectures that the selection of the particular head may have depended upon its resemblance, more or less close, to the features of the monarch, as even though the likeness should not be very exact, the work would surpass anything that the unskilful gemcutters of this age could produce.[53]

[52] Deloche " Anneaux Sigillaires," Paris, 1900, pp. 192, 193.
[53] C. W. King, " On the Use of Antique Gems in the Middle Ages."

Of the seal of the Prophet Mohammed, we are told
by Ibn Kaldoun that when he was about to send a letter
to the Emperor Heraclius, his attention was called to
the fact that no letter would be received by a foreign
potentate unless it bore the impression of the Prophet's
seal. Mohammed therefore had a seal made of silver,
bearing the inscription *"Mohammed rasûl Allah,"* " Mo-
hammed the Apostle of God "; these three words, accord-
ing to Al-Bokhari, were disposed in three lines. The
Prophet made use of this seal and forbade the making
of any one like it. After his death it was employed by
his successors, Abu Bekr, Omar and Othman, but the
last-named unluckily let it fall from his hand into the
well of Aris, whose depth it had never been possible to
measure. A duplicate was executed to replace the
original, but its loss was greatly deplored, and was looked
upon as a possible presage of ill-fortune.[54] The title
inscribed upon it was prouder in its simplicity than that
assumed by any other ruler, not excepting those who
claimed for themselves a divine ancestry, or divine at-
tributes. These could at most pretend to rank as divin-
ities of a lower order, while Mohammed claimed to be
the mouthpiece of the one and only God.

Burton writes that it is " a tradition of the Prophet "
that the carnelian is the best stone for a signet ring, and
this is still the usage among Mohammedans in the Orient.
In the Arabian tale entitled " History of Al Hajjaj ben
Yusuf and the Young Sayyed," we read that the signet
should be of carnelian because the stone was a guard
against poverty.[55]

[54] " Prolégomènes Historiques," of Ibn. Kaldoun, in Notices
et Extraits des Manuscripts de la Bibliothèque Impériale, vol.
xx, pt. i, pp. 61–62, Paris, 1865.

[55] Burton, " Supplementary Nights," 1868, vol. v, p. 52.

Some Arabic signets bore peculiarly apt inscriptions. One of these reads: " Correspondence is only a half-joy," a delicate piece of flattery for the recipient of a letter bearing this seal. Another signet gives the following very necessary warning to the person to whom the letter is addressed, should it happen to contain something which ought not to be revealed. " If more than two know it, the secret is out." [56] Such inscriptions are certainly more significant than a motto of less special meaning.

In an essay on Arabic signets, Hammer-Purgstall [57] calls attention to a fundamental distinction between talismans and signets. With the former, the inscription is engraved so that it may be read as it stands, while with the latter the characters are reversed so that only the impression gives them in their proper order. Besides this, the talismans rarely contain the wearer's name, which is the most essential part of the signet. Nevertheless, there can be little doubt that in many cases the signet was at the same time a talisman.

That lovers—even Mohammedan lovers—in the seventeenth century, had romantic designs engraved upon seal rings, is illustrated by what Garzoni relates concerning the seal ring of " Mahometh Bassa." This bore the figure of a silk-worm upon a mulberry leaf, the design commemorating the wearer's love for a Moorish girl, and signifying that he drew his life from her as did the silk-worm from the leaf.[58]

[56] Hammer-Purgstall, " Abhandlung über die Siegel der Araber, Persen und Türken," Denkschriften der Kaiserl. Akad. der Wissenschaften, Phil.-Hist. Kl., Wien, 1850, p. 29.

[57] *Ibid.*, p. 1.

[58] Garzoni, " Piazza Universale," German transl., Franckfurt am Main, 1641, p. 697.

Tavernier relates that in his time, the last half of the seventeenth century, the secret treasure of the Sultans in Constantinople was guarded in an innermost treasure-chamber of the Serail. This chamber was only opened at intervals to receive the surplus gold that had been collected from the Empire or received in any way, when the total sum had reached 18,000,000 livres (over $7,000,000 according to the value of the livre in Tavernier's day). The gold was contained in sacks, each of which held 15,000 ducats. When an addition to the treasure was to be deposited, the Sultan himself led the way to the treasure-chamber and stamped his seal, with his own hand, on red wax spread over the knot of the cord with which the sack was secured. This seal was engraved on the bezel of a gold ring and constituted no design, but simply the name of the reigning sovereign, the characters being probably intricately combined in the elaborate and cryptic manner used in the case of the imperial name and titles.[59]

A Byzantine signet ring of the sixth or seventh century of our era, in the British Museum, shows the head of Christ, beneath which bending figures of two angels in profound adoration are depicted. Angel-figures almost exactly similar may be seen in Byzantine ivory carvings of this later period, the type evidently being one of those rigidly defined in the hieratic art of the school. With this ring were found coins of Heraclius (610–641), the Greek emperor in whose reign fell the death of Mohammed (June 8, 632) and the overthrow of the Sassanian Persian monarchy by the Mohammedans.[60]

[59] Jean Baptiste Tavernier, " Relation du Serrail," Paris, 1702, pp. 480, 481.

[60] O. M. Dalton, " Byzantine Art and Archæology," Oxford, 1911, p. 540; figs. 319, 320 on p. 537.

How important the possession of a royal seal-ring was considered to be, as proving the title of a successor, appears in the story that at the death-bed of Alexius Comnenus (1084–1118), Emperor of the East, when the son and rightful successor, John Comnenus, perceived that his mother Irene was working to exclude him from the throne and to seat thereon his blue-stocking sister Anna, he took off the imperial ring from the hand of his dying father and thus ensured for himself the title to the Eastern Empire.[61]

Saint Bernard of Clairvaux (1091–1153), the enthusiastic preacher of the Second Crusade in 1147, excuses himself in some of his letters that he has failed to seal them, because he could not lay his hand on his signet. In a letter to Pope Eugene III, the saint complains that several spurious letters bearing his name have been circulated, sealed with a counterfeit seal; he also notifies the pontiff that from this time his letters will bear a new seal, on which will be his portrait and his name.[62]

Well-to-do merchants of medieval times, not entitled to armorial bearings, often had special individual marks or symbols engraved upon their signets. This custom obtained on the continent as well as in England, and allusion is made in the Old English poem of the fourteenth century, " Piers Plowman," to " merchantes merkes ymedeled in glasse." [63] Probably emblems of this kind came to have a certain association with the

[61] Nicetas, " Histoire de l'Empire Grec, Règne de John Comnénus," Paris, 1693, p. 7.

[62] P. J. Mariette, " Traité des pierres gravées," Paris, 1750, vol. i, p. 21.

[63] " Catalogue of the Special Exhibition of Works of Art at the South Kensington Museum, June, 1862," section 32, " Rings," by Edmund Waterton, p. 622.

business which in many cases descended from father to son through a number of generations.

A royal signet ring once believed to be that of Saint Louis (Louis IX, 1214–1270) and long preserved in the treasury of St. Denis, as an object of reverent care, is now in the Louvre Museum. The fact that the crescent is introduced as a symbol fails to connect the ring with the Crusader St. Louis, as this symbol was not used by the Saracens of his time, but was only adopted as a Mohammedan device after the Turks captured Constantinople, the crescent having been a recognised symbol in ancient times in Byzantium long before the city came to be called Constantinople.[64]

The engraved stone in the ring is a table-cut sapphire, the monarch being figured standing, with a nimbus around his head; he is crowned and bears a sceptre. The letters S L on the stone have been interpreted to mean rather *sigillum Ludovici* than *Sanctus Ludovicus,* and one critic suggests the possibility that it may have been executed in Constantinople, in Byzantine times, for Louis VII, who was there in 1147, and was received with high honors by Manuel Comnenus, the Greek emperor's courtesy being rather bred of fear of French aggression than of affection for the French crusader. As we have good evidence that gem-cutting was not practised at this time in France, it seems plausible enough that Louis VII should have availed himself of this opportunity to have a signet engraved for him by a Greek gem-cutter.[65]

[64] C. W. King, " Antique Gems and Rings," London, 1872, p. 399.

[65] Jules Labarte, "Dissertation sur l'abandon de la glyptique en Occident au Moyen Age et sur l'époque de la renaissance de cet art," Paris, 1871, pp. 12–18.

The signet ring of King Charles V of France (1337–1380) was set with an Oriental ruby on which was engraved " the bearded head of a king." This signet was used by King Charles to seal the letters written by his own hand. The somewhat vague description in the inventory suggests that this may have been an antique gem, the supposedly royal head being that of some Greek divinity. The art of engraving on such hard stones as the ruby does not seem to have been practised in the thirteenth or fourteenth centuries, the revival of this art belonging to a later period. Evidently the head was not that of Charles himself or of any of his predecessors, for, had this been the case the inventory would hardly fail to note the fact.[66]

When a certain Bratilos was sent as a messenger by the eastern emperor Cantacuzene (1341–1355) to his empress Irene, to announce the outbreak of a dangerous revolt, he bore a sealed letter from the emperor.[67] While on his journey, however, he began to fear that he might be waylaid and robbed of the important document. This peril he effectively provided against by memorizing the letter and then destroying it, after he had removed the wax impression of the imperial signet, which he could safely guard in his mouth, and which served to accredit him when he came before the empress.[68] Not long afterward Cantacuzene was defeated and deposed by John V, Palæologus, and retired to a monastery, where he lived until 1411, composing a history of his own times in his leisure moments; his wife also took the religious vows under the name of Eugenia.

[66] Labarte, " Inventaire du mobilier de Charles V," Paris, 1879, p. 86, No. 555.

[67] Joannis Cantacuzeni, " Historiæ," vol. i, lib. iii, cap. xlvii.

[68] Migne's Patrologia Græca, vol. cliii, Paris, 1866.

Much has been written about the ring or rather the engrave seal of Michaelangelo. This gem enjoyed such high esteem that it was very often copied, the copies sometimes acquiring the repute of being originals. Four of them, two in paste, one in amethyst, and one in carnelian, exist in Denmark, the two latter having the dimensions of the original gem. The copy in carnelian— the stone in which the original was cut—is exceptionally well executed.[69] The original seal is now in the Bibliothèque Nationale in Paris and came into the possession of Louis XIV in 1680. The king wore it set in a ring.

It was brought to France in 1600 by a Sieur Bigarris, director of the Mint, and its history was at the time traced back to Agosto Tassi, goldsmith in Bologna, to whom Michelangelo had bequeathed it. The gem was the work of Pier Maria di Pescia, and bears his symbolic signature, a boy fishing (*pescia,* fishing). The dimensions are given as 15 mm. by 11 mm., the form being oval, and in this restricted space is a design embracing twelve human figures, two genii, a horse, a goat and a tree. Two of the figures appear to have been copied from a detail of Michelangelo's Sistine Chapel frescoes: a woman helping another woman to place a basket of grapes upon her head. Watelet and Levesque in their *"Dictionnaire des Arts,"* published in 1791, characterize this seal as " the most beautiful engraved gem known."

The Royal Collection at Windsor Castle contains a gold ring set with a cameo portrait of Louis XII, of France (1498–1515), cut in a pale ruby of clear lustre. The work is believed to have been executed during the lifetime of the king, and was considered by Rev. C. W. King to be the earliest Renaissance portrait cut on a

[69] Emil Hannover in " Politikon " Kjobenhavn, April 10, 1911.

stone of the hardness of a ruby. He regarded it as a work of the famous Renaissance gem-cutter Domenico dei Camei, this artist having engraved a portrait of the Milanese duke Ludovico Sforza, surnamed Il Moro, on the same hard material. The gold plate at the back of the bezel holding the gem bears the inscription " Loys XIIme Roy de France décéda I Janvier, 1515," the stone having been set in the ring at some time after the monarch's death. [70]

This collection also contains an imperfect specimen of a squirt-ring. The hoop is of enamelled gold set with a garnet engraved in relief with a mask or bacchic head finely executed by a sixteenth-century artist. The hole at the base of the hoop, with its internal screw-worm, indicates that it was once provided with a squirt for projecting perfumed liquids. [71]

A sixteenth-century portrait by the German painter, Conrad Faber, depicts a well-to-do burgher, possibly a burgomaster, who wears a seal ring on the index finger of his left hand and a ring with a precious stone setting on the fourth finger of the same hand. In this hand he holds something which may be a staff of office; it is surmounted by an octagonal block of ebony in which is inlaid a medallion figuring St. George and the Dragon. The city, as carefully delineated in the background as in the finest of engravings, appears to be one of the historic Rhine cities, and is evidently that with which the sitter was identified.

For signet rings, antique gems continued to be those

[70] C. Drury Fortnum, " Notes On Some of the Antique and Renaissance Gems and Jewels in Her Majesty's Collection at Windsor Castle," London, 1876, pp. 12, 13; cut double linear size on p. 13.

[71] *Ibid.*, p. 15.

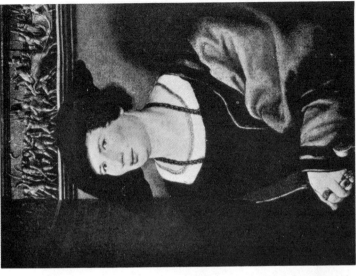

PORTRAIT OF A MAN, BY THE SIXTEENTH-CENTURY GERMAN PAINTER, CONRAD FABER

Seal ring on index of left hand, sapphire-set ring on fourth finger of this hand, which holds what seems to be a wand or staff of office, surmounted by an octagonal ebony block, with inserted medallion of St. George and the Dragon

Metropolitan Museum of Art, New York, Kennedy Fund, 1912

PORTRAIT OF BENEDIKT VON HERTENSTEIN, BY HANS HOLBEIN

Showing seal ring on index finger, two rings on third finger, and three on little finger of left hand

Metropolitan Museum of Art, New York City

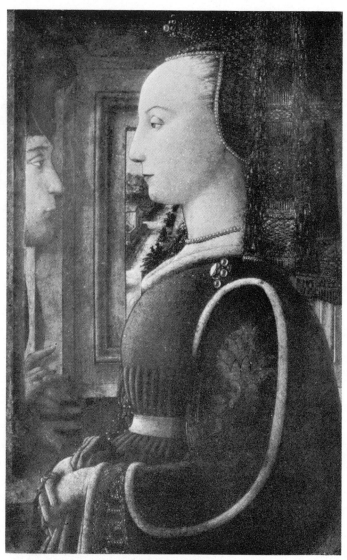

MAN AND WOMAN AT A CASEMENT

The woman wears three rings (sapphire, ruby and some other stone) on the index of right hand, and two on the middle finger of this hand, one of them on the second joint. The young man has a large oval topaz on the little finger of his left hand. Florentine, Fifteenth Century

Metropolitan Museum of Art, New York

most favored until the Renaissance period, and even to a considerable extent during this period. However, the development and elaboration of the science of heraldry and the great importance accorded to the possession of armorial bearings soon induced the engraving of these upon the signets, in preference to using antique gems or copying their types. In Elizabeth's reign and in those of her immediate successors, it is believed that scarcely a gentleman was to be found who did not own and wear a signet ring on which appeared his coat-of-arms. Those not fortunate enough to have the right to display armorial bearings, sometimes sought to make their signets individual by using as designs rebuses expressing more or less well the pronunciation of their names.[72]

Arms were sometimes blazoned on rings by enamel applied to the base of a setting; thus the arms engraved on a rock-crystal or a white sapphire, would appear with their proper hues, the colors showing through the transparent stone, and their effect being heightened by the brilliant medium. A fine example of this kind of ring is one made for Jean Sans-Peur, Duke of Burgundy (1401–1419) ; another is the signet ring of Mary, Queen of Scots, now in the British Museum. [73]

Bequests of signets to near relatives occur not infrequently in wills of the fifteenth and sixteenth centuries, as for example in that of John Horton, dated 1565, wherein appears the following: " Item, I give unto my brother Anthony Horton, for a token, my golde

[72] O. M. Dalton, " Franks Bequest, Catalogue of the Finger Rings, Early Christian, Byzantine, Teutonic, Mediæval and Later (British Museum)," London, 1912, p. xxxi.

[73] " Catalogue of the Special Exhibition of Works of Art at the South Kensington Museum, June, 1862," section 32, " Rings," by Edmund Waterton, p. 623.

ringe w^{th} the seale of myne armes, desirenge him to be good to my wiffe and my childringe as my trust is in him." Besides this seal ring, the testator willed " a golde ringe w^{th} a turkes [turquoise] in it " to his " singular good Lord the Lord Eueerye," with a plea for friendship toward his wife and children. A ring set with a diamond was bequeathed in 1427 by Elizabeth, Lady Fitzhugh to her son William.[74] This was almost certainly one of the uncut, pointed diamonds used for settings at this early time.

The signet ring of Mary Stuart is one of the chief treasures in the ring collection of the British Museum. It was made for her use after her betrothal to the French Dauphin, later, for a few months, King of France as Francis II (1543–1560), just before her marriage, as after that time the arms of France would have been combined with those of Scotland. The following description is given of this ring in the exceedingly valuable catalogue of the Franks Bequest by O. M. Dalton[75]:

316. Gold; the shoulders ornamented with flowers and leaves once enamelled; oval bezel containing a chalcedony engraved with the achievement of Mary, Queen of Scots. The shield is that of Scotland surrounded by the collar of the Thistle, with the badge, and supported by two unicorns chained and ducally gorged; the crest, on a helmet with mantlings and ensigned with a crown, is a lion sejant affronté, crowned and holding in the dexter paw a naked sword; in the sinister a sceptre, both bend-

[74] O. M. Dalton, " Catalogue of the Finger Rings, Early Christian, Byzantine, Teutonic, Mediæval and Later, bequeathed by Sir Augustus Wollaston Franks, K.C.B. (British Museum)," London, 1912, p. li, footnote.

[75] Franks Bequest, Catalogue of Finger Rings, Early Christian, Byzantine, Teutonic, Mediæval and Later (British Museum), London, 1912, p. 53.

wise. Legend: *In Defens*, and the letters M R. On the dexter side is a banner with the arms of Scotland; on the sinister side, another, with three bars and over all a saltire. The metals and tinctures appear through the crystal on a field of blue. Within the hoop at the back of the bezel is engraved a cipher in a circular band and surmounted by a crown, once enamelled. The cipher is formed of the Greek letter φ and M, for the names Francis and Mary.

In this example of sixteenth-century French goldsmithing, the colors of the arms have been applied beneath the crystal so that they would not be effaced in using the signet for sealing. In 1792 this ring was in the possession of Queen Charlotte, wife of George III. After her death it became the property of the Duke of York, and when his plate and jewels were sold at Christie's, in London, March, 1827, it was bought by Mr. Richard Greene, F.S.A., and was acquired from him in 1856 by the British Museum.

A signet ring believed by many to be that of the immortal Shakespeare, was found on March 16, 1810. It was picked up on the surface of the mill-close that adjoins Stratford churchyard; the finder was the wife of a poor laborer. How lightly it was esteemed at the outset is shown by the low price at which it was acquired by Mr. R. B. Wheeler, who paid only thirty-six shillings ($9.00), considered to be the value of the fifteen pennyweights of gold in the ring. In fact, the only circumstances seeming to connect it with Shakespeare are the initials W. S., and the facts that the ring appears to be of Elizabethan workmanship and that it was found at Stratford-on-Avon, Shakespeare's home.[76] The initial

[76] See also Catalogue of the Books, Manuscripts, Works of Art and Relics, at present exhibited in Shakespeare's Birthplace, with 61 illustrations, Stratford-upon-Avon, 1910.

letters are bound together with a design composed of an ornamental band with tassels, so arranged as to outline a heart. A queer coincidence, if the report be true, is that a certain William Shakespeare was at work nearby when the ring was found.[77]

One of the somewhat less well-known Shakespeare portraits depicts the poet wearing a thumb ring on his left hand. This is the work of Gerald Soest, who was born twenty-one years after Shakespeare's death; its inspiration is probably to be sought in the Chandos portrait of which it is an amplification and re-arrangement. The face, however, wholly lacks the dignity and expression of the Chandos, being exceedingly weak and commonplace. The hands give the effect of having been copied from those in some other portrait, and, of course, under all these circumstances we would scarcely be justified in assuming that Shakespeare wore a thumb ring, although he may well have done so, in view of the fact that the fashion was common enough in his time. Queen Elizabeth, even, is depicted as wearing one in Zucchero's portrait of her at Hampton Court.[78]

Another English poet, that master of impassioned verse, Byron, had in his possession a most interesting bloodstone signet ring, engraved with the following three family mottoes: " Tout prest " (Quite ready), motto of the families Monk, Murray and Younger; " Confido, conquiesco " (I trust and am contented), motto of the Dysart, Hodgett, Maroy, Tollmache and Turner families; " Pour y parvenir " (In order to accomplish, or

[77] Halliwell, " Life of William Shakespeare," London, 1848, p. 334.

[78] " Catalogue of an Exhibition Illustrative of the Text of Shakespeare's Plays," New York, The Grolier Club, 1916, plate opposite p. 96, from a mezzotint by G. F. Storm, 1847.

Sidney Lee.

Oard: C. Wellstood

1, Shakespeare's gold signet ring, found in Stratford-upon-Avon, March 16, 1810. 2, brass signet supposed to be that of the physician, John Hall, Shakespeare's son-in-law. 3, wax impression from Shakespeare's ring. (Photographed expressly for this book as attested by signatures of Sir Sidney Lee, Chairman of the Executive Committee of "Shakespeare's Birthplace," and of the Librarian, F. C. Wellstood.) 4 and 5, gold signet ring owned by Lord Byron, with impression from it. The seal shows the crests and mottoes of three families. Photographed for this book. In the possession of Judge Peter T. Barlow, New York

Dr George F. Kunz

Dear Sir.

In response to your application of May 17th please find enclosed a photograph of the rings of Shakespeare and John Hall which are preserved in the Museum at Shakespeare's Birthplace. A wax impression of Shakespeare's signet ring also accompanies this letter.

Yours faithfully

Sidney Lee.

Onsdt C. Wellstood

succeed), motto of the families Manners and Manners-Sutton. This ring was owned by Sir Walter Scott, and at the dispersal sale of his personal effects at Abbotsford it was acquired by the late Samuel Latham Mitchell Barlow, the great art connoisseur and collector, by whose son, Judge Peter T. Barlow, of New York, it has been inherited, in whose possession it now is, and through whose courtesy it is here reproduced.

Many interesting facts in regard to the history of the diamond engraved for Queen Henrietta Maria, wife of Charles I, have been presented by Mr. C. Drury Fortnum, who purchased the diamond from the collection of the Duke of Brunswick in 1879.[78] In the catalogue of the Duke's collection this stone is described as the signet of Mary, Queen of Scots, an attribution which had been current for many years; but Mr. Fortnum has shown that the initials on the diamond should be read MR, the cross-bar in the first character representing the letter H, and the whole signifying Maria Henrietta Regina.

Fortunately we have the original of the treasury order given by Charles I, under date of January 16, 1629, directing the payment of a sum of money to the engraver for his work. As this is probably the only case in which the original record of payment for engraving an historical diamond has been preserved, it is reproduced here from Mr. Fortnum's paper in Archæologia.[80]

Charles by the grace of God King of England, Scotland, France, and Ireland, Defender of the Faith, &c.

[79] See Archæologia, vol. xlvii, 393, and vol. l, p. 114.

[80] Vol. xlvii, London, 1883, p. 393. The original document is in the privy seal books of the Clerk of the Pells, now in the Public Record Office, No. 11, p. 142.

To the Trēr and Undertrēr of oᴿ Exchecqᴿ for the time being greeting:

Wee doe hereby will and cōmand yoᵘ out of oᴿ treasure remaining in the Receipt of oᴿ Exchecqᴿ forthwith to pay or cause to be paid unto Francis Walwyn or his assignes the some of two hundred three-score and seven pounds for engraving, polishing, Dyamond boart and divers other materialls for the Cutting and furnishing of oᴿ Armes in a Dyamond with l'res of the name of oᴿ deerest Consort the queene on each side, And these oᴿ l'res shal be yoᴿ sufficient warrᵗ and discharge in this behalfe.

Given under oᴿ privy Seal att oᴿ pallace of Westmᴿ the sixteenth day of January in the fourth yeare of oᴿ Raigne.

Jo: Packer.

As a general rule a signet ring was one of the last objects of value that an owner would part with, but we know that after Charles' execution Henrietta Maria was reduced to dire straits and was obliged to sell all her possessions in order to procure the bare necessaries of life. In Tavernier's account of his travels in the East he states that in 1664, he showed to the representative of the Shah of Persia a ring engraved with the royal arms of England, and which had belonged " to the late King of England." As letters and papers have been preserved, dating from 1656 to 1673, and sealed by Charles II with the diamond signet used by his father, we have proof that Charles II had that signet in his possession in 1664, and Mr. Fortnum's conjecture that the engraved diamond in Tavernier's hands was that of Henrietta Maria is plausible enough.

The Shah of Persia sent the diamond back to Tavernier, requesting information as to what was engraved upon it, but the French jeweller, fearing possible complications, did not venture to go beyond the

vague statement that the stone bore the arms of a
" European prince." The Shah does not appear to have
bought this diamond; probably he did not care much for
historic souvenirs of European royalties, and possibly
he doubted whether Tavernier had the right to offer for
sale what might be the signet of a European monarch.
However, the Shah's minister did not fail to express his
admiration of the skill shown by the " Franks " in the
art of diamond-engraving.[81]

Already, in the Vetusta Monumenta of Astle, pub-
lished by him in 1792, the seal is figured as that of Mary
Queen of Scots, and is said to have been in the pos-
session of Louis XIV. If this statement be correct, the
signet might have been among the diamonds sold by
Tavernier to Louis XIV, on the former's return to
Europe. It seems to have shared the fate of a large
number of the jewels belonging to the French crown
and to the royal family, and next appears in a sale held
in London June 19, 1817, being described in the cata-
logue as " the engraved diamond ring of Mary, Queen
of Scots, upon which are engraved the arms of Eng-
land, Scotland and Ireland, quartered," and authen-
ticated by a communication from " that correct and
learned antiquary the late Robert Gough, Esq." to the
following effect:

That it descended from Mary to her grandchild Charles I,
who gave it on the scaffold to Arch Bishop Juxon for his son
Charles II, who in his troubles pawned it in Holland for £300,
where it was bought by Governor Yale and sold at his sale for
£320, supposed for the Pretender. Afterwards it came into the
possession of the Earl of Ilay, Duke of Argyle, and probably
from him to Mr. Blashford.

[81] " Les six voyages de Jean Bapiste Tavernier," La Haye,
1718, vol. i, pp. 540, 541.

In these statements there is probably a confusion between the diamond of Henrietta Maria, known later as that of Mary, Queen of Scots, and a diamond signet of Charles I, for such a signet is said to have been given to Bishop Juxon by Charles just before his execution. We have every reason to believe that Henrietta Maria bore her own signet with her when she left England.

The ring containing this historic diamond was purchased at the sale of June 19, 1817, by Dr. Curry (probably James Curry, M.D., physician at Guy's Hospital) for the sum of £90 6s ($450), although a contemporary letter states that the sum was £86, and adds that the stone itself was worth but £10. The ring was subsequently acquired by an agent, Van Prague, and after passing through several hands came into the possession of Mr. Leverson, a diamond dealer of Paris, who sold it to the Duke of Brunswick. At one time it was owned by the Earl of Buchan, and it was exhibited at Holyrood in 1843, when several rock crystal models were made of it. One of these served Mr. Fortnum as a standard of comparison for the identification of the Duke of Brunswick's diamond.

The stone is a table diamond and is engraved with the arms of England and France in the first and fourth quarters, with those of Scotland in the second quarter, and those of Ireland in the third. In 1887, on the occasion of Queen Victoria's Jubilee, this signet was presented to the queen by Mr. Drury Fortnum, and it is now in the royal collection at Windsor Castle.[82]

One of the most interesting engraved diamonds is the signet of Charles I of England, when Prince of

[82] H. Clifford-Smith, " The King's Gems and Jewels at Windsor Castle," *The Connoisseur*, 1903, vol. v, p. 244.

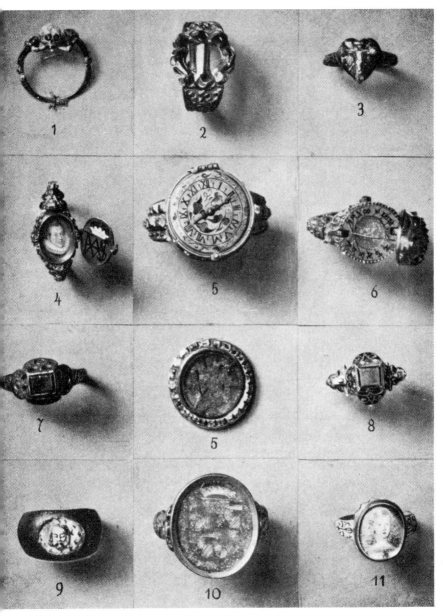

RINGS FROM THE COLLECTION OF THE IMPERIAL KUNSTGEWERBE MUSEUM, VIENNA

1 and 3, rings of Empress Eleonora, wife of Ferdinand III (1608–1657); enameled gold; Seventeenth Century. 2, gold ng said to have belonged to Mary of Burgundy, daughter of Charles the Bold, and wife of Maximilian I, Emperor of ermany. Bears an M formed of black diamonds and has twice on the inner side the monogram of Maria in Gothic apitals. 4, ring with miniature portraits of Emperor Mathias and his wife Empress Anne; enameled gold; 1612–1619. , (a) ring with watch by Johann Putz of Augsburg, and (b) lid made of an emerald on which the Austrian double-eagle engraved; Seventeenth Century. 6, ring with a sun-dial, the lid representing a hedgehog studded with black diamond zenges; Seventeenth Century. 7 and 8, two rings set with topaz; enameled gold; Sixteenth and Seventeenth Century. bronze ring, with head of Christ in white enamel on blue ground, the hair being of gold; Seventeenth Century. 10, ring t with a rock crystal, engraved with the arms of an Austrian archduke. On the inner side is a sun-dial; Seventeenth entury. 11, ring with a miniature portrait of Empress Claudia Felicitas; enameled gold

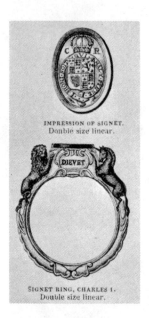

IMPRESSION OF SIGNET.
Double size linear.

SIGNET RING, CHARLES I.
Double size linear.

SIGNET RING OF CHARLES I

The richly ornamented gold hoop
has on its shoulders a lion and a uni-
corn of chiseled steel. On the bezel
is a steel plate engraved with the
Royal arms, those of France and
England in the first and fourth quar-
ters; in the second, the arms of Scot-
land; and in the third, the Irish harp.
On the sides of the gold base of the
bezel is the inscription: "*Dieu et
mon droit,*" inserted in steel letters

Wales.[83] This is a large shield-shaped diamond en-
graved in intaglio with the Prince of Wales' feathers
between the letters C.P. and issuing from a coronet;
on a ribbon beneath appears the motto I C H D I E N.
The stone is set in a ring of enamelled gold. The en-
graving is finely executed and deeply cut. This signet
has often been regarded as that of Charles II, but all
doubt as to the original owner is set at rest by the exist-
ence of an autograph letter of Charles I, in the posses-
sion of M. Labouchère of Paris, bearing its impress.

The Royal Collection at Windsor Castle also contains
the signet used by Charles I, as King. It has a richly
ornamented hoop, to which are attached, at the shoulders,
chiseled steel figures of a lion and a unicorn. The gold
bezel has a steel facing constituting the seal. This is
engraved with the royal arms; in the first and fourth
quarters, the arms of England and of France; in the sec-
ond quarter, those of Scotland; in the fourth quarter,
the Irish harp. On the gold base of the bezel is the
motto: Dieu et mon Droit, inserted in letters of steel.
This constitutes an exceptionally fine example of com-
posite metal-work. The archæologist, Rev. C. W. King,
suggests that it may be the work of the " Inimitable
Simon," as he was called, who later engraved dies for the
coinage of the Lord Protector, Oliver Cromwell, al-
though he admits that it may have been executed by
Vanderdoort, who was commanded in 1625 to make pat-
tern pieces for the coinage of Charles I, at the beginning
of the King's reign.[84]

[83] Fortnum, " Collection at Windsor Castle," London, 1876,
p. 141.

[84] C. Drury Fortnum, " Notes on Some of the Antique and
Renaissance Gems and Jewels in Her Majesty's Collection at
Windsor Castle," London, 1876, pp. 26, 27.

A signet ring used by Kaiser William II is set with a reddish-white onyx, on which has been engraved a shield bearing the German eagle, and surmounted by a crown and the letters, W. II. I. R., Wilhelm der Zweite, Imperator Rex. This signet belonged to the present Kaiser's grandfather William I, and has been adapted to the present monarch's use.

Signet rings were very popular in the latter part of the eighteenth century and into the nineteenth century. Then, later on, they were revived in the latter part of the nineteenth century, this revival continuing into the twentieth century. In the earlier period it was customary to engrave the crest and motto, or the full arms and motto, on the ring stone, which was generally bloodstone or carnelian, occasionally white chalcedony, more rarely lapis lazuli, in contradistinction to the large seal fobs, in which the favorite stones were amethyst, rock crystal, smoky topaz (quartz variety), pale chalcedony or some lighter colored material. Many signet rings were engraved upon gold, the sides of the rings being also engraved, as a general rule.

Since the year 1900, great interest has been aroused in seal rings, many of the designs of which are incised in gold or in platinum, the entire ring being of gold or platinum, or having a platinum disk set in a gold hoop. The entire variety of fancy stones is used: pale amethyst, ruby, beryl, aquamarine, zircon, garnet, sard which has been stained brown, carnelian (rarely), bloodstone, and jade—both the nephrite variety from New Zealand and Russia and the jadeite variety found at Bahmo, Burma. Occasionally the seals of rings are made of fine sapphires, emeralds, or rubies, and sell for from $1,000 to $10,000, or even more.

Seal rings were extensively worn in the period from about 1865 to 1885. Frequently these had absolutely nothing engraved upon them. The setting was often an oblong, rectangular onyx, sometimes one inch or one and a quarter inches long. Occasionally upon this was inset a rose diamond initial; or else the initial was cut upon the stone—when the onyx was black on top— rarely a crest. In many cases the stone was white above and pink below, a sardonyx, and the initial was cut through the light layer. Or else it was white or pale gray on a black ground. The general effect was thus gray, the gem being of the type known as nicolo.

Then came the cameo rings, with designs either black on white or brown on white, sardonyx; or white on green, chrysonyx. Later again taste developed for intaglio rings. In this instance, instead of stones of a brownish or whitish gray,—chalcedony,—those of a pale brown or a dark brown were chosen and these were called sard. Because of the brown hue, the term onyx was also applied to them. This must not be confused with the antique sard which resulted from burning a stone of a different hue, as in the case of the antique carnelian also. The translucent or opaque varieties, with rich red or dark brown top, were called sard, whereas the paler translucent and almost transparent varieties,— when pale red, yellowish red or almost yellow,—were called carnelian.

While the natal gem in a simple but effective setting is the most appropriate ring for a girl or boy, a small seal ring for the boy, when he is about 12 years old· is not un- fitting, the seal being so well-executed that it may serve him when he has reached manhood. For very young children, no stone can be given the preference over the turquoise, which in its delicacy and beauty of color can-

not be excelled. Small pearls are also used, or tiny brilliant rubies.[85]

In a brightly-written tale for children, the style of which is rather pronouncedly " up-to-date," a sapphire signet is an important element of the story. Long years ago, in the island of Bermuda, in the Revolutionary period, this heirloom was surreptitiously secured by a young girl, to whom it was destined on her coming of age, but who was childishly impatient to gain possession of it before the time. The little heroine comes to New York and under the stress of a weird Tory plot, hides away her signet in the false bottom of an old trunk, stored away in the garret of the Charlton Street house in which she has lived. Here, more than a century later, a group of bright children find a diary of the long-dead heroine written in cipher. One of them is clever enough to unravel this mystery and they finally succeed in finding the hidden signet.[86]

Two characteristic Oriental seal rings are owned by Miss Joan St. Michael Peters and Miss Katherine Harrower, both of New York City. The gems with which they are set were bought by the Rev. Dr. John P. Peters from an Arab, in the Kut-el-Amara region, where the British invaders of Mesopotamia underwent such a disastrous defeat. They are engraved carnelians. Miss Peters' ring offers the design of a winged figure. The excellence of the cutting might seem to indicate that it was done some time between 500 B.C. and the beginning of our era, but a later date has been assigned to it by Prof. A. V. Williams Jackson of Columbia

[85] George Frederick Kunz, " The Etiquette of Gems," *Saturday Evening Post*, June 27, 1908, p. 5.

[86] Augusta Huiell Seaman, " The Sapphire Signet," New York, The Century Co., 1916.

Gold ring with miniature portrait, given by Washington to Lafayette on the latter's return to France. See pages 191 and 192. It is now in the possession of Mr. Gösta Frölén of Falun, Sweden

Photograph of two impressions in sealing wax, made by President Woodrow Wilson, of his seal ring, the inscription reading "Woodrow Wilson," in Pitmanic shorthand. 1916

Episcopal seal of Right Rev. David H. Greer, Bishop of New York. Motto: *Crux mihi grata quies* (The Cross is my grateful rest). The shield bears the monogram of the bishop's name, above which are two keys in saltire; below is the coat-of-arms of New Amsterdam. As crest is an Episcopal mitre

University, who pronounces it to be a Sassanian gem, and hence not older than the third Christian century. The other ring, that belonging to Miss Harrower, appears to be of the Seleucidan period, and may be dated from 300 to 200 B.C. The inscription, difficult to decipher, should be read " Khan " in Prof. Jackson's opinion.

One of the most intrinsically valuable of ancient signets is that engraved for Constantius II (317–361 A.D.). This is of sapphire, the stone weighing 53 of the older carats (54.40 metric carats). The design shows the emperor in the act of spearing an enormous wild boar on the plains of Cæsarea, the Greek inscription *xiphius* denoting the sword-like tusks of the animal. The exploit is performed before a reclining female figure, a personification of the city Cæsarea of Cappadocia. A Latin inscription C O N S T A N T I U S . A U G is considered to prove that this is veritably the emperor's signet. This remarkable gem is in the collection of Prince Trivulzio of Milan.[87]

A novel idea finds expression in the ring of President Wilson, on which he has had engraved his name in stenographic symbols. This is in thorough agreement with his aim to utilize business methods in the administration of national affairs, to do away with routine and take the most direct route to the solution of national problems. One of our two ex-Presidents, William H. Taft, sent us this reply: " I never wear a finger ring and never have done so. For that reason, I cannot comply with your request." [88]

[87] C. W. King, " The Natural History of Precious Stones," London, 1870, p. 254; Duffield Osborne, " Engraved Gems," New York, 1912, p.293. First published by Ducange, in the seventeenth century.

[88] From letters of Ex-President Taft and of Private Secretary Tumulty to the author.

IV

SOME INTERESTING RINGS OF HISTORY

THE principal types of the rings used as insignia, religious or secular, or as signets, as well as of those devoted to some special purpose or believed to possess talismanic or magic virtue are treated of in other chapters. There are many rings, however, which owe their chief or only interest to their association with some particular historic personage, event or period, while often the mere fact that the ornament has been owned by a famous person suffices to make it precious and interesting; in a number of cases the ring itself has been closely connected with some important historic happening or else with some cherished legend. Examples of this are the ring of Essex in Elizabeth's time, and the legendary ring of Edward the Confessor, regarding the stone setting of which several discrepant accounts exist.

The Bibliothèque Nationale in Paris has in its Cabinet des Médailles, two massive gold rings, in each of which the *chaton* is formed by an ancient coin. In one is set a rare gold quinarius of Maximinus (235-238 A.D.) with his effigy, and the ring is believed to have been made during this giant emperor's brief reign; the other bears a golden solidus probably of Clotaire II, King of the Franks, who reigned from 584 to 628 A.D. This coin shows a figure of the king with the name Chlotarius Rex, and the mint-mark of the city of Arras. The coin is more than ¾ inch in diameter.[1]

[1] Chabouillet, "Catalogue générál et raisonné des camées et pierres gravées de la Bibliothèque Nationale," Paris, 1858, p. 388, 389; Nos. 2636, 2639.

In a Frankish sepulchre at Laubenheim, near Bingen, Hessen-Darmstadt, was found a gold ring on the bezel of which is engraved the head of a woman, turned to the right, around which are the letters of the Gothic name Hunila. A princess of this name was married, about 280 A.D., to Quintus Bonosius, one of the Thirty Tyrants who established themselves in the Roman Empire during the short and troubled reign of Probus (280-281). While the ring we describe cannot be assigned to such an early period, but probably belongs to the end of the sixth or the beginning of the seventh century of our era, the intrinsic value and the workmanship, superior for the place and time, render it likely that this Hunila, also, was of royal race and station. In the sepulchre which yielded this ring there was a chain of amber and amethyst beads.[2]

The Persian poet-philosopher, Saadi, relates in his Gulistan, or " Garden of Roses," a story illustrating how a happy chance may do more to help the attainment of a temporary success than special ability or training. A Persian sovereign, passionately devoted to archery, determined to make a crucial test of the skill of his most famous archers, and to stimulate their efforts by the bestowal of a rich prize. To this end he caused a ring set with an immensely valuable precious stone to be suspended above the dome of Azad on the mosque near Shiraz, and proclaimed to all men that this ring would be given to the one who succeeded in shooting an arrow through its hoop. Despite the apparent impossibility of the task, several hundred of the Shah's archers strove to fulfil the conditions of the trial, but in vain.

[2] M. Deloche, " Étude historique et archéologique sur les anneaux sigillaires et autres des premiers siècles du moyen âge," Paris, 1900, pp. 90–92, figure.

Suddenly the Shah and his companions, who were closely
watching the contest, saw, to their amazement, an arrow
speed through the air and exactly traverse the ring.
None of the archers before the mosque had been shoot-
ing at the moment, and only after a careful search had
been made did it come out that the arrow had been shot
off by a youth at play in a near-by garden of a mon-
astery. Nevertheless, the royal word had been pledged,
and the ring was adjudged to the youth. The latter,
however, showed his wisdom by breaking his bow and
arrows, and never trying another shot, thus keeping
unsullied his reputation as a great archer.[3]

One of the Latin treatises of Petrarch tells of a
carbuncle or ruby, worn set in a ring by John II of
France, and believed to possess talismanic power. The
poet remarks, however, that this stone did not preserve
the King from being defeated and made prisoner at the
battle of Poitiers in 1356. This ruby was taken by the
English, but was returned to John several years later,
so that he was able again " to see an object of infinite
value, but of no use whatever." While admitting the
beauty of gems, Petrarch did not share the belief com-
mon in his day that they possessed occult powers.[4] Of
the diamond he says that, while in ancient times it was
a gem worn only by kings, in his own day luxury and
pride had increased to such an extent that many who
were not kings possessed the stone, and even some of
the common people wore it on their fingers.[5]

A ring called the " Friday Ring " is listed among
the jewels of Charles V of France (1337–1380), in the

[3] " The Gulistân or Rose Garden," trans. by Edward B.
Eastwick, London, 1880, p. 148.

[4] Francisci Petrarchæ, " De remediis," Genevæ, 1613, p. 151.

[5] Francisci Petrarchæ, *op. cit.*, p. 147.

inventory made in 1379. This had on either side a
double black cross in niello work, and was set with a
cameo bearing a crucifix and the figures of the Virgin
Mary, St. John and two angels. The name was de-
rived from the fact that the king wore this ring every
Friday, doubtless in memory of the Crucifixion, which
took place on that day.[6] There is also mention of
another ring, set with a large ruby, " the form of a half-
bean. This is the ruby which belonged to St. Louis
(1215–1270), and which has always been guarded suc-
cessively by the kings of France." [7] There seems to be
some likelihood that this was the highly prized ruby lost
by King John II about 1357, and in this case it must
have been restored to the French treasury. Still another
ring was set with a large ruby, called the " ruby de la
Caille," which had formerly belonged to the dukes of
Brittany and had been given to King Charles by Mon-
signeur d'Anjou. A note to this inventory informs us
that the term " ruby d'Alexandrie," so often met with in
old French lists of jewels, denotes a ruby bought in
Alexandria, where many of the finest precious stones
from the East were dealt in during medieval times.[8]

The battlefield of Agincourt, in the department of
Pas-de-Calais, not far removed from the trenches of
the Anglo-French army in the great war of to-day, was
visited in 1815 by General Sir John Woodford, who
was serving with the Grenadier Guards. Hoping to
unearth a few relics of the famous battle he had some
excavations made, and his efforts were rewarded by the

[6] Labarte, " Inventaire du mobilier de Charles V," Paris,
1879, p. 83, No. 524.

[7] *Ibid.*, p. 80, No. 491.

[8] *Ibid.*, p. 16, note; for the ruby of the dukes of Brittany,
see p. 80, No. 492.

discovery of several knightly rings inscribed with mottoes or posies. About 1850 one of these rings, which had probably been worn by a French noble, was shown at a meeting of the London Archæological Institute. The battle of Agincourt, where the French army was decisively defeated by Henry V of England, was fought October 25, 1415, on the day of Sts. Crispin and Crispian, and inspired Shakespeare with the following proud lines addressed by the English king to his soldiers:

> And Crispin Crispian shall ne'er go by
> From this day to the ending of the world,
> But we in it shall be remembered.

Hungary's great hero, John Hunyady (1387?–1456), had in his coat of arms a raven holding a ring in its beak. The legendary explanation of this is that King Sigismund once gave a ring to his mistress, the hero's mother, as a passport for entrance to the court. One day the royal parent wished to see his offspring, and the child's uncle received orders to bring it to the court. On his way thither, while traversing a piece of woodland, the man came to a clearing and sat down on the grass to repose himself, giving the precious ring, his token to the king, to the child as a plaything. Suddenly a raven swooped down from a tree, picked up the ring and flew away with it; but the man caught up a bow he had with him and sped a shaft after the bird, which fell dead to the ground with the ring still tightly held in its beak. When, in later years, the illegitimate child grew up and finally ascended the throne of Hungary, this event was figured on his coat of arms by the emblems of the raven and the ring.[9]

[9] Szendrei, " Catalogue de la collection de bagues de Mme. Tarnóczy," Paris, 1889, pp. xxvii, xxviii.

When the Constable Louis of Luxembourg was con-
demned to death in 1475, in the reign of Louis XI of
France, he drew from his finger a small gold ring set
with a diamond and requested the father confessor to
offer it to the image of Our Lady of Paris. Then,
turning to the Franciscan monk, Jean de Sordun, he
said: "Here is a stone I have long worn on my neck
and which I have greatly prized, for it resists poison,
and also protects against pestilence. I pray you to
take this stone for me to my son, to whom you will say
that I beg him to keep it for love of me." This touch-
ing mission was never fulfilled, for after the execution
of the Constable, the court ordered that the stone should
be given to King Louis. The diamond ring, however,
was duly dedicated to the image of the Virgin.[10] Of
Louis XI himself, the chronicler quaintly says: "Be-
fore his death he suffered much from various diseases
for the cure of which the physicians who attended him
concocted dreadful and wonderful medicines. May these
illnesses procure the salvation of his soul!"[11]

Some interesting historic rings are in the fine col-
lection of Dr. Albert Figdor, Vienna. One of them is
a gold ring believed to have belonged to Mary of Bur-
gundy, (d. 1482) daughter of Charles the Bold, and
wife of Maximilian I of Germany. On the ring is the
letter M formed of black diamonds, and the monogram
of the name Maria, in Gothic characters, appears twice
on its inner side. Two enameled gold rings of Empress
Eleonora, third wife of Ferdinand III of Germany

[10] Chroniques d'Engarrand de Monstrelet, Paris, 1596,
vol. ii, "Autres nouvelles chroniques," f. 55 recto. These "new
chronicles" are from various sources, and were composed by
one of the continuators of Monstrelet's work.

[11] *Ibid.*, f. 78 recto.

(1608-1657), are good examples of seventeenth century work. More interesting is a ring bearing miniature portraits of Emperor Mathias of Germany (1557–1619) and his wife Empress Anne.[12]

The first historical instance of writing with a diamond point concerns Francis I, who wrote, with the diamond of his ring, upon a pane of glass in the Castle of Chambord, the following oft-quoted lines:

> Souvent femme varie,
> Mal habile qui s'y fie.

The king " engraved " these lines in such a conspicuous place that they might be seen by his favorite, Anne de Pisseleu, Duchesse d'Estampes, and make it clear to her that his jealousy was aroused by her conduct.[13] The story runs that the celebrated sister of Francis, Marguerite de Valois, authoress of the Heptameron, who was on very friendly terms with the Duchesse d'Estampes, immediately capped this distich by writing with her diamond-point the following rejoinder: [14]

> Souvent homme varie,
> Bien folle qui s'y fie.

Brantôme, who relates that he saw the window-pane inscription of Francis I at Chambord, merely cites the first words: " Souvent femme varie," and as there is considerable lack of agreement as to the second line, this may have been added by those who reported the writing, according to their own idea of what a continua-

[12] Communicated by L. Weininger, of Vienna.

[13] See for original accounts Lettres inédites de la Reine Marguerite, pt. i; Brantôme, ed. Lalanne, vol. ix, p. 715 and also Bermier, Hist. de Blois, Paris, 1682, p. 8.

[14] Cyril Davenport, " Jewellery," Chicago, 1908, p. 126.

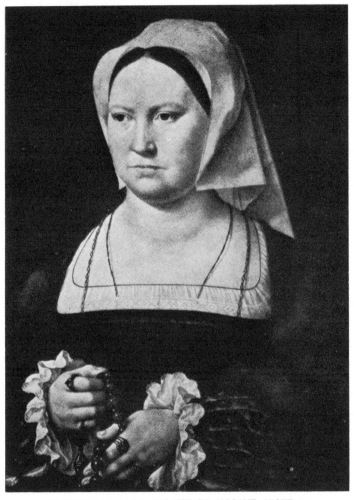

PORTRAIT OF A LADY. PAINTED IN COLOGNE, ABOUT 1526

Ring set with a pointed diamond on index of right hand, small ring on little finger of the same hand; two rings on index of left hand and one on fourth finger of the same hand; all set with precious stones

Königliche Gemälde-Galerie, Cassel

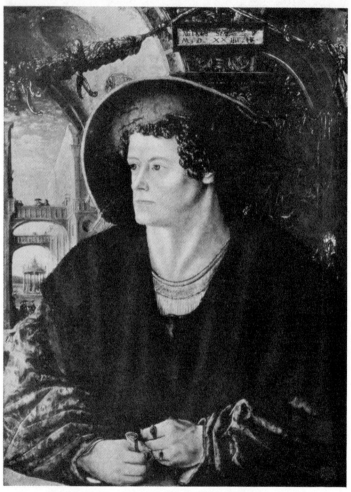

PORTRAIT OF A MAN, BY HANS FUNK, PAINTED IN 1523
Large seal ring on right hand forefinger and two on left hand, one on forefinger and one on fourth finger
Gallery at Basel, Switzerland

tion should be. There is a rather vague rumor that the glass was broken out by order of Louis XIV, the fact being that it is no longer in existence and evidently disappeared at least a couple of centuries ago.[15]

A ring set with a pyramidal diamond, one of the type used by Francis I on this occasion, is shown in the Londesborough Collection. This ring, which dates from the sixteenth century and is of Italian workmanship, is known as a " tower ring," possibly because those confined in the Tower of London were able to use such rings for writing names or verses upon the window-panes of their prison.[16]

Still another story of diamond-point writing, probably even less well attested than the anecdote of Francis I, is that referring to Queen Elizabeth and Sir Walter Raleigh.[17] On the occasion of an interview with the wily queen, Sir Walter, rather distrustful of the royal encouragement accorded him, is said to have gone to a window in the royal audience chamber and written on the window-pane with his diamond ring:

Fain would I climb, but that I fear to fall.

For answer the queen scratched beneath this the following admonition, at once an encouragement and a warning:

If thy heart fail thee, do not climb at all.

An eighteenth century instance of diamond-point writing on a pane of glass was reported in an old news-

[15] Theodore Andrea Cook, " Old Touraine," New York, 1895, p. 195.

[16] Catalogue of a collection of ancient and mediæval rings and personal ornaments, London, 1853, p. 15. Privately printed.

[17] Cyril Davenport, " Jewellery," Chicago, 1908, p. 127.

paper.[18] A celebrated English beauty of the eight-
eenth century, while sojourning at the famous English
watering-place, Bath, wrote on a window-pane the
following impromptu lines:

> In vain, in vain is all you've said,
> For I'm resolved to die a Maid.

In answer to this a gentleman of her acquaintance
cut this rejoinder, the idea being better than the rhyme:

> The Lady who this resolution took,
> Wrote it on Glass to show it might be broke.

The visitor who relates this states that on returning
to Bath at a later time, he found that the window-pane
had been removed, and a new one substituted. Did this
mean that the vow had been broken?

The use of rings set with natural diamond-points in
a symbolical sense, as in the case of the three interlaced
rings forming the *impresa* of Cosimo de' Medici, prob-
ably had to do with the ancient tradition that the
diamond conferred courage or even invincibility upon
the wearer. It is in this sense that this type of ring is
figured on the reverse of certain " campaign medals "
issued in commemoration of important expeditions.
Such is the medal struck for Henri II of France when,
in 1554, he set out from Champagne to invade Flanders.
On the reverse of this medal there is within the ring a
palm branch and an olive branch, significant of an un-
conquerable soul and of victory. Across the bottom of
the hoop is a fish of a species very common in Flanders,
on the head of which is a crown, this apparently denot-
ing the ruler of that land. The diamond emphasizes

[18] S. D. C. in *The Boston Chronicle*, Feb. 17, 1769, from
a copy in the Union League Club Library, New York City.

MEDAL SHOWING RING, STRUCK IN 1578 FOR JOHN
CASIMIR, COUNT PALATINE, TO COMMEMORATE HIS
ALLIANCE WITH THE DUKE OF ANJOU AGAINST THE
SPANISH IN THE LOW COUNTRIES
The clasped hands signify indissoluble friendship; the palm and olive
branches, victory and peace; and the diamond, courage

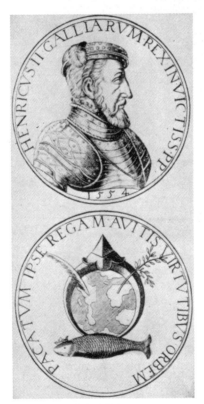

MEDAL SHOWING RING, STRUCK FOR
HENRI II OF FRANCE, IN 1554, IN
COMMEMORATION OF HIS CAMPAIGN
TO FLANDERS
The diamond is a symbol of dauntless courage;
the crowned fish probably denotes the ruler of
Flanders; the palm branch and olive branch above
signify the French King's victory

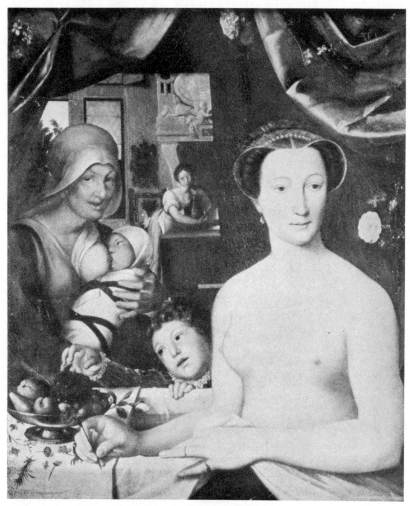

PORTRAIT OF DIANE DE POITIERS (1499–1566)

Mistress of Henri II of France, who gave her the splendid Château de Chenonceaux. She had great artistic taste and possessed many jewels. To her ability, knowledge and power were due some of the finest architectural and mobiliary achievements of the period

Musée de Versailles

the idea of an unbroken and unconquered soul. In a similar though slightly different sense must be explained the diamond-set ring on a " campaign medal " struck in 1578 for John Casimir, Count Palatine; this is also a memorial of one of the periodical incursions into unhappy Flanders. As the Count Palatine was at this time in alliance with the then Duke of Anjou, brother of Henri III of France, the hoop of the ring terminates in two clasped hands, denoting the fast friendship of the allies, which was, however, of very uncertain duration.

The rich Arundel Collection, chiefly brought together by a Lord Howard of Arundel, towards the end of the seventeenth century, incorporated in the Marlborough Cabinet and later dispersed, included a beautifully adorned gold ring set with a splendid lapis lazuli on which a Roman engraver had cut the design of Hercules wrestling with Antæus. The hoop of this ring is ornamented on the inside with two fleur-de-lys in white enamel, the entire ring being covered with arabesques of entwined vine branches in black enamel. In his description, Rev. C. W. King conjectures from the style of ornamentation that the ring may have belonged to one of the Valois kings of France.[19]

On the accession of Frederick the Great, he is said to have found in the royal treasury a case containing a ring, accompanied by a memorandum to the following effect, in the handwriting of King Frederick I (1688–1740) : " This ring was given to me by my father on his deathbed, with the reminder that so long as it was preserved in the House of Brandenburg, this would not

[19] C. W. King, " Notices of Collections of Glyptic Art exhibited by the Archæological Institute in June, 1861," pp. 20, 21 ; reprint from Archæological Journal.

only prosper, but would grow and increase." The way
in which Frederick the Great spoke of this ring illus-
trates at once his habitual scepticism and his devotion
to family tradition, for while declaring that he put no
faith in the peculiar virtues of such an object, he gave
strict injunctions that it should be carefully preserved.
A rather doubtful tradition designates this ring as the
one said to have been surreptitiously removed from the
hand of Frederick William I, when he was dying, by
the Countess Lichtenau. The dying king feebly
protesting against this spoliation, murmured: " Her den
Ring " (Give back the ring), but the countess saved
the situation by saying to those assembled in the death-
chamber: "He wants to have a herring!" This same
tradition attributes the subsequent disastrous defeat of
Prussia by Napoleon I to the loss of the ring, which the
countess finally yielded to Frederick William III in
1813, whereupon the fortunes of war changed and
Prussia was avenged for her humiliations.

Hofrath Schneider, for a long time reader to Em-
peror William I, relates that when he questioned that
monarch touching the story of the ring, he only learned
that it had been a long time in the Hohenzollern family;
that it was an old-fashioned ring, and that it was set
with " a plain, dark-colored stone." Emperor William
did not display much interest in the matter and did not
appear to have any superstitious reverence for the ring.[20]

An old Portuguese ring has a half-sphere of rock
crystal set in silver. At the side of the bezel is a minute
catch, and when this is put back, the crystal setting,
hinged on the opposite side, can be raised, revealing
beneath a tiny St. Andrews cross in gold, with a small

[20] See Schneider, "Aus dem Leben Kaiser Wilhelms," Berlin,
1888, vol. i, pp. 154–161.

ruby set in the centre. This ring is in the possession of
an Englishman, a descendant of the Duke of Peter-
borough who fought in the Peninsula War under Wel-
lington. In one of the battles he was seriously wounded,
and was kindly and carefully nursed by a Portuguese
family. A not unnatural result was that he fell in
love with one of the daughters and married her. The
ring is said to have formed part of her ancestral jewels,
and this may be regarded as a characteristic example
of the Portuguese art of the past in ring-making.[21]

A gold ring, said to be one of six made for distribu-
tion among the conspirators who planned Napoleon's
escape from Elba in March, 1815, is to be seen in the
British Museum. The bezel has a hinged lid, on the
inner side of which is engraved in relief the head of
Napoleon; on the outer side is an enamelled design
showing three flowers on stems, a laurel wreath running
around the edge.[22] Whether the story of its having
belonged to one of the conspirators be true or not, the
concealment of the Napoleon head shows that this ring
was made for, and worn by, an adherent of the fallen
emperor, at a time when it would have been dangerous
to proclaim his loyalty openly.

ENGLISH RINGS

In the British Museum are two Anglo-Saxon rings
of unrivalled historic interest. They bear, respectively,
the names of Ethelwulf, father of Alfred the Great and
of Ethelswith, his sister, the queen of Mercia. Both of

[21] Communication by Mrs. Isabel Moore, formerly of Wood-
stock, N. Y., now in the Azores.

[22] O. M. Dalton, " Franks Bequest, Catalogue of the Finger
Rings, Early Christian, Byzantine, Teutonic, Mediæval and
Later (British Museum)," p. 206.

these rings are of gold. In that of King Ethelwulf the flat hoop rises in front in the form of a high mitre-shaped bezel showing the design of a conventional tree flanked by two peacocks; the ground-work is of niello. The nielloed legend around the hoop reads: E T H E L - W V L F . R E X. This ring was found in a cart-rut at Laverstock, Wiltshire, in the summer of 1780. The ring of Ethelwulf's daughter, Ethelswith, has a circular bezel with the figure of the Lamb of God; here also the design is chased on a niello ground. On each shoulder of the ring is figured a monster on a similar ground-work. The inscription, engraved inside the ring runs: E A D E L Z V I D . R E G I N A. Ethelwith's ring was found in the West Riding of Yorkshire, between Aberford and Sherburn, and was tied to a dog's collar by the farmer who discovered it. For this ignoble use it served during some six months until, to his surprise, the farmer learned that his ring was of gold.[23]

The famous ring known as that of Edward the Confessor (1024–1066),[24] and which was to be used as the Coronation Ring of the Kings of England, was granted on November 14, 1389, by King Richard II, to the Abbot, etc., of Westminster, for the shrine of the Confessor in this church. It is described as " a certain ring with a precious ruby inserted therein." The King reserved the privilege of wearing it when he was in England, but should he go abroad it was to be returned to

[23] O. M. Dalton, " Catalogue of the Finger Rings, Early Christian, Byzantine, Teutonic, Mediæval and Later, Bequeathed by Sir Augustus Wollaston Franks, K.C.B. (British Museum)," London, 1912, pp. xvi, 29, 30, pl. ii(Nos. 179, 180).

[24] See pp. 342, 343, in chapter on Rings of Healing.

the shrine. A few years later the Abbot of Westminster appears to have been guilty of some negligence in sending this ring to the sovereign when the latter required it for use, and the repentant abbot craves pardon of the king and prays that his fault shall not invalidate the church's rights to the possession of the relic. Nearly eighty years later, a record dated December 21, 1468 (7 Edward IV) registers the delivery by the former keeper, Thomas Arundell, of the vestments, cloths, relics and jewels of the Shrine of St. Edward in Westminster to his successor, Richard Tedyngton.[25]

The jewels and precious stones of this shrine were taken away and pawned by Henry III in 1267, the monarch having entered into a solemn engagement, under the Great Seal, to return them in a year's time from the ensuing Michaelmas. Henry also sent to the then Abbot of Westminster a "Letter Obligatory" promising the restitution of the gems and submitting himself in the matter to the judgment of the Pope and the Papal Legate. The precious jewels were really restored to the Abbey shortly afterwards, as is shown by a document dated February 10, 1269 (53 Henry III). The ruby ring, being a later gift, could not have been among them.[26]

A contemporary entry referring to this shrine in Edward I's time (1272–1307), is interesting as casting a sidelight on the English coinage at the end of the thirteenth century. Under date of 1299, provision is made for returning to the church of Westminster the

[25] Fourth Report of the Royal Commission on Manuscripts, London, 1874, p. 191.

[26] Idem., *loc. cit,*

half of 38 marks of gold (about \$9,500 intrinsic value) that had been taken from the shrine of St. Edward for the jewels sent to Queen Margaret on her first coming to Westminster, " the coinage being so debased and real sterlings rarely found." [27]

The cross on the summit of the Imperial State Crown of England, as described by Prof. Tennant, is surmounted by a rose-cut sapphire. There is a tradition that this sapphire was once set in the ring of Edward the Confessor, a ring which, according to popular belief, was endowed with wonderful curative virtues, and gave its successive owners the power to consecrate the so-called cramp rings.[28] This attribution of the sapphire is in disagreement with the early notice of the ruby ring given to Westminster Abbey by Richard II as that of the saintly Edward, and also to the usage long observed of setting a ruby in the Coronation Ring. King, in his account of Edward's ring, calls attention to an entry in the inventory of Henry III's jewels describing a sapphire weighing 52 dwts (about 337 metric carats), and suggests that this may be the large sapphire of the English crown.[29]

When Pope Hadrian IV (1154–1159) acknowledged the sovereignty of Henry II of England over Ireland, he sent to the monarch by John of Salisbury, the messenger who bore the Brief of Investiture, a valuable ring set with an exceptionally fine emerald. This historical fact probably suggested the name Emerald Isle as a designation for Ireland. The ring and the

[27] *Idem, loc. cit.*

[28] See pp. 341–345.

[29] King, " Precious Stones and Metals," London, 1870, p. 319, note.

Brief were carefully guarded in the royal archives at the time John of Salisbury wrote his recital.[30]

During the crusade which brought into martial rivalry two of the most romantic figures of history, Richard Cœur de Lion and Saladin, an English knight, Sir William D'Annay, killed a Saracen prince, in 1192, and not long afterwards vanquished a lion near the ancient Syrian city of Acre, later known as St. Jean d'Acre, as it was placed under the care of the knights of the Order of St. John. As a special and appropriate offering to King Richard, Sir William brought him a paw of the slain lion, and received from the king as a recognition of the bravery he had displayed a ring from the royal finger. The knight was also directed to bear on his crest a " demi Saracen " holding in one hand a lion's paw and in the other a ring, so that the memory of the gallant deeds and of the royal recompense should never be forgotten. In 1856 this ring was in the possession of Dawnay, Viscount Downe, a lineal descendant of the crusader, who still bore the crest assigned by Richard Cœur de Lion.[31] The ring is of silver and is set with a so-called toadstone, the palatal tooth of a ray, famous in mediæval times as a talisman against poison.[32]

[30] O. M. Dalton, " Catalogue of the Finger Rings, Early Christian, Byzantine, Teutonic, Mediæval and Later, Bequeathed by Sir Augustus Wollaston Franks, K.C.B." (British Museum), London, 1912, p. xiii.

[31] Hon. R. C. Neville (4th baron Braybrooke), " The Romance of the Ring, or the History and Antiquity of Finger Rings," Saffron Walden, 1856, p. 19.

[32] On the toadstone, see the present writer's " The Magic of Jewels and Charms," Philadelphia and London, 1915, pp. 162–167.

Pope Innocent III (1198–1216) sent to Richard Cœur de Lion four gold rings, each set with a different stone. With the rings, the pope sent a letter from St. Peter's in Rome, dated May 28, 1198, in which he wrote that the four stones were symbolical. The verdant hue of the emerald signified how we should believe, the celestial purity of the sapphire, how we should hope, the warm color of the garnet, how we should love, and the clear transparency of the topaz, how we should act. Moreover, the ring-form also possessed a symbolical meaning, roundness denoting eternity, which has neither beginning nor end. Hence the royal conscience had in the ring a monition to pass from terrestrial to celestial matters, from temporal to eternal things.[33]

In the ruins of the palace at Eltham in Kent was found a gold ring set with an Oriental ruby surrounded by five diamonds in their native crystalline state, placed at equal distances from one another. This ring weighed over half an ounce (exactly, $267^1/_{10}$ grains) and bore the following inscription in Old French:

> Qui me portera expliotera
> Et a grant joye revendra.
>
> (Whosoever weareth me will do doughty deeds,
> And will return filled with joy.)

This motto is believed to indicate that the ring had been given to a Crusader to wear on his expedition for the rescue of the Holy Land from the hands of the infidels. That it should have been found on English soil seems to be proof that the wearer returned safely to his native land.[34]

In 1774, after long and urgent solicitation, the Dean

[33] Migne's Patrologia Latina, vol. ccxiv, cols. 179, 180.
[34] Archæologia, vol. xix, London, 1821, pp. 411, 412.

of Westminster, Dr. John Thomas, later Bishop of
Rochester, consented to the opening of the tomb of
Edward I of England (1272-1307) and the disinter-
ment of his body. The corpse was found closely wrapped
in coarse, thick linen cloth, the face being covered
with a face-cloth of crimson sarcinet.[35] The features
were still in great part well-preserved though the skin
was dark brown, almost black. The monarch had been
clothed with royal vesture and royal insignia, but no
ring was found on either of the hands. The disinterment
of King Canute's body, however, resulted in the finding
of a ring set with a large and fine stone, of what par-
ticular kind we are not informed.

When, in 1562, the iconoclastic Calvinists of Caen
broke open the tomb of Matilda, wife of William the
Conqueror, in the Abbey of the Holy Trinity, there
was still to be seen on one of the queen's fingers a gold
ring set with a fine sapphire. This was yielded to the
Abbess, of the house of Montmorency, who later gave it
to her father, the famous constable of France, Anne de
Montmorency, when he attended Charles IX on the
latter's visit to Caen in the following year. The tomb
of William Rufus, the Conqueror's son, in Winchester
Cathedral, was opened in the reign of Charles I, and
in the dust of the king lay a large gold ring. So cus-
tomary was it at this period to have a royal ring interred
with the sovereign's body, that even when Richard II
left special directions in his will that the crown and
sceptre to be buried with him should not be enriched
with any precious stones, he expressly ordered that a

[35] A fine, thin silk stuff, plain, but especially valued for its
softness.

ring set with a precious stone and worth 20 marks should be put on his finger.[36]

When, in 1360, the Earl of Richmond married the Lady Blanche, daughter of the Duke of Lancaster, King Edward III gave as presents a ring with a ruby and a belt garnished with rubies, emeralds and pearls.[37] The rubies may have been considered especially appropriate, since the red rose was the emblem of the House of Lancaster. More than a century later, in the reign of Henry VII, when Perkin Warbeck utilized his striking resemblance to Edward IV in support of his claim that he was one of the princes slain in the Tower, in 1483, by order of Richard III, and succeeded in persuading Edward's sister, Margaret, and also King James IV of Scotland, of the truth of his pretensions, one of his rural agents in England was called in the conspirators' correspondence "The Merchant of the Ruby," a designation designed to cast off possible suspicion by representing the agent to be only a gem dealer.

There still exists in the English records a paper dated in 1445, the year of Margaret of Anjou's marriage, and signed by King Henry VI. In this the king directs that a warrant of discharge be given to "our Trusty and Wellbeloved Squire John Merston, Tresorier of our Chambre and Keper of our juwelles," for sundry jewels which had been confided to his care. The following item refers to the ring of Margaret of Anjou: [38]

[36] Sir Joseph Ayloffe, "An Account of the Body of King Edward the First As It Appeared in the Tomb in the Year 1774," Archæologia, vol. iii, London, 1775, pp. 389–391. See also Rhymer's "Foedera," vol. viii, p. 75.

[37] "Issues of the Echequer," from Henry III to Henry VI, ed. by Frederick Devon, London, 1837, p. 170.

[38] Rhymer, "Fœdera," London, 1727, vol. xi, p. 76.

"A Ryng of Gold, Garnished with a fayr Rubie, somtyme Yeven unto Us by our Bel Oncle the Cardinal of Englande, with the which we were Sacred in the Day of oure Coronation at Parys, delivered unto Mathew Phelip, to Breke, and thereof to make an other Ryng for the Quenes Wedding Ring."

There is no mention here of any engraving on the stone of this ring, which had been used in 1431, when Henry VI was crowned in Paris. If the spinel in the Marlborough Collection, engraved with a head somewhat resembling that of Henry VI on his coins, really adorned this ring, the engraving may have been executed subsequent to Henry's marriage with the unfortunate Margaret of Anjou.

Rings set with precious stones were given as prizes at the tournament held by Henry VII of England in 1494. The prize for jousting was to be a ruby ring, while the best in the tourney and the one delivering the most telling strokes was to be rewarded with a diamond ring. The Earl of Suffolk, Thomas Brandon, who later married King Henry's daughter Margaret, after the death of her first husband Louis XII of France, was successful in gaining one of the ruby rings, bestowed upon him by the "Ladie Margaret," his future wife, and Sir Edward A. Borough fought so stoutly in the mêlée that he was adjudged worthy of a diamond ring. An extra prize of an emerald ring was given to the Earl of Essex for his valor.[39]

In 1681 the Duke of Norfolk presented to the College of Arms in London the sword, dagger, and ring worn by James IV of Scotland (1473–1513) at the battle of Flodden Field, fought August 22, 1513, in

[39] William Jones, "Finger-Ring Lore," London, 1877, p. 197.

which he met his death. This ring was set with a turquoise and had been sent to James by the queen of France, as a pledge of friendship and regard, when she solicited the good offices of the Scottish monarch with Henry VIII, who had just laid siege to Térouanne. Another account states that when the queen sent the ring to James, she charged him to break a lance for her sake. This ring is said to have been taken from the body of King James by Thomas, Duke of Norfolk, an ancestor of the donor.[40] The belief that the turquoise protected those who wore it from falls and wounds, probably determined its selection, but the result in this case was hardly calculated to increase the stone's prestige.

On the site of this disastrous defeat of the Scotch by the English army under the Earl of Surrey, an inscribed ring was found in 1783. The inscription, in Norman French, reads: " On est mal loiauls amans qui se poet garder des maux disans " (Only a lover of scant loyalty can escape calumny). The words are disposed in groups of two, and between each pair is a boar's head, the crest of the Campbells. This has led to the conjecture that the ring belonged to the second son of the Duke of Argyll, Archibald Campbell, who met his death in the forefront of the fight.[41]

At the spoliation of the tomb of St. Thomas à Becket at Canterbury in 1538, among the precious objects taken away was "[a stone with] an angel of gold pointing thereunto, offered by the King of France: [which King Henry put] into a ring and wore it on his thumb." This jewel, containing a diamond, was the

[40] Archæologia, vol. xxxiii, p. 335 *sqq.*, London, 1849.

[41] William Jones, " Finger-Ring Lore," London, 1877, p. 478.

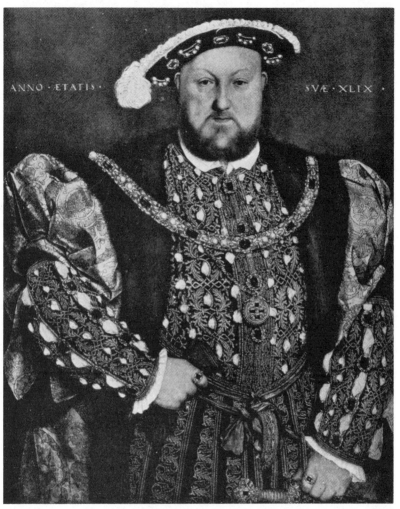

ANNO · ÆTATIS · SVÆ · XLIX ·

PORTRAIT OF HENRY VIII, BY HANS HOLBEIN, PAINTED IN 1540
Rings of identical form and setting on index fingers of each hand and on little finger of left hand.
These are designed to match exactly the jewels on his collar and sleeves
Reale Galleria d'Arte Antica, Palazzo Corsini, Rome

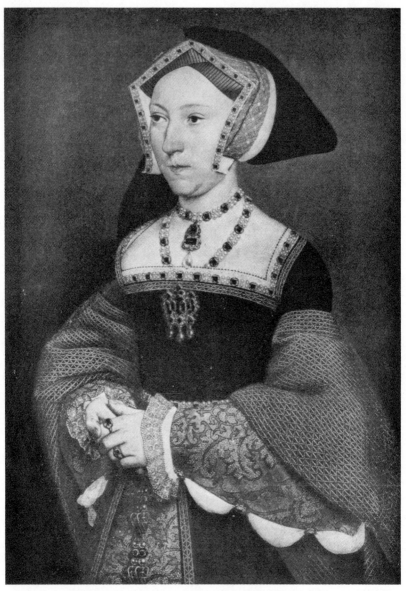

PORTRAIT OF JANE SEYMOUR (CA. 1510–1537) THIRD WIFE OF HENRY VIII, AND MOTHER
OF EDWARD VI, BY HANS HOLBEIN, THE YOUNGER
Rings set with precious stones on index and fourth fingers of left hand
Kaiserliche Gemälde-Galerie, Vienna

most prized ornament of the shrine, and is believed to have been given by Louis VII of France on the occasion of his visit in 1179. Henry VIII must have tired of his massive thumb ring, for in the inventory of the precious stones delivered to Queen Mary, March 10, 1554, shortly after her accession, there appears the following entry: "A collar of golde set with sixteen faire diamounts, whereof the Regal of France is one, and fourteen Knotts of perles, in every Knotte four perles.[42]

Two pretty New Year's gifts for January first, 1571, were delivered to Lady Mary Sidney on the last day of the year 1570. One of them was a ring " set with a rose "; the other was more ambitious in design, being described as " a jewell with the storie of time " set with diamonds and rubies, certainly an appropriate gift for the day. This cost but £10 or $50, a much larger sum, however, in those bygone days than it is accounted to be to-day, for the purchasing power of money was many times greater.[43]

The earliest mention of the diamond ring given by Elizabeth to Mary Queen of Scots occurs in Camden's account of the events of Elizabeth's reign. After relating the events that determined Mary to seek Elizabeth's protection, Camden continues:

She therefore sent John Beatoun to her [Elizabeth] with the diamond she had formerly received from her as a symbol of mutual good-will, signifying to her that she was about to come to England and ask for aid in case her subjects continued to make war against her.[44]

[42] Gasquet, " Henry VIII and the English Monasteries," London, 1906, p. 409. Cott. MS. Tib. e. viii, f. 269.

[43] Third Report of the Royal Commission on Historical Manuscripts, London, 1872, p. 231.

[44] Camdeni, "Annales rerum Anglicarum et Hibernicarum regnante Elizabetha," Francofurti, 1616, pp. 151, 152.

This is said to have been a gimmal-ring, two dia-
monds joining together to form a heart. One half was
kept by Elizabeth who gave the other half to Mary.
This appeal to the tender mercies of the Virgin Queen,
and Mary's hope, were in vain, for " she cutt off her
head for all that " as Aubrey dryly puts it.[45]
Several epigrams on this diamond were written by
the Scotch poet and publicist George Buchanan (1506–
1582), the best being as follows: [46]

> Quod te jampridem fruitur, videt, ac amat absens,
> Haec pignus cordis gemma, et imago mei est.
> Non est candidior, non est haec purior illo,
> Quamvis dura magis, non magis firma.

This has been rendered:

> The gem which saw thee near and loves thee still,
> Is pledge and image of my heart and will.
> My heart is not less white or pure than this,
> And though less hard, 'tis quite as firm I wis.

A memorial ring was sent by Mary of Scotland, just
before her execution at Fotheringay Castle, February 8,
1587, to her faithful follower and kinsman, Lord John
Hamilton, with an affectionate message and her last
farewell. This ring, set with a sapphire, was handed
down from generation to generation in the Hamilton
family, and was seen, in 1857, at Hamilton Palace, by
Miss Agnes Strickland. She described the sapphire as
being large, of rectangular form, and cut with a number
of facets, a kind of rose-cutting; the setting was of blue
enamelled gold in the style favored by sixteenth century

[45] In Thoms' "Anecdotes and Traditions," London, 1839,
p. 107 (Camden Soc. Pub.).

[46] Buchanan, " Poems," St. Andrews, 1594, p. 117.

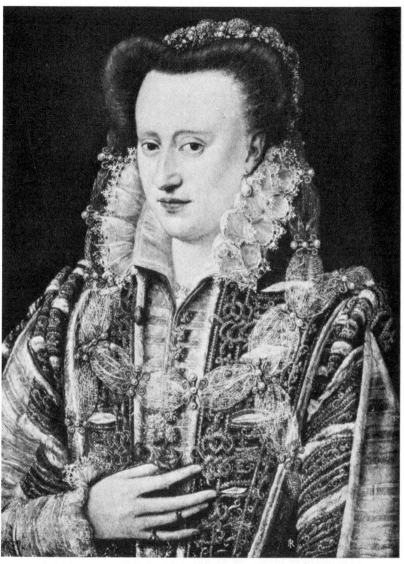

PORTRAIT OF MARY, QUEEN OF SCOTS (1542–1587). FRENCH SCHOOL
Rings on the second joint of fourth finger of right hand, and on little finger of the same hand
Museo del Prado, Madrid

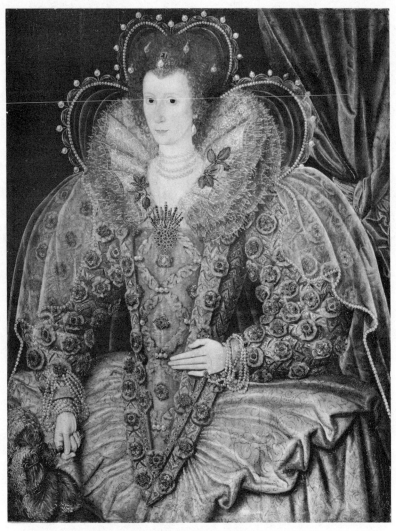

PORTRAIT OF QUEEN ELIZABETH, BY THE FLEMISH PAINTER LUCAS DE HEERE
On little finger of left hand, ring set with a large, oblong, table-cut stone
Metropolitan Museum of Art, New York

goldsmiths.[47] It might be looked upon as a noteworthy coincidence, that as a sapphire was a memorial of Mary's death, another sapphire was the token to her son, James I, of Elizabeth's death and his accession to the throne of England.

On the night before her execution, Mary Stuart found an opportunity to ask her apothecary, a Monsieur Gorion, whether he could safely convey a letter and two diamonds to those for whom they were intended, and whether he would promise to perform this service faithfully. He assented, saying that he could make some drug in which the objects might be safely concealed, so that he could carry them away with him. One of these diamonds was to be given to Mendoza, for a long time Spanish ambassador to the court of Elizabeth; the other, and larger one, was destined for Philip II of Spain. This was to be received as " a sign that she was dying for the truth, and was also meant to bespeak his care for her friends and servants." [48]

Of rings which have been treated as sacred relics, none can be said to recall a more painful tragedy than one donated to the monastery-church of the Escurial. On April 15, 1587, the Spanish king Philip II had a nocturne and a requiem sung in the church in memory of the unfortunate Mary of Scotland. When the echoes of the solemn chants had died away, the king gave to the abbot a ring set with a diamond which had belonged to the unhappy victim, with the injunction that it should be placed among the sacred relics and preserved as " a symbol of the purity and the firm faith of this saintly

[47] Agnes Strickland, " History of Mary, Queen of Scots," London, 1873, vol. ii, p. 446.

[48] James Anthony Froude, " History of England," London, 1899, vol. xii, chap. 69, pp. 248, 249.

queen." [49] This ring, or at least the large diamond of its setting, must have been the farewell gift which we have just noted.

Although not a betrothal ring, that given by Queen Elizabeth to the Earl of Essex was most certainly a love token. When this nobleman was high in the queen's favor she bestowed upon him a gold ring set with a sardonyx cut with her portrait; giving him, at the same time, a solemn promise that whatever charges might be brought against him she would accord him her pardon if he sent her this ring. Some years later, Essex—who in the meanwhile had lost the queen's favor—was impeached for high treason and condemned to death. In this extremity, he endeavored to find some means of transmitting to the queen the ring she had given him. Fearing to trust his keepers with the execution of his wish, Essex found no better way than to throw the ring to a boy who was passing the prison, directing him to give it to Lady Scrope, Lady Nottingham's sister. Unfortunately for Essex, the boy gave the ring, by mistake, to Lady Nottingham, whose husband was one of his bitterest enemies, so that the token never reached the queen, who was convinced that her former favorite was too proud and obstinate to seek her mercy. She thereupon left him to his fate. Years afterwards, when Lady Nottingham was on her death-bed, she asked for the queen and confessed that she had failed to deliver the ring sent to her by Essex. This confession aroused the queen's wrath to such an extent that she burst forth in violent reproaches and rushed from the room exclaiming: "God may forgive you; I never shall!" The proud heart of the virgin queen was broken by this

[49] C. Justi, " Felipe II amigo del arte "; España moderna, April, 1914, pp. 26, 27.

Gold ring set with an oval cameo-portrait, on onyx, of Queen
Elizabeth. Sixteenth Century. Two views
British Museum

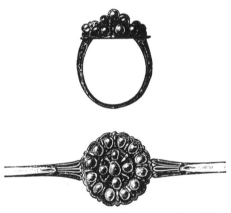

Gold ring set with pearls pierced and threaded; two views.
Venetian (?) late Seventeenth Century
British Museum

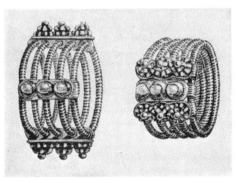

Multiple silver rings. Four hoops connected by three ver-
tical bars; one of these is set with two corals and a glass paste.
North African (?)
British Museum

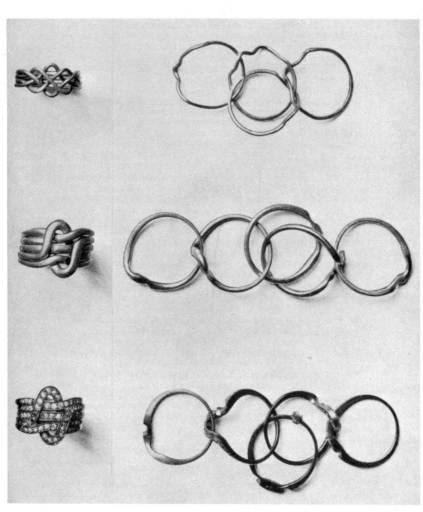

PUZZLE OR MAGIC RINGS, PLAIN AND JEWELLED

revelation, and, weighed down by remorse for the death of Essex, she expired a few weeks later.

Quite recently this historic Essex ring has found its way to the auction-room, and to judge from the price it brought, the purchaser must have been convinced of the truth of the legend concerning it, as its merely artistic qualities—which are in no wise remarkable—and the fact that it is incidentally a product of sixteenth century art would scarcely suffice to justify the amount paid for it. The sale took place at Christie's in London, on May 18, 1911, and after spirited bidding the ring was adjudged for $17,060. A firm of dealers in antiquities were the nominal purchasers, but they are said to have acted for Lord Michelson of Hollingly, a baron in the lately overthrown Kingdom of Portugal, and the senior partner in the firm of Stern Bros., of London. This ring is stated to have been bequeathed by mother to daughter in a long line of Essex's descendants, beginning with his daughter Lady Francis Devereux. Finally it came to Louisa, daughter of John, Earl of Greville, and wife of Thomas Thyme, second Viscount Weymouth and great-grandfather of the late owner.

Some authorities do not think that the story of the Essex ring has a satisfactory historical foundation.[50] It first appears in a book published about 1650 and entitled " History of the most renowned Queen Elizabeth and her great Favourite, the Earl of Essex. In Two Parts. A Romance." In 1658 Francis Osborn repeats it in his " Traditional Memoires of Elizabeth." It was even treated dramatically by John Banks (fl. 1696) in his play " The Unhappy Favourite." Certain later writers claim to have learned of it through trustworthy

[50] See Dictionary of National Biography, vol. xiv, London, 1888, pp. 437, 438; in Sir Sidney Lee's article on Essex.

informants, as for example, Louis Aubery, Sieur de Maurier, who published in Paris, in 1680, a history of Holland and therein states that Sir Dudley Carleton told the story to Prince Maurice of Saxony. In the English translation of this work the episode has been omitted. Still later, at the end of the seventeenth century, it is given by Lady Elizabeth Spelman on the authority, as she alleged, of Sir Robert Carey, brother of Lady Scrope. In earlier versions the ring was represented to have been sent directly by Essex to Lady Nottingham; in Lady Spelman's recital, however, as we have already noted, Essex instructs the boy to whom he entrusts the ring to deliver it to Lady Scrope, sister of Lady Nottingham. It is suggested that this variation was made to offset the objection that Essex would never have chosen his enemy, Lady Nottingham, as an intermediary between himself and the queen. Manningham, in his "Diary," the only contemporary who alludes to a ring in connection with Essex's relations with Elizabeth, only states that "the queen wore till her death a ring given her by Essex." Possibly this fact may have served as a nucleus for the romantic tale.

A portrait of Queen Elizabeth, elaborately bepearled as usual, the work of the Flemish painter, Lucas De Heere, shows her with a ring on the little finger of her left hand. It is set with an oblong, table-cut stone. This interesting portrait, which is in the Metropolitan Museum of Art, New York, while conforming generally to the type with which we are familiar, differs in some respects therefrom. The very slender neck, the delicacy of form and face, may, of course, represent mannerisms of the artist.

The sapphire set in the ring thrown out of the window of Queen Elizabeth's death chamber by Lady

Scrope to her brother Robert Carey, as a signal that
the queen was dead, so that he might be the first to bear
the news to her impatient successor, James I, was ex-
hibited in the great Loan Exhibition of Ancient and
Modern Jewellery shown at the South Kensington
Museum in London, in 1872. As there shown, this
historic sapphire was the central ornament of a dia-
mond star, or cinque-foil. The original ring was given
to John, Earl of Orrery, by the Duchess of Bucking-
ham, natural daughter of James II, and the small
brilliants surrounding it in its present setting are the
same as those which were about it in the ring.[51]

By the terms of his will, dated December 18, 1630,
Sir Edward Coke, of Godwick, bequeathed among other
jewels two of historic significance. One of these was
a ring " set with a great Turkey (turquoise), which
King Henry the Eighth used to wear, and was painted
with it on his forefinger." The other jewel, also a ring,
is curiously suggestive when we recall that an attempt
(unsuccessful, of course) had been made to poison the
unfortunate Sir Thomas Overbury with diamond dust,
before poison of a more effective sort was administered
to him. The ring in question is described here as set
with " a Diamon cut with faucetts (facets)" and the
statement is added that it had been given to Sir Edward
by Anne of Denmark, Queen of James I, " for the
discovery of the poisoning of Sir Thomas Overbury." [52]

A gold ring, said to have been one of five such rings
given by Charles I to Bishop Juxon, on the scaffold,
just before the king's execution, was shown in the Loan

[51] Catalogue of the Loan Exhibition of Ancient and Modern
Jewellery and Personal Ornaments, 1872, London, 1873, p. 33,
No. 137.

[52] Historical Manuscripts Commission, Report of MSS. in
various collections, vol. iv, Dublin, 1907, p. 323.

Collection exhibited in the South Kensington Museum, in London, in 1872. The statement is made that this ring was presented by Bishop Juxon to Sir John Halloway, and from him passed into the possession of the Dalby family. The ring bears a death's head in white enamel on a black ground, and has the motto, " Behold the ende "; around the edge is the inscription, " Rather death then fals fayth "; at the back are the initials " M " and " L," tied with a mourning ribbon.[53]

The " Verney Ring," with a portrait of Charles I of England, is, if genuine, the only relic of a heroic tragedy. It is said to have been bestowed by Charles I upon Sir Edmund Verney, one of his most faithful followers in the perils of the Civil War. Sir Edmund was killed at the battle of Edgehill, in 1642, where the Cavaliers were utterly defeated, but even in death he still held the royal standard in his grasp. The ring was taken from his hand, and the body abandoned; it was never recovered. As he was helped into the world by a Cæsarean operation, it became a common saying in the neighborhood of Edgehill that Sir Edmund was neither born not buried.[54]

With that striking indifference to moral right and wrong so characteristic of Charles II of England, he did not hesitate to bestow a choice ring from his own hand upon the notorious Jeffreys, when the latter was leaving London on one of his circuits always marked

[53] South Kensington Museum: Catalogue of the Loan Collection, 1872; London, 1873, p. 72, No. 838. The ring is figured in the *Gentleman's Magazine* for 1797, vol. lxvii, pt. ii (Oct.), on plate opposite p. 827, figs. 5 and 6; see also pp. 830 and 1017.

[54] Catalogue of the Special Exhibition of Works of Art at the South Kensington Museum, June, 1862," section 33, " Miscellaneous Rings," by R. H. S. Smith, p. 637.

by the browbeating of witnesses and accused, and the imposition of capital sentences, wherever possible. It was at a somewhat later date, in 1685, just after the accession of James II, that Jeffreys conducted the trials of the unfortunate Duke of Monmouth's adherents, which came to be known as the " Bloody Assize." This fact of the presentation was published in the Royal Gazette, thus notably strengthening Jeffreys' prestige. So general, however, was the reprobation of his heartless and bloodthirsty administration of his judicial office that the ring was called " Jeffreys' blood-stone." [55]

In March, 1748, as some ploughmen were tilling a field seven miles from Mullingor, County Westmeath, Ireland, they discovered a grave, the bottom, sides and ends of which were formed each of a single slab of stone. Within the grave were the bones of a man of gigantic stature, and also an urn and a valuable ring, set with twenty-five diamonds. Bishop Pococke, treating of this ring, mentions the fact that Rosa Failge, eldest son of Cathoir More, known as Cathoir the Great, who reigned in 122 A.D., was called the " Hero of Rings," but the writer adds that the ring could scarcely have belonged to him, since diamonds do not appear to have been known in Ireland at this early date.[56]

A most interesting Washington relic is a pearl and gold ring made in his lifetime and containing a lock of his hair placed beneath a conical glass. This is encircled by a setting of blue and white enamel, a square of red being set at each corner, and around this a circle of thirteen pearls, the number of the original States. This

[55] Gilbert Barnet (Bishop of Salisbury), " History of His Own Time," London, 1724, 1736. First published by his son Thomas, after the bishop's death in 1715.

[56] Archæologia, vol. ii, pp. 32–35, London, 1773. Figured on plate i, figs. 1 and 2.

ring was given by Washington to Lieut. Robert Somers.
The latter lost his life while fighting the Algerene
pirates in Tripoli, but before his departure he confided
the ring to the care of his sister, Sarah Keen. It is
now owned by Vice-Chancellor E. B. Leaming of
Camden, New Jersey, who inherited it from his paternal
grandmother, an heir to Somers' estate. Only two
other rings containing Washington's hair are known of,
one in Washington's Headquarters at Newburgh on
the Hudson, the other in the Boston Museum.[57]

In far-away Sweden there has been preserved a his-
toric Washington relic. This is a ring given by the
Revolutionary leader to Lafayette before the latter's
return to France after the victorious Yorktown cam-
paign. The ring passed from Lafayette to his intimate
friend, Baron Erik Magnus Staël von Holstein, Swed-
ish ambassador to France. The latter, on a visit to his
native land gave it to his brother, Major Bogislaus Staël
von Holstein, in whose family it was transmitted as an
heirloom until it reached the hands of the maternal grand-
father of the present owner, Mr. GöstaFrölen of Falun,
Sweden. The ring is of gold and is set with a miniature
portrait of Washington.

It is said that two other rings were given by Wash-
ington about the same time to two Swedish noblemen,
who had served as adjutants to Rochambeau. The
presentation occurred at a banquet given in their honor,
just before their departure for their native land, at the
City Tavern in Philadelphia, November 11, 1782. In
bestowing these gifts Washington is said to have used
the following words: " I am happy to be here amongst
men belonging to the race of my own early ancestors."
All trace of these rings has been lost.

[57] George Frederick Kunz and Charles H. Stevenson, " The
Book of the Pearl," New York, 1908, p. 438.

V

BETROTHAL (ENGAGEMENT) RINGS, WEDDING (NUPTIAL) RINGS, AND LOVE TOKENS

SPECIAL wedding-rings, as we understand them, were not used at an early period, the espousal ring being employed at the wedding ceremony also. At a later time, a signet was set in the *anulus pronubus,* or betrothal ring, to signify that the spouse was to have the right of sealing up the household goods, and occasionally a small key formed part of the ring, with a similar significance. We have a testimony to this view in the words of the marriage ceremony: " With all my worldly goods I thee endow." The wives of our day are quite disposed to accept this passage in its literal sense, although some may incline to a more liberal interpretation of the promise to love, honor and obey their husbands. The ring as a pledge of love is said to be first mentioned in Roman literature by Plautus in his " Miles Gloriosus " (Act IV, sc. i, v. 11); this passage, however, does not refer to a nuptial ring, but rather to a love token.

Somewhat distantly related to the betrothal or wedding rings were those given by lovers to the objects of their affection. Of such a ring the Roman poet Ovid writes, apostrophizing it as " a ring soon destined to encircle the finger of a beauteous girl, a ring having no worth except the love of the giver." It was to be a gift to the poet's ladylove Corinna.[1] The ring sent by

[1] Federici Augusti Junii, " De annulo Romanorum sponsalitio," Lipsiæ, 1744, citing Ovidii, lib. ii, Amor. Eleg. xv.

a fair lady, as a token of love to a handsome soldier, in the " Miles Gloriosus " of Plautus was also of this class.

The custom of placing the betrothal or wedding ring upon the fourth finger seems undoubtedly to owe its origin to the fancy that a special nerve, or vein, ran directly from this finger to the heart. Macrobius, in his Saturnalia,[2] alludes to the belief in the following words: " Because of this nerve, the newly betrothed places the ring on this finger of his spouse, as though it were a representation of the heart." Macrobius asserts that he derived his information from an Egyptian priest.

It has been conjectured that this was not the real source of the custom, but that in the church service it was usual for the Christian priest to touch three fingers successively with the ring while saying: " In the name of the Father, of the Son and of the Holy Ghost," and then to place it upon the last finger touched. We know that this was the usage in the bestowal of episcopal rings, and later with wedding rings, but the express statement cited from the pagan writer Macrobius shows that in the earlier marriage or betrothal ceremony this custom must have had an entirely different origin.

During the reign of George I of England it was not unusual to wear the wedding ring on the thumb, although it had been placed on the fourth finger at the marriage ceremony. Possibly this custom may have arisen because exceptionally large wedding rings were favored by fashion at that time. That wedding rings were often worn on the thumb in the middle of the seventeenth century is proved by the lines from Samuel Butler's Hudibras quoted on another page.[3]

Ecclesiastical rituals in France from the eleventh to

[2] Saturnalia, lib. vii, cap. 13.

[3] See page 222.

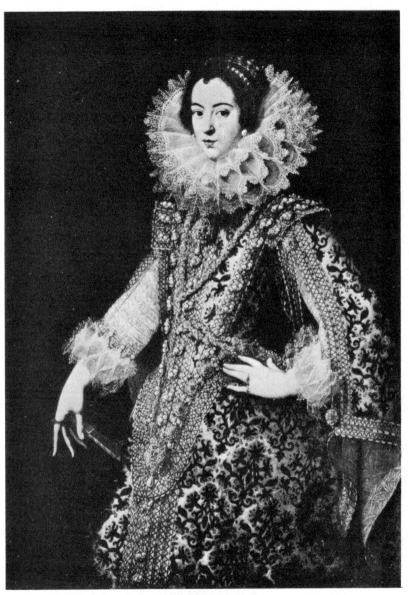

PORTRAIT OF AN UNKNOWN WOMAN BY PANTOJA DE LA CRUZ
Rings on thumb and index of right hand, and on fourth and little fingers of left hand
Museo del Prado, Madrid

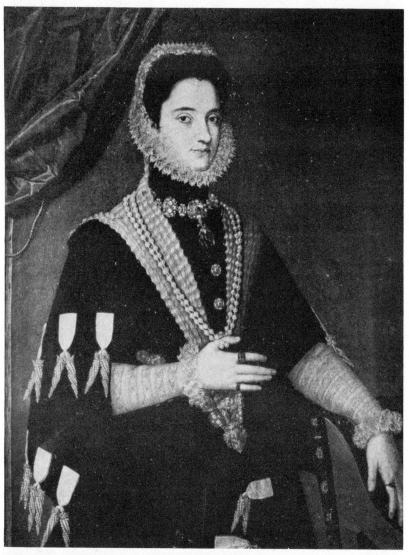

PORTRAIT OF THE EMPRESS MARY, DAUGHTER OF CHARLES V AND WIFE OF MAXIMILIAN II,
BY JUAN PANTOJA DE LA CRUZ

Two rings on index and one on little finger of right hand; one on index of left hand; all set with precious stones
Museo del Prado, Madrid

the fifteenth century prove, with but few exceptions, that the nuptial ring was to be placed on the right hand of the bride, in most of the dioceses upon the middle finger of this hand, but in the diocese of Liége on the fourth finger. As Isidore of Seville, writing in the early part of the seventh century, declares that the betrothal ring was put on the fourth finger, and repeats the Roman fancy as to the vein intimately connecting this particular finger with the heart,[4] it seems likely that this rule was generally followed in the Roman Empire up to its end, and even later in some parts of what had once been Roman provinces, while the early French rules were derived from a Gallic usage which had never been supplanted by the Roman one.[5] That the Gauls and Britons of the first century wore their rings on the middle finger is already noted by Pliny.[6]

A gold ring, a unique relic of Anglo-Saxon times in England, was found in an ancient burial place at Harnham Hill, near Salisbury.[7] It was on a finger bone of the left hand of a skeleton, and resembles exactly our wedding-ring of to-day. In the same cemetery was unearthed a twisted ring of silver, a mere band twice encircling the finger; a section of the finger-bone remains within the ring. These relics are believed to

[4] Isidori, "De ecclesiasticis officiis," lib. xx, cap. 8, in Migne's "Patrologia Latina," vol. lxxxiii, cols. 811, 812.

[5] Deloche, "Le port des anneaux dans l'antiquité romaine, et dans les premiers siècles du moyen âge," Paris, 1896, pp. 96–98; Mémoires de l'Académie des Inscriptions et Belles Lettres, vol. xxxv, pt. 2.

[6] Naturalis Historia, lib. xxxiii, cap. 24.

[7] John Yonge Akerman, "An Account of Excavations in an Anglo-Saxon Burial Ground at Harnham Hill Near Salisbury," in Archæologia, vol. xxxv, p. 266, and Plate XII (opp. p. 278).

date from the seventh century. On or near the skeleton with which this silver ring was found were several amber beads; the remains were evidently those of an elderly person, although of one not over 55 years of age, according to Professor Owen.

That part of the Order of Matrimony relating to the marriage vows and to the wedding ring, in the Sarum Rite or Use current in England in pre-Reformation times, runs as follows, after the bride and groom have clasped hands:[8]

Ich N. take the N. to my wedded wyf, to haven and to holden fro this day forward, for betre for wors, for rychere for porere, in syknesse and in helthe, til deth us departe, and theerto y plith the my trewthe.

Then the woman:

Ich N. take the N. to my wedded hosebund, to haven and to holden fro this day forward, for betre and for wors, for rychere and for porere, to be boneyre and buxum . . . and at borde, till dethe us departe and thereto y plith the my trewthe.

Then let the man lay gold, silver, and a ring on a dish or book; and let the Priest ask if the ring hath been blessed already; if it be answered not, then let the Priest bless the ring.

Bless, O Lord, this ring (looking at it) which we hallow in Thy Holy Name, that whosoever she be that shall wear it may be steadfast in Thy peace and abide in Thy will, and live, increase, and grow old in Thy love, and let the length of her days be multiplied.

But if the ring shall have been already blessed, then,

[8] " The Sarum Missal done into English by A. Harford Pearson," London, 1844, p. 552. The directions and blessings are translated from the Latin; the vows of the bride and bridegroom are from an old English version.

Gold ring in which are inserted representations of two winged figures cut in intaglio in a brown chalcedony. Antique workmanship. See page 363
Collection of B. G. Fairchild, Esq., New York City

Locket ring, opening at the bezel and on the sides, leaving room for the introduction of hair, or tiny portraits. When closed the ring appears to be plain and smooth

Antique Syrian ring of bronze, wet with a yellowish green paste. Half of the circlet has broken away

Gold ring set with octahedral diamond.
Late Roman. British Museum

Twisted hoop of silver on the bone of a finger. From an ancient sepulchre at Harnham Hill, England. Saxon, 7th century

Archæologia, vol. xxxv, pl. opp. p. 278

WEDDING RINGS FROM SYRIAN TOMBS OF CHALCEDONY, AGATE,
AND BANDED AGATE

as soon as the man have laid it on the book, let the Priest take the ring and deliver it to the man; and let the man receive it in his right hand, with the first three fingers, holding the right hand of the Bride with his left hand, and say, after the Priest:

With this ryng ich the wedde, and with my body ich the honoure and with al my gold ich the dowere.[7a]

And then let the bridegroom put the ring on the thumb of the Bride, saying—

In the Name of the Father; (on the first finger) and of the Son; (on the second finger) and of the Holy Ghost; (on the third finger). Amen.

And there let him leave it, because in that finger there is a certain vein which reaches to the heart; and by the purity of the silver is signified the inward affection which ought ever to be fresh between them.

In the modern Protestant Episcopal service, the bestowal of the ring is ordered as follows:

Then shall they again loose their hands; and the Man shall give unto the Woman a Ring. And the Minister, taking the Ring, shall deliver it unto the Man, to put it upon the fourth finger of the Woman's left hand. And the Man holding the Ring there, and taught by the Minister, shall say:

With this Ring I thee wed, and with all my worldly goods I thee endow: In the Name of the Father, and of the Son and of the Holy Ghost. Amen.

It will be noted that the ring is first given by the man to the woman, then taken from her by the priest who returns it to the man, upon which the latter puts it on the fourth finger of the woman's left hand.

Four fine specimens of later Byzantine work in ring-making are in the British Museum. These are all marriage-rings of massive gold, the designs being simi-

lar, with certain variations. The bezels bear engraved figures of Christ alone, or of Christ and the Virgin, bestowing a blessing upon the newly wedded pair; beneath is the Greek word ὁμόνοια (or ὁμόνναι), signifying their spiritual union. All but one have on the hoop in Greek characters the inscription: " My peace I give unto you " (John, xiv, 27). On the remaining ring there is on the hoop a decoration in niello, depicting very roughly scenes from the Gospel. The character of the work indicates that it probably belongs to the tenth century.[9] A massive gold ring found not long since in Mainz, bears a Greek inscription showing that it was executed for the nuptials of King Stephen Radislav of Servia (1228–1234) with Anna Comnena, daughter of Emperor Theodore Angelus Comnenus, Duke of Thessalonica, the region of the Saloniki of to-day. The inscription on this early thirteenth century ring of Byzantine workmanship is nielloed on the gold.[10]

Some interesting inscriptions appear on certain of the Greek betrothal rings in the collection of the British Museum. A gold ring of about the fourth century B.C. bears a Greek inscription which may be rendered as follows: " To her who excells not only in virtue and prudence, but also in wisdom." In marked contrast to this rather elaborate dedication is the inscription on another ring, which bears the single word μέλι " Honey." It strikes us strangely enough to find this particular term of endearment, so freely used by the Negroes, on a ring from classic times. Perhaps the most beautiful of all these inscriptions is on a late Greek ring and runs:

[9] O. M. Dalton, " Byzantine Art and Archæology," Oxford, 1911, p. 544, fig. 329.

[10] *Ibid.*, p. 546.

" I rejoice in the gift because of the affection of the giver."[11]

The custom of bestowing a ring upon the betrothed bride has been traced back in Rome to the second century B.C. Plain iron rings were first used for this purpose and they were still favored even when the wearing of gold rings had become general among certain classes of the Roman citizens. However, in the course of the second century of our era, and perhaps earlier, gold rings came into use in the ceremony of betrothal. Pliny's assertion that the bride wore an unset iron ring has been interpreted to mean no more than that, in the case of those entitled to wear gold rings, the bridegroom after having given the bride a gold ring, later bestowed upon her one of iron for wear within doors. For it appears to have been a rather general usage, in or before Pliny's time, to wear gold rings only when in public, and within the house iron rings. That the nuptial ring was of gold, in the second century at least, is plain from the statement of St. Clement of Alexandria, who declares that this ring was not bestowed upon the spouse as an ornament, but that she might seal up whatever was worthy of special care in the household.[12]

Perhaps the earliest allusion in Christian literature to the betrothal ring appears in one of Tertullian's writings, dated from the end of the second century A.D., wherein he says: "Among our women the time-honored

[11] Marshall, " Catalogue of the Finger Rings, Greek, Etruscan, and Roman, in the Departments of Antiquities, British Museum," London, 1907, pp. 99, 100; No. 579, pl. xvii.

[12] Federici Augusti Junii, " De annulo Romanorum sponsalitio," Lipsiæ (1744), pp .xiii, xiv; citing Pliny's " Hist. Nat., lib. xxxiii, cap. i, and Clement's " Pædogogus, lib. iii, cap. xi.

rules of their ancestors, which enjoined modesty and sobriety, have died out. In former times women knew nothing of gold except the single betrothal ring, which was placed on one of their fingers by the fiancé." [13] That this usage had endured for many years is clearly apparent from the allusion to times long past. In a curious passage,[14] St. Augustine, in the fourth century, writes: "No priest shall hesitate to wed a couple who present themselves before the altar, if the bride and bridegroom are not able, because of poverty, to give rings to each other; for the (offering of) the earnest-money is a matter of decorum, not of necessity."

One of the rare marriage rings or love tokens of the early Christian centuries, bears incised on its circular, button-shaped chaton, a male and a female bust, the faces turned toward each other. Above is a cross, the lower part of its upright shaft much longer than the upper part or the arms. This ring is of Byzantine workmanship and has been approximately dated about 440 A.D. It is a good example of the so-called bicephalic rings, rings bearing two heads, and weighs 3⅝ dwt., or 87 grains.[15]

This usage was introduced among the ancient Germans by the Romans. The significance of the betrothal ring is noted in a law of the Visigoths, promulgated by Chindaswinthe (642–643 A.D.). There had evidently been a disposition to treat lightly the obligations of betrothal, for we read: "Since there are many who,

[13] Tertulliani, "Opera Omnia," ed. Migne, Parisiis, 1879, vol. i, col. 353. Apol. adv. gen.

[14] August. Epist. 119 ad Januar. cap. 18.

[15] C. Drury Fortnum, "On Finger Rings of the Early Christian Period," in Journal of Archæology, vol. xxviii, pp. 266–292; figured on p. 291.

forgetful of their plighted faith, defer the fulfillment of their nuptial contracts, this license should be suppressed." Therefore, it was provided that when a solemn declaration had been made before witnesses and the espousal ring had been given and accepted as representing earnest-money, the marriage ceremony must follow, if either of the parties should fail to agree to a rupture of the engagement; that is, it could only be broken by mutual consent.

A celebrated betrothal ring was that sent by Clovis I (465–511 A.D.) to Clothilda in 493. The following account is given of the bestowal of this ring:

"Aurelian pursued his journey from these parts [of Burgundy], bearing with him the ring of Chlodwig that he might gain the better credence thereby. When he arrived at the city where Chrotechilda resided with her aunt, Aurelian presented himself and said: ' Chlodwig, King of the Franks, hath sent me to thee; if such be the will of God, he wishes to associate thee with himself in his majesty, as spouse. That thou mayst be assured of this, he hath sent thee this ring.' Accepting the ring, she was filled with great joy, and answered: ' Take a hundred solidi as a reward for thy labor. Return quickly to thy lord and say to him: ' If thou desirest to associate me with thyself in matrimony, send envoys straightway to my paternal uncle Gundobard, and ask him for my hand.' " [16] The money gift was a considerable one for the time, as the solidus was worth intrinsically about $3 of our money, and six or eight times as much in purchasing power in that age.

A most interesting ancient wedding ring, presum-

[16] Fredegari, " Historia Francorum epitomata," cap. xviii; in Patrologia Latina, ed. J. P. Migne, Parisis, 1879, vol. lxxi, col. 584.

ably of the Gallo-Roman period, was unearthed toward 1850 in the neighborhood of Mulsanne, dept. Sarthe, France. It is of massive gold and weighs 24 grams, 20 centigrams, or over ¾ ounce. On the bezel, which is square, are rudely engraved two figures, that of a warrior resting on his lance and that of a woman holding out her arms to him. On the shoulders, toward the bezel, is a foliated ornamentation, and along the edge of the bezel are engraved the two names " Dromacius " and " Betta," the characters being filled in with the black enamel called niello. This ring is believed to date from the fifth century A.D.[17]

The religious aspect of the ring in the ritual of the Greek Church finds an exponent in Symeon, Archbishop of Thessalonica, who wrote about a half-century before the capture of Constantinople by the Turks in 1453. In his description of a typical marriage ceremony he states that the officiating priest laid upon the altar two rings, an iron one symbolic of masculine force, and a gold one typical of the less hardy but purer feminine constitution. These rings he consecrated. After bestowing his benediction upon the bride and bridegroom and offering a prayer for them, he gave the woman the iron ring, as from the man, and to the man the gold ring on the part of the woman, and changed them three times, in adoration of the Holy Trinity, the perfecter and sustainer of all things. Hereupon he joined the right hands of the spouses, demonstrating their unity in Christ and that the man had received the woman from the hand of the Church. The rings also

[17] Hucher, " Sigillographie du Maine," *Bulletin Monumental*, vol. xviii, p. 308.

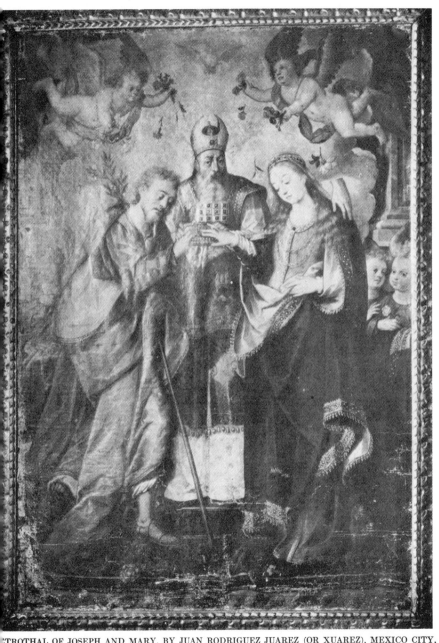

BETROTHAL OF JOSEPH AND MARY, BY JUAN RODRIGUEZ JUAREZ (OR XUAREZ), MEXICO CITY,
(1666–1734) CALLED THE "MEXICAN CARRACCA"
In the possession of the author

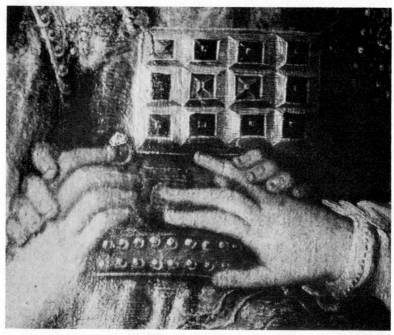

Right hand of the Virgin, right hand of St. Joseph, and hands of the high-priest, showing the manner of placing the wedding ring at Hebrew marriages as depicted in the picture of Rodriguez Juarez [Xuarez]. The ring contains an octahedral diamond crystal set in gold

signified the agreement and sealing of the marriage contract.[18]

According to Buxtorf (De sponsal. et divort.), the Jews did not place the betrothal ring upon the annular finger, but upon the index. As to this there is a curious statement in the "Opus aureus contra Judæos,"[19] by Victor de Carben, a converted Jew. He states that, at the betrothal ceremony, care should be taken that the fiancée extends her index finger to receive the ring, lest it should be put, by mistake, upon the middle finger, for it was on this finger that Joseph placed the ring when he betrothed Mary. Buxtorf adds that he has never been able to find this statement in Jewish writings.

One of Ghirlandajo's frescoes in the church of Santa Croce, in Florence, depicts the betrothal of the Virgin. Here the ring is placed by Joseph on the fourth finger of the Virgin's right hand, and the famous Sposalizio by Rafael in the Brera Gallery in Milan illustrates the same usage. Possibly the ring was transferred to the left hand at the actual marriage ceremony.

The custom of the Greek church at the present day in relation to betrothal or wedding rings differs in some respects from that observed in other Christian churches, for the priest places a ring on the fourth finger of each of the contracting parties, who then proceed to exchange them with each other.

The old custom of exchanging rings and betrothal vows obtains in the Russian branch of the Eastern Church. For the succeeding marriage ceremony, or "crowning," the same rings are again used. The rubric

[18] Symeonis Thessalonicensis Archiepiscopi, "Opera Omnia," in Migne's Patrologia Græca, vol. clv, Paris, 1866, cols. 505, 508, "De honesto et legitimo conjugio."

[19] Coloniæ, 1509, cap. 11.

states that the bride's ring should be of silver to show that she is the less honorable vessel, while the bridegroom's ring is of gold to signify the superiority of the man. The brides, however, have shown a disposition to resent this inequality, and, in modern times at least, they are given gold rings also. The old Russian custom is for the husband to wear his ring on his forefinger.[20]

In the Greek and Russian churches, the rings—of gold for the man, of silver for the woman—are bestowed at the betrothal ceremony, when also a contract between the parties is made. The later nuptial ceremony is generally designated as "the crowning," a crown being placed on the heads of bride and bridegroom by the officiating priest.

The question was often raised whether the mere fact of giving or accepting a ring constituted a definite promise of marriage. The best authorities decided the question in the negative. In reference to this matter Peter Müller writes: " If when a ring is given there is no promise of marriage, the ring shall not be regarded as a betrothal ring, but as a simple gift. Whence it may be inferred that a contract of marriage cannot be proved by a ring alone, since mere donations, bestowed through liberality, do not produce any obligation." [21]

The connection between the wedding ring and the bestowal of earnest-money is clearly indicated in the marriage service as given in the Prayer-Book of Edward VI. Here, after the words "with this ring I thee wed," there is added: " This gold and silver I give thee "; and at these words the bridegroom usually placed in the bride's hands a purse containing a sum of money. There can, indeed, be little doubt that the espousal ring

[20] Communicated by Mrs. Isabel F. Hapgood.

[21] Petri Mülleri, " De annulo pronubo," Jenæ, 1734, p. 22.

was rather the type of a valuable consideration offered at the consummation of the marriage contract, than a symbol of the bondage and subjection of the spouse as many have maintained.

That the ring was sometimes given conditionally is shown by a curious old German formula to the following effect: " I give you this ring as a sign of the marriage which has been promised between us, provided your father gives with you a marriage portion of 1000 reichsthalers." [22]

It is not possible to indicate with any precision at what date the betrothal ring became the wedding ring, but this change seems to have taken place in England about the time of the Reformation. This did not, how- ever, entail the abandonment of the betrothal ring, but rather the substitution of another, and frequently less simple ring, to mark the betrothal. Of course, the change was gradual and the usage varied in different countries, since the employment of a separate marriage ring was rather a matter of custom than of ecclesiastical ordinance.

The Manx usages and customs are so strange in many cases that the ring traditions of the Isle of Man also present certain peculiarities. Thus if a man was found guilty of having done injury to a maiden, the latter was given a sword, a rope and a ring, signifying that she could either have him beheaded, or hung, or else could force him to wed her. That the last-men- tioned choice was the one most frequently made is very probable, as the rehabilitation of her good name thus attained might well outweigh any satisfaction to be gained from the exercise of revenge.[23]

[22] Petri Mülleri, " De annulo pronubo," Jenæ, 1734, p. 31.
[23] Cyril Davenport, " Jewellery," Chicago, 1908, p. 114.

The use of rush-rings in England, in 1217, for mock marriages, is vouched for in the " Constitutiones " [24] of Richard, Bishop of Salisbury. It is provided that whoever places a rush-ring, or a ring of cheap or precious material, in sport and jest upon a woman's hand, that she shall the more willingly become friendly with him, although imagining himself to be joking will be constrained to marry. Another authority declares that when the ecclesiastical court enforced matrimony as a penalty or a reparation for bad conduct, a rush ring or a ring of straw was used at the ceremony.[25]

There are several passages in English poetry of the Elizabethan age and later, referring to this use of a " rush ring." In his " Two Noble Kinsmen," Fletcher writes:

> Rings she made
> Of rushes that grew by, and to 'em spoke
> The prettiest posies; Thus our true loves ty'd;
> This you may loose, not me, and many a one.

In the seventeenth century Sir William Davenant (1605–1668) speaks in the following mocking strain of such a ring:

> I'll crown thee with a garland of straw then
> And I'll marry thee with a rush ring.

The ballad called the Winchester Wedding has these lines:

> Pert Strephon was kind to Betty,
> And blithe as a bird in the spring;
> And Tommy was so to Katy,
> And wedded her with a rush ring.

[24] Cap. 55.

[25] " Glossarium ad scriptores mediæ et infimæ Latinitatis," Parisiis, 1733, vol. i, col. 457.

The "rush ring" is touched on in an old English ballad of Shakespeare's time, in which occur the lines: [26]

> Then on my finger I'll have a ring
> Not one of rush, but a golden thing;
> And I shall be glad as a bird in spring,
> Because I am married o' Sunday.

A purely spiritual view of the meaning of a wedding-ring is expressed by Guillaume Durant, Bishop of Mende (died 1296). For him it was the symbol of the mutual love of the espoused, at once a pledge and a symbol of the union of their hearts. However, the more mercenary significance of the ring, as a sign of the marriage gift to be bestowed upon the bride by the bridegroom before the wedding, is quite clearly brought out in the old French Rituals, wherein its composition and meaning are defined. A simplification of the ring itself seems to have taken place from about the thirteenth century when gold rings adorned with precious stones were generally worn. The metal used at a later time varied in different dioceses. While in that of Limoges the ring was of gold, the rituals of the dioceses of Auxerre, Lyons and Paris prescribe a silver ring. In the Manual of the priests belonging to the diocese of Paris, it is strictly enjoined that there shall be no inscription or figure upon the ring, and that no precious stone shall be set therein. The officiating priest receives it from the bridegroom together with one or more pieces of money " as sign of the constituted endowment." The Manuel de Beauvais, published in 1637, also prescribes that the nuptial ring shall be severely plain and entirely without inscription. The

[26] Cited in H. R. D. Anders, " Shakespeare's Books," Berlin, 1904, p. 189.

ritual of the Abbey of St. Victor is even more definite, for here the blessing of the ring is preceded by the reading of the endowment on account of marriage (*dotalitium propter nuptias*). Hence the " dower " was not given with the wife, but was bestowed upon her by the husband.[27] This has been erroneously looked upon by some as a survival of the primitive custom of wife-purchase; it differs, however, essentially from this in that the wife receives the endowment for her own use and as her own property. A curious superstition is condemned by the Ritual of Evreux. As the ring was handed to the bride by the bridegroom, the former would let it fall on the ground to conjure a possible evil spell.

It has been remarked by Jacob Grimm (1785–1863) the great lexicographer and student of German archæology, that in early times, among the christianized Germans, the fiancé gave the ring to the young woman, who was thenceforth bound to carry out the marriage contract. On the other hand, according to the poetical recitals of the thirteenth century, the fiancée gives a ring to her future husband, without receiving one from him. The same writer regards the usage of betrothal rings as one introduced among the Germans by Christian influence, not one that can be looked upon as properly Germanic.[28]

The contracting parties often exchanged rings at the betrothal ceremony, which in many cases was cele-

[27] Deloche, " Le port des bagues dans l'antiquité romaine et dans les premiers siècles du moyen âge," Paris, 1896, pp. 61–63; from Mémoires de l'Académie des Inscriptions et Belles Lettres, vol. xxxv.

[28] Jacob Grimm, " Deutsche Rechtsalterhümer," Berlin, 1854, pp. 177, 178.

brated in the church with all due solemnity. Shakespeare's "Two Gentlemen of Verona" contains an allusion to a more informal exchange of rings:

Julia: Keep this remembrance for your Julia's sake.
Proteus: Why then we'll make exchange; here take you this.
(Giving a ring.)
Julia: And seal the bargain with a holy kiss.

In our own time, in Germany, two rings, one for the bride and the other for the bridegroom, are given at the marriage ceremony, and these rings are called "Trauringe," a name which designates the ring as an emblem of faith and trust, just as does the Italian name for the betrothal ring, *fede,* or faith.

From the almost innumerable poesies inscribed upon espousal rings we select a few of the more noteworthy. An antique Roman ring has the words: "Pignus amoris habes" (Thou hast a pledge of love); [29] another shows the simple form "Proteros Ugiæ" (Proteros to Ugia), the names being inscribed between two clasped hands.[30] A sentiment given by one who was no believer in unrequited love reads: "Love me, I will love thee." A massive gold ring of early date, found in 1823 at Thatford, in Suffolk, gives us the following inscription in Old French: "Deus me octroye de vous servir a gree com moun couer desire" (God grant me to serve thee acceptably as my heart desires).[31] On a ring in the collection of the late Sir John Evans we have the following graceful inscription: "Je suis ici en lieu d'ami" (I am here in the place of a friend).

[29] This recalls Juvenal's "digito pignus fortasse dedisti" (perhaps thou hast set a pledge on a finger). Sat. vi, 27.

[30] Fairholt, "Rambles of an Artist," London, n.d., p. 90, fig. 97.

[31] *Ibid.,* p. 124, fig. 124.

An elaborate wedding-ring, probably executed in Germany, in the latter half of the fifteenth century, is in the fine collection of the court jeweler Koch, of Frankfort-on-the-Main. Out of richly ornamental foliage work arise the figures of the wedded pair, evidently carefully rendered portraits. Although somewhat lacking in purely artistic harmony, this production of the ring-maker's art is an excellent illustration of the quality of the best German goldsmith work of the time in the smaller objects.

The Figdor Collection in Vienna contains a fifteenth century betrothal ring made in France. It is of gold and bears the inscriptions: " Il est dit " (in small letters) and " ELLE ME TIENT" (in capitals), literally: " It is said (spoken) " and " She holds me." A betrothal ring in the form of a so-called " Puzzle Ring," has six connecting hoops. Three of these are enameled, two others bear closed hands, and the last shows a key and the head of a winged angel. This is of seventeenth century workmanship.[32]

A wedding-ring of simple Gothic design formed part of a grave treasure, the characteristic inscription: " In Mir Ist Treue " (In me is fidelity), leaving no doubt as to the use to which the ring had been put. This plain triangular band is in the Germanic Museum in Nuremberg and is assigned to the thirteenth century. Another most interesting ring from the same period was found in the territory formerly known as the Fürstenbergerhof, at the southwest end of the city of Mainz; it is now owned by the family Heerdt of that city. The clasped hands engraved on the lower part of the hoop designate this clearly as a betrothal or wedding-ring.

[32] Communicated by L. Weininger, of Vienna.

An English ring of the early part of the fifteenth century bears this couplet:

> Most in mynd and yn myn herrt
> Lothest from thee ferto deparrt.

In seventeenth century rings the religious sentiment predominates: " I have obtaind whom God ordaind "; " God unites our hearts aright " ; " Knitt in one by Christ alone "; " Wee join our love in God above." A little more human, if less devotional, are the mottoes: " United hearts death only parts "; "A faithfull wife preserveth life," and " Love and live happily."

There have been many types of betrothal rings from the simplest up to the most elaborate and ornate. One having a graceful symbolism was found near Vassy, dept. Haute Marne, France, in June, 1868. The hoop is of yellow gold, alloyed sufficiently to give it consistence. Instead of one chaton, it has two placed close to one another and each set with a small, cabochon-cut emerald. The choice of this stone is a good indication that we have to do here with a betrothal rather than a wedding ring, for the emerald was emblematic of hope, of unfulfilled desire and of virginity. Around the setting runs the following inscription in Old French, beginning with the sign of the cross: CE QUE DESIR HOM DONE UN BIEN. This may be rendered: " What one desires brings happiness," the idea being perhaps that so beautifully expressed by St. Thomas Aquinas: " The soul dwells with the loved one rather than in the body it animates." [33] While the letters of the French inscription are so much worn as to make the decipherment of two words a little uncertain, the gen-

[33] *Anima magis est ubi amat quam ubi animat.*

eral sense is clear enough, and constitutes a very fine
motto for such a ring.[34]

The ring which had been used by Louis IX (St.
Louis) at his betrothal to Marguerite de Provence, in
1231, was so greatly prized by him that on his deathbed
he expressed the wish that it should be interred with his
body. On its gold hoop he had caused to be engraved the
lilies of France and certain military emblems.[34a]

A graceful thought is expressed in the following Old
French inscription on a ring found near Poitiers:

Mon cuer se est resioui aussi doit il si maist Dieux.
A mon gre ne puis mieux aueir choisi.

"My heart is rejoiced, and so should it be, if God aid me.
For I feel I could not have chosen better."

A shorter motto, but one full of significance, ap-
pears on a ring in the museum of Poitiers; it consists
merely of the two words: " Sans Partir." This could
mean either " we shall never separate," or else that the
donor would never abandon his love. Another brief
motto, found on a ring in the Louvre dating from the
reign of Francis I, runs " Riens sans amour," or " Love
is all in all."[35]

At weddings in Spain and also in some parts of
France, in connection with the bestowal of a ring, the
curious usage has been observed of giving thirteen
pieces of money to the bride. This gift, called in French
a *treizain,* has its origin, as the name indicates, in the

[34] Barbier de Montault, " Un anneau du XVe Siècle," Tours,
1876.

[34a] Jean Szendrei, " Catalogue de la collection de bagues de
Madame Gustave de Tarnóczy," Paris, 1889, p. xlviii.

[35] Barbier de Montault, " Un anneau du XVe siècle," Tours,
1876, pp. 14–17. For additional " posies " see pp. at end of
this chapter.

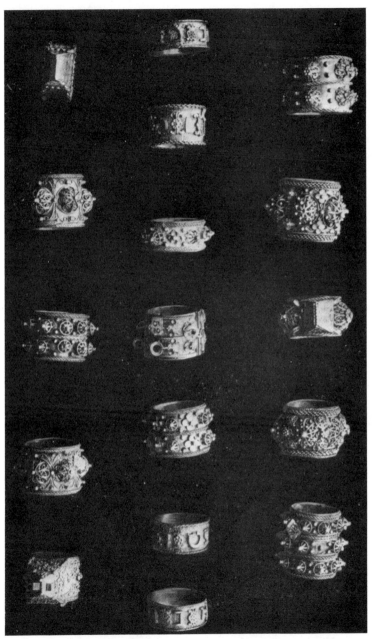

JEWISH BETROTHAL RINGS IN GOLD, SET WITH PRECIOUS STONES
Musèe de Cluny, Paris

Jewish wedding rings, one with Temple dome, the other with slant-roofed
structure. Each bears the Hebrew words *Mazzel Tob*, or "Good Luck"
Fairholt's "Rambles of an Artist"

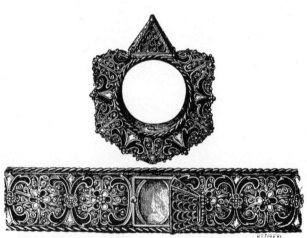

Jewish wedding ring, with five bosses and as bezel a projecting figure. This is hinged
and covers a gold plate. On the inside *Mazzel Tob* or "Good Luck"
British Museum

Jewish marriage ring. Gold hoop with
five bosses of filigree enriched with flowers
in pale blue, green and white enamel, and
a gable-like projection with two small
windows. Nürnberg. Sixteenth Century
British Museum

Jewish wedding ring; broad
gold hoop, the sides showing the
Creation of Eve, the Fall, and the
Expulsion from Eden. German.
Sixteenth Century
British Museum

ancient custom of giving to the purchaser of a dozen articles, an extra one, ostensably as a testimonial of good will, but really to induce further purchases. This old usage is said to have been observed at the marriage of King Alfonso XIII of Spain in 1906.

The Hebrew betrothal rings were elaborate and somewhat clumsy productions, frequently of massive gold. The broad hoop was surmounted by the representation of a temple, sometimes with a Moorish dome, but usually with a slanting roof. This is a curiously conventionalized figuration of Solomon's Temple, similar to that found upon certain spurious Hebrew coins. Upon the temple or else around the ring, are generally the Hebrew words FIO ERG, equivalent to " Good Fortune." [36] Several such rings are described in the privately printed catalogue of the Londesborough Collection (London, 1853, p. 4). A more artistic specimen, also in the Londesborough Collection, bears the figures of Adam and Eve in Paradise, accompanied by representations of animals, all in high relief.[37] The specimens described belong to the sixteenth century. The learned Jesuit, Athanasius Kircher, cites a statement to the effect that the inscription *mazzel tob,* engraved upon many Hebrew betrothal rings, referred to the planet Jupiter as the " good star." [38] This planet was, indeed, called by the Hebrews *cocab zedeq,* " star of righteousness " or " justice," but there is little doubt that *mazzel tob* should be rendered " good fortune " or " propitious fate."

[36] Shown in Fairholt's " Rambles of an Artist," p. 127, figs. 152, 153.

[37] *Ibid.*, p. 128, fig. 154.

[38] Kircheri, " Œdipus Ægyptiacus," Romæ, 1652, vol. i, p. 283.

The earliest Jewish wedding-rings are said to have been plain golden circlets, without setting, indeed a silver substitute or even one of a cheaper metal was not forbidden. Pearls, favorite gems with the Jews, were sometimes used for settings at a later period. The purely ceremonial or symbolic significance of the Jewish wedding ring in early times is exemplified in its great size, the major part of these rings being much too large for wear. Sometimes, at the wedding feast, rings of this type were used as holders of myrtle-branches. The circlet surmounted with the temple figure was occasionally formed of two cherubim.[39]

A ring supposed to have been the wedding ring of the Roman Tribune, Cola di Rienzi (ca. 1313–1354), is of silver, with an octagonal bezel; the hoop bears the names: " Catarina " and " Nicola," those of Rienzi and of Catarina di Raselli, his bride. The letters have been placed in sharp relief by cutting away the background and filling it up with niello. Between the names are two stars. As Rienzi chose a star as his emblem on the coins he struck during his brief rule in Rome, this device coupled with the names makes the attribution of the ring not without some good foundation.[40] This ring was bought by Mr. Waterton in Rome for a trifling sum. It had been pledged in a Monte di Pietà, and was disposed of at one of the periodical clearing sales.

In the fifteenth century the betrothal ceremony was usually performed in the presence of a notary public, not of a priest, and this continued to be the usage until

[39] Jewish Encyclopædia, vol. x, art. Rings by Albert Wolf, of Dresden, Saxony.

[40] " Catalogue of the Special Exhibition of Works of Art at the South Kensington Museum, June, 1862," section 32, " Rings," by Edmund Waterton, pp. 630, 631.

after the Council of Trent, which ended in 1563. At the betrothal, by proxy, of Lucrezia Borgia with Giovanni Sforza, February 2, 1493, twin gold rings set with precious stones were given, one to be put on the fourth finger of the fiancée's left hand, "whose vein leads to the heart" as the record specifies, while the other was to be placed on the bridegroom's little finger.[41]

In one of the very risqué tales forming the "Cent Nouvelles Nouvelles," the authorship of which has been attributed to King Louis XI of France (1461–1483), it is related that a lady, while bathing, lost a diamond ring; the narrator adds: "This was one her liege lord had given her on the day of her espousal, and she prized it the more highly on this account." Although diamond rings were not common at this time, the recently invented art of facetting the diamond was rapidly bringing these stones into fashion and favor. There is, indeed, a record, or at least a family tradition, that one of the three large diamonds cut in facets by Lodowyk van Berken of Bruges, about 1476, at the order of Duke Charles the Bold of Burgundy, was set in a ring and given by the duke to Louis XI, with whom he was then seeking to get on a friendly footing. This diamond is described as having been cut as a "triangle and a heart." This possibly means that the triangular shape was slightly modified into a heart shape.[42]

A Scotch legend relates that a married woman by ill-chance let her wedding ring fall into the river Clyde. On her return home her husband noted its absence and,

[41] See Gregorovius, "Lucrezia Borgia," pp. 375, 376, of Ital. translation.

[42] Robert de Berquen, "Les Merveilles des Indes Orientales et Occidentales," Paris, 1661, pp. 14, 15. Robert de Berquen writes of Louis (Lodowyk) as "one of his ancestors."

believing she had given it to a lover, became furiously jealous, used the harshest language to her and even threatened her life. In her despair the innocent wife went and cast herself at the feet of St. Kentigern, Bishop of Glasgow, supplicating him to render her faithfulness manifest. The bishop had compassion upon her, and uttered a prayer that the ring might be restored. His prayer was answered, for ere a few hours had passed a fisherman came to him bearing as a gift a large salmon he had just caught, and in the mouth of the fish was found the lost ring. The husband, convinced of his injustice, was kinder to his wife than ever before, so as to make good the wrong he had done her. To the story given in this legend are ascribed the figures of a salmon with a ring in its mouth on the coat-of-arms of the city of Glasgow, as well as on the armorial bearings of several of the bishops of that city from the time of Bishop Wishert, who lived under Edward II of England (1307-1327).[43]

Among historic wedding rings especially worthy of note is that commemorating the marriage of Martin Luther to Catharina von Bora, June 13, 1525.[44] Both Luther and his wife had taken the vow of celibacy in the Roman Catholic church, and he was bitterly reproached by Roman Catholics for contracting this marriage. Replying to his accusers, he is declared to have said that he married " to please himself, to tease the Pope, and to spite the Devil." The inscription on this ring is: " D. Martino Luthero Catharina v. Boren, 13 Jun. 1525." This probably indicates that the ring was

[43] Alfred Maury, " Croyances et Legendes du Moyen Age," Paris, 1896, p. 277, note.

[44] Fairholt, " Rambles of an Artist," p. 128, fig. 155. The authenticity of the ring may be regarded as somewhat doubtful.

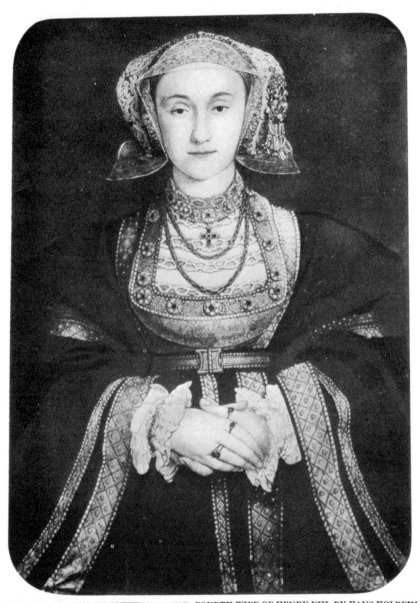

PORTRAIT OF ANNE OF CLEVES (1515–1557), FOURTH WIFE OF HENRY VIII, BY HANS HOLBEIN

Thumb-ring on left hand, one ring on index finger, and two on fourth finger of right hand. This portrait, when shown to Henry, pleased him so well that he agreed to the marriage, but he expressed sore disappointment when he at last saw the new queen

Musée du Louvre, Paris

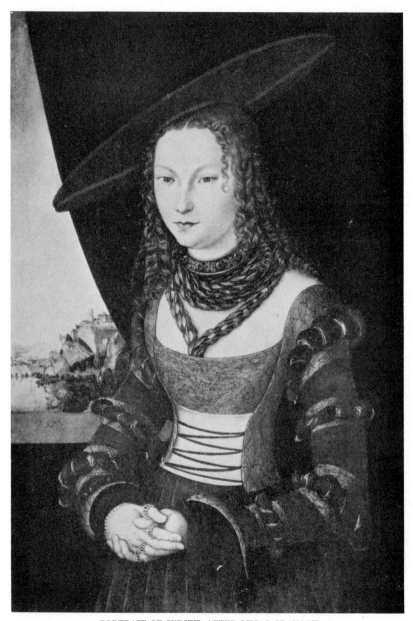

PORTRAIT OF JUDITH, AFTER LUCAS CRANACH
Rings worn beneath gloves, which have slits to relieve the pressure and to show the rings. **Right**
hand has four rings, on thumb, index, fourth finger, and little finger, respectively
Kaiserliche Gemälde-Galerie, Vienna

given to Luther by his wife in memory of the wedding. It is stated to have belonged to a family in Leipsic as late as 1817. A copy of the ring is in the writer's possession. It was given him by Mrs. Edith True Drake, as a memento of her husband Alexander W. Drake, of whose collection it had formed part. The original ring is set with a small ruby, and bears in high relief representations of the crucifixion, and of the instruments of the Passion; the pillar, scourge, spear, etc.

A pendant to this is a ring given either to Luther or his wife, as a memento of his marriage, by some friend. This is of the type of gimmal rings, divisible but not separable. On one hoop the setting is a diamond, on the other a ruby. The bezel separates into two halves when the ring is opened, and reveals on the two hidden sides the initials c v d and m l d, for Catharina von Bora and Martin Luther, Doctor. On the inner side of the conjoined hoops is the inscription: "*Was Got zusamen fiegt sol kein mensch scheiden*" (Those whom God hath joined, shall no man put asunder), in the old German spelling.[45] The diamond is on the Luther side of the divided bezel, and signifies power, durability and fidelity; the ruby on the side marked with the wife's initials is taken to mean exalted love. Both this ring and the one already described are believed to have been designed by the artist, Lucas Cranach, who was a friend of Luther's and assisted at his marriage. The ring is in the Grossherzogliches Museum at Brunswick.

A very noteworthy ring, in the Waterton Collection at the Victoria and Albert Museum, London, belonged to Henry, Lord Darnley, and commemorated his marriage with Mary, Queen of Scots. On the bezel are the

[45] Julius Köstlin, " Life of Luther," trans. from the German, New York, 1883; pp. 334, 335.

initials M H, entwined with a true-love knot, and within
the hoop is engraved HENRI L. DARNLEY, and
the date, 1565. Between the two groups of letters con-
stituting the inscription, is figured a lion rampant on a
carved shield. This ring is said to have been found in
the ruins of Fotheringay Castle, where Mary Stuart
was executed.[46]

A peculiar class of rings bears the name of " gimmal
rings." This designation is derived from the Latin
gemelli, " twins," and indicates the form of the orna-
ment. Two rings are joined together by a pivot so
that when united they constitute a single ring, although
they can be easily separated. On each circlet there is a
band, so disposed that when both are brought together
the hands are clasped and hold the separate rings in
place. Occasionally, there are three or more rings com-
bined in the same way, the designation " gimmal ring "
being used for these also. The following lines by
Herrick refer to this latter type:

> " Thou sent'st to me a true-love knot; but I
> Return a Ring of *jimmals* to imply
> Thy love had one knot, mine a *triple* tye."

A specimen of this type of ring is given in the
privately-printed catalogue of Lady Londesborough's
collection (London, 1853, p. 17). This is described as
" a triple gimmal, the first and third circlet having
each a hand, so that, when joined, the two hands are
clasped together and serve to conceal two united hearts
on the third ring. Of German workmanship." It was
customary to separate the conjoined rings at the be-
trothal ceremony and to give the upper and lower to
each of the betrothed, respectively, while the middle

[46] Fairholt, " Rambles of an Artist," p. 132, fig. 165.

Ring with pointed diamond used for
writing on glass
Fairholt's "Rambles of an Artist"

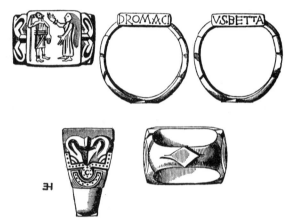

Massive gold Gallo-Roman ring. Found near Mulsanne, dept. Sarthe,
France, about 1850. Believed to be a wedding ring; five views. Fifth
Century. See page 202
Abbe Barraud, "Des Bagues de Toutes les Epoques," Paris, 1864

Rings of Mary Stuart. 1, signet ring; 2, wedding
ring of Mary and Darnley, with date of marriage, 1565;
two views
Fairholt's "Rambles of an Artist"

Gold betrothal ring, bezel in form of clasped hands, hoop shaped as two amoretti. Sixteenth Century

British Museum

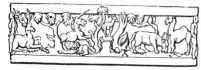

Hebrew wedding ring. Adam and Eve in Paradise

Wedding ring of Martin Luther, two views. Original had a small ruby in the centre

Fairholt's "Rambles of an Artist"

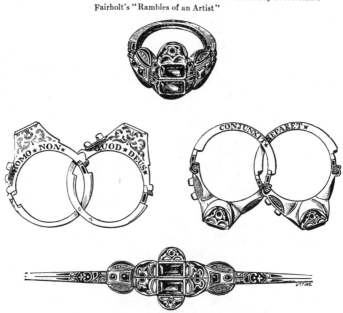

Wedding ring of gimmal type. German, Sixteenth Century. Set with a ruby and an aquamarine. Inscription visible when ring is separated: *Quod Deus conjunxit homo non separet* (Let man not separate what God hath joined together). The betrothal or wedding ring of Sir Thomas Gresham (1519–1579) is of similar design

British Museum

ring was given to an intimate friend of the lady. When the marriage was solemnized, the rings were reunited and bestowed upon the bride. As a general rule all rings bearing clasped hands were termed gimmal rings, although the designation properly belonged to two or more separate rings joined together.

The following lines from Don Sebastian, a play written by Dryden (1690), explains quite fully the character and use of a gimmal ring:

> A curious artist wrought 'em
> With joynts so close as not to be perceiv'd;
> Yet are they both each other's counterpart.
> (Her part had Juan inscrib'd, and his had Zayda,
> You know these names were theirs:) and in the midst
> A heart divided in two halves was plac'd.
> Now if the rivets of those Rings inclos'd
> Fit not each other, I have forg'd this lye:
> But if they join, you must for ever part.

In Burgon's life of Sir Thomas Gresham, the merchant prince of Queen Elizabeth's time and founder of the Royal Exchange, we are shown his wedding ring. This is a gimmal ring composed of two hoops, one bearing the inscription " Quod Deus conjunxit " (What God hath joined together) and the other: " Homo non separet " (Let not man put asunder).[47] The two hoops are set with a red and a white stone, respectively.

A curious development of the gimmal-ring was the so-called " puzzle-ring " consisting of pieces of gold wire ingeniously bent and intertwined so that they appeared to form a single indivisible ring, although by a certain clever twist they could easily be separated into several

[47] Burgon, " The Life and Times of Sir Thomas Gresham," London, 1839, vol. i, p. 51.

independent hoops. This type was derived from the East.

On a gimmal ring belonging to the first half of the fifteenth century, in the Londesborough Collection, is an engraved head of Lucretia; at the back appear two hands clasped. This type seems to have been common in Shakespeare's time, for in Twelfth Night (Act II, sc. 5), Malvolio exclaims, after examining the seal on a letter: " By your leave, wax. Soft!—and the impressure her Lucrece with which she uses to seal." [48] The choice of this image for a betrothal ring must have been intended either as a tribute to the lady's chastity, or else as a kind of amulet to protect her from attacks on her virtue.

The talismanic quality of the turquoise is noted by Edward Fenton, in his " Secrets of Nature " (1569), wherein he says: " The Turkeys doth move when there is any perill prepared to him that weareth it." In his commentary on Shakespeare's Othello, Steevens remarks that the poet probably had the mystic virtues of this stone in mind when he made Shylock mourn the loss of the turquoise his wife Leah had given him before their marriage.[49] In the original text of this passage the name is spelled " turkie," and this old spelling is interesting as showing the identity of the name given to the stone with that bestowed upon the fowl known to us as a turkey. In this latter case the spelling and pronunciation have been retained, while in the former we have the modified form turquoise, both names in-

[48] Catalogue of a collection of ancient and modern rings and personal ornaments formed for Lady Londesborough, London, 1853, pp. 8, 9. Privately printed.

[49] Cited in Furness, " Variorum Shakespear," vol. vii (Othello), Phila., 1888, p. 132.

Gold puzzle rings. 1, three hoops, cruciform bezel; 2, with four hoops. Two views of each, closed and open. Seventeenth Century

British Museum

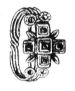

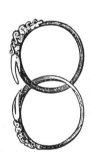

Gimmal ring, open

Edward's "History and Poetry of Finger Rings"

Silver betrothal ring; two views. On the shoulder appears the legend: "God Help." English, Fifteenth Century

British Museum

Curious old posy ring. The motto is to be read: Our
hands and *hearts* with one consent, Hath tied this *knot* till
death prevent

British Museum

Wedding rings with "posies." English, Seventeenth Century
Fairholt's "Rambles of an Artist"

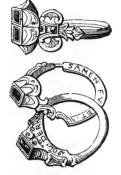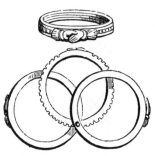

Two Gimmal rings, one double, the other triple. Betrothal or wedding rings
Fairholt's "Rambles of an Artist"

dicating an association of the respective objects with Turkey, as the land from whence they were erroneously believed to come. As Shylock's turquoise seems to have been set in a betrothal ring, it is singular to note that at the present day the turquoise is a favorite stone for betrothal rings in Germany.

In Shakespeare's Cymbeline, where the diamond is so often mentioned in connection with a ring given as a sign of faithfulness, a passage occurs denoting that this stone was sometimes set in a betrothal ring in Shakespeare's time. The line runs (Act I, sc. 4):

> This diamond was my mother's: take it, heart;
> But keep it till you woo another wife.

The preciousness and dazzling lustre of diamonds are also alluded to in this play. It is worthy of note that while in all of Shakespeare's plays the diamond is only mentioned twenty-one times, seven of these mentions are in his Cymbeline.

An emblematic wedding-ring with a deep, and perhaps somewhat ambiguous significance, was bestowed upon his spouse by Bishop Cokes. Upon it was engraved a hand, a heart, a mitre, and a death's head, the inscription reading:

> These three I give to thee
> Till the fourth set me free.[50]

A frankly humorous inscription was that placed upon the wedding-ring of Lady Cathcard when, in 1713, she wedded her *fourth* husband, Hugh Maguire. This was as follows:

> If I survive
> I will have five

[50] Evans, " Posy Rings," London, 1892, p. 13.

A similar poesy is said to have been used at a later date by John Thomas, Bishop of London, on the ring which he used at his fourth marriage:

> If I survive
> I'll make them five.[51]

The Puritan reaction in England during the Commonwealth, against the customs of the English Church, extended to the use of the wedding-ring, and Samuel Butler in his Hudibras alludes to this tendency in the following lines:

> Others were for abolishing
> That tool of matrimony, a ring
> With which the unsanctify'ed bridegroom
> Is marry'd only to a thumb.

There is a possibility that this curious custom of wearing a wedding ring on the thumb may have had some connection with the old fancy that the second joint of the thumb was dedicated to the Virgin Mary, whose supposed espousal ring is preserved in the Cathedral of Perugia. It is true that this ought rather to apply to a betrothal ring than a wedding ring. The following list gives the religious dedication of the various finger-joints: In the right hand the upper joint of the thumb was dedicated to God, the lower joint to the Virgin; the first joint of the index to St. Barnabas, the second to St. John, the third to St. Paul; the first joint of the middle finger to St. Simon Cleophas, the second to St. Thaddæus, the third to St. Joseph; the first joint of the annular to St. Zacchæus, the second to St. Stephen, the third to St. Luke; the first joint of the little finger to St. Leatus, the second to St. Mark, the

[51] *Ibid.*, p. 13.

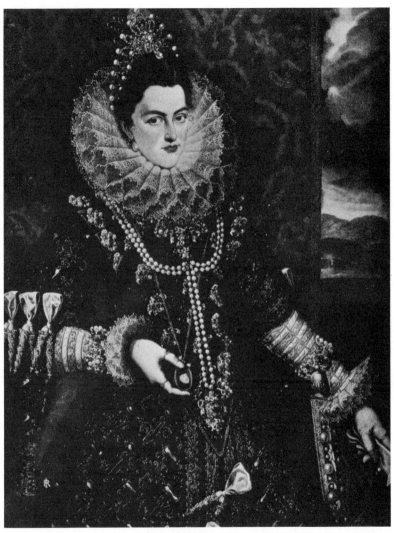

PORTRAIT OF CLARA EUGENIA, DAUGHTER OF PHILIP II OF SPAIN, BY GONZALES
Rings on thumb and index of right hand, which holds a miniature of Philip. Elaborately jewelled dress
and splendid pearl necklace and head-ornament
Museo del Prado, Madrid

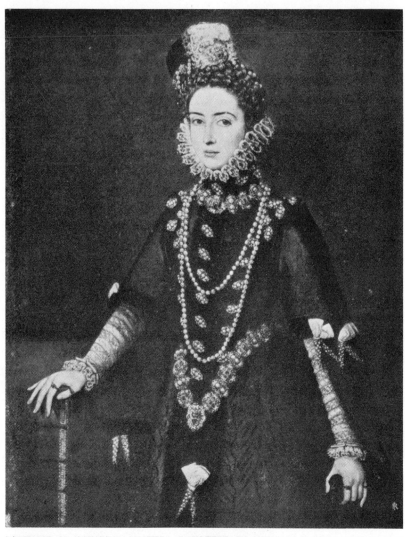

PORTRAIT OF CATARINA MICHELA, DAUGHTER OF PHILIP II OF SPAIN, BY COELLO
SANCHEZ

Thumb ring on right hand and ring on index of same hand; both with precious-stone settings. Similar rings
on index and little fingers of left hand

Museo del Prado, Madrid

third to St. Nicodemus. The dedication of the left hand fingers was: First joint of thumb, to Christ, second joint to the Virgin; first joint of the index to St. James, the second to St. John the Evangelist, the third to St. Peter; first joint of the middle finger to St. Simon, the second to St. Matthew, the third to St. James the Greater; first joint of the annular to St. Jude, the second to St. Bartholomew, the third to St. Andrew; first joint of the little finger to St. Matthaias, the second to St. Thomas, the third to St. Philip.[52]

As in Europe a couple of centuries ago, so in the India of to-day, a wedding ring is often worn on the thumb. This is of gold, about an inch wide. It is only worn, however, for a short period, sometimes only during the several days devoted to the celebration of the wedding ceremonies; in other cases, it is worn for six months, or occasionally even for twelve months after marriage. Eventually it is melted down, the precious metal being then worked up into some other ornament.[53]

The great lexicographer, Dr. Samuel Johnson, was devotedly attached to his wife, although the alliance can scarcely be looked upon as a love match on the learned doctor's side. His patient devotion to his sickly and rather ugly wife goes to show how wide is the divergence between theory and practice, for in his dictionary Johnson defines a ring as: " a circular instrument placed upon the noses of hogs and the fingers of women to restrain them and bring them into subjection." After his wife's death Dr. Johnson preserved

[52] Thomas Joseph Pettigrew, " On Superstitions Connected With the History and Practice of Medicine and Surgery," London, 1844, pp. 36, 37.

[53] Col. T. H. Hendley, " Indian Jewellery," Journal of Indian Art and Industry," vol. xii, p. 5, 1907–1909.

her wedding-ring in a box bearing the following inscription:

"Eheu! Eliza Johnson, Nupta July 9° 1736, Mortua, eheu! Mart. 17° 1752."

That the betrothal ring was occasionally worn on the index finger is shown in two celebrated seventeenth century pictures, the "Betrothal of Marie de'Medici," by Rubens, and the "Betrothal of St. Catherine," by Murillo. Sometimes, however, the little finger was chosen for this honor and an interesting example of this custom is given by a document in the Hohenzollern Museum in Berlin. Here is exhibited a list of the rings worn by Queen Louisa of Prussia on the day of her death, written down by her husband, King Friedrich Wilhelm III, and the first entry reads: "Our betrothal ring, on the little finger of the right hand." The list closes with the following simple and touching words in the King's handwriting: "At Hohenzieritz, on the most unhappy day of my life, July 19, 1810," this being the day of Queen Louisa's death. It may be noted that at the present day, while the usual custom in South Germany is to wear the wedding ring on the fourth finger of the left hand, in North Germany the right hand is generally given the preference. This applies both to men and women.

King George IV of England is said to have had two rings made, each provided with a secret spring which, on being pressed, opened a panel and revealed the king's portrait and that of Mrs. Fitzherbert, respectively. The ring containing the king's portrait was bestowed by him upon Mrs. Fitzherbert, whom he is said to have married in 1785, and that with her portrait was kept by him, and, before his death, entrusted to the Duke of Wellington, the latter promising solemnly that he would place it upon his royal master's breast when

his remains were in the coffin. Mrs. Fitzherbert left her ring to Miss Dawson Damer.[54] Another ring given by George IV to Mrs. Fitzherbert was exhibited in the Victoria Exhibition, at the New Gallery, London, and is described as being a gimmal, the two hoops closely fitting together, with the inscription " Geo. Adolph. Frederick " on the inside of one and " Maria Anne " on that of the other.[55]

In former times rings used to be presented to the chief guests at a wedding, and at the marriage of Queen Victoria with Prince Albert, six dozen such rings were bestowed, each one having a profile portrait of the bride engraved upon it, with the inscription, " Victoria Regina." The revival of this graceful custom would serve to perpetuate among the wedding guests the memory of the ceremony at which they had assisted.

Wedding rings figuring two clasped hands are still used by the peasants of Normandy, and in Galway also rings bearing two hands clasping a heart have been passed down from generation to generation, from the mother to the eldest daughter. This illustrates the general rule that long after a custom or a form of personal adornment has ceased to be in favor with the higher classes it continues to be popular with the peasantry.

The inscriptions on rings occasionally seen, which appear to be a medley of meaningless letters, are often the makeup of two names interlocked, such as "George" and " Sophia " :

GAEIOHRPGOES

the one name reading to the right and the other to the left.

[54] G. Bapst, " Les Joyaux de la Couronne," Paris, 1889, p. 18.

[55] Cyril Davenport, " Jewellery," Chicago, 1908, p. 112.

In some parts of Ireland the belief in the special
virtue of a gold wedding ring is so strong that when
the bridegroom is too poor to buy one he will hire it for
the occasion, and it is reported that a shopkeeper of
Munster realized quite a little sum annually by renting
rings for weddings, to be brought back to him after the
ceremony. Strange to say, there is said to have been a
superstitious fancy in Yorkshire, England, that to wed
with a borrowed ring would bring good luck.[56]

A Scottish tradition in regard to a ring used at a
wedding is imbued with the gloomy superstition so
characteristic of Scotland. The heir of a noble family
was about to be married to a Dutch lady of rank, but
when the wedding-day came was so apathetic, or so pre-
occupied, that he forgot the hour of the ceremony, and
had to be hurried from his breakfast to the church. In
his haste he had forgotten all about the wedding-ring,
and was obliged to use a ring offered to him by a by-
stander when the ceremony reached the point where one
had to be put on the bride's finger. What was her
terror, however, when she saw that it was a mourning-
ring that had been placed upon her hand, one bearing
the sinister design of a skull and cross-bones. This she
felt to be an omen that death would soon overtake her,
and she brooded so much over the happening that she
sank into a decline, and died before a year had passed.
The effect of the mind upon the body is so great, espe-
cially in highly nervous organisms, that such a tragic
result of a mere piece of carelessness is far from being
impossible.

In modern times betrothal rings are often of the
type called " regard rings," where the letters of a word

[56] William Tegg, " The Knot Tied: Marriage Ceremonies
of All Nations," London, 1877, p. 314.

are indicated by the initial letters of the stones set in the ring, as, for example:

R uby
E merald
G arnet
A methyst
R uby
D iamond

In a similar way the Christian name of either of the betrothed may be indicated, as, for instance:

S apphire
O pal
P eridot
H yalite
I olite
A methyst

Although a diamond ring is the one most appropriate as an engagement ring, it has long been recognized that for a wedding ring nothing can replace the simple hoop of precious metal, which may, indeed, be rendered a trifle less plain by some very chaste and beautiful engraving. A reason for the preference given to the ring without setting is offered by Fuller in his " Holy State," where he says: " Marriage with a diamond ring foreshadowed evil, because the interruption of the circle augured that the reciprocal regard of the spouse might not be perpetual." [57]

An attempt is being made in Germany to introduce the use of wedding-rings with moderate ornamentation and appropriate mottoes patterned on those of former times, in place of the severely plain gold hoop that has for a long time been decreed to be the only proper

[57] Fuller, " Holy State," chap. xxii, Of Marriage.

form of wedding-ring. If the tendency to over-orna-
mentation is kept strictly within bounds and if the
mottoes are well chosen, there is some reason to think
that the innovation, or rather revival, may meet with
some success, as it will afford scope for individuality of
taste to assert itself, and for the expression of senti-
ment in a way that has not been possible under present
conditions.

A wedding ring of iron and gold artistically com-
bined has gained some favor of late, as symbolizing the
union of strength and beauty, of the more solid with
the more brilliant qualities. The uncompromising plain-
ness of the plain gold ring, which represented a reaction
to primitive forms from the over-ornamentation of the
Rococo period, will probably give place to certain simple
and chaste designs which can be made to symbolize some
of the thoughts and sentiments connected with the mar-
riage ceremony. But the unstable, oxidizing quality of
the iron will not recommend this metal for durability.

The recurrence of a great national crisis will often
cause the revival of some custom or usage of an earlier
one. Thus it is that in the present War of Nations,
Germans have revived the practice of exchanging gold
rings for iron ones that was resorted to in the dark time
of Napoleonic supremacy in Germany. The total value
of the metal secured in this way is of course relatively
small, though not entirely negligible, but the spirit of
devotion to the Vaterland finds both a real and a sym-
bolic expression in the deposition of many a valued
heirloom on the country's altar. To avoid a rust stain
on the finger these iron rings—which usually bear the
figure of the Iron Cross—are frequently lined with a
thin layer of gold. Not only rings but gold and silver
objects of all kinds and valuable jewels have been

brought in by patriotic Germans, to such an extent, indeed, that the Viennese jewellers are urging that the metals should be immediately melted, as in case the objects or ornaments should be put on the market, they would compete disastrously with the jewellers' shops. It is stated that up to the middle of September, 1915, as many as five thousand wedding rings were donated in the single Prussian province of Posen, and the estimate has been made that about one million dollars will be realized from the total offerings throughout the Germanic countries.

The ancients and the alchemists called gold the metal of the sun and silver the metal of the moon, but within the past two centuries the world has become familiar with platinum, a metal of equal dignity with gold, but with the pure whiteness of the somewhat tarnishable silver.

Platinum, because of its durability and purity, may well be called the metal of Heaven, and within the past century we have added to our list of metals aluminum, a metal which constitutes a fair percentage of the earth's surface. This can be appropriately termed the metal of the earth. These two metals, platinum and aluminum, have been used to a great extent; platinum for the purpose of mounting jewels—the stars of Heaven, as it were, in their heavenly setting—and aluminum, the metal of earth, for a great variety of purposes.

Surely platinum, the metal of Heaven, is a most appropriate material for a wedding ring, and as gold has always been termed the metal of man, so platinum, the metal of Heaven, might be dedicated to woman, the fairest gift of Heaven, and an alliance ring made of these two metals would be an ideal matrimonial ring.

Many of those who were married before platinum

was used for wedding rings have recourse to an ingenious device by which a plate of platinum is spun or turned over the entire part of the setting which is visible, so that the gold ring will appear to be of platinum, either plain, carved or chased. Great ingenuity is required in this mounting, because it is in most cases impossible to permit the metal to do more than touch the inner part of the ring. Otherwise, the size of the circlet would be reduced. Alliance rings are sometimes made one side gold and one side platinum.

At the present time many platinum wedding rings are made perfectly plain, others are engraved with a laurel wreath, as a peace or anti-divorce symbol, with oak leaves for strength, ivy for clinging devotion, and some other symbolic devices. Many alliance rings are made of two parts, one bearing the names of the engaged couple, the other the date of the engagement. Narrow gold rings with diamond settings are also used, closely resembling the type of diamond ring that has been worn as a guard-ring for many years.

That men should be forced to wear wedding rings is a proposition recently agitated in London. Public attention was called to this question by newspaper reports to the effect that a young lady had testified at a divorce suit that she had innocently encouraged the attentions of a married man, because she had no means of knowing that he was married. In many continental countries married men are always expected to wear such rings, although there is of course no legal compulsion to do so, any more than in the case of a wife. We can hardly deny that anything serving to fix the status of both men and women in the matter of their marital relations is eminently desirable.

Apropos of wedding rings, the notice of a special

Lady's gold ring, with French motto: "*Mon cœur est à vous*" (My heart is yours)
Albert Figdor Collection, Vienna

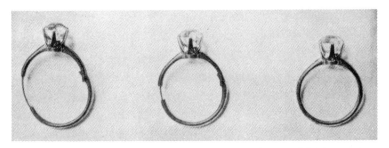

Engagement ring with adjustable hoop; fully open; half-open; and closed

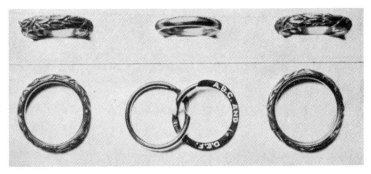

Ornamental wedding rings, and separable alliance wedding ring of "gimmal" type closed and open

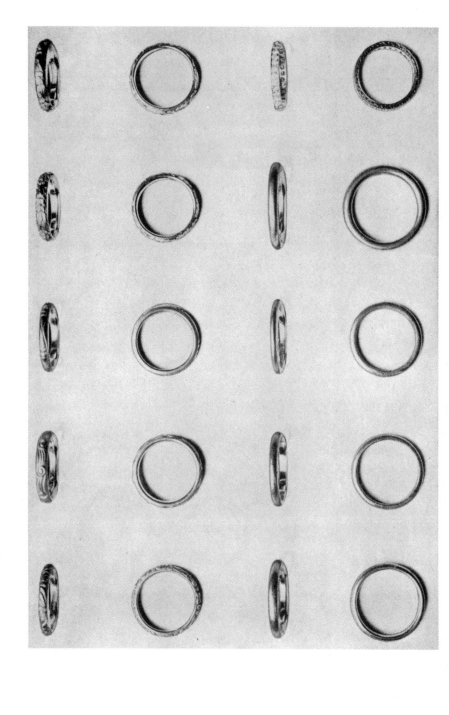

marriage ceremony performed for a man and woman who were both ardent advocates of woman suffrage, suggests that such unions might be signalized by the use of a ring of a characteristic type. In this case the parties to the marriage contract were careful to emphasize the fact that the union was one between equals, each of whom made the same pledge of fidelity and love to the other. Perhaps a ring enamelled with the suffragette colors might be acceptable to the pioneers of the new era. As in many old-fashioned marriages the woman was accorded a *de facto* primacy, the man who willingly accepts the doctrine of the equality of the sexes may be rather a gainer than a loser by his adherence to the new faith.

In England, it is said that a movement has been initiated to abolish the use of the wedding-ring, possibly in some sense as a war measure, to constitute a slight check on the use of gold for ornamental purposes. It is, however, conjectured that its real source is rather to be sought in the general movement for the complete independence of women, the wedding-ring being looked upon by some extremists as an antiquated badge of slavery. It is hardly probable that such a movement will meet with any considerable measure of success, for the idea that the ring is a symbol of faith has become too deeply rooted in the popular mind to warrant the rejection of the time-honored usage.

Perhaps the objection of the extreme advocates of " woman's rights " might be satisfied by the introduction of an interchange of rings both at engagements and marriages. This exchange of rings is an acknowledgment of the mutuality of the relation, and it has been practiced, and still is practiced in many countries on the European continent. Moreover, the introduction

of this usage in England and the United States would afford scope for a broadening of the symbolism connected with these rings, by differentiating them in some way, so that they might signify the special virtues each of the contracting parties bring to their mutual relation. This differentiation would in no wise imply any subjection, but would merely emphasize those fundamental distinctions, without which the true progress of the world would be checked. Real equality consists in the untrammeled development of the characteristic excellences, not in any arbitrary reduction of all to some preconceived standard.

Of all the marriage-medals that have been struck none can be said to equal in beauty of design and tenderness of sentiment that designed in 1895 by the great French medallist Oscar Roty (1846-1911). The obverse shows the bridegroom about to place the wedding-ring on the bride's hand, but in the very act of doing so, he is impelled to look upward, as though calling for Heaven's blessing upon his marriage. The girlish bride has her head slightly bent down in token of assent. The scene is in the open country; the figures are seated opposite to one another on plain stone seats, and the landscape background is Rafaelesque in its delicate beauty. Beneath, in the exergue, is the single word " Semper," an earnest that the solemn contract so gladly and so religiously entered into will be kept for this world and for the great future. The reverse shows a statue of Cupid on a fountain pedestal; alongside rises the trunk of a sturdy oak. On the right is ample space for a dedicatory inscription. The companion-piece, Roty's second marriage medal, executed ten or more years later, although a noble work, falls something short of his first effort. Here the bridegroom, who displays no ring,

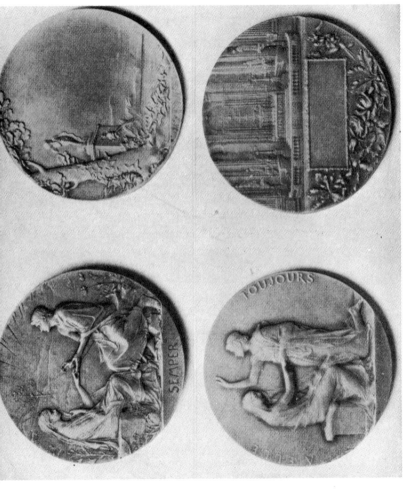

MARRIAGE MEDALS BY THE GREAT FRENCH MEDALLIST, OSCAR ROTY (1846-1911)
The upper medal shows the putting on of the wedding ring

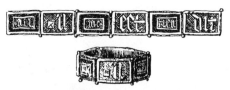

BETROTHAL RING OF GOLD IN FORM OF SO-CALLED "PUZZLE RING"

Six connecting hoops, three of them enameled, two others with clasped hands, and the sixth with a key and a winged angel's head. Seventeenth Century

Albert Figdor Collection, Vienna

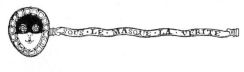

BETROTHAL RING OF GOLD

Inscribed in Old French "*Il est dit*" and "*Elle me tien*" (literally "It is said (spoken)" and "She (or it) holds me"). French. Fifteenth Century

Albert Figdor Collection, Vienna

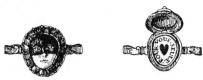

LOVE RING OF GOLD, ENAMELED AND SET WITH PRECIOUS STONES

The bezel has a lid on which is enameled a head wearing a domino mask; it is framed by seventeen rubies. When the lid is raised there appears beneath an oval, enameled with a heart, around which is the motto: "*Pour vous seule*" (For you alone). The interior of the lid is hollowed out to serve as a receptacle for hair. On the ribbon-like hoop is the inscription: "*Sous le masque la vérité*" (Beneath the mask is truth). About 1800. Formerly belonged to the great Viennese tragic actress Charlotte Wolter

kneels before the bride with uplifted head, the French motto reading " A Elle Toujours " (" Forever Hers"); on the reverse is a church altar. Under this is a plaque, enclosing which are roses, oak-leaves and acorns.

A type of ring of occasional use, not distantly related to the wedding ring, comprises the so-called "pacifying," or teething rings, generally made of ivory, rubber or celluloid, and large enough for one or two fingers of a child. Diagonally on the hoop is a flat, circular piece of the same material as that of which the ring is made, and which prevents it from slipping into the mouth of the child. Upon this flat piece is mounted a small bit of rubber or ivory for the child to suck or bite upon, to develop its teeth, or at least to keep it quiet.

What might be called a " Latitude and Longitude Ring," would be an attractive memento of engagement and marriage. There would be a narrow band showing, around it, a degree of latitude marked with longitudes, and having a small star at the place where the parties became engaged, and a double star at the spot where they were married.

A few appropriate inscriptions on modern engagement rings are as follows: " Our engagement "; " My love to thine "; " To her who merits all my love "; " To my Pet "; " To my ' Chiquita ' from Bill," this last in Spanish. In a more serious vein we have: " Time-Eternity," and " Perfect love casteth out fear." Occasionally there is a note of sadness, as appears in the inscription: " Faithful, but unhappy." A ring bearing the words " Stick to me, my darling " may show that the fiancé was a trifle distrustful of his lady love's constancy; another who sets in his ring " Firm and True " makes us infer that he had more faith. The three words " Bessie sweet sixteen " show that early engagements

sometimes occur even in our sophisticated age. On ornaments other than rings, bestowed in connection with either engagement or marriage, we read: " My heart I take not back from thee. H. B. L." and " Thine own wish, wish I thee. A. B. T. & R. V. P." A curious inscription runs: "A nasty cold face and metal eye," and we have: " For my sake wear this, it is a manacle of love." Modern wedding rings are often inscribed with pious sentiments, such, for instance, as: "All for Jesus"; " Each for the other, both for God "; " Our unity is Christ "; " Mercifully ordain that we may grow old together "; " In Christ and in Thee my comfort shall be "; " God gave thee to me "; " Through weal and through woe, to each other on earth, to God in Heaven. Always true to Bertha." A somewhat philosophic sentiment appears in the words: " Ultimate Good, not present pleasure." Latin inscriptions are now quite rare, but here is one: " Si Deus nobiscum, quis contra nos? " (If God be with us, who can be against us?)

In other cases the legend is more worldly: " Love for Love " and " He that taketh a wife hath a good thing." Let us hope that this optimist was not mistaken in his confidence. Another bridegroom declares that he, at least, has a " good thing," for he places in his ring the simple motto: " Carrie suits." If she suits him, that is enough. Lastly, we have the most satisfactory inscription of all, since it testifies to the result of one fortunate experiment; this reads: " In token of 30 years fidelity as Wife and Mother."

The use of a diamond ring for betrothals seems to have been general toward the end of the fifteenth century, for royal personages at least, to judge from a letter written from Ghent on July 30, 1477, by Dr.

Wilhelm Moroltinger to Archduke (later Emperor) Maximilian, just before his betrothal to Mary of Burgundy, daughter of Charles the Bold. This letter runs: "At the betrothal your Grace must have a ring set with a diamond and also a gold ring. Moreover, in the morning your Grace must bestow upon the bride some costly jewels." [58]

From time immemorial we have had wedding-rings, but it seems that in view of the great number of divorces now granted we might well introduce the custom of giving " divorce-rings," for at no time in the history of the Christian world have there been more divorces than at the present day. This divorce-ring might be differentiated from the old-fashioned wedding-ring by substituting the inscription A B C *from* D E F for A B C *and* D E F.

A novel idea in divorce-rings is reported from Chicago, where a fashionable divorcée had her wedding-ring made smaller so that she could wear it on the little finger of her left hand as a divorce-ring. However, we fear that if this idea should be generally adopted, the little finger would scarcely offer room for the series of rings that some of our theatrical stars would have to wear. Perhaps in some cases this wearing of the wedding-ring, even in a modified form, after a divorce, might be intended to indicate that the old love had not wholly vanished, and that some day those who had been put asunder could be rejoined, as occasionally happens now-a-days.

At weddings in Tunis, the Arabs have the custom of placing the wedding-ring upon the first finger of the left hand, and the finger and toe-nails of the bride

[58] Jahrbuch der Kunsthistorischen Sammlungen des allerhöchsten Kaiserhauses, vol. i, Pt. II, p. xxi, Wien, 1883.

receive an especially rich coloring of henna on this occasion, staining them a deep red; her eyebrows also are heavily pencilled and joined across the nose so that they form a single bar over the eyes. In order to make the home-coming as auspicious as possible, a gilded pair of horns are set above the portal of the house, along with the favorite charm known as "the hand of Fatima," believed to afford safety from the malign influence of the Evil Eye, so much dreaded in the East and in some Occidental lands also.[59]

An interesting incident in which a ring plays an important part is related in connection with the visit of Secretary, afterward President Taft, accompanied by a number of prominent Americans, to the Sulu Islands a few years ago. Mrs. Longworth, then Miss Alice Roosevelt, was one of the party, and the Sultan of Sulu, Jamalul Kiram II, expressed a great desire to be introduced to her. The favor was readily accorded, and on the day set for the interview the Sultan and several Sulu dattos, or chiefs, duly presented themselves. One of the dattos was a mortal enemy of the Sultan, but naturally on this occasion all personal or political feuds were forgotten for the time being. After the Sultan had been presented to Miss Roosevelt, came the turn of the rebellious datto, who approached the sprightly young American girl, greeted her, and presented to her a native pearl of great beauty, which was graciously accepted.

The chagrin of the Sultan may easily be imagined, for he had forgotten to provide himself with a suitable gift, and now his mortal enemy was basking in the sunshine of favor, while he himself, the lord paramount,

[59] Johnson, "Tunis of To-day"; in the National Geographic Magazine, vol. xxii, p. 747; No. 8, Aug., 1911.

was neglected. Suddenly his eye fell upon a ring set with a magnificent pearl which he wore on his left hand. He immediately took off this ring, and again approaching Miss Roosevelt, gave it to her. As the Sultan's pearl far exceeded in beauty and value that given by the datto, the former's dignity was cleared of all reproach and the situation was saved. A curious sequel to this incident was the circulation of a report in the press to the effect that the Sultan of Sulu had made an offer of marriage to Miss Roosevelt. This proved how closely the gift of a ring is associated with the idea of engagement or marriage.

A Pennsylvania (U. S. A.) court has been called upon to decide whether the gift of an engagement ring bestowed by a man just prior to a declaration of bankruptcy, should be looked upon as a transfer of assets to the prejudice of the creditors. The fact that in this case the fair recipient of the ring was a jeweller's daughter might be thought to render it likely that this particular engagement ring was of substantial intrinsic value. The court reserved its decision.

A choice of pretty " posies " for rings was offered to seventeenth century readers in a London publication entitled " Love's Garland; or Posies for Rings, Handkerchiefs and Gloves, and Such Pretty Tokens as Lovers Send Their Loves." Unyielding constancy found expression in the couplets:

> Where once I choose
> I ne'er refuse.

> Hearts content
> Can ne'er repent.

Another verse makes a very modest claim for an expression of gratitude on the part of the recipient:

> The sight of this
> Deserves a kiss.

The warmth of reciprocated love is thus asserted:

> In thee a flame
> In me the same.

Another lover wishes to proclaim that his love will rise superior to all offenses:

> No bitter smart
> Can change my heart.

A more serious and trusting posy runs:

> To me till death
> As dear as breath.

A ring mentioned in an old English record dating from 1473, offers apparently an early example of a so-called " posy " ring. It is here termed a " hope rynge with scrytorio " (inscription) ; this, together with a brooch adorned with the figure of a " jyntylle woman," was pledged with a certain Richard Walker to secure a small loan of £4 8d.[60]

A good example of a " ring posie " is given by Ben Jonson in his play " The Magnetic Lady, or Humours Reconciled," first licensed for performance in 1632, during the reign of Charles I, and but five years before Jonson's death. Here, when bride and groom come before the parson to be wedded, he asks the bridegroom:

Have you a wedding ring?

[60] Historical Manuscripts Commission, Twelfth Report, Appendix, Pt. IV, MSS. of Duke of Rutland at Belvoir Castle, vol. i, London, 1888, p. 6.

To which the latter replies:

> Ay, and a posie:
> Annulus hic nobis, quod sic uterque, dabit.

This the parson quickly renders as follows:

> This ring will give you what you both desire;
> I'll make the whole house shout it, and the parish.

On other pages a number of characteristic and striking ring-inscriptions are given, but in view of the wide range of these " posies " (poesies) and mottoes, a fairly full list of them, compiled from various sources, may be of interest here.[61] The French mottoes are nearly all in Old French, and the English spellings of those of the seventeenth century are delightfully irregular.

> Till death divide.

> *Nemo nisi mors.*
> (No one but Death).

> *Tout pour bein feyre.*
> (All to do well).

> *In bone fay.*
> (In good faith).

> *Sans mal desyr.*
> (Without evil wish).

> *Amor vincit om.*
> (Love conquers all things).

> Till my life's end.

[61] A number of posies of the list comes from Joseph Maskell's excellent little monograph, " The Wedding-Ring," London, 1888, pp. 31–35.

Erunt duo in carne una.
(They shall be two in one flesh).

Semper amemus.
(May we love forever).

In Christ and thee my comfort be.

Honeur et joye.
(Honor and joy).

Let reason rule affection.

God continue to love us.

Mon cur avez.
(You have my heart).

Deux corps ung cuer.
(Two bodies and one heart).

Amour et constance.
(Love and constancy).

God unite our hearts aright.

Knit in one by Christ alone.

God's providence is our inheritance.

Our contract was heaven's act.

In thee, my choice, do I rejoice.

God above increase our love.

My heart and I, until I dye.

Not two, but one, till life be gone.

When this you see, remember me.

Julia is mine own peculiar.

I cannot show the love I O.

We strangely met, and so do many,
But now as true as ever any. 1658.

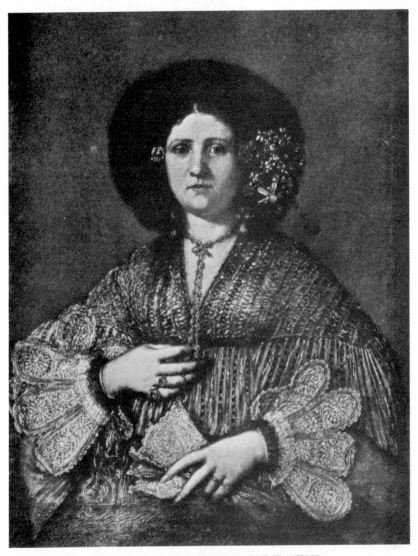

PORTRAIT OF YOUNG WOMAN. DUTCH SCHOOL

Large rings on little fingers of right and left hands; large ring on third joint of left-hand fourth finger, and smaller one on second joint of the same finger; plain gold ring (wedding ring?) on fourth finger of left hand

Kaiserliche Gemälde-Galerie, Vienna

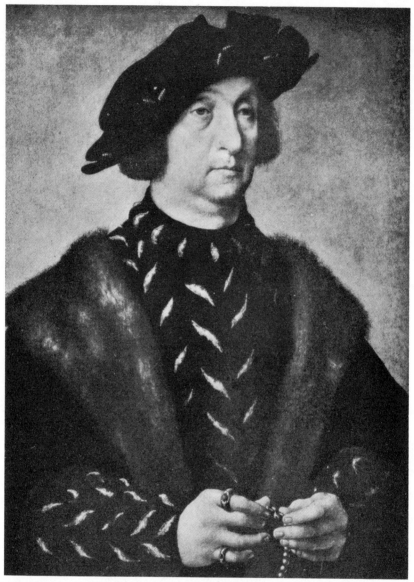

PORTRAIT OF A MAN, BY THE ARTIST KNOWN AS THE "MASTER OF THE DEATH OF MARY,"
FROM HIS MOST NOTED PICTURE
Rings on index and little fingers of right hand
Königliche Gemälde-Galerie, Cassel

As we begun, so let's continue.

My beloved is mine, and I am hers.

True blue will never stain. 1653.

Against thou goest, I will provide another. **1658.**

In loving thee, I love myself. 1658.

Let him never take a wife,
That will not love her as his life.

A heart content cannot repent.

I do not repent I gave consent.

No gift can show the love I owe.

What the heart saw the love hath chosen.

Love one little, but love one long.

Love him who gave thee this ring of gold,
'Tis he must kiss thee when thou art old.

This circle, though but small about,
The devil, jealousy, will keep out.

If I think my wife is fair,
What need other people care? 1653.

God's appointment is my contentment.

Love, I like thee; sweet, requite me.

With heart and hand at your command.

My heart in silence speaks to thee,
Though absence barrs tongue's liberty.

Faithful ever: deceitful never.

I like, I love as turtle dove.

As gold is pure, so love is sure.

Despise not mee: y^t joyes in thee.

If you deny, then sure I dye.

Your right is my delight.

As true, bee just.

No better smart shall change my heart.

This ring is a token I give to thee,
That thou no tokens do change for me.

My dearest Betty is good and pretty. 1658.

I did commit no act of folly,
When I married my sweet Molly. 1658.

'Tis fit no man should be alone,
Which made Tom to marry Joan. 1658.

Sue is bonny, blythe, and brown;
This ring hath made her now my own. 1658.

Like Phillis there is none:
She truly loves her Choridon. 1658.

My life is done when thou art gone. 1653.

This hath no end, my sweetest friend:
Our loves be so, no ending know.

God send her me my wife to be.

As God decreed so we agreed.

Take hand and heart, I'll ne'er depart.

Love and dye in constancy.

A virtuous wife that serveth life.

As long as life yr loving wife.

I will be yours while breath endures.

Love is sure where faith is pure.

A virtuous wife doth banish strife.

God did forsee we should agree.

Love me, and be happy.

None can prevent the Lord's intent.

Virtue surpasses riches.

Let virtue rest within thy breast.

Time lesseneth not my love.

Joye without end.

Let lykinge last.

This and giver are thine for ever.

Think on mee.

Let love increase.

Thou art my star, be not irregular. 1653.[62]

Without thy love I backward move. 1613.

Thine eyes so bright are my chief delight. **1653.**

This intimates true lovers' states. 1653.

Thou wert not handsome, wise, but rich;
'Twas that which did my eyes bewitch. 1658.[63]

As we begun, so let's continue. 1658.

What the eye saw the heart hath chosen. **1658.**

More faithful than fortunate. 1658.

Constancy and heaven are round,
And in this the emblem's found.

As God hath knit our hearts in one,
Let nothing part but death alone.

[62] From the " Card of Courtship, or the Language of Love,"
published in 1653; cited in Tegg's " The Knot Tied," London,
1877.

[63] From " The Mysteries of Love and Elequence," London,
1658; in Tegg's " The Knot Tied."

God our love continue ever,
That we in heaven may live together.

Weare me out, love shall not waste,
Love beyond lyvie still is placed.

Weare this text, and when you looke
Uppon your finger, sweare by th' booke.

There is no other, and I am he,
That loves no other, and thou art she.

Eye doth find, heart doth choose,
Faith doth bind, death doth loose.

As God hath made my chyce in thee,
So move thy heart to comfort me.

God yt hath kept thy heart for mee,
Grant that our love may faithful bee.

Fear ye the Lord then rest content,
So shall we live and not repent.

Divinely knit by grace are wee,
Late two, now one, ye pledge here see.　**1657.**

Breake not thy vow to please the eye,
But keepe thy love, so live and dye.

Love thy chast wife beyond thy life.　**1601.**

I love the rod and thee and God.　**1646.**

Pray to love; love to pray.　**1649.**

More weare—more wear.　**1652.**

Endless as this shall be our bliss.　**1719.**

Be truly wise lest death surprise.

Live in love and fear the Lord.

Godly love will not remove.

United hearts death only partes.
You and I will lovers die.
We joyn our love in Christ above.
God gives increase to love and peace.
God did decree our unitie.
Heart content cannot repent.
Live, love, and be happie.
Noe heart more true than mine to you.
In thee I find content of mind.
A blessing we do hope to see.
In love divine we love to joine.
Hearts united live contented.
In love and joy I will live and die.
In thy breast my heart shall rest.
The love is true that I.O.U.

My love is fixed I will not range.
I like my choice too well to change.

This is the thing I wish to win.
My promise past shall ever last.
Well projected if accepted.
God thought fit this knott to knitt.

Thy Desart hath won my heart.
True love is the bond of peace.
Let our contest be who loves best.
Thine eyes so bright are my chief delight.
Our loves be so no ending know.
My pledge I prove of mutuall love.
Gift and giver, your servants ever.

Lel ami avet.
(Thou hast a loyal friend).

Remember Him who died for thee,
And after that remember me.

Take hand and heart, ile ne'er depart.

Breake not thy vow to please the eye,
But keepe thy love, so live and dye.

I will be yours while breath endures.
I am sent to salute you from a faithfull friend.
This and my heart.
Too light to requite.
Your sight, my delight.
For a kiss, take this.
My heart you have and yours I crave.
The want of thee is grief to mee.

Privata di te moriró.
(Deprived of thee I shall die).

Mon esprit est partout,
Mon cœur est avec vous.
(My mind is everywhere,
My heart is with you).

Faithfull ever, deceitfull never.

God's blessing be on thee and me.

Love him in heart whose joy thou art.

A loving wife prolongeth life.

Desire hath set my heart on fire.

Both or neither, chuse you whether.

Parting is vayne when love doth remayne.

SOME RINGS IN THE MUSEUM OF FINE ARTS, BOSTON

1, silver and gilt; pierced with scrolls and the "Little Monk" of Munich. Modern. Bavarian. 2, Tyrolese. Peasant's engagement ring of silver with design of two hearts and scrolls. 3, French (?). Said to have belonged to a collateral branch of the Montmorency family. Gold, large garnet with emerald each side; the crown composed of pearls and small diamonds. Bought in London. 4, Chinese ornament. 5, heavy silver, set with malachite. 6, Chinese ornament. 7, Italian (?). Peasant's engagement ring of silver. 8, Italian. Gold, set with a turquoise, a horse's head in white enamel at either side. 9, Tyrolese. Silver, set with a chamois tooth for good luck. 10, French. Bishop's ring of gold and silver. Enameled bezel set with an almandine and diamonds. Bought in Geneva. 11, Italian. Sixteenth Century style. Gold set with a garnet. 12, Italian (?). Silver, set with a large crystal (?). Black and white enamel on bezel. 13, Italian. Gold, set with a cluster of red and green stones alternating; a crystal in the centre. 14, gilt, set with red glass (?). 15, bronze, decoration in relief. 16, Italian. Gold set with turquoises. 17, French (?). Gold, set with a brilliant. 18, Laplandish. Silver-gilt with pierced design

Fig. I.

JACQUES GUAY, COURT GEM ENGRAVER OF LOUIS XV, ENGRAVING GEMS IN HIS WORKROOM AT THE LOUVRE

Mariette, "Traité des Pierres Gravées," Paris, 1750

I fancy none but thee alone.

God sent her me my wife to be.

This is your will, to save or kill.

If you deny, then sure I dye.

Your sight, my delight.

Joyfull love this ring do prove.

In thee I prove the joy of love.

Silence ends strife with man and wife.

This ring doth binde body and minde.

Death never parts such loving hearts.

Body and mind in thee I finde.

Ryches be unstable
 And beauty will dekay,
But faithful love will ever last
 Till death dryve it away.

One of those posies might seem to refer covertly to the length of the foregoing list:

This hath no end, my sweetest friend. **1653.**

The sacred and peculiar quality of a ring that has been given to a man by his wife as a memorial of marriage is expressed in strong terms in Shakespeare's Merchant of Venice (Act v, sc. 1). One of these rings was given by Nerissa to Gratiano, the other by Portia to Bassanio. When Gratiano is charged with having parted with his ring, he defends himself by making light of it but is rebuked for this by Nerissa. The verses run as follows:

Gratiano: . . . a hoop of gold, a paltry ring
 That she did give me, whose posy was
 For all the world like cutler's poetry
 Upon a knife, "Love me, and leave me not."

Nerissa: What talk you of the posy or the value?
 You swore to me, when I did give it you,
 That you would wear it till your hour of death,
 And that it should be with you in your grave.

Portia, joining in Nerissa's feigned rebuke, says:
 You are to blame, I must be plain with you,
 To part so lightly with your wife's first gift;
 A thing stuck on with oaths upon your finger
 And so riveted with faith unto your flesh.
 I gave my love a ring and made him swear
 Never to part with it; and here he stands;
 I dare be sworn for him he would not leave it,
 Nor pluck it from his finger, for the wealth
 That the world masters.

Bassanio, however, is forced to confess that he, too, has relinquished his ring. Of course, as all readers of Shakespeare know, both Portia and Nerissa have these rings in their own possession, since they themselves were, in disguise, the judge and the clerk to whom Bassanio and Gratiano unwillingly yielded them.

While the finger-ring was known to the Chinese from a very early period, it never seems to have enjoyed great favor with them. According to primitive court etiquette in that land, the Emperor's " leading lady "—for the time being—had to wear a silver ring at court. In case she presented her sovereign with a descendant, she was rewarded by the gift of a gold ring, which she wore on one of the fingers of her left hand. About the mid-period of the Han dynasty (206 B.C.–221 A.D.) nephrite (jade) rings were known as well as those with stone setting but they were only rarely used as ornaments.[64]

[64] T. Wada, " Die Schmuck- und Edelsteine bei den Chinesen," Tokyo, 1904, reprint from the " Mitteilungen " of the Deutsche Gesellschaft für Natur- und Volkeskunde Ostasiens, vol. x, Pt. I.

VI

THE RELIGIOUS USE OF RINGS

THE adornment of rings with religious emblems, and their use as insignia of office for the higher ecclesiastics and for the priests of the ancient ethnic religions will be considered in the present chapter. Of special interest are the rings used by Roman Catholic popes, cardinals and bishops, the usage in this direction having varied considerably in the different periods. With regard to the engravings on many ancient rings it may often be difficult, however, to know whether a religious symbol, or the conventional figure of a divinity, has been used in a strictly religious sense, or merely for ornamental purposes.

The employment of rings as religious symbols is often bound up with their use in some other way, as in the case of many seal rings for instance. This was undoubtedly the case with a large number of the ancient rings noted in earlier chapters. Here we have endeavored to group together those which were more exclusively religious in their character, the ecclesiastical rings, especially those worn by Roman Catholic popes, cardinals and bishops, constituting of course a large part of these. A very few examples will serve as brief illustrations of the religious use of rings in pagan times.

There is in the Louvre, among the Egyptian antiquities, a gold ring engraved with figures of two horses. The symbol of the Sun-God which it bears is believed to signify the gratitude of Rameses II—to whom this

ring is attributed—for the aid of the divinity in secur-
ing the king's victory over the Khetas in one of his
Asiatic campaigns. Unquestionably many of the en-
graved scarabs set in Egyptian rings had a specifically
religious significance, and the same is true of the en-
gravings on the chatons of gold rings, as, for example,
in the case of that worn by the priest in charge of the
Pyramid of Cheops (Khufu). Some of these have
already been described in the chapter on signets, the
essential use of these rings being for sealing. In many
other cases the presence of a divine name as a com-
ponent of the royal name, or in a royal title, probably
had not much more of a distinctly religious meaning
than the " Dei Gratia " on the coins of European rulers.

The rings worn by the high priests of Jupiter (flam-
ines Diales), who had, ex-officio, the rank of senators,
were made hollow and of openwork. This particular
form is said to have been chosen for mystic and symbolic
reasons, as showing that everything indicating hardness
or severity, the restriction of liberty, or arduous labor,
was to be held aloof from this flamen, who, with those
of Mars and Quirinus (Romulus), belonged to the
group of greater priests selected from the patrician
order.[1] The conjecture that we should seek here the
origin of Christian episcopal rings is very far-fetched,
the general symbolism of the ring as an emblem of
eternity, and its bestowal as a mark of rank, having
been probably sufficient determining factors.

No one, man or woman, was permitted to enter the
sanctuary of the " Mistress " at Lycosura, wearing a
ring on any finger; only rings destined for dedication

[1] Pompei Fasti, " De verborum significatu," lib. xx, s. v.
Edera, ed. of Ed. Thewrewk de Ponor, Budapest, 1889, p. 58.

might be brought into the temple.[2] This is attested by an inscription from the second century B.C.; the regulation must, however, date from an earlier period. The same prohibition as to wearing rings was decreed in the case of all those who wished to seek for enlightenment from the oracle of Faunus, and the petitioners were also required to abstain from meat and to preserve their chastity. The ring was supposed to interfere with the freedom of the spirit to receive the divine grace or counsel.[3]

Of rings apparently dedicated to some deity, the rich British Museum collection has several examples. A bronze ring, having a thin rounded hoop, to the ends of which a transverse oval plate has been soldered, bears an inscription in Greek letters signifying " Great is the name of Serapis "; this ring is late Roman, from a time when the worship of Serapis was wide-spread in the Roman world. An octagonal ring of solid gold may have been dedicated to Apollo, as it is engraved with the name of this divinity; the two sides of the octagon flanking the central one bear, respectively, engravings of a crescent and of a star. An inscription found in Delos records several rings dedicated to the Delian temple by Stratonice, wife of Seleucos I, Nicator (365–281 B.C.). One of these was a gold ring, set with a sard on which was engraved the image of Apollo, the temple god; a gold ring dedicated to both Apollo and Artemis, and having the image of a Victory; and another gold ring, set with a stone on which was engraved an inscription

[2] Adolf Furtwängler, " Die Antiken Gemmen," Leipzig and Berlin, 1900, vol. iii, p. 446.

[3] F. G. Frazer, " The Golden Bough," vol. iii, London, 1911, p. 314.

signifying that it was dedicated by Queen Stratonice, daughter of Demetrius, to the Artemis of Delos.[4]

In a list of jewels dedicated to Isis, engraved on the base of an ancient statue of that goddess at Alicante, Spain, four rings are noted. Two of them had emerald settings, while the other two, placed on the little finger of the statue, were set with diamonds. This inscription contains the name of the donor, Fabia Fabiana, and the statement that the gift was made on behalf of her granddaughter Avita. The statue has disappeared, but the inscription still calls to mind the honor it received in long past time and the brilliancy of the jewel decoration, for beside the rings, a pearl and emerald earring was inserted in either ear; about the neck was a necklace of four rows of emeralds and pearls; two circlets composed of eleven beryls and two emeralds clasped the ankles, and two bracelets set with eight emeralds and eight pearls spanned the wrists. [5]

There does not appear to have been any " Rabbi's Ring " worn as an insignia of office, although many rabbis owned and wore engraved rings, perhaps using them as signets. Of this class may be an old ring referred to the time of Judah Hanasi (175–247 A.D.), now in the Albertinus Home in Dresden, Saxony. It is set with an amethyst on which has been engraved the seven-branched candlestick, one of the adornments of the Temple and figured on the Arch of Titus, in Rome, as among the treasures borne off by the victorious Romans after the fall of Jerusalem in 70 A.D. Rabbi Judah

[4] F. H. Marshall, " Catalogue of the Finger Rings, Greek, Etruscan, and Roman, in the . . . British Museum," London, 1907, pp. xxix, xxx, Nos. 629, 640.

[5] Montfaucon, " L'antiquité expliqué," vol. ii, Pt. II, Paris, 1719, pp. 324, 325; Plate 136.

ben Ezekiel (220–299 A.D.) had a ring showing the figure of a man's head. The design on a ring of Rabba bar Rabbi Huna (ca. 300 A.D.) depicted a palm, while on a fifth century ring worn by another Rabbi Judah Hanasi was engraved the figure of a fish.[6]

The following principal symbolic or typical designs have been observed upon early Christian rings:[7]

The lyre, rare.

A ship, denoting the life-voyage of the Christian to the port of salvation.

An anchor, emblem of constancy and of hope.

A dove, symbolical of innocence and typical of the Holy Spirit.

Alpha and Omega, the Greek characters, first and last of the alphabet. Symbol of Christ, as in Rev. i, 8: " I am Alpha and Omega, the beginning and the ending, saith the Lord."

The Monogram of Christ formed of the first two Greek letters of the name Christos, the so-called Chrisma combining the X (Ch) and the P (r).

The Good Shepherd, with the lost sheep on his shoulder.

Scenes from the life of Christ.

Episodes of the story of Jonah, as Jesus cited this story when speaking of the Resurrection.

Daniel in the Lion's Den, a triumph of faith which must have appealed strongly to the Christians in time of persecution, when those of the faith were often given as prey to wild beasts.

[6] Communicated by Prof. Cyrus Adler of the Dropsie College for Hebrew and Cognate Learning, in Philadelphia, the information being derived from the Hebrew Encyclopædia entitled " Ozar Yisrael," vol. v, p. 6, col. i, s. v. Tabaath. Prof. Richard Gottheil of Columbia University confirms the views expressed by Prof. Cyrus Adler that the ring was never the distinguishing mark of a Rabbi.

[7] Abbé Barraud, " Des bagues à toutes les époques," Bulletin Monumental, vol. xxx, pp. 624–641.

Elijah borne to heaven, probably typical of the resurrection.

Orpheus playing on the lyre. This pagan design was given a Christian meaning, mainly because of certain spurious Orphic poems foreshadowing the birth of Christ.

Fall of Adam and Eve. Here the meaning is quite obvious: "As in Adam all died so in Christ shall all be made alive," as the apostle Paul wrote.

The Ark of Noah; God's promise to save mankind.

A lion, evidently signifying the Lion of the Tribe of Judah, applied to Christ.

A lamb, typical of Christ and of Christians. In the Gospel of John, ii, 36, John the Baptist exclaimed on seeing Jesus: " Behold the Lamb of God."

A hare. This may denote the dangers which so often menaced the early Christians, who had to be constantly apprehensive, as a hare is of the hunters.

A phœnix; naturally figuring the Resurrection.

A peacock. This has a similar meaning, for the peacock, Juno's bird, had been used by the Romans as an emblem of the apotheosis of an empress.

A cock, as awakener of grace, and typical of the awakening of mankind to the true faith.

A serpent. This may seem strange as a Christian symbol, but it denotes foresight, and recalls the Gospel monition, " Be ye wise as serpents and harmless as doves." A Christian gem evidences this interpretation, for on either side of the serpent is figured a dove.

The vine; suggested by the words of Christ: " I am the vine and ye are the branches."

A blade of wheat. The harvest of souls?

The symbolic design of a ship traversing the sea was used in early Christian funeral sculptures, and also in pagan Rome, to denote the course of life. For the Christians the tempest-tossed vessel of life found its port and resting place in death. This idea is rudely figured in a design on a sepulchral stone, in memory of

a certain Firmia Victoria, from one of the early Christian cemeteries of Rome. On it appears a ship riding the waves, and in the background a four-storied tower from which rises a flame, the lighthouse marking the final port toward which the vessel bends its course.[8]

Of the few designs engraved upon Græco-Roman rings which were permitted to the early Christians, the dove, as has been noted, symbolized the Holy Spirit; a fish became a Christian symbol because the Greek word for fish (*ichthus*) gave the initial letters of Iesus Christos, Theou huios, Soter (Jesus Christ, The Son of God, the Saviour). An anchor, or the representation of a fisherman, recalls to mind the Fisherman's Ring of the Roman pontiff.

The fish symbol appears on an engraved Gnostic gem bearing the head of Christ surrounded with the Greek letters of his name. This offers one of the types current in the third and fourth Christian centuries. We have the testimony of St. Augustine that the diversity of types in his time was very great, and that no record remained of what Christ's physical appearance really was.[9] The oldest portrait is believed to be that on the ceiling of a chapel in the cemetery of St. Calixtus at Rome, and the type presented here is that which has persisted essentially to the present day.

The ring of the Christian martyr Saturus was a precious memorial of his death for the faith. When he had already received his death-blow, he took off his ring and moistening it with the blood that was flowing

[8] Raoul Rochette, " Tableau des Catacombes de Rome," Paris, 1837, pp. 235, 236.

[9] S. Augustini, " De trinitate," lib. viii, cap. 5, 6. Figured in Raoul Rochette, " Tableau des Catacombes de Rome," Paris, 1837, title page.

from his wound, handed it to the Roman soldier,
Pudeus, who was present at his death, but was a secret
convert to the Christian faith, charging the soldier to
guard it as a heritage and a reminder that true faith
was rather confirmed than weakened by the martyr's
death.[10]

A tender and beautiful allusion to a religious ring
is contained in the account of the life and death of St.
Marcina the Younger (ca. 330–379 A.D.), by her
brother St. Gregory Nyassa. When, after the death of
this pious daughter of Basil the Great, her body was
being prepared for burial, there was found, suspended
by a cord from her neck and resting just over her heart,
an iron ring. On its chaton was engraved a cross, and
in a hollow space beneath was secreted a small fragment
of the True Cross. This ring the brother removed, de-
claring that it should be his precious heritage, the more
sacred that it recalled the cross of Christ, not only by
its engraved design, but still more by the priceless
memento placed beneath this.[11]

An antique ivory ring found at Arles in France
bears inscriptions denoting that it had been designed
for use as a Gnostic amulet, and illustrating the peculiar
eclecticism of Gnostic belief. The monogram of Christ
appears here between the two Greek letters A and Ω,
symbolizing the beginning and the end [12]; added to this
is the name ΑΒΡΑΣΑΞ (Abrasax, Abraxas), the favorite
designation of the Creative Energy among the
Gnostics.[13]

[10] Ruinart, "Acta sanctorum martyrum sincera et selecta,"
Paris, 1689, p. 40.

[11] Gregorii episcopi nysseni, " Opera," vol. iii, in Migne's
Patrologia Græca, vol. xli, Parisiis, 1858, col. 990.

[12] See Rev. I, viii.

[13] C. W. King, "Antique Gems," London, 1860, p. 358.

A Christian talismanic ring in the British Museum is set with a red jasper upon which is engraved, in Greek characters: ιησογς οεογ γιος θηρε, "Jesus son of God, preserve (me)."[14] To jasper at all times has been accorded a high rank among talismanic stones, more especially to the green and red varieties, the latter being particularly favored where protection was sought against death from wounds or hemorrhage.

Oriental Christian rings include many unusual types. The British Museum has one of gold, with engraved and nielloed ornament; on the flat octagonal hoop is depicted the Annunciation, in the rigid, hieratic style of Byzantine art. The Virgin is seated on a high-backed chair; before her stands the archangel Gabriel. The hoop bears as inscription the first words of the angel's greeting, in Greek characters Χαῖρε κεχαριτωμένη ὁ Κύριος μετὰ σὁυ (Luke i, 28: "Hail thou that art highly favoured, the Lord is with thee."). This ring is believed to belong to the seventh century A.D., and is a very characteristic example of the type.[15]

Three Merovingian rings found in August, 1885, on the skeleton finger of a woman, at Aigusy, dept. Aisne, offer proof that in this period many rings were sometimes worn on a single finger. The upper and lower are plain silver rings, but the central one, of bronze, has a circular bezel on which is engraved a cross, with, at its angles, the nails of the Passion. Another ring, from the same locality, with a cross of simpler form engraved on the chaton was found attached to a chain. Both ring and chain are of bronze, the ring, presumably

[14] King, "The Gnostics," London, 1864, p. 139.

[15] O. M. Dalton, "Franks Bequest, Catalogue of the Finger Rings, Early Christian, Byzantine, Teutonic, Mediæval and Later [British Museum]," London, 1912, p. 7, No. 39.

a signet, having been worn suspended by the owner, instead of on the hand. A silver ring from the same French department, bears the Latin inscription V I V A S, and in six compartments the following symbolic figures: a dove holding a branch; a lamb, above which is a star; an upright palm; a stag; a fantastic animal figure, and a hare. These symbols, most of which are characteristically Christian, and the Latin invocation " mayst thou live," *vivas,* usually followed by the words " in Deo " (in God), point clearly to the religious faith of the owner of the ring. It is true that the presence of a gold solidus of Valentinian II (375–392) in the mouth of the deceased person, as " Charon's toll," might be thought to indicate that we had here to do with a pagan, were it not well known that this custom was maintained to some extent after the decisive triumph of Christianity.[16]

According to Mercato a toadstone set in a silver ring was preserved in the Monastery of Saint Anne in Rome. The popular belief was that this ring had belonged to the Virgin Mary, and it was considered to be a cure for fistulas, if the stone were rubbed around them twelve times.[17]

The ring known as the betrothal ring of the Virgin Mary, now in the cathedral of Perugia, has had a long and eventful history. The following details are taken from a monograph written by Abbot Adamo Rossi. According to the legend, this ring was given by Mary to St. John, the " beloved disciple," and was taken by him to Rome in 95 A.D. Here it seems to have come into the possession of the Romans, and about 275 A.D.

[16] M. Deloche, " Étude historique et archéologique sur les anneaux sigillaires," Paris, 1900, pp. 139–142, figs.

[17] Mercati, " Metallotheca Vaticana," Romæ, 1719, p. 185.

it was in the hands of Mostiola, a cousin of Marcus Aurelius Claudius, and a convert to Christianity. In the reign of Aurelian began what was known as the eighth persecution of the Christians, and Mostiola was obliged to flee from Rome. She sought refuge in Clusium, the ancient capital of the Etruscans, the Chuisi of a later time, but she was seized by the Roman authorities and died a martyr's death. In the eighth century a church was erected at the spot where she was buried and the ring was guarded therein as a precious relic.

About the middle of the thirteenth century this ring was transferred, for greater security, from the Church of St. Mostiola, which lay outside the city, to the cathedral, where it was seen, April 17, 1355, by Emperor Charles IV, on his return from his coronation. In 1420, by order of the bishop, the ring was taken to the Church of St. Francesco. There was a belief that a mysterious virtue emanated from it which acted miraculously upon the sight of those who gazed upon it. Learning of this, Filippo Maria, Duke of Milan, who suffered from a disease of the eye, requested, in 1445, that the ring might be brought to him. Although Pope Eugene IV supported his request, the historian inclines to the belief that nothing came of the matter, *for the Duke became completely blind a year later.*

Among the Franciscan friars who had the care of the ring was a certain " Fra Vinterio " (Winter), called " the German," from the land of his birth. Possibly because he was a foreigner, he became an object of dislike, and upon the occurrence of a robbery of some articles of value, his fellow monks eagerly seized upon the occasion to fix the guilt upon the unfortunate Winter. He was cast into prison and subjected to the

most cruel tortures, but as no avowal could be wrung
from him, he was finally released and resumed his life
in the community. However, although outwardly calm,
the cruelties to which he had been subjected burned into
his soul, and aroused thoughts of vengeance. He could
think of but one way to punish his tormentors effectively,
and that was by taking away the precious ring. If this
were lost, the Chiusans would place the blame upon its
careless guardians and would perhaps drive them from
the city. Winter succeeded in taking wax impressions
of the keys of the chamber where the ring was kept and
of the case wherein it lay. He had duplicate keys made
from these impressions, and, on the night of July 23,
1473, he secured possession of the ring. Of course he
was no longer safe in Chiusi and he made all haste to
Perugia, where he determined to rid himself of his treas-
ure and curry favor with the Perugians by conferring it
upon them. His offer was accepted without hesitation,
and when the Chiusans energetically demanded the re-
turn of the ring, the Perugians refused compliance.

The matter was brought before the Roman court
and was the subject of prolonged controversy. For a
time it seemed as though resort would be had to arms,
but finally, in 1486, a decision was reached to the effect
that the ring should remain in Perugia. Here it has
been preserved ever since, and many wonderful stories
are told of its miraculous virtue. In seasons of pro-
longed drought and also when the land was deluged by
superabundant rains, the betrothal ring of the Virgin
was solemnly borne from the chapel of St. Joseph, where
it was kept, to the high altar, and the result was always
fortunate.

Whatever may be thought of the credibility of the
legend, there can be no question that this ring is one of

the most highly prized relics. It is of chalcedony, and its form seems to indicate that it was at one time set with a precious stone. On only four days in the year, March 19, the second Sunday in July, July 30, and August 2, can this unique ring be seen by the public.

The betrothal ring of the Virgin is in the Capella del Santo Anello, in the left aisle of the Cathedral, where the celebrated painting by Perugino, the Spozalizio, now at Caen in Normandy, was preserved until 1797, when it was taken off by the French invaders. The ornate tabernaculum was executed by the goldsmith Cesarino del Roscetto in 1519.

The espousal ring of St. Anne, mother of the Virgin Mary, was preserved in the monastery of St. Sylvester, at Rome. It is of unwrought silver, with a clear crystal set in the middle, surrounded by black spots and opaque at the back, so that it reflects images, just as does a mirror. On the festival of the betrothal of St. Anne, the eyes of those whose sight was weak were touched with the ring.[18] The curative results of this application were doubtless all that could be desired, more especially as weak sight is often caused by nervous depression, or nervous derangements.

The body of St. Caius, martyred in 296 A.D., was exhumed from the Cemetery of Calixtus, in Rome, on the anniversary of the sainted pope's birth, April 21, 1622, in the reign of Pope Gregory XV. Within the sepulchre were found three coins of Diocletian, in whose reign St. Caius (283–296 A.D.) received the papal crown, and also the pope's ring, probably his signet, although no exact description of it has reached us.[19] In the suc-

[18] Giacinto Gimma, "Della storia naturale delle gemme," Napoli, 1730, vol. i, p. 39.

[19] Pauli Aringhi, "Roma subterranea," Romæ, 1651, p. 701.

ceeding century there is notice of another ecclesiastical
signet-ring, for in a letter of St. Augustine (354–430)
to Victorinus, the Church Father concludes with the
words: " I have sent this epistle sealed with a ring which
shows the profile-head of a man." [20] As in the case of all
the very early bishops' rings, this one of St. Augustine
was merely his personal signet and had no direct connec-
tion with his sacred office.

A massive ring of Pope Pius II (Aeneas Syl-
vius Piccolomini, 1457–1464) has on the sides of the
hoop the coats-of-arms of the Piccolomini and Tiara
families; below the bezel are figures symbolical of the
Four Evangelists. This interesting papal ring is in the
collection of Dr. Albert Figdor, Vienna.[21]

The " Fisherman's Ring," or Annulus Piscatoris, is
the gold seal ring of the pope, a new one being made
for each successive pontiff. As testified to by early
records, the custom of breaking the ring on the death
of a pope has long obtained. After the attending
physicians have pronounced him to be dead, the Cardinal
Camerlengo, or Papal Chamberlain, approaches the
body, and taps it thrice with a golden hammer, each
time calling on the pope by name. The ring is then
handed by him to the papal master of ceremonies, who
breaks it; he is permitted, or perhaps required, to keep
the fragments. The design on the seal depicts St.
Peter seated in a bark and holding a net in each hand,
the name of the reigning pope being inscribed above.
The ring takes its name from the words of Christ to
Peter, after the latter made the miraculous draught of
fishes (Luke, v, 10): " From henceforth thou shalt

[20] Santi Aurelii Augustini, " Opera Omnia," ed. Migne,
Parisiis, 1884, cols. 226, 227.

[21] Communicated by L. Weininger, of Vienna.

FIVE VIEWS OF THE RING OF POPE PIUS II (ÆNEAS SYLVIUS PICCOLOMINI, 1457–1464)

On the sides of the hoop are the coats-of-arms of the Piccolomini and Tiara families, and below the bezel are figures symbolical of the Four Evangelists

Albert Figdor Collection, Vienna

"Ring of the fisherman"
Fairholt's "Rambles of an Artist"

Hand of "Judith" from picture by Lucas Cranach: Rings
beneath glove-fingers slit to give them room

Impression of the Annulus Piscatoris (Ring of the Fisherman)
of Pope Clement VIII (1592–1605)
Archæologia, vol. xl, p. 140

catch men." In Mark i, 17, a similiar announcement is made to both Simon (Peter) and his brother Andrew: " Come ye after me, and I will make you to become fishers of men."

The ring is broken to prevent the sealing of any pontifical document during the vacancy of the papal see. When the army of the French Republic occupied Rome in 1798, the Republican emissary Haller, after informing Pius VI that he would be taken from Rome, demanded all his papal rings. After surrendering the others, the pope pleaded that he might be allowed to keep the Fisherman's Ring, but as the Frenchman sternly insisted that this also must be given up, the pope reluctantly yielded. However, when on examination, the ring was found to be of small value, it was restored to the pontiff.

The earliest existing mention of the Fisherman's Ring seems to be in a letter addressed by Pope Clement IV, in 1265, to his nephew Pietro Grossi of St. Gilles, in which he states that in addressing members of his family he used the Sigillum Piscatoris, the *private* seal of the popes.[22] It was not until the fifteenth century that this originally private seal came to be generally used for the papal Briefs. An impression of the Fisherman's Ring of Clement VIII made in 1598, in the sixth year of the pope's reign, is surrounded with a bit of twisted vellum. A comparison of this seal with the one used by Pius IX, shows the modifications of the established design due to the preferences of the engravers of successive rings. The ring of Pius IX was of plain gold, weighing about an ounce and a half, the design was engraved on an oval plate. It is said to

[22] Platina " De vitis Pontificorum "; " Vita Clementis IV."

have been made out of the gold constituting the Fisherman's Ring of his predecessor, Gregory XVI.[23]

It is thought probable that the custom of breaking the Fisherman's Ring on the demise of a pope was first instituted at the death of Leo X in 1521. The papal engravers are believed to have kept a new ring ready in case of sudden need, leaving a blank space for the new pope's name. When his election has been confirmed, the Cardinal Camerlengo places the ring on his hand, asking him at the same time by what name he elects to be called. The ring is then removed and given to the engraver for the addition of this name. In later times it has been kept permanently in the guardianship of the Cardinal Chamberlain, and has not been generally used for stamping documents, an iron die of like design being employed for this purpose.

In at least one instance this ring was not destroyed at a pope's death. When Pius VI expired at Valence, Aug. 29, 1799, his Fisherman's Ring was left unbroken and, with a new inscription, served for his successor, Pius VII. When this latter pope fell into disgrace with Napoleon in 1809, because he refused to nullify the marriage of Jerome, Napoleon's brother, to Miss Patterson, he was carried off from Rome to France, and obliged to surrender his Annulus Piscatoris to General Radet. Before relinquishing it, however, he took the precaution of having it cut down the middle. Later when he was restored to the Roman See, a substitute ring was made, as the original, given back by Louis

[23] Edmund Waterton, " On the Annulus Piscatoris, or Ring of the Fisherman "; Archæologia, vol. xl, figures on pp. 140 and 142.

XVIII after Napoleon's downfall, could no longer be used because of its mutilation.[24]

Besides the Fisherman's Ring, the popes now have two others, the papal ring which they habitually wear, and the pontifical ring, which is only assumed for the pontifical ceremonies. The pontifical ring of Pius IX was worth more than $6,000. It is of gold, of remarkably fine workmanship, and is set with a magnificent oblong brilliant. This ring could be made smaller or larger at will, so that it might serve for future popes.[25]

By a special privilege the ring ordinarily worn by a pope may bear a cameo, that usually worn by Pius IX showed an image of the Virgin Mary. The Fisherman's Ring is but rarely worn. When after a pope's death, the ring has been broken, as we have noted, a cheap facsimile, or the broken ring, is sometimes buried with the pope.[26]

Of the three main classes of ecclesiastical rings, the pontifical ring with its single precious stone, worn over a glove and exclusively at pontifical ceremonies, is so large that its stone setting covers the first phalanx of the fourth finger of the right hand, on which it is worn. The " gemmed ring," a mark of distinction, may have but one stone, or a central stone surrounded by brilliants, just as the regulations provide. A third class

[24] Edmund Waterton, " On the Annulus Piscatoris, or Fisherman's Ring," Archæologia, vol. xl, pp. 138–142, London, 1866.

[25] Abbé Barraud, " Des Bagues à toutes les époques et en particulier de l'anneau des évêques et des abbés," Bulletin Monumentale, vol. xxx, pp. 390, 391, 1864.

[26] X. Barbier de Montault, " Le costume et les usages ecclésiastiques selon la tradition romaine," Paris, n.d., vol. i, p. 161.

of ecclesiastical rings are those of plain gold, commonly with a smooth chaton; sometimes, however, this may be engraved with armorial bearings, so that the ring can be used as a signet. In Rome those who have received the degree of doctor of divinity have the word R O M A engraved upon the chaton of the ring.[27]

One of the earliest notices of a bishop's ring, not however in the strictly ecclesiastical sense, but of one worn by a bishop, is given in a letter written by St. Avit, Archbishop of Vienne (494–525), to his colleague, Apollinaris, Bishop of Valencia (ca. 520): " The ring you have been kind enough to offer me should be made as follows: In the middle of a very thin iron hoop, representing two dolphins facing each other, a double seal should be set by means of two pivots, so that either side may be shown or hidden at will and in turn, and offer, alternately, to the eyes a green stone or a pale electrum.. Let not this metal be as I have sometimes seen it, easily tarnished in the cleanest hands, and similar to the impure mixture of gold that has not been exposed to the fire; let it not resemble the alloy which formerly the king of the Goths introduced into his coinage, an emblem of his downfall. Let my electrum be of a medium color, having at once the tawny hue of gold and the whiteness of silver, precious by their union and enhancing the brilliant green of the emerald when it appears. Let my monogram be engraved on the seal surrounded by my name, so that it may be read. Opposite the setting, the middle of the ring shall be formed by the tails of the dolphins; to set between these an oblong stone shall be sought, pointed at the extremities." [28] It will be noted that this was not a gold ring,

[27] *Ibid.*, pp. 158, 159.

[28] Sancti Aviti, Epist. lxxviii, Migne, " Patrologia Latina," vol. lix, col. 280.

but an iron one, and thus essentially different from the recognized episcopal rings.

The oldest formula used at the conferring of the pontifical ring upon a bishop, is found in the Sacramental of St. Gregory, 590 A.D. and, translated into English, runs as follows: "Receive this ring of distinction and honor, a symbol of faith, that thou mayst seal what is to be sealed, and reveal what is to be revealed, and that to believers baptized into the faith, who have fallen but are penitent, thou mayst by the mystery of reconciliation open the gates of the Kingdom of Heaven." A much shorter formula is that in the Pontifical of Ecgberht, Archbishop of York; it reads: "Receive the ring of the pontifical honor that thou mayst be endowed with sound faith." At present the following simple formula is used: "Receive the ring of faith as a sign that thou wilt guard the Bride of God, Holy Church, with undaunted faith."

A very early mention of the true episcopal rings is to be found in the writings of Isidore, Archbishop of Seville from 601 to 636 A.D.[29] He definitely states that the ring was one of the canonical insignia of the episcopate and terms it " a sign of pontifical honor, or a seal of secrets," adding that priests must keep many secrets confided to them hidden in their breasts as though beneath a seal.[30] At about the same time a decree of Pope Boniface IV, promulgated in the third council of Rome, in 610, mentions a pontifical ring, and in the fourth council of Toledo, in December, 633, a canon treating of the restitution to his office of an unjustly deposed

[29]Isidori, " De ecclesiasticis officiis," lib. ii, cap. v, 12.
[30] Migne, "Patrologia Latina," vol. lxxxiii, cols. 783, 784.

bishop, directs that he be given anew his stole, his ring, and his pastoral staff.[31]

The liturgical kissing of a bishop's hand usually means a kiss impressed upon the ring he is wearing at the ceremony. That in the works of Rabanus Maurus, Archbishop of Mainz (786–856), and in those of others of his time, no mention is made of episcopal rings of investiture, cannot be taken to prove that none were worn in this period, but only that they were not yet in general use.[32] The distinct evidence contained in the canon of the Council of Toledo, over which Isidore of Seville presided in 633, and the still earlier formula of investiture in the Sacramental of Gregory, 590 A.D., must be accepted as conclusive evidence that such rings were conferred.

Until after the eleventh century, almost all the Episcopal rings were used as signets and the Sacramental of St. Gregory alludes to this use. The ring was generally worn on the index finger of the right hand, the middle of the three fingers uplifted in conferring a blessing; but, when celebrating mass, the bishop transferred it from the index finger to the annular. At the present day it is always worn on this latter finger. The removal of the ring from the index is explained by Garanti,[33] as being an act of humility, since the ring was regarded as a kind of crown upon the index, " for sages say that the ring is the crown of the hand," and this crown should be removed in the presence of Christ. In our day bishops wear but one ring, but in old pic-

[31] Philippe Labbé and Cossart, " Sacros. concil.," vol. v, cols. 1618, 1714.

[32] Wetzer and Welte's " Kirchenlexikon," 2d ed., Freiburg im Breisgau, 1897, vol. x, p. 211, art. Ringe by K. Schrod.

[33] Ed. Merati, p. 1737.

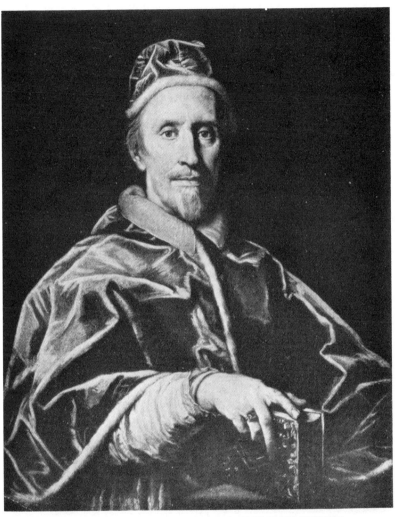

PORTRAIT OF POPE CLEMENT IX (1667–1670) BY CARLO MARATTA
Ring with square-cut, beveled stone on fourth finger of right hand
Metropolitan Museum of Art, New York. Gift of Archer M. Huntington, Esq.

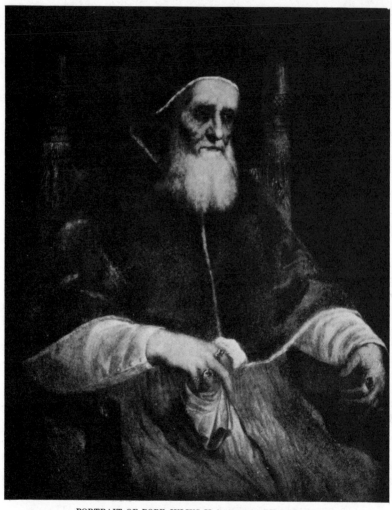

PORTRAIT OF POPE JULIUS II (1503–1513) BY RAFAEL
Six rings, three on each hand; on index, fourth and little fingers
Uffizi Palace, Florence

tures and effigies they are shown wearing several, and
sometimes even a thumb ring. The celebrated por-
trait of Leo X, by Raphael, represents the pope wear-
ing no less than six rings, and the hands of Julius
II in Raphael's portrait are adorned with rings of equal
number.

While the sapphire eventually became the stone
especially assigned for use in episcopal rings, the older
specimens which have been preserved for us show that,
in early times, many other precious stones were em-
ployed for this purpose. Indeed, the emerald, or some
green stone, seems to have been given the preference at
one time, if we can judge from the letter sent by Avitus,
Archbishop of Vienne to Apollinaris, Bishop of Valen-
cia. Besides rubies and emeralds, balas-rubies, tur-
quoises, chalcedonies and even the opal were used, while
pearls and garnets, also appear occasionally.

Possibly the earliest known specimen of an episcopal
ring is in the treasury of the cathedral of Metz. It is
believed to have belonged to Arnulphus, who was con-
secrated Bishop of Metz in 614. This ring, which has
been sometimes ascribed to the fourth century, is set with
an opaque milk-white carnelian.

An episcopal ring found at Oxford and now in the
Waterton Collection, Victoria and Albert Museum, is a
curious specimen of the adaptation of antique gems to
Christian uses. The gold circlet is set with an antique
plasma engraved with the bust of a female, the pagan
original doing duty for some Christian saint, or perhaps
for the Virgin Mary.[34] An intaglio of Jupiter-Serapis
was provided by the monks of Durham with an inscrip-
tion designating it to be a portrait of St. Oswald.

[34] Edmund Waterton, " On Episcopal Rings," *The Archæ-
ological Journal*, vol. xx, London, 1863, p. 228.

Cameos were also used, on occasion, as we read in the enumeration of the precious stones and rings donated by Henry III to the shrine of St. Edward in Westminster Abbey,[35] the following entry: " j chamah in uno annulo pontificali."

Occasionally a stone was taken from some antique ornament and set in an episcopal ring. Of this kind is the pierced sapphire in Mr. Waterton's collection, and probably another ring described in the Wardrobe Books of Edward I and which belonged to Robert, Bishop of Coventry and Lichfield, who died in 1295. The old description calls this " a golden ring with a perforated ruby." [36] The same records mention a gold ring with a sapphire, the ornament being, as was supposed, the work of St. Dunstan, who is reputed to have been a skilful worker in metals.

A letter written in 867 by Charles the Bald to Pope Nicholas I, mentions a ring sent to Ebbo, Bishop of Rheims, by Judith, the mother of Charles the Bald. This ring was given by the empress at the time of the birth of her son, so that Ebbo, who had been made bishop because of his piety and sanctity, should remember the child in his prayers. In later years, whenever the good bishop was in trouble, he used to send his ring to the empress with an humble petition for aid, and the letter of Emperor Charles was written as a result of a most earnest appeal of Bishop Ebbo, after he had been deposed from his office and subjected to persecution.[37]

It is said that only one episcopal ring from Anglo-Saxon times has been preserved in England. This relic

[35] Rot. Pat. Hen. III. m. 20 d.

[36] Liber 28, Ed. I; fol. 278, p. 344.

[37] Philippi Labbei et Cossarti, " Sacrosancta concilia," vol. viii, col. 878.

Christian ring of glass. Design
shows snake and doves, a cross,
the Greek letters *alpha* and *omega*
and the Latin word *Salus*. Bosio.
"Roma Sotterranea," Roma, 1650

1, Venetian ring. Bezel with engraved figure of St. Mark is hollowed
to enclose relics. 2, poison ring set with a diamond and two rubies.
The poison was concealed beneath the bezel. See pages 36–39
Fairholt's "Rambles of an Artist"

Gold ring of Ahlstan, Bishop of Sherborne (824-860 A.D.)
Archæological Journal, vol. xx, p. 226, 1863

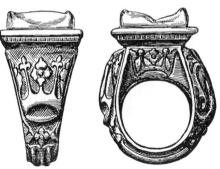

Bishop's ring of investiture. Bezel set with flat
crystal; two views. Said to have belonged to
Robert of Anjou, King of Naples (1309-1343 A.D.)
British Museum

Lady's memorial ring of enameled gold inscribed "R. C.
Not lost but gone before," in gilt letters on a white enamel
ground. English, about 1800

Albert Figdor Collection, Vienna

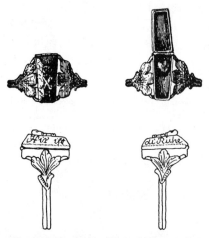

Mourning ring of gold. The head has the form of
a coffin with skull and cross-bones on the lid. When
this is lifted a heart is disclosed within. The hoop
has two wires. On the sides of the coffin is inscribed:
"*Hir ist die Ruhe*" (Here is rest). German. Eighteenth
Century

Albert Figdor Collection, Vienna

Massive silver mourning ring inscribed in Old French, *dort couat* (rest in peace).
Found at Huy near Statte, Belgium. French. Fifteenth Century

Albert Figdor Collection, Vienna

forms part of the Waterton Collection in the Victoria and Albert Museum; it is of gold, nielloed, and shows the letters of the name Ahlstan. This name was borne by a Bishop of Sherborne who held the office from 824 to 867 A.D., his death occurring four years before the accession of Alfred the Great.[38]

Niello is a mixture of silver, copper, lead, crude sulphur, and borax; frequently a little antimony is added. The mixture is fused and pressed into the design engraved upon a silver plate; when it has cooled off it forms a deep black, brilliant, and tough, though not hard, substance, like an enamel. The antimony on cooling, spreads slightly, thus obviating any danger of undue contraction of the alloy, which might fail to fill out the design exactly; occasionally, however, the antimony expands unequally, producing some slight irregularities of outline or surface. Sometimes the alloy is applied to the silver background of the design, instead of to the design itself, so that the latter appears white against a rich dark foundation. This variety of enamelling was already used in Roman times; in our day it is most extensively employed in Russia, where very beautiful work of the kind is done, the lines being of hair-like fineness and delicacy.

In 886, at the degradation of two bishops who had been consecrated without the consent of their metropolitan, their episcopal vestments were rent, their croziers broken on their heads, and their episcopal rings rudely snatched from their fingers. Here, as in cases of military degradation, the ignominious removal of the

[38] Edmund Waterton, "Episcopal Rings," in *The Archæological Journal* vol. xx, p. 227, fig. p. 228.

insignia of rank served to give public emphasis to the sentence passed upon the condemned.[39]

The Cathedral of Chichester has yielded a number of fine specimens of mediæval episcopal rings. Notable among these as a curiosity is one that belonged to Bishop Seffrid who died in 1151, for it is set with a Gnostic gem showing the well-known cock-headed figure generally cut to represent the divine principle the Gnostics called Abrasax (or Abraxas). This is an intaglio on jasper, and the ring was found in the bishop's tomb. The fact that he was willing to wear it shows either that he was ignorant of its being a Gnostic, and hence an heretical design, or else that he was more than usually tolerant. Another of the Chichester rings came from the tomb of Bishop Hilary (1146–1169); it is of massive gold and is set with a sapphire. When the tomb was opened the ring was on the thumb of the skeleton. In a stone coffin on which were cut the letters Episcopus, with no personal name, there was found a ring adorned with an octagonal sapphire, on four sides of which was set a small emerald. As the sarcophagus contained a pastoral staff and remains of a vestment, this was undoubtedly an episcopal ring. It will have been remarked that of these rings two were set with sapphires, but the ring of Archbishop Sewall (d. 1258), found in his tomb in the Cathedral of York, and that from the tomb of Archbishop Greenfield (d. 1315), were each set with a ruby.[40]

[39] Ph. Labbei et Cossarti, " Sacrosancta Concilia," vol. ix, col. 395, of the Council of Nimes.

[40] Edmund Waterton, " Episcopal Rings," in *The Archæological Journal*, vol. xx, p. 235, figs. 6, 7 and 8 on plate opposite that page.

Gold ring with inscription. "Buredruth" is probably a personal name, and the Greek characters *alpha* and *omega* should have a religious significance. Late Saxon

British Museum

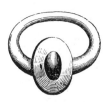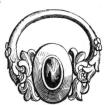

Episcopal rings. 1, found in York Minster, tomb of Archbishop Sewall (d. 1256); 2, found in tomb of Archbishop Greenfield (d. 1315)
Fairholt's "Rambles of an Artist"

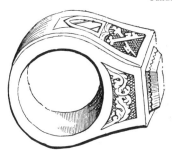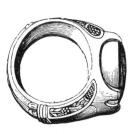

1, Papal ring set with large crystal, Londesborough Collection; 2, ring of Bishop Stanbury of Hereford (1452–1474). Found in his tomb, 1843; two views
Fairholt's "Rambles of an Artist"

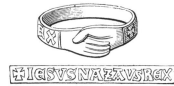

1, silver ring, two clasped hands; inscription signifies Jesus Nazarenus Rex. 2 and 3, rosary rings, with bosses used to count the prayers recited
Londesborough Collection.
Fairholt's "Rambles of an Artist"

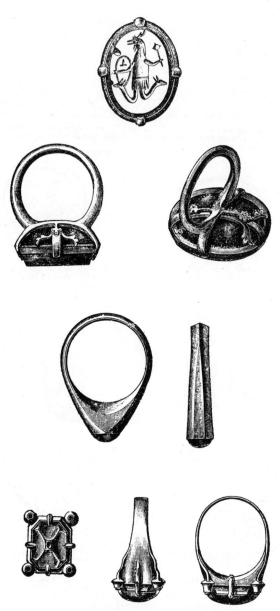

1, gold ring set with Gnostic intaglio on jasper. Found in tomb of Seffrid, Bishop of Chichester (1125–1151); three views. 2, gold ring set with a sapphire. Found in tomb of Hilary, Bishop of Chichester (1146–1169); two views. 3, gold ring set with a sapphire and four emeralds. Found in tomb of unknown bishop

The mystic significance of the episcopal ring as typifying the union of Christ with his Church was expressed by Innocent III (1198–1216) in these words: " The ring is a sacrament of faith, by which Christ endows his spouse the Holy Church." [41] This can be taken as confirmatory of the theory that the episcopal rings were directly derived from the betrothal rings, and were not merely attributes of ecclesiastical rank. So closely was the Bishop bound to his see, that his abandonment of it to go to another was regarded by some as equivalent to the commission of adultery.

A fine example of a sapphire-set episcopal ring was found in 1844, during some alterations to the chapel of Notre Dame in the Cathedral of Troyes. Several stone coffins were discovered, among them that containing the remains of Hervée, Bishop of Troyes, consecrated in 1206. The body was clothed in full episcopal vestments. The ring had fallen from the hand but was found at the left side of the body. It had a diameter of 2 cm. (about 4/5 inch) and was set with a fine oblong sapphire held in place by four claws.[42] The opening of the tomb of Pope Boniface VIII (1294–1303) revealed the presence, on the gloved hand of the dead pope, of a splendid gold ring, set with a sapphire of quite exceptional size and beauty.[43]

In 1804, at the opening of a thirteenth-century archbishop's sepulchre in the Cathedral of Mainz, believed

[41] " De sacro altaris mysterio," Migne's Patrologia Latina, vol. ccxvii, col. 796.

[42] Arnaud, " Notice sur les objets trouvés dans plusieurs cercueils de pierre à la cathédral de Troyes," Troyes, 1844, p. 13.

[43] Catalan, " Pontificale romanum," vol. iii, p. 358, citing the annals of Abraham Begovius, ad annum 1303, num. 8.

to be that of Archbishop Sigfroi III, 1249, a fine pontifical ring was found; it is set with a large ruby.[44] The bezel is of disproportionate size in comparison with the dimensions of the rather slender circlet.[45] This ring is large enough to be worn over a glove in accord with liturgical requirements. It has been noted that in process of time the width and thickness of the circlet were gradually increased, at first to make it harmonize better with a large bezel; gradually, however, both bezel and hoop were made so large as to render the ring a burden to the wearer, and even difficult to keep from slipping off the finger. Indeed, it was sometimes necessary to wear a second, closer-fitting ring *under* it as a guard.[46]

The treasury of Canterbury Cathedral contained in 1315, according to an inventory of the " Ornamenta Ecclesiastica," a very rich and elaborate pontifical ring. It is described as a large square ring, set with an oblong emerald, four plasmas (leek-green quartz), and four garnets. The other episcopal rings listed on this inventory were set with sapphires bordered with small gems, one of them having a " black sapphire " set *à jour,* and held in place by claws. While at this period great latitude was exercised regarding the particular stone to be chosen for the chief adornment of the ring, it was required that it should be one of the more precious stones.[47]

The color of the stones chosen for the adornment

[44] R. Rucklin, " Das Schmuckbuch," Leipzig, 1871, vol. ii, pl. 56, fig. 5.

[45] See also Hefner, " Trachten," pl. 9.

[46] *Op. cit.*, vol. i, p. 167.

[47] Edmund Waterton, "On Episcopal Rings," *Archæological Journal*, vol. xx, p. 228, London, 1863; citing Dart, " Hist. of Cant. Cath.," p. 346, fol. 279, and Duranti, " De ritibus," lib. ii, cap. ix, sec. 37.

of episcopal rings always had a symbolical significance. The glowing red of the ruby indicated glory, the clear blue of the sapphire, chastity and happiness, the pure white of the rock-crystal, guilelessness, while the hue of the amethyst called to mind the color of the wine used in the Holy Eucharist. The emerald, as is well known, signified by its green color the virtue of hope and also the Resurrection.

The general rule, expressed or understood, that a sapphire should be set in an episcopal ring, seems to have been more commonly observed in England in the earlier centuries than it was on the Continent. Undoubtedly many of these stones were obtained at the time of the Crusades. As English examples, Mr. O. M. Dalton cites the rings of three early bishops, [48] namely, those of Flambard (1099–1128), Geoffrey Rufus (1133–40) and William de St. Barbara (1143–52), now in the Durham Chapter Library; all have sapphires. The same stone serves as setting for the ring of William of Wykeham, a massive plain gold hoop, exhibited by the Dean of Winchester at South Kensington in 1862, to which the cathedral also contributed a thirteenth-century episcopal ring set with a large sapphire cut *en cabochon*.[49] There is as well the ring of William Wytlesey, Archbishop of Canterbury (d. 1374) in the possession of Sir Arthur Evans and that of John Stanbery, Bishop of Hereford (d. 1474). The inventory of 28 Edward I lists sapphire-set rings of the arch-

[48] O. M. Dalton, " Franks Bequest, Catalogue of the Finger Rings, Early Christian, Byzantine, Teutonic Mediævel, and Later [British Museum]," London, 1912, pp. xxxvii, xxxviii.

[49] Catalogue of the special exhibition of works of art . . . at the South Kensington Museum, June, 1862, London, 1863, p. 636.

bishops of Dublin and York as well as of the bishops of Salisbury and St. Asaph. The rebel Piers Gaveston, favorite of Edward II, carried off with him, among other royal jewels, sapphire rings that had belonged to the Bishop of Bath and Wells and to the Abbot of Abingdon. In the inventory of Elizabeth's favorite ecclesiastic, Archbishop Parker of Canterbury, is listed " a ringe with a blewe sapphire," valued at four pounds sterling.

Old records show that even in the fourteenth century, the sapphire, although greatly favored for prelates' rings, did not yet enjoy any exclusive preference.

For example, during the reigns of Clement V, and John XXII, in Avignon (1307–1334), the papal registers for 1317 note, in one case, " seven gold rings with various stones for new cardinals, 68 gold florins." This, however, is followed by another entry recording " four gold rings with Oriental sapphires for the consecration of prelates, 26 gold florins," and again " a gold ring with an Oriental sapphire for Cardinal A, 23 florins." Three years later, in 1320, we have " seven rings for the seven new cardinals, three set with Oriental sapphires, three others with Oriental emeralds, and one with a balas-ruby, the total cost being 106 gold florins.[50]

That the topaz at one time shared with the sapphire the honor of being especially fitted for use in ecclesiastical rings is shown by a passage in a rare fourteenth-century manuscript written in Italy. Here we are informed that the topaz was the most honorable of stones

[50] Maurice Faucon, " Les arts à la cour d'Avignon sous Clément V et Jean XXII," in Mélanges d'Archéologie et d'Histoire II^ème Anneé, pp. 76, 77; IV^ème Année, p. 107.

" above all other stones," and that for this reason the great prelates wore it on their fingers.[51]

The green variety of tourmaline found in Brazil, and often called " Brazilian emerald," was for a long time and is now used quite freely in Brazil as a setting of episcopal rings. [52] While this is a departure from the general usage of selecting a blue stone, preferably sapphire, for this purpose, it nevertheless finds a parallel in the employment of emeralds for bishops' rings in quite ancient times, as is the case with one of the earliest of these rings, that described, or we should rather say proposed, in the letter of St. Avitus, Bishop of Vienne in France.

When a prelate has been raised to the rank of cardinal, he has to resign any ring he may have been entitled to wear previously, and awaits the bestowal of the special cardinal's ring by the pope. It is conferred by the pope personally at the consistory wherein he assigns a title to the newly-chosen cardinal. This ring is made by a pontifical jeweller; it is of gold, with a sapphire in the bezel and, on the inside, the arms of the Sovereign Pontiff. Withal it is rather inexpensive, the average cost having been put at about $32, although each cardinal is obliged to pay into the Congregation of the Propaganda the sum of $642 (3,210 francs) as a "ring tax." This payment, however, gives him the valuable right of bequeathing his property as he pleases by

[51] Italian XIV Century MSS. in the author's library. What appears to be a topaz ring is on the fourth finger of the right hand in Titian's portrait of Archbishop Filippo Archinto, painted in the middle of the sixteenth century.

[52] Edinburgh Review, July, 1866, p. 247.

testament; otherwise everything would go to the Church.[53]

As in many portraits of cardinals and high church dignitaries they are depicted as wearing two or more rings, it has been erroneously conjectured that each ring represented a separate benefice, there being thus as many rings as benefices. The ceremonial regulations, however, clearly indicate that the wearing of many rings is simply a matter of taste, all except that on the annular finger of the right hand being purely ornamental.[54]

A ring on the fourth finger of the right hand is shown in Carlo Maratta's portrait of Pope Clement IX (1667–1670), given to the Metropolitan Museum of Art, New York, by Archer M. Huntington, Esq., in 1891. The ring bears no design, the setting being a large, square, beveled stone. The beard and mustache of the pontiff are of the type familiar to us in portraits of Cardinal Richelieu, who died in 1642.

A splendid example of the cardinal's ring was recently made for Cardinal Farley. It is set with an exceptionally large and fine sapphire, of rounded oval form and an inch in length; the color is rich and deep; the stone weighs $18\frac{1}{2}$ carats and is a Cinghalese sapphire. A bordering consisting of twenty-eight diamonds surrounds the central stone and serves to render more strikingly beautiful the rich blue of the sapphire, often called the "cardinal's stone" because it is the one used for cardinal's rings. This is noteworthy, as red is preeminently the cardinal's color, as is shown in his robes, hat, etc.; hence we might rather expect that the ruddy

[53] X. Barbier de Montault, " Le costume et les usages ecclésiastiques selon la tradition romaine," Paris (1897), vol. i, p. 162.

[54] *Ibid.*, vol. i, p. 159.

ruby would have the preference. However, the fact that the sapphire denotes chastity and celestial purity has caused this stone to be chosen for the adornment of the rings worn by those who, from their exalted ecclesiastical rank, are more especially called upon to set a high example to the priesthood. The shank of Cardinal Farley's ring is one of the most beautiful examples of American goldsmithing in existence. The chasing of the circlet shows on one side the ample facade and the lofty spires of St. Patrick's Cathedral in New York, and on the other side emblems of the cardinalate. It was the gift of a priest who has known the Cardinal for many years.[55]

When the Right Rev. David H. Greer was consecrated Bishop of New York, some of his friends presented him with a very handsome amethyst signet, but unfortunately this tribute was stolen from his home by burglars, two or three years ago. When necessity arises of making an official signature he uses a steel impression stamp of the seal of the diocese. He has a fac-simile impression stamp of the seal which was stolen, but he seldom or never uses this.[56]

The amethyst seal of Bishop Greer bore for its motto, " Crux Mihi Grata Quies " (The Cross is for me a grateful rest). This is the motto of Mrs. Greer's family. On the shield is the monogram of the bishop's initials, D. H. G.; above are two keys in saltire; on the lower part of the shield just beneath the monogram, is the coat-of-arms of New Amsterdam; as crest is an

[55] This ring is figured as frontispiece to the writer's " Curious Lore of Precious Stones," Philadelphia and London, 1913.

[56] From a letter written by Bishop Greer to the author, September 22, 1916.

episcopal mitre. This was not, however, a seal ring.

The so-called "mitred abbots", those who governed the larger monasteries, or whose notable services in the cause of the Church were thought to merit some special mark of honor, were sometimes given the right of wearing the episcopal ring at solemn ceremonies. We are told that at the deposition of Abbot Rainaldus, head of the great Benedictine Abbey of Monte Casino, not far from Naples, he publicly laid his staff and his ring upon the shrine containing the body of St. Benedict.[57]

The energy with which some of the leading theologians of the twelfth century protested against the use of episcopal rings by abbots, merits illustration by an extract from the writings of St. Bernard, who in a tractate addressed to Henri, Archbishop of Sens, writes:[58]

"Several have clearly enough indicated where were their thoughts when, having obtained apostolic privileges by many intrigues and by bribery, they appropriated to themselves and use, in virtue of these concessions, the mitre, the ring and the sandals, just as do the pontiffs themselves. . . . Oh, Monks, whither will this lead you? Have you banished all fear from your souls? Can the blush of shame no longer rise to your cheeks?"

Not only abbots, but abbesses also, are represented on their monuments as wearing rings, as for example Agnes Jordan, Abbess of the Bridgetine Convent of Syon, whose brass figure at Denham, Bucks County, England,[60] shows a ring on her finger. However, in 1572, the year of his accession to the papal throne,

[57] Kirchmann, "De anulis," Lugd. Bat., 1672, p. 185.

[58] Tractatus de officio episcopi, ad Henricum Senonensem episcopum, cap. ix.

[60] H. Druitt, Costume in Brass, p. 98.

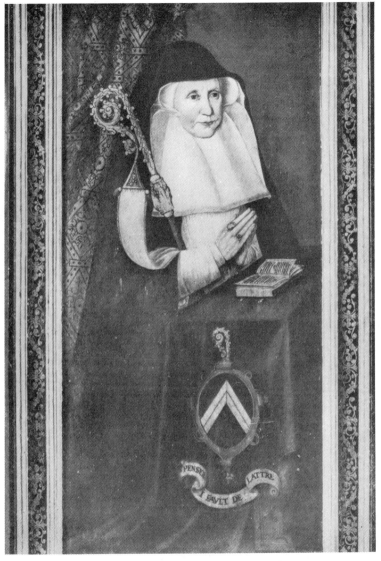

ABBESS PRAYING. FRENCH SCHOOL

Seal ring on index of right hand; ring with precious stone setting on fourth finger of the same hand

Musée du Louvre

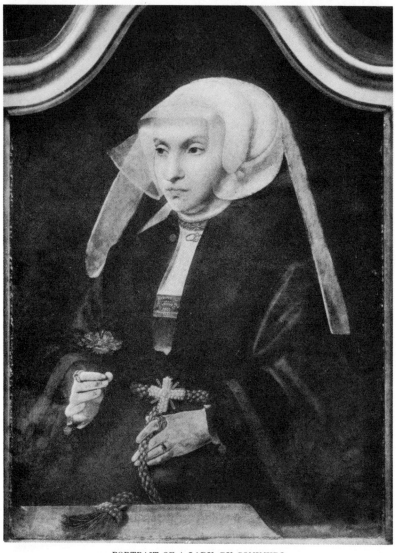

PORTRAIT OF A LADY, BY CONINXBO
Two rings on index of right hand and two on index of left hand; smaller one on fourth finger of left hand
Musée de Bruxelles

Gregory XIII abolished this custom; how long it had endured has not been determined.[61]

Certain other prelates of lesser rank than bishops have the right to wear rings, such as the protonotaries, for example, but as a rule they are not permitted to wear them while celebrating an ordinary mass, low or high; only when officiating pontifically may they wear pontifical rings. The ring commonly worn is much smaller than that accorded to a bishop and is set with a single stone, as is expressly ordained in the constitution *Apostolicæ Sedis* of Pius IX, dated in 1872.[62]

That the canons of a cathedral should generally be allowed to wear rings has been repeatedly decided adversely in the Roman Catholic Church, a recent instance being when the Bishop of Nicaragua submitted this question to the Sacred Congregation of Rites in Rome, because the practice had become common in Nicaragua. In reply he was informed that this must not be tolerated, except in case of a special indulgence from the pope, and the bishop was required to suppress the abuse. The reply was dated August 20, 1870, just a month before the entry of the Italian army into Rome and the cessation of the papal rule over the city.[63]

In a letter written December, 1751, Pope Benedict XIV relates the finding of a gold ring so small that it would fit the finger of a three-months' old babe,

[61] " Dictionnaire d'archéologie chrétienne et de liturgie," ed. by Dom Fernan Cabrol, vol. i, Paris, 1907, col. 2187, art. *anneau* by Leclercq.

[62] X. Barbier de Montault, " Le costume et les usages ecclésiastiques selon la tradition romaine," Paris (1897), vol. i, pp. 163, 164.

[63] *Ibid.*, vol. i, pp. 164–170.

and bearing certain characters indicating a priestly quality of the infant. This the pope understood not as signifying that it had been made a deacon, but that its parents had consecrated it to the service of the church, so that it should later become a monk or priest.[64]

His Grace, the Most Reverend Archbishop Evdokim, the highest dignitary of the Russian Church in the United States, has stated that neither the Metropolitan, nor the Archbishops nor clergy of the Russian Church wear rings of any kind. They use seals but these are not in the form of signets. In this respect, the usage differs from that in many other churches.

The ring given to the King of England at his coronation bears a close relationship to the episcopal ring, and emphasizes the religious authority of the sovereign. This appears very clearly in the English ceremonial, where the Archbishop of Canterbury pronounces the following prayer of consecration:

Bless, O Lord, and sanctify this Ring, that Thy servant, wearing it, may be sealed with the ring of faith, and by the power of the Highest be preserved from sin; and let all the blessings which are found in Holy Scriptures plentifully descend upon him, that whatsoever he may sanctify may be holy, and whatsoever he may bless may be blessed. Amen.[65]

The Coronation Ring of the English kings is of pure gold and is usually set with a large table ruby of a violet hue, the flat surface engraved with the figure of a St. George's cross. About the ruby are set twenty-six diamonds. As the ring is designed to serve for

[64] *Ibid.*, vol. i, pp. 175, 176.

[65] The complete ceremonies and procedures observed at the coronation of the kings and queens of England, London (1902), p. 30.

successive coronations, the circlet is jointed so as to fit a larger or smaller finger. A queen consort is given at the ceremony of coronation a ring of pure gold also bearing a ruby, but unengraved; about the stone are sixteen smaller rubies, so graded as to size that the largest are placed nearest to the central stone, the size diminishing as the distance increases. The ruby has been chosen as emblematic of faithfulness. These rings are put on the fourth finger of king and queen, and the king's ring is called by some writers "The Wedding-Ring of England," the sovereign being regarded as espoused to the nation over whose welfare he is to watch.[66]

The coronation ring of William IV of England, although scarcely a notable example of the jeweller's art, is striking enough in its way. In many earlier coronation rings, for which the ruby (or a spinel) was the stone traditionally favored, a St. George's cross was engraved on the ruby, but in the case of William IV's ring the cross is formed of five rubies, a square central stone and four oblong ones for the arms of the cross, all set over a large cabochon-cut sapphire, this affording a blue background for the red cross, similar to the blue field of the cross of St. Andrew. There is also a bordering of brilliants. This ring while effective enough in the sharp contrast of color, is lacking in harmony and taste.[67]

The insignia of the Prince of Wales include most of the emblems belonging to royal insignia, and each of them has its especial and peculiar significance. Unity

[66] Debrett's Dictionary of the Coronation, London (1902), pp. 38, 126.

[67] Cyril Davenport, " Jewellery," Chicago, 1908, Plate xvi, opp. p. 110.

is typified by the ring; the coronet is an emblem of friendship. The staff in conjunction with the ring suggests the religious side of the princely or royal office, for these emblems form an important part of the episcopal insignia. A special local association results from the fact that Welsh gold, mined by Welshmen in the Merionethshire mines, is used in the manufacture of these ornaments. A gold medal bearing the head of the Prince of Wales on the obverse, and on the reverse a representation of the Eagle Tower of Carnarvon Castle, was struck for the present holder of the title.

At the coronation ceremonies of the kings of France, the officiating ecclesiastic said to the sovereign in handing him the Coronation Ring: "Receive this ring, a symbol of holy faith and of the stability of the Kingdom, a sign of power, by which thou shalt be able to defeat all enemies with triumphant power, to destroy all heresies, to unite all subjects and to maintain them constantly bound together by the Catholic faith." This formula dates back at least as far as 986 A.D., and was probably in use at an even earlier date.[68] The close union of Church and State is strongly emphasized, as well as the necessity for uniformity of belief, this having been a source of strength for the State when voluntarily present, but a cause of manifold and dreadful misfortunes when the religious convictions of the subjects became discordant.

When a nun is consecrated the priest places a ring on her finger, reciting the following words from the Roman pontifical:

[68] Abbé Barraud, " Des bagues à toutes les époques, et en particulier de l'anneau des évêques et des abbés," Bulletin Monumental, vol. xxx, p. 17.

I espouse thee to Jesus Christ, Son of the Supreme Father, who will preserve thee from all ill. Accept, therefore, this ring of faith, a symbol of the Holy Spirit, that thou mayst be called a spouse of God, and be crowned for ever.

Before the rings are bestowed they are heaped up on the altar and are collectively blessed by the officiating priest. As the formula used defines the character and quality of the ring more closely than do the simple words of presentation, it is here given as follows, this formula already appearing in the pontifical of Pierre, Bishop of Senlis, 1350; [69]

Creator and preserver of the human race, grantor of spiritual grace and bestower of bodily health, O God, send forth thy blessing upon these rings that those who may wear them, shall possess celestial virtue, perfect faith and true fidelity, shall maintain, as spouses of Christ, their vow of virginity, and shall persevere in constant chastity. By Christ Our Lord.

A pretty usage was observed at the reception into the order of the Augustinian nuns of Saint Thomas, at Villeneueve. On taking the vow, a ring was placed on the nun's finger by a poor little girl, who said at the same time: "Remember, dear sister, that you have become this day the spouse of Jesus Christ and the servant of the poor." The sister, after having respectfully accepted the gift made her by one who represented the Lord, kisses the child who has reminded her of the poor to whose service she is consecrated.[70]

[69] Abbé Barraud, " Des bagues à toutes les époques et en particulier de l'anneau des évêques et des abbés," Bulletin Monumentale, vol. xxx, p. 32.

[70] X. Barbier de Montault, " Le costume et les usages ecclesiastiques selon la tradition romaine," Paris, (1897), vol. i, p. 174, note.

According to an old recital, a miraculous ring was once found by a pious nun in the convent garden. One day when she was engaged in tending a bed of flowers, there came over her the ardent wish to receive a divine sign in the shape of a ring, testifying to the reality of her espousal with Christ. The Lord answered the fervent aspiration of his handmaiden, for suddenly there appeared before her in the flower bed an actual ring, no deception of the senses, but a material body. This story is related by Johann Nider in his Latin work, "Formicarius," published in Strassburg in 1517, and the writer asseverates that he saw the ring, which was of a white substance resembling pure silver.[71]

A Ring of Widowhood, sealing a widow's vow to remain faithful to the memory of her dead husband, was not rarely bestowed, three or four centuries ago, to serve as a mark of the solemn vow. A noteworthy instance is that of Katherine Rippelingham, who, in her will dated February 8, 1473, describes herself as "advowes" ("vowed"), and expresses the wish to be interred in "Baynardes Castell of London." In a codicil she leaves to her granddaughter, Alice St. John, "her gold ring with a diamante therein wherewith she was sacrid," or consecrated. In another will, that of William Herbert, Lord Pembroke, the wife is enjoined to remember her promise that she will take the order of widowhood, so that, as the testator continues, "ye may be the better maistres of your owen, to perform my will, and to help my children, as I love and trust you."[72]

[71] Cited by William Jones, " Finger-Ring Lore," London, 1877. pp. 236, 237.

[72] Henry Harrod " On the Mantle and Ring of Widowhood," Archæologia, vol. xl, pt. 2, p. 308; London 1864.

In view of the bad results of a second marriage when a widow falls into the hands of some designing man, to the destruction of her children's welfare, this usage, so long discontinued, of binding herself by a solemn vow, had something to recommend it in times far past, when more stress was laid upon the sanctions and prohibitions of religion than is generally the case in our day.

At a solemn ceremony of this kind, held at the Priory of Campsey, in 1382, during the reign of Richard II, Isabella, Countess of Suffolk, took the vow in the presence of the Earl of Warwick, Lords Willoughby and Scales, and other nobles. The old Norman French form of her pledge has been preserved and may be given here for its historic interest: "Jeo Isabella, jadys la femme William de Ufford, Count de Suffolk, vowe à Dieu, en presence de tres reverentz piers en Dieu, évesques de Ely et de Norwiz, qe jeo doi estre chaste d'ors en avant ma vie durante." (I, Isabella, formerly the wife of William de Ufford, Count of Suffolk, vow to God in presence of the very reverend fathers in God, the bishops of Ely and of Norwich, that I shall remain chaste from now on during my entire life.)[73]

[73] Op. cit., p. 309, citing Gough, " Sepulchral Monuments," vol. i, p. cxix.

VII

MAGIC AND TALISMANIC RINGS

FROM their close contact with the person as well as from their symbolic form, the significance of many designs engraved upon them, and the supposed virtues of stones set in them, some rings have enjoyed the repute of possessing magic powers, both in ancient and mediæval times, and even much later. In a number of cases, we can find some clue to the attribution of a special virtue to a magic ring; in other cases, however, the circumstances leading to this are no longer to be ascertained, and we must content ourselves with the fact that such and such a ring, or type of rings, has been thought to have such and such a mysterious influence.

No ancient talisman enjoyed a greater repute in mediæval legend than the "Ring of Solomon" or "Solomon's Seal" as it was often called. An Arab legend tells that by means of the power inherent in his ring, the Hebrew King was able to succeed in all his undertakings. However, for the space of forty years he was deprived of its aid, as he once thoughtlessly took it off his hand when he was in the bath and it was carried away by a malevolent genius. At the end of the forty years it was found again in the body of a fish served on the monarch's table. In Rabbinical legend this ring is said to have been set with a marvellous precious stone, perhaps a diamond, which served as a magic mirror wherein Solomon was able to see reflected the image of any

distant place or of any persons in regard to whom he wished to be informed.[1]

A variant of the legend we have just given is found in another Arabian tradition, which recounts that Solomon was so much infatuated with a female prisoner, the daughter of a Gentile prince, and named Aminah, that he entrusted to her care his precious signet, given to him by the four angels that presided over the four elements. A mighty Jinn succeeded in gaining possession of the ring, and, by its power, assumed Solomon's form, at the same time changing that unhappy monarch's appearance to such an extent that his courtiers no longer recognized him, and drove him from his kingdom. However, one of Solomon's ministers was shrewd enough to see through the disguise of the Jinn, and proceeded to exorcise the evil spirit by reciting certain verses of the Law. The Jinn fled affrighted, and dropped the ring into the sea. Here it was swallowed by a fish, and in due time this fish was caught by Solomon, who had entered the employ of a fisherman. Once again in possession of his ring, Solomon soon regained his kingdom.[2]

The great Persian poet Hafiz of Shiraz thus uses Solomon's Seal to point a moral: [3]

> Matters of beauty other there be, beside sweet speech,
> And Solomon-hood by a seal-ring alone is not begot.

The legend of the mystic ring of Gyges is related

[1] Giovanni B. Rampolli, "Annales Musulmani," vol. viii, Milano, 1824, p. 544 *sqq.*, note 90.

[2] Burton "Supplementary Nights," London, 1886, vol. iii, p. 72, note.

[3] The poems of Mohammed Hafiz of Shiraz, translated by John Payne, London, 1901, vol, iii, p. 230; epodes II, 2.

by Plato in his Republic.[4] According to this recital the ring was found under very extraordinary circumstances by "an ancester of Gyges the Lydian," but the text seems to be corrupt, and Gyges himself was probably said to have been the finder. Gyges (or his ancestor) was at the time a shepherd in the service of the Lydian King. One day a violent storm occurred, followed by an earthquake which opened up a deep chasm in the earth, near the place where this shepherd was feeding his flock. Moved by curiosity, he descended into the chasm and saw therein a hollow, brazen horse, with openings at the sides; bending down and looking through these openings, he discerned within the horse the body of a man of immense size. A golden ring glittered on the finger of the corpse. This the shepherd removed, and climbing out of the chasm, straightway took his departure. When, a few days later, all the shepherds assembled to prepare their monthly reports to the king, the man who had found the ring was of their number. As he sat with the others he carelessly turned and twisted the ring which he had placed on his finger, until, by chance, he turned the bezel toward the inside of his hand. Immediately he became invisible, and heard the other shepherds talking of him as though he were absent; but when he turned the ring around again, so that the bezel was outside, he reappeared. He repeated this experiment several times until he had assured himself of the strange virtue of the ring. Realizing then the extraordinary opportunities that this power afforded him, the shepherd asked and obtained the privilege of bearing the reports to the king, and soon found means

[4] Lib. ii, cap 3; Platonis Dialogi, ed. Hermann, vol. iv, Lipsiæ, 1883, pp. 37, 38.

to seduce the queen, and, by her aid, to slay the king and gain possession of the kingdom.

Although the legend does not expressly state that the ring was set with a stone, the use of the term "bezel" (σφενδόνη) suggests that some precious stone was the seat of the magic power the ring possessed. The traditions current at a later period with regard to the opal, which was reputed to render the wearer invisible, make it not improbable that, in the original legend, the ring of Gyges was represented to have been set with an opal, or rather perhaps with one of the rainbow-hued specimens of iridescent quartz. Plato may well have omitted this detail, for he was making a didactic use of the story and would naturally treat his material very freely.

An old author conjectures that the stone set in the ring of Gyges was a serpent-stone from India. In that land brilliant and exceedingly beautiful stones were said to be found in the heads of certain crested snakes that abode in the mountains. If such a stone were set in a gold or silver ring, at the time when the planetary or stellar control of the stone was in the ascendant, the wearer of the ring was sure to have the fullest possible benefit from its powers.[5] The idea that serpents were endowed with supernatural wisdom was held by many ancient peoples, and in India legend assigned to these mysterious and dreaded reptiles the guardianship over diamonds, and also over the corundum gems, chief among which are the fair sapphire and the glowing ruby.

The gold ring of Minos, King of Crete, although of course purely mythical, is usually ranked among the magic rings. It is said to have been used by the Cretan,

[5] Cæselii, "Commentarii antiquorum lectionum," Venetiis, 1516, p. 141; lib. iii, cap. xxv.

who claimed Jupiter as his father, to test whether Neptune were really the father of Theseus. Taking his ring off his finger, Minos cast it into the sea, and commanded Theseus to bring it back to him, if the latter wished people to believe Neptune to be his father. He himself, Minos, could easily furnish proof of his descent from Jove by praying for a celestial sign. This he did, and immediately a loud thunder-clap resounded in the heavens. Not to be outdone, Theseus, not even stopping to make any supplication, threw himself into the sea to seek the ring. On this, there appeared a multitude of dolphins, and Theseus was softly borne away to the Nereides, who gave him the ring so that he might restore it to Minos.[6]

The legendary ring of Helen of Troy is said to have borne as its setting an astroites or star-gem taken from the head of a mysterious fish called *pan,* because in appearance it resembled the god Pan. Perhaps the gem was simply one of the head-stones existing in certain fishes of other species. This stone, which emitted rays of flame, was conceived to be a most potent love-charm, drawing to its wearer the love of anyone he, or she, might wish to fascinate, and the particular specimen of this strange gem which Helen wore was a signet, engraved with the image of the god by whose name the fish was called.[7]

Among the rings miraculously found after they have apparently been irrevocably lost, was one of iron

[6] Hygini, " Astronomica," ed. by Emile Chatelain and Paul Legendre, Paris, 1909, p. 19. Bibliothèque de l'École des Hautes Études, Fasc. 168.

[7] King, " Handbook of Engraved Gems," London, 1866, p. 184, citing Ptolemy Hephaistion, bk. ii, and Suidas.

given to Seleucus I, Nicator (365–281 B.C.), whose wide dominions stretched from the western seaboard of Asia Minor to India. This prized ring was lost by chance near the river Euphrates, but was later recovered at the very spot where the ruler's mother had predicted it would be found.[8] Whether this was revealed to her in dream or trance the recital does not state.[9]

A talismanic bronze ring in the British Museum is set with an amethyst on which has been engraved a human eye, evidently a charm against the Evil Eye. This dread influence was also combated by a peculiar type of ring having gold nails or studs inserted in them. This is a Græco-Roman type of about 500 to 200 B.C., and does not appear to have gained favor with the Romans. In a large and massive gold ring of the late Roman period, the entire bezel has been given the form of an eye. This ring weighs 975 grains, or over two ounces; it was found in Tarsus, and belongs to the third Christian century.[10]

In a few ancient rings gold and silver have been combined, as shown by a striking example in the British Museum, where the upper part of the hoop is of gold and the lower half of silver. This has been conjectured to have been designed to render the ring a talisman, the joining of gold and silver having a similar effect to that obtained by inserting a gold nail in the bezel of a silver ring. The bezel of the massive ring we have

[8] This may have been the ring supposed to have been given by Apollo, before the birth of Seleucus.
1601, p. 3.

[9] Abrahami Gorlæi, "Dactyliotheca," Delphi Batavorum,

[10] F. H. Marshall "Catalogue of the Finger Rings, Greek, Etruscan and Roman, in the British Museum," London, 1907, pp. xxiii, xxxiii, 131, Plate XX, fig. 801.

noted is set with a sard engraved in intaglio with the design of a shepherd seated on a rock.[11]

The wearing, at certain religious ceremonies, of a ring set with a gem on which was engraved a design having some fancied connection with the ceremony, appears not to have been uncommon in the Roman world. An instance of this is given by the historian Suetonius, who states that when Nero was about to take the auspices (the bird-augury), Sporus gave him a ring the gem of which represented the carrying off of Proserpina, goddess of the infernal regions.[12] The finding of a ring with a particular design was also looked upon as a harbinger of good fortune. Shortly after the choice of Galba as emperor (68 A.D.), there was found in building the fortifications of a city, on the spot the emperor had selected for a military exercising ground, a ring of antique workmanship engraved with the figure of a Victory with a trophy. This was accepted as a happy presage.[13]

Josephus tells us of a magic ring which was used by a Jew named Eleazar. In the presence of the emperor Vespasian, of his son, and of his court, this man cured those suffering from demoniacal possession. His method was to introduce into the nose of the patient a ring having beneath its device an herb designated by Solomon. The evil spirit was attracted by the odor of the herb and immediately passed out of the man's body. After this Eleazar exorcised it by chanting

[11] F. H. Marshall. "Catalogue of Finger Rings, Greek, Etruscan, and Roman, in the Departments of Antiquities, British Museum," London, 1907, p. xxxiii, No. 386; see Plate XII.

[12] Suetonii, " Nero," cap. xlvi.

[13] Suetonii, " Galba," cap. x.

certain "psalms of Solomon." Furthermore, in order to convince the spectators of the presence of the evil spirit, he used to place on the ground a vase filled with water, and command the demon to upset it. As the text of Josephus indicates that this experiment was successful, Eleazer must have had recourse to some clever deception in the matter.[14] This tale shows that rings somewhat similar to those described in the Cyrianides (a work written in Alexandria about the third or fourth century of our era) were used in the first century. It is true that Josephus does not say that the ring was set with a stone, but merely states that it bore a device.

The god Mercury was popularly regarded as a bestower of magic rings, to judge from the words Lucian, the greatest humorist of ancient times, puts into the mouth of one of his characters. Timolaus, in "The Ship," expresses the wish that Mercury would grant him a number of wonder-working rings; one of these should preserve his health and protect him from wounds and other injuries; another should make him invisible as did the ring of Gyges; a third should give him the strength of ten thousand men; a fourth was to give him the power to fly through the air, and a fifth, the power to sleep at will, and the privilege of seeing all doors open before him. The crowning gift, however, would be a ring possessing the virtue of attracting the love of all fair women, and the affection and respect of his fellow men.[15] We might infer from this that rings engraved with the figure of Mercury were supposed to be especially propitious; very possibly the story of the magic

[14] Flavii Josephi, "Antiquitates Judeorum," Basileæ, 1540, p. 203.

[15] Luciani, "Opera Omnia," ed. Jocobitz, Lipsiæ, 1881; Navigium, 42, 43, 44.

rings of Apollonius of Tyana, later embodied in the life of this strange personality written by Philostratus, was known to Lucian, and suggested this description of the various and wonderful powers inherent in rings of this kind.

The same author mentions a magic ring used to frighten away ghosts.[16] This was made, by an Arab, out of an iron nail from a cross, and the virtue ascribed to it recalls that attributed to a piece of wood from a gallows. In each case an object that was associated with a violent and ignominious death was believed to have the power of exorcising unwelcome visitants from the grave.

The Church father Clemens Alexandrinus, born about 150 A. D., says, giving Aristotle as his authority, that a certain Execestus, a tyrant of Phocis, owned and wore two magic rings, and by means of the stones set in these rings he had knowledge of future events. They seem to have done him but little service, however, for he met his death by assassination, although it is stated that the gems gave him warning of this.[17]

Flavius Philostratus, who flourished under Septimius Severus (193–211 A.D.) and later, wrote at the request of the Empress Julia Domna, a remarkable life of Apollonius of Tyana in which he laid special stress upon the miracles ascribed to this pagan saint. The work was used later to oppose the teachings of the Christians. Here we read that Apollonius possessed seven enchanted rings corresponding to the seven planets, the gift of the Hindu prince Iarchas. These he wore, one by one, in the order of the week days; "for it is said that he revered them as divine, so that

[16] Philopseudos, 17.

[17] Clementis Alexandrini, " Stromata," lib. i.

he changed them each day and made them partakers of his greatest secrets." [18]

The Leyden Papyrus (No. V), of the third century of our era, contains a number of directions, in Greek and Demotic Egyptian, for the preparation of amulets and talismans, and gives two formulas for the making of magic rings. The text of one is defective in part, but can be rendered as follows: [19]

" A ring for constant use and for prosperity . . . very efficacious for kings and emperors. Take an azure jasper, engrave on it a dragon in the form of a circle, the tail in the mouth, and in the midst of the dragon (an animal) having two stars on its two horns, and the sun above (with the name) Abrasax, and place as an inscription upon the stone the same name, Abrasax, and on the . . . engrave the great and supreme appelation, Iao Sabaoth. Wear the stone in a gold ring. May it be always useful for you, existing pure and . . . for whatever you may desire. Consecrate the ring and the gem which projects above it. The design upon the gold, which has been described above, has the same virtue."

The names Abrasax and Iao Sabaoth indicate that this ring was probably designed to be a talisman for adherents of the Marcian form of Gnosticism.

A second formula runs thus:

"Ring to obtain (a wish) a favor and success; it renders glorious, great, admirable and rich; it insures love. It is proper and excellent to be worn on all occasions, this incomparable ring. It bears the wonderful

[18] Longi, " De annulis signatoriis " Francofurti et Lipsiæ, 1709, p. 39.

[19] " Dictionnaire d'archéologie chrétienne et de liturgie," ed. by Dom Fernan Cabrol, vol. i, Pt. II, Paris, 1907, cols, 2215, 2216, s. v. anneaux.

name of the sun, cut in a heliotrope, and is fashioned as
follows: A complete serpent, like a circle, holding
its tail in its mouth; on the inside is a scarab, sacred
and radiant. As to the name, thou shalt engrave this
in sacred characters on the reverse side of the gem, as
is taught by the prophets, and thou shalt wear the ring
in all purity. Having it with thee, all thy wishes will be
fulfilled; the hatred of kings and emperors toward thee
will be appeased; when thou wearest it all that thou
sayest to others will be believed, all will favor thee, all
doors will be open to thee. Thou wilt rend the bonds
and break the stone-walls, if thou takest out the stone,
that is the gem, and pronouncest the name inscribed
beneath it. This ring is equally useful for demoniacs,
give it to them, and on the instant the demon will flee."

Dreams of rings set with precious stones have a
special significance, and Achametis tells us, from his
Hindu sources, that if anyone should dream of receiv-
ing a ring set with a red stone, the splendor of the
stone signified great authority and much joy to the
dreamer. If, however, a man had a dream of a ring
set with a yellow stone, the vision portended that his
wife would be liable to illness and chagrin.[20]

An Anglo-Saxon dream-book from the time before
the Norman Conquest, gives the significance of various
dreams about rings. Thus, for example, merely to
see a ring betokened a desired place; should one dream
of receiving a ring as a gift, however, this denoted free-
dom from care. If the dreamer fancied himself to be the
owner of a gold ring, this indicated that great honor
was going to be his portion. Lastly, the dream that

[20] Artemidori Daldiani et Achametis Sereini "Oneiro-
critica," Lutitiæ, 1603, p. 259.

a gem had been lost from a ring was a very bad omen
and portended some serious accident.[21]

Three subjects of the Eastern Emperor Valens
(364–378 A.D.), believing that he had incurred the pub-
lic hatred to such a degree that he would soon perish
at the hands of his enemies, sought the aid of the di-
viners Hilarius and Patricius to learn what would be
his fate and who would succeed him. The diviners,
having engraved around the edge of a basin the charac-
ters of the Greek alphabet, suspended above it an
enchanted ring, which, by its vibrations marked in turn
the letters that composed the words of the response of
the oracle. It was conceived in the following terms:
" The successor of Valens will be an accomplished
prince. The curiosity of those who have consulted the
oracle will be destruction to them, but their murderers
will themselves incur the vengeance of the Gods." As
the oracle had failed to designate the prince clearly, the
inquirers demanded his name. Thereupon the ring
struck successively at the letters T. H. E. O. D., and
one of those present exclaimed that the Gods named
Theodore. The others all accepted this view and the
matter appeared so evident that no further attempt at
research was made.[22]

A curious type of magic ring is vouched for by St.
Augustine, in the fourth century, who notes as a super-
stitious practice the wearing of a ring (or " finger-
band " *ansula*) made from the bone of an ostrich.[23]

[21] Rev. Oswald Cockayne, "Anglo-Saxon Leechdom," vol.
iii, London, 1866, pp. 199, 205, 215 in "A Book of Dreams
by the Prophet Daniel."

[22] Lebeau, " Histoire du Bas-Empire," livre XIX; vol. iv,
p. 307, ed. Desaint et Saillant, Paris, 1759.

[23] St. Augustine, " De doctrina christiana," lib. ii, cap. 20.

Whether the attribution of a magic quality resulted from the rarity of the bird for the Romans, or from some analogy with its habits, is left to our imagination to determine.

A talismanic ring of the late Roman times, about the fifth century A.D., was found by Lieut. Scheibel, in 1896, embedded in sand that had been dredged from the bed of the Save River, near Vincovce, Slavonia, Austria. The hoop is divided by ridges into eleven compartments in which are engraved the Greek letters *Z H CAIΣ APIΩN* (equivalent to "Long live Arion"). This ring is in the Albert Figdor Collection, Vienna.[24]

Among the legends which gathered about the personality of Charlemagne, none is more interesting than that which tells of a precious stone which exercised a magic power over him. This legend is of German origin and probably localized in Aix-la-Chapelle; it does not appear in any of the numerous French *chansons de geste* treating of Charlemagne and his times. It seems to have originated about the thirteenth century, although it may have been current at an earlier date, and we have two principle versions, one given by Brandwaldius,[25] and the other by Petrarch.

The first-named version describes the acquisition of the stone in much the same terms as are employed in the story from the Gesta Romanorum regarding the stone brought by a serpent to the blind Theodosius;[26]

[24] Communicated by L. Weininger, of Vienna.

[25] Scheuzeri, "Itinera per Helvetiæ alpinas regiones," Lug. Bat., 723, vol. iii, pp. 381-383.

[26] See the present writer's "The Magic of Jewels and Charms," Philadelphia and London, 1915, pp. 238, 239.

Silver-gilt ring with Greek inscription ΧΡΟΝΟΣ Δ'ΑΝΑΙΡΕΙ ΠΑΝΤΑ ΚΑΙ ΩΗΘΗΝ ΑΓΕΙ (Time removes all things and brings forgetfulness). In the interior a sun-dial. Sixteenth Century
Albert Figdor Collection, Vienna

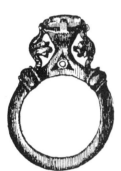

Ring of gilt bronze, set with a square table-cut rock crystal
Albert Figdor Collection, Vienna

Gold ring. The hoop has eleven ridges between which are the Greek letters ΖΗΣΑΙΣ ΑΡΙΩΝ (Long live Arion). Found by Lieutenant Scheibel, in 1896, in sand dredged from the bed of Save River, near Vincovce, Slavonia, Austria. Late Roman, about Fifth Century
Albert Figdor Collection, Vienna

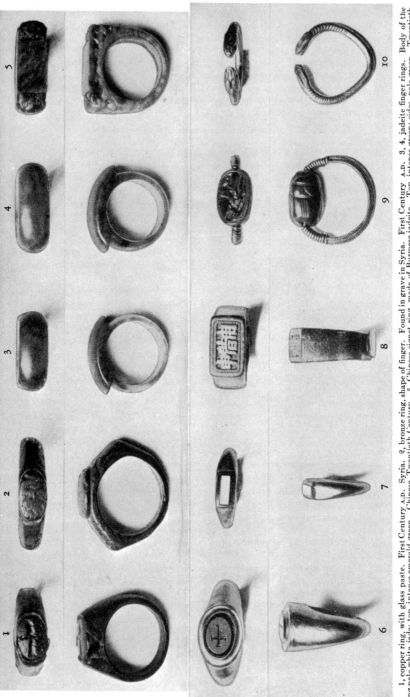

1, copper ring, with glass paste. First Century A.D. Syria. 2, bronze ring, shape of finger. Found in grave in Syria. First Century A.D. 3, 4, jadeite finger rings. Body of the ring pale white jade; top, intense emerald green. Chinese Twentieth Century. 5, Chinese signet ring, made of Burmese jadeite. Top, intense green; sides, pale green. Twentieth Century. 6, antique Christian hollow ring of fine gold with Greek Cross engraved on garnet. Second Century A.D. 7, antique ring of fine gold with Nicolo. Black band surrounding white oblong. 8, Chinese ring of fine gold, with motto. Shank of ring is in two parts, all fine gold, so they can be made to fit any finger. 9, ancient Greek ring of twisted gold. Sard engraved

indeed, the resemblance is so close that one of these tales must be derived from the other. Here also the serpent rings a bell outside the palace gates, and finally succeeds in obtaining justice against a toad which has secured possession of its nest. Grateful for this service, the serpent appears before Charlemagne, when he is seated at meat, crawls up on the table and, lifting the cover of a beaker, drops therein a precious stone. From this point we have the specifically Carolingian legend. The stone possessed a strange, hidden power, by means of which it attracted the affections of the first owner to any one who subsequently acquired it. Charlemagne gave it to his wife and immediately all his thoughts became centered in her. Naturally enough she in no wise objected to this, but when she was taken dangerously ill she could not endure the thought that some other woman should acquire the stone, and take her place in Charlemagne's heart; therefore, when at the point of death, she slipped it beneath her tongue and soon thereafter expired. The power of the charm over Charlemagne's mind was so great that after his wife's body had been interred he caused it to be exhumed, and spent his days and nights with it. This state of things continued for no less than eighteen years, until, finally, one of Charlemagne's ministers discovered the cause of the enchantment and removed the stone from beneath the tongue of the corpse. Instantly the spell was broken, but all the emperor's regard was now directed toward his minister, whose presence became indispensable to him. Marking this, and fearing that the gem might fall into unworthy hands, the minister threw it into a spring, which chanced to be that of Aix-la-Chapelle. Even here the stone did not lose its power, and the place became the favorite resort of Charle-

magne, who established himself there and built a church and a palace near the resting place of the charmed stone.

A somewhat different version of this tale is given by Petrarch,[27] who states that he had it from the priests of Aix-la-Chapelle. There is here no mention of a serpent bringing a stone, and the object of Charlemagne's love is not his wife but a woman who possesses a magic ring. The emperor is so thoroughly infatuated that when she dies he has the body decked out with gorgeous apparel, adorns it with precious stones and refuses to leave it. Anxious to relieve his sovereign from this obsession, the Bishop of Cologne prays to God for a solution of the mystery, and is told, in a vision, that the cause lies beneath the tongue of the corpse. He searches in the place indicated and finds there a gem set in a slender ring. When this is removed Charlemagne regains his normal state, and gazes with surprise and horror upon the object of his love. The story then proceeds in much the same way as in the older German version.

The remains of Charlemagne, and presumably whatever ornaments may have been buried with him, were disinterred at Aachen (Aix-la-Chapelle) in 1000, by order of the German emperor Otto III. The bare fact of the discovery of Charlemagne's bones is recorded in the early chronicle,[28] but according to legends of a later time, when the imperial crypt was opened, the emperor was to be seen seated on a marble throne and adorned with imperial vesture and ornaments. Such had been his persistent vitality that his finger-nails had continued to grow after his death, and had pierced through the gloves on his hands.[29]

[27] Petrarchæ, Epistolarum libri, Lugduni, 1601, pp. 10, 11.

[28] Annales Lamberti, in Monum. Germ., vol. iii, p. 91.

[29] Monum. Germ. Script., vol. vii, p. 106.

The magic ring of the Nibelungen was given by the Asar Loki to Hreidmar, as wergeld for the murder of Hreidmar's son Otr, whom Loki had killed. As Otr had assumed the shape of an otter when he met his death at Loki's hands, the latter was required to furnish enough blood-ransom to fill the otter's skin. This he obtained by capturing the dwarf Andvari and forcing him to give up his riches to ransom his life. His other treasures Andvari yielded with much hesitation, but he was extremely loath to part with his ring, and when finally forced so to do, he pronounced a curse upon all who should ever come into possession of it. This curse was fulfilled by the successive violent deaths of Hreidmar, killed by his son Fafner who wished to rob him of his treasure; of Fafner, who in the snake or dragon form he had assumed was slain by Sigurd; of the hero Sigurd himself and of Brunhilde upon whom he bestowed the fatal ring.[30] This is the legend as related in the Volsung Saga, composed in the fourteenth century from older traditions.

Caxton's English version of the tale of Reynard the Fox, derived from the eleventh century " Roman de Renard," contains a detailed description of a magic ring.[31]

A rynge of fyn gold, and within the rynge next the fyngre were wreton letters enameld wyth sable and asure, and there were thre Hebrews names therein. I coude not my self rede ne spelle them, for I understonde not that langage, but moister Abrion of Tryer, he is a wyse man, he understandeth wel al

[30] " The Edda," by Winchell Faraday, Pt. II, London, 1903, pp. 16, 17.

[31] The history of " Reynard the Fox," trans. and pub. by William Caxton, 1481; ed. by Edmund Goldsmid, Edinburgh, 1884, vol. ii, pp. 55, 56. Privately printed.

maner of herbes . . . And yet he bileveth not on God, he is
a Jewe, the wysest in conynge, and especially he knoweth the
vertue of stones. I shewde hym this ryng, he saide that they
were the thre names that Seth brought out of Paradys, when
he brought to his fadre Adam the oyle of mercy. And who
somever bereth on hym thise thre names, he shal never be hurte
by thondre, ne by lyghtnyng, ne no witchecraft shal have
power over hym, ne be tempted to doo synne. And also he
shall never take harm by colde, thaugh he laye thre wynters
nyghtis in the feelde, thaugh it snowed, stormed, or froze never
so sore, so grete myght have thise wordes.

This wonder-working ring was set with a stone "of
three maner colours," red, white and green. The red
part had the fabled quality of the ruby for "the shynyng
of the stone made and gaf as grete a lyghte as it had
been mydday." The white portion was a remedy for
diseases of the eye, for headache, and, indeed, for al-
most all ills, "sauf only the very deth," if the part
affected were stroked with the stone, or, when the
malady was internal, if the patient drank of water in
which the stone had been placed. The third color was
"grene lyke glas," with some small spots of purple.
This procured love and friendship for the wearer and
also victory in battle; even should he be "al naked in
the felde agayn an hondred armed men," he would
escape with honour. However, the ring must only be
worn by one of gentle birth.

The "Lapidario," an astrological treatise on stones,
written at the instance of the Castilian King, Alfonso
X, the Wise, (1221–1284), ostensibly a translation
from a "Chaldee" original, but probably mainly based
on Arabic lore, gives, under the obscure name *ceritiz,*
an account of an Indian stone found on the banks of
the river of the same name. It was of a very dark

Dela piedra zumorat. xxxv:
El terçero grado del sig-
no de tauro. es la pie-
dra a que llaman za-
moriça: z otrossi es-
dicha piedra delos her-
manitanos. E es falla-
da en las riberas dela
mar a que dizen ara-
uita. e es aquella mar
por que passo moysen

las fijos de israel: çerca dela çibdat a que llaman trarita.
a las ondes daquella mar quanto faze tormenta:
echa las a la orella. Et es mucho amariella de color:
e luzia como el oro claro. passa la el uiso. Et es fuerte
e que bantar: tar dellas grandes z dellas pequeñas:
e siempre la fallan de figura de castaña. De su na-
tura es fria z seca: z muy fuerte en estas sus compliçiones
e preçian la mucho en aquella tierra: usan della en
sortijas z en anniellos. por que el omne que la
trae consigo: non a sabor ninguno de plazer de mu-
ger: aun que lo comiençe: non puede acabar nin-
guna cosa mientre la piedra touiere consigo. Et por
esto los sabios antigos dauan la a los religiosos z a los
hermitannos: z a aquellos que prometen de tener
castidat. Et algunos delos grandes que auian poder: de
non yazer con sus mugieres si non en tiempos seña-
lados por amor delas enprennar mas ayna z fazer
los fijos mas sanos z mas fuertes. trayen las siempre
consigo en todo el otro tiempo: si non quanto querien
engendrar. Et si quieren desta piedra mouan a beuer
a algun omne preso de tres dragmas: ninguna iamas
aura poder de yazer con mugier. Et por ende los reyes
de yndia quanto algunos quieren castrar por que
guardassen sus mugieres: dauan les a beuer desta
piedra por duelo que las auien delos tornar sus mi-
embros: nunca tanto como si fuessen castrados. Et la
estrella que es en la nariz delas que son en la caruilla
la ymagen de tauro. a poder z señerio sobrel esta pie-
dra della nasçe la fuerça z la uertud. Et quanto es-
ta estrella fuere en el asçendente: muestra esta pie-
dra manifiesta mente sus obras.

THE "HERMIT STONE," A TALISMAN OF CHASTITY WHEN WORN SET IN A RING

Lapidario del Rey D. Alfonso X, Codice Original, Madrid, 1881, fol. 14

ARIES

Dela piedra aque dizen ceuliz: xxxxxxxxxxxx?

el quarto grado del signo de aries es la piedra aq llaman ceuliz. Et es fallada en tierra de india en una ysla por o corre un rio que a assi nombre: fallan la en las riberas de aquella agua. Et es de color tan uerde: que tira ya quanto contra negro. Esta piedra es muy fuerte: et pesan ciento et ueynte dragmas. Et quanto la alimpian puliendo la: catan se los omnes en ella assi como en espeio trayente. Et es otrossi es de su natura caliente: et seca. Et a en si tal propietat q si la touiere la mugier colgada sobressi. o encastona da en sortija. quando yoguiere el uaron con ella: nunqua se emprennara si non de maslo. Esso mismo fara qual quier animal sobre que la colgaren. Et esta uertud recibe dela estrella que es en el retornamiento del rio. la que tanne en los pechos de cayntos. Et quanto es esta estrella en medio del cielo: muestra esta piedra mas manifiesta miente sus obras

FINDING OF STONE WHICH WHEN SET IN A RING ASSURES MALE OFFSPRING
TO THE WOMAN WHO WEARS IT
Lapidario del Rey D. Alfonso X, Codice Original, Madrid, 1881, fol. 3

green hue, was exceedingly tough and its weight is fixed at 120 drachmas. When cleaned and polished it cast a reflection like that of a fine mirror. A piece of this stone set in a ring and worn by a woman would assure her a series of boy babies.

Another ring-stone, one having a different effect, was that called the "hermit's stone," which was washed up by the waves on the shore of the Red Sea. Its color was yellow, transparent, and had a sheen like that of pure oil; possibly this may have been chrysolite. It was eminently and rigidly a stone of chastity. The lapis lazuli was dedicated to Venus, and any man who wore one set in a ring, while Venus was in the ascendant, would attract the love of women, especially of those with blue-gray eyes. On a woman's hand, it had a corresponding effect upon the opposite sex.[32]

An old German lay tells of a magic gold ring set with a diamond. Should the woman wearing this ring prove unfaithful in love, the gold turned to dross, and the diamond became glass. The Latin name of the diamond, *adamas,* is the form used in this poem.[33] This word, which primarily signified an exceedingly hard metal, finally came to mean the diamond, or at least what was believed to be a diamond, although it might in reality be only a colorless corundum, much less hard than the genuine diamond, but harder than any of the other precious stones except the colored corundums, ruby, sapphire, etc.

The thirteenth century German romance, "Wolf-dietrich," celebrates a ring given by the empress to

[32] "Lapidario del Rey D. Alfonso X, codice original," Madrid, 1881, folios 3 recto, col. 2; 14 recto, col. 2; 106, verso, col. 2.

[33] Mauricii Pinder, "De adamante," Berolini, 1829, p. 68.

the hero of the poem. This ring was set with a stone destined to double the strength of the wearer, and to protect him from the sheets of flame ejected by the fearful dragon he was about to combat. However, before his encounter with this fabulous monster, Wolfdietrich determines to return the ring, and sends it back to the empress, whereupon she bursts into tears, exclaiming: " I let it down from the battlements with my own hand. Does he value it so lightly, that he sends it back to me?"

In a satirical and malicious life of Pope Boniface VIII (ca. 1228–1303), the bitter opponent of the French king Philippe le Bel (1268–1314), written by, or at the instance of his royal enemy, it is related that when this pope was dying and was told that he must prepare his soul for the great change, he cast his eyes upon a stone set in a ring he was wearing, and exclaimed " O you tricky spirits imprisoned in this stone, why have you deceived me to abandon me now in my extremity?" And so speaking he snatched off the ring and threw it away.[35]

One of the old monkish tales from mediæval times, collected under the title of "Gesta Romanorum," runs as follows:

Frediricus, who reigned in a Roman city, had been a long time without offspring. Finally, by the advice of wise counsellors, he married a beautiful girl in parts far distant and lived with her in an unknown land and had offspring. After this, he wished to return to his realm but could not obtain his wife's

[34] "Der grosse Wolfdietrich," ed. Holtzmann, Heidelberg, 1865, pp. 243, 271.

[35] C. W. King, "Antique Gems and Rings," London, 1872, p. 393; citing "La vie, état et condition du pape Maleface, racontés par des gens de foi."

consent; indeed, she always repeated that if he abandoned her she would kill herself. Hearing this, the emperor caused two splendid rings to be made, and had engraved upon two gems images of the following efficacy: one of remembrance and the other of forgetfulness. Having set these in their appropriate rings he gave one—that of forgetfulness—to his wife, and kept the other for himself . . . The wife began straightway to forget the love of her husband, and the emperor, noting this, journeyed back to his realm with great joy, and never re-turned to his wife. He ended his life in peace.[36]

Welsh legend offers us parallels to the ring of Gyges and to that set with the "Stone of Remembrance" told of in the Gesta Romanorum. In the old Welsh epic, the Mabinogion, the following directions are given by a damsel to her lover in regard to a ring of the former type: "Take this ring and put it on thy finger with the stone within thy hand; and close thy hand upon the stone, and as long as thou concealest it, it will conceal thee." This Stone of Invisibility was regarded as one of the thirteen rarities of the ancient British regalia, formerly treasured up in Caerleon, Monmouthshire, and in another Welsh legendary cycle (the Triads) it is said to have "liberated Owen, the son of Urien, from between the portcullis and the wall." Whoever con-cealed the stone would be concealed by it. Here indeed the similarity with the story told of the ring of Gyges is so close that it is apparent we only have to do with an adaptation of the classic tale. As to the stone of Remembrance, however, the Welsh tradition seems to be essentially an independent one. The Mabinogion makes Iddawe say to Rhonabwy: "Dost thou see this ring with a stone set in it upon the Emperor's hand?

[36] "Die Gesta Romanorum," ed. Wilhelm Dick, Erlangen, 1890, pp. 10, 11.

It is one of the properties of that stone to enable thee to remember that thou seest here to-night, and hadst thou not seen the stone, thou wouldst never have been able to remember aught thereof." This refers to a dream or vision accorded to Rhonabwy while he lay upon an enchanted calf-skin.[37]

Dactylomancy, as it was called, was resorted to in the Middle Ages by those who sought to probe the mysteries of the future. This art was practiced by the use of a ring (sometimes bearing the figure of one of the constellations), which was suspended by a thread in the middle of a glass or metal vessel. The number and quality of the strokes it made against the sides of the vessel as it swung free on the thread, were interpreted by the magician according to a secret formula, and were explained by him to signify that some expected or dreaded event would or would not take place.[38]

Among the Sagan Kerens of southeastern Asia there is a curious superstitious use of a ring in connection with funeral feasts. On such occasions a metal ring is suspended from a support just over a brass basin. One by one the relatives of the deceased person approach and strike a succession of quick taps on the edge of the basin with a piece of bamboo. When it comes to the turn of the one who was most beloved by the departed, the spirit is believed to answer the call by making the string twist about and lengthen, so that, finally, it either parts and permits the ring to fall into

[37] Wirt Sikes: "British Goblins: Welsh folk-lore, fairy myths, legends and traditions," London, 1880, pp. 365-366.

[38] Pierre Lacroix, "Sciences et Lettres au Moyen Age," Paris, 1877, p. 238.

the basin, or else swings and lengthens sufficiently to
cause the ring to strike the basin edge.[39]

A magic ring is introduced by Sir Thomas Malory
in his "Morte d'Arthur," written in 1469 or 1470, the
tale being of course borrowed from some one of the
numerous sources he used in this compilation of the
story of King Arthur and the Knights of the Round
Table. The ring was given by Dame Liness to Sir
Gareth, who wished to hide his personality while com-
peting in a tournament. The dame assured the Knight
that this ring had such virtue that it would turn green
to red, blue to white, and vice versa, and so through
all the range of colors. The lady required, however,
a solemn promise that her ring would be returned to
her at the close of the tournament, for in addition to
its other virtues, it possessed marvellous cosmetic
powers, increasing her beauty to an extraordinary
degree.

In the tourney, the baffling changes of color in
Sir Gareth's arms and equipment confused his assail-
ants and rendered him more easily victorious than
he would otherwise have been, good knight that he
was. Having ridden for a moment out of the press
of knights to adjust his helmet, which had become
loosened, a dwarf approached him, offering a cup of
wine to quench the knight's thirst, at the same time
asking to hold the ring lest Sir Gareth should let it slip
from his finger while drinking. The knight gave it
to him, but in his eagerness to join again in the affray,
forgot to take it back. But now his armor retained its
normal yellow tint, and, fearing recognition, for it was
important for him to conceal his personality at this

[39] Mason in Journal of the Asiatic Society of Bengal, 1865,
Pt. II, p. 200; Bastian, "Oestliches Asien," vol. i, p. 146.

time, he noted that his ring was not on his hand. He quickly sought the dwarf and obliged him to surrender the magic ring. No sooner was it on his finger than his armor changed color, and he was able to avoid a threatened pursuit, as all were in search of the Yellow Knight.

A ring having magic power to protect the wearer from danger appears in the mediæval romance of Sir Eglamore. The tale appears to have been known to Shakespeare, to judge from the line: "What think'st thou of the fair Sir Eglamore," which occurs in Two Gentlemen of Verona. This ring was given to the gallant knight by his lady love: [40]

> Then said Arnada, that sweete thing
> "Have here of me a gold ring
> With a precyous stone;
> Where-soe you bee on water or Land
> And this ring upon your hand
> Nothing may you slone." [41]

Sometimes the virtues of the ring are conceived in a poetic spirit and are associated intimately with the giver, as we find in the romance of Ywaine and Gawin. Here the stone set in the ring given by Ywaine protects the wearer from imprisonment, illness, loss of blood, and danger in battle, but the lady tells her lover that this virtue exists in the ring "while you it have and think on me," that is, only so long as his love endures.[42]

[40] Bishop Percy's Folio Manuscript, ed. by John W. Hales and Frederick J. Furnivall, London, 1868, Vol. II, p. 363.

[41] Slay.

[42] Ritson, "Ancient English Medical Romances," London, 1802, vol. I, p. 65.

That the magic virtues of the images and talismans were liable to wane and pass away, was taught by Albertus Magnus, who likened these powers to those of animate objects which were also transitory. When the period fixed by heaven had come to an end, the power of the image would be broken and it would be useless, cold and dead. This, in his opinion, accounted for the fact that many talismanic figures failed to display any efficacy, although they had done so in ancient times.[43]

In the "Book of Thetel," as quoted by Konrad von Megenberg,[44] one of the engraved gems is described as follows:

A man seated upon a footstool, crowned, and stretching forth his hands to the heavens. Beneath him are four men appearing to support the stool. Take mastic and terebinth (turpentine) and put them under the stone in a silver finger-ring, having twelve times the weight of the stone in the ring. If this be placed beneath the head of a sleeping person, he dreams of what he longed for when awake.

The curious statement that the metal ring was to weigh twelve times as much as the stone, seems to indicate an influence of the superstition in regard to the number twelve.

The Londesborough Collection contains a ring which represents a toad swallowing a serpent. This was evidently used as an amulet and the design seems to have some connection with the curious superstition that a serpent, to become a dragon, must swallow a serpent.

[43] Jacobi Gaffarelli, " Curiositates inauditæ," Hamburgi, 1706, p. 112; Latin trans. citing Alberti, "De mirabilibus," tr. 3, cap. 3.

[44] Konrad von Megenberg, " Buch der Natur," ed. by Dr. Franz Pfeiffer, Stuttgart, 1861, p. 472.

A Greek proverb, found in Suidas (ab. the tenth century A.D.), is aptly rendered by Dryden (Edipus, Act III, sc. 1) as follows:

A serpent ne'er becomes a flying dragon till he has eat a serpent.

Hence this ring combined the curative or talismanic powers attributed to the toad, the serpent and the dragon.[45]

The ring of St. Mark, said to have been long preserved in the treasury of St. Mark's cathedral at Venice, was believed to have been acquired in a miraculous way. In the time of Henry III (1216–1272) the body of the saint, which had been taken to the cathedral, was suddenly missed and no trace of it could be found. Resort was then had to prayers and supplications, and these appear to have been answered, for one day the sacristan, while traversing the nave, saw an arm emerge from one of the pillars. He hastened to report this wonderful thing to the Doge and the cathedral clergy, who on reaching the building became witnesses of the miracle. As they were kneeling reverently before the column the hand of the apparition opened and let fall a ring, which was picked up by the Bishop of Olivolo. At the same instant, hand and arm disappeared, and the column opened, revealing in its interior an iron casket in which were the lost remains of St. Mark.

Not many years later this ring served to give proof of an appearance of the saint. One February day a fearful storm arose, piling up the waters of the lagoons and threatening the destruction of Venice. In the midst

[45] Catalogue of a collection of ancient and mediæval rings and personal ornaments, London, 1853, p. 5. Privately printed.

of the tempest, a man approached one of the gondoliers on the Riva dei Schiavoni, near the cathedral, and asked to be rowed across the canal to San Giorgio Maggiore. It was in vain that the gondolier protested he could not make head against the storm; he was at last forced to yield to the importunities of his would-be passenger. But what was his surprise to find that his boat proceeded as easily as though no storm were raging. On their arrival at San Giorgio Maggiore they were joined by another man, and the gondolier was now directed to proceed to the Lido. This time his reluctance was less difficult to overcome, although the storm was growing worse, for he felt encouraged by the ease with which he had already made part of the journey. And sure enough his long row to the Lido was equally uneventful. Here a third man joined the party, and the gondolier was told to row out between the castles on either side of the entrance into the open Adriatic. Feeling that he could now refuse nothing, the gondolier undertook to accomplish this apparently impossible task, and succeeded in reaching the sea. Here there arose before them a ship manned by the demons of the storm, who were steering their way in toward Venice, bringing utter destruction with them. And now the three men in the little boat stood up and pronounced an exorcism of such power that the ship foundered, and the demons, howling fearfully, were swallowed up in the deep. Immediately the tempest was stilled and the waves died down. The gondolier was now ordered to take his passengers back to the places where they embarked, and when the last of them, the first one he had picked up, stepped on to the Riva dei Schiavoni, he announced himself to be Mark, the Evangelist, and dropped a ring worth five ducats into the gondolier's hand, telling him to show it to the authori-

ties and say that it was St. Mark's ring, in proof of which they would find that its carefully locked receptacle in the cathedral was empty.[46] This proved to be true, and the gondolier received a liberal pension as a reward for having aided, however humbly, in the preservation of Venice by St. Mark.[47]

The marvellous ring of Gyges may have suggested to Abbot Tritheim, or Trithemius, of Spandau (1462–1516) the idea of fabricating a ring which would give the wearer the power of becoming invisible at will. The Abbot asserts that he had made such a ring out of the material called electrum, a natural alloy of gold and silver, having the color of amber. To possess the requisite power, the ring must be cast at the hour at which the person designing to use it was born, and it should be inscribed with the word "Tetragrammaton" signifying the four letters composing the Ineffable Name. When this ring was placed upon the thumb of the left hand, the wearer immediately became invisible. Besides this virtue, when worn on any finger, the ring preserved the wearer from poison and betrayed the presence of enemies by changing color.[48]

Rings bearing the Latin inscription "Jesus autem transiens per medium illorum" (Jesus, however, passing through their midst),[49] were thought to confer in-

[46] William Jones, " Credulities, Past and Present," London, 1880, pp. 208–210.

[47] The Venetian artist, Paris Bordone (1500–1570) painted a picture depicting the gondolier in the act of delivering St. Mark's ring to the Doge.

[48] Johannes Tritheim's " Wunder-Buch," Passau, 1506 (Reprint, p. 275).

[49] Luke iv, 30: " But he passing through the midst of them went his way." This refers to his escape at Nazareth from those who sought to cast him down from the hill.

visibility upon the wearer. This inscription occurs on the hoop of a gold ring set with an uncut diamond, shown at the Special Exhibition at the South Kensington Museum, June, 1862.

This motto, "Jesus autem transiens," etc., was in medieval times regarded as a great charm against the dangers that menaced a traveller on his journeys. In his quaint old English, Sir John Mandeville says of this that these words were sometimes pronounced by "some men when thei dreden them of thefes on any way, or of enemyes, in token and mynde that our Lord passed through out of the Jews' crueltie and scaped safely fro hem." On the gold noble which Edward III had struck in commemoration of his victory in the naval battle of Helvoet Sluys in 1340, and of his escape from the perils he underwent therein, this motto appears as the legend.[50]

Lambeccius narrates that he once told Emperor Leopold I (1657–1675) of a magic gold ring, said to have been long preserved in the Austrian treasury, and whose special virtue was that it could be used as an oracle to foretell the results of an approaching battle. If victory was to crown the Austrian army, this ring would shine with an unwonted splendor. It was said to be made from the gold offered by the Magi to the Infant Jesus. While, however, sacred ceremonies were being performed before the Emperor Frederick, grandson of Rudolph I., just before his departure for a disastrous battle with Louis of Bavaria, the ring vanished from the eyes of man. Later, it was said to have been

[50] O. M. Dalton, " Franks Bequest, Catalogue of the Finger Rings, Early Christian, Byzantine, Teutonic, Mediæval and Later [British Museum]," London, 1912, p. 138, Nos. 877, 878, 879; see Plate XV.

recovered and Lambeccius suggested that a ring he had recently observed in the treasury, bearing certain characters difficult of interpretation, might be the ring made from the offering of the Magi.[51] The omen of victory observable in this ring must have been suggested by what Josephus writes of the high-priest's breast-plate. According to his story " God announced victory in battle " by means of the twelve stones set in this breast-plate, and he proceeds " such a splendour shone from them when the army was not yet in motion, that all the people knew God himself was present to aid them."

A magic ring was made in the seventeenth century by a Florentine monk, named Nicolaus; this was designed to drive away gnats. It bore a charmed figure executed during the ascendency of the planet Saturn. The charm is said to have worked successfully. Since Saturn was usually regarded as a bearer of ill-luck, the operation of the magic figure must have depended upon sympathetic magic, the enlisting of the help of an evil power to combat a nature-plague.[52]

It is related that long ago in the Principality of Anhalt, a princess had the habit of going to the window after dinner and shaking out the crumbs from her napkin. Intention or chance induced a great toad to station itself under this window so as to eat up the precious crumbs. In due time the princess was wedded, and one night, shortly before the birth of a child, she saw a maid enter the room with a lighted candle in her hand. Approaching the bedside she handed a gold ring to the princess, telling her at the same time that it was

[51] Petri Lambeccii, "De Augustissima Bibliotheca Cæsarea" Vindobonae, 1665, p. 28.

[52] Jacobi Gaffarelli, " Curiositates inauditæ," Hamburgi, 1706, p. 118; Latin trans.

sent by the toad, out of gratitude for the food she had given it, with the earnest warning to guard the ring carefully, as the fortunes of Anhalt were bound up with it. Moreover, every precaution was to be taken on Christmas Eve to guard against fire.[53] It is stated that this ring was still to be seen in Dessau in 1722, and that it was customary to put out all the fires in the palace on Christmas Eve, and to have watchmen patrol the building all through the night.[54]

A luminous ring is poetically described in Titus Andronicus, a play somewhat doubtfully attributed to Shakespeare who probably merely revised and embellished, in or about 1590, an original from some other hand. In any case, the lines referring to the luminous stone are highly expressive. After the murder of Bassianus, Martius searches in the depths of a dark pit for the dead body and suddenly cries out to his companion, Quintus, that he has discovered the bloody corpse. As the interior of the pit is pitch-dark, Quintus can scarcely believe what he hears, and asks Martius how the latter could possibly see what he has described. The answer is given in the following lines:

Martius, Upon his bloody finger he doth wear
 A precious ring, that lightens all the hole,
 Which like a taper in some monument,
 Doth shine upon the dead man's earthy cheek,
 And show the ragged entrails of this pit.
 Titus Andronicus, Act II, Sc. 4.

For the superstitious among certain Oriental peoples

[53] William Jones, " Credulities Past and Present," London, 1880, p. 211.

[54] Citing Beckmann, " Geschichte des Fürstentums Anhalt," Dessau, 1722.

any injury to an amulet-ring was looked upon as a sure presage of coming misfortune. It is related of a Turk in the town of Jablanica, Bosnia, that having broken his amulet-ring, he started out forthwith on an arduous ten-hours' journey to Mostar, the nearest place where his ring could be repaired, and he no doubt pursued his way in fear and trembling lest the threatened ill-fortune should befall him ere he reached the goldsmith who could mend his ring and thus restore its virtue.[55] In the National Hungarian Museum at Budapest is a silver ring set with a carnelian, on which are engraved Oriental characters. This was found, in 1812, in the garden of the royal palace at Budapest. Rings of a similar kind are often worn by Turks and Arabs, and are greatly valued as talismans, as they are believed to afford the wearers protection in battle, in the chase, and when indulging in dissipation.[56]

The ring with its smooth circle, having neither beginning nor end, is a fit symbol of eternity, and is often figured in this connection; and yet its material substance is transitory. This aspect is illustrated by the Eastern story that a wise man and favorite of a king once gave him a ring on which was the inscription: " Even this shall pass away." In bestowing it upon the king, the sage said: " When in dire distress your soul is weighed down with trouble, look at this ring! When in the midst of festivities, joy and wild hilarity, look at this ring! *Even this shall pass away.*" [57]

[55] William Jones, " Credulities Past and Present," London, 1880, p. 177.

[56] " Cimeliotheca Musei Nationalis Hungarici," Budæ, 1825, p. 55.

[57] Communicated by Mr. George Osborn.

In an illustrated work on ancient jades, in two quarto volumes, published in 1889 by the well-known scholar and statesman, Wu Ta-cheng (b. 1833), this writer conjectures that archer's rings of *white* jade were reserved for the emperor's use. At the present day rings of this type are made in Peking from the antler of a species of elk. The Catholic missionary, Father Zi, states that the rings most highly valued are those made out of jade of the Han period (*Han yü*), of a white gray with red veining and green stripes. Rings found in the graves of students who have passed the military examinations are of reddish hue, and the opinion prevails that they afford protection against malevolent spirits.[58]

In the symbolism of the ring, the complete circle is regarded by the Chinese as denoting the combination of all divine principles, as these are supposed to move in an everlasting and unbroken circle, having neither beginning nor end. An evil significance, however, attaches to an incomplete or half-ring, called *küeh,* a sound that means " to cut off, to slay; to pass sentence; to decide, to settle." An early instance of the use of such a ring to signify banishment is related of the Prince Shên-shêng whose father sent him on a fatal military expedition in 659 B.C., at the instigation of one of his concubines. This ring, which was attached to a girdle, was equivalent to a formal decree that the prince was cast off and should never return. In consequence of the ambiguity of Chinese spoken and written words, a half-ring or at least one not describing a closed circle is said to have been worn at one time by Chinese scholars, because one of the meanings of the sound *küeh* is " to de-

[58] Berthold Laufer, " Jade, a Study in Chinese Archæology and Religion," Chicago, 1912, pp. 284, 285.

cide," as has been noted above.[59] The Chinese writer Pan Ku (d. 92 A.D.) says that those who cultivated moral conduct without end, wore a complete ring suspended from the girdle, while those able to decide questions of aversion and doubt, wore half-rings, this being again a symbolic use of the double meaning of *küeh.*

As the Chinese word signifying " a jade-ring " has the same sound (*huan*) as the word meaning " to return, to repay," and is expressed with the same phonetic symbol, the sending of such a ring by an emperor to an exiled official was a symbolic summons for the official to return. However, a jade-ring could also be a signal for besieging a city, since the syllable *huan* can mean " an enclosing wall." [60] As an illustration, the word " ring," a ring; and " ring," imperative of " to ring," might make the sending of a ring to a bell-ringer signify that he should let his bells peal forth.

Quite a number of finely-executed gold rings, with or without settings, as well as other pieces of jewelry, are made by Chinese goldsmiths in San Francisco. Silver is never used. Seal rings are occasionally made; the favorite setting is jade, next to which comes the opal; diamonds are also used for this purpose. No wedding rings are given, although the bestowal of a ring as a gift is highly appreciated. The prices range from $6 for a plain gold ring to from $20 to $200 for one of mandarin-style, set with a piece of jade. Sometimes short inscriptions are engraved on rings, such as " Long

[59] Berthold Laufer, " Jade, a Study in Chinese Archæology and Religion," Chicago, 1912, pp. 210, 211; Field Museum of Natural History, Pub. 154, Anthropological Series, Vol. X, citing A. Conrady in preface to Stentz, " Beiträge zur Volkskunde Süd-Schantung's," p. 10.

[60] *Ibid.,* p. 210.

SHOP OF A CHINESE SILVERSMITH IN SAN FRANCISCO
As the workers were unwilling to have their pictures taken, the only figure is that of the proprietor

MODERN CHINESE RINGS

6

Inset ring stones. 1, moss agate in dark gray jasper; 2, garnet in chalcedony; 3, almandine garnet in brownish chalcedony; 4, aquamarine in red jasper; 5, sardonyx; 6, topaz in lapis-lazuli; 7, banded agate. Part of a collection of rings that all fit in one setting. See page 65

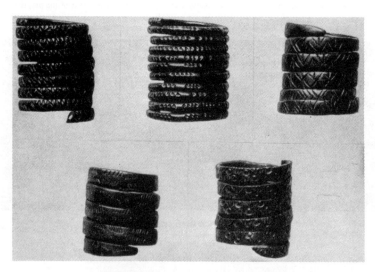

Spiral brass rings made in the Philippine Islands

Life," or " Beautiful." [61] In the plate representing the interior of a Chinese jeweller's shop in San Francisco, the proprietor of the place is shown seated in the background. None of the artisans, however, were willing to face the camera, either from superstitious dread of having their pictures taken, or perhaps through fear of being molested in some way by the Government.

When the nine gems of the great Hindu charm, the *naoratna,* are set in rings, the Burmese usage is to place the ruby in the centre, and group around it the eight other stones. Rings of this description were worn by Burmese kings and nobles as preventives of disease or danger. Sometimes an incantation is recited over these nine stones, which are then immersed in water, the belief being that whoever drinks of this water will secure immunity from all evil.[62]

In the masterpiece of Hindu dramatic literature, the Çakuntalâ of the poet Kâlidâsa, written about the sixth century of our era, a ring plays a most important part. The heroine, the daughter of the nymph Menakâ and the sage Viçvamitra, has had it foretold to her that the man who loves and marries her will entirely forget her, until his love and memory are revived by a ring. In due time she is beloved of the King Dushyanta, who marries her, but soon leaves her, to return to his court. When she follows him thither he fails to recognize her. Thereupon she remembers what had been predicted in regard to a ring, but finds to her dismay that the one the King gave her has been lost. In the next act of the play a fisherman is dragged in by guards who charge him with hav-

[61] Communicated through Prof. Austin F. Rogers, Leland Stanford University, by Mr. Wah S. Lee.

[62] Personal communication from Kien Taw Sein Ko, of Rangoon, Burma.

ing in his possession the royal signet-ring and with having invented the tale that he found it inside a fish. The king, however, admits the truth of the story, rewards the fisherman, and gladly receives the ring. As soon as he places it on his finger he recognizes his bride and his love for her is renewed.[63]

The Khedive Tewfik Pasha related, about 1880, his experience with a certain Ahmed Agha, a Turk, who possessed a magic ring. It was a plain hoop of gold set with a red stone (probably a carnelian), and was said to have come from Mecca. The Turk claimed that by its help visions could be seen, and the Khedive consented to make a test of the ring's virtue. Ahmed said that he required for the experiment the assistance of a child under ten years of age, whereupon the Khedive summoned a little girl from the harem to act as assistant, or we might rather say principal. The Turk attached to this girl's head a silver plate on which a verse of the Koran was engraved, and placed in her hand the mystic ring with the red stone which, he declared, would change from red to white if the experiment was to be successful. A few moments after the preparation had been made, the girl cried out: "The stone has changed to white." Hereupon the Khedive asked her to describe a number of persons she had never seen, and she invariably gave correct answers. Tewfik was so much impressed by the experiment that he exclaimed: "I can believe it, and yet I cannot understand it." A few days later he sent word to the Turk that he wished to borrow the ring, but the man besought him not to take it away. An offer of £100 from a court noble was also refused. Finally, Ahmed was summoned

[63] Arthur A. Macdonel, "A History of Sanskrit Literature," New York, 1914, pp. 354-358.

to the court and the Khedive again urged him to surrender the ring, but when he repeated his prayers that it should not be taken from him the Khedive lost patience and said to him: "You are mistaken in thinking that I believe in the power of your ring or in things of that kind. I wish you good morning." Poor Ahmed was only too glad to get off so easily and he left Cairo never to return there.[64]

In this case, as in many others, a change of color is asserted to take place in the stone, an indication that the mineral substance responds to some impression from without. It is as though part of the virtue of the stone had left it, for with a colored stone we might say, in a poetic sense, that its color is its life and soul. Hence in this particular instance the loss of color was probably thought to indicate that some in-dwelling spirit had passed from the stone to the little girl and dictated her responses; possibly if the ring were arranged with some mechanical or hollow space a colored foil could be pressed under the white stone, or a liquid passed under it, giving the delusion of the change from white to red and red to white.

In Scandinavia, carnelians were used as ring-stones in very early times; a fine specimen of such a ring was found in Ysted, in the province of Scania, and another at Verdalen, Norway. That these were credited with power as amulets seems highly probable, for some of the early Norse rings were so highly valued by their owners that they were designated by individual names. Thus we are told of a gold ring named Hnited, "The Welded," which was given as a precious gift by Ulf the Red to King Olaf. This particular ring was welded

[64] Butler, " Court Life in Egypt," London, 1880, pp. 238–242.

together from seven pieces of exceptionally pure gold, the number of pieces evidently having a mystic significance.[65]

There is or was a superstition among the Swedish Lapps that at times, on the lonely moorlands, might be seen visionary herds of reindeer, packs of dogs, or even apparitions having the form of Laplanders. When one who sees any such objects goes in pursuit of them, they disappear before they can be reached; if, however, while they are still visible a steel or brass ring is thrown at them, they immediately become real living creatures. Popular legend even has to tell of men or women who in this way have secured wives or husbands, respectively, in reality changelings, *trolls,* apparently or really transformed into human beings.[66]

An onyx ring is made the cause of a series of wonderful transmigrations in an old-fashioned tale written about 1840 by John Sterling, of whom Thomas Carlyle has left us a most interesting biography.[67] In this story, the hero, a young barrister discouraged in his profession and disappointed in love, finds himself one night in an exceptionally depressed frame of mind. Opening, at chance, an old necromantic work, he is fascinated, perhaps hypnotized, by the vaguely mystic sentences, and is scarcely astonished to perceive, standing before him in his deserted room, what appears to be the figure of an aged man, who in the most-approved magician fashion offers him an onyx ring, engraved

[65] Du Chaillu, "The Viking Age," New York, 1889, vol. ii, pp. 310, 326.

[66] Torsten Kolmodin, "Lapparne och deres Land: Skildringar och Studier," Stockholm, 1914, Pt. III, p. 30.

[67] John Sterling, "The Onyx Ring," Boston, 1850, xxii 263 pp. 8 vo.

with the head of Apollonius of Tyana, and of such virtue that if he puts it on the forefinger of his right hand, he will be able to transfer himself into the body of any existing personage. His identification with the new personality will indeed be so complete, that his old existence will be entirely forgotten. This is to last for a week, at the expiration of which his memory will suddently be revived for a short time, and he will have the choice to remain as he is, to change his fleshly tabernacle again, or to return to his own body. In the last-named case, however, his special power will be taken from him, and he must continue in his own form.

The offer is accepted and a series of transmigrations begins, in the course of which the hero becomes in turn a baronet, a farmer, a traveler, a divine, a poet, a political reformer and an old basket-maker. In this last *avatar* he is involuntarily forced to return to his own body, for the basket-maker dies before the week is up. The various characters through whose lives he passes belong to his immediate neighborhood, and the slight plot of the story can thus be carried forward without interruption. When at last the barrister comes to himself, he has just recovered from a long period of unconsciousness, and there is a little intentional uncertainty whether the vision and its consequences really took place, or were only the products of a fevered mind. Among the old basket-maker's effects is found an onyx ring enclosed in an old box and engraved with a man's head.

The greater part of the splendid precious stones in the collection of the English banker Henry Philip Hope were set in rings. One of the finest and most interesting of these gems was the beautiful sapphire often called " Le Saphire Merveilleux," the title of a story

written by Mme. de Genlis, who had seen the stone when it formed part of the collection of the Duke of Orleans. Its peculiar charm is that its color changes when seen by artificial light. In daylight it is a beautiful sapphire blue, but by candle light, or other yellow light it acquires an amethystine hue.[68] This fine sapphire, interesting both for its rare dichroism and its historic associations, was sold about 1898 for £700 ($3500). It weighs 19⅛ metric carats. Another attractive gem in the Hope Collection is a cabochon-cut amethyst, engraved in intaglio with the figure of a Bacchante carrying a thyrsus. At the back of the stone are two strata of different colors, one a whitish gray, the other showing brown spots on a velvet ground. This peculiarity has been skilfully utilized by the engraver, who has cut on the stone the form of a panther in relief.[69]

The so-called " Pennsylvania Dutch," largely Germans from the southern parts of Germany, made, in the early days, rings out of horse-shoe nails.[70] The good-luck supposed to be inherent in the horse-shoe was probably believed to extend to the detachable nails also, so that these rings might have been looked upon as endowed with magic or talismanic virtue.

Lord Bacon (1561–1626) in his "Sylva Sylvarum," published in 1626, suggests a curious test of telepathy. This is that two parties to an agreement or contract, should exchange rings, each wearing the other's ring,

[68] Catalogue of the Collection formed by Henry Philip Hope Esq., arranged and described by B. Herz, London, 1839, 6 + 112 p., 42 pl., folio; see p. 38, No. 3. Plate XI.

[69] *Ibid.*, p. 86, No. 5.

[70] Communicated by the Rev. John Baer Stoudt, of Northampton, Pa.

and they are then to note whether, in case the contract or promise should be broken by one of the parties, the other would become sensible of this by means of an influence transmitted through the ring. He adds that it has been regarded as a help to the continuance of love to wear a ring or a bracelet of the loved one, but he believes that "this may proceed from exciting the magnetism, which, perhaps, a glove, or other like favour, might do as well."

The peculiar inherent virtue of a ring given by, or exchanged with, a loved person, renders it far more prized than a merely beautiful or costly ring. While we may regard as superstition any fancy that the material ring possesses any magic quality, that lent to it by association or by memory is none the less real though it is only in the brain or heart of the wearer. The effect of this association of a ring or other jewel with a person is also to be seen in the case of rings bestowed by royal personages as tokens of gratitude or favor. In olden times they were often regarded as amulets and believed to transfer something of the power or genius of the bestower to the recipient. Indeed the qualities were conceived to have embodied themselves in the ornament, which was therefore handed down from generation to generation as a precious heritage, one sure to bring good fortune to the wearer. In the case of lovers the token served as a connecting link, transmitting and transfusing the love sentiment.[71]

Besides the zodiacal, or natal rings, there were also made in mediæval times a number of planetary rings, the metal supposed to be especially under the guardianship of the Sun, Moon or five planets known to the

[71] Jacobi Wolfii, " Curiosus amuletorum scrutator," Francofurti & Lipsiæ, 1692, pp. 660, 661.

ancient world, being in each case chosen as the material for the ring of the special planet. These rings were frequently set with the precious stone assigned to the planet, and thus a series was obtained of seven rings, each of a different metal and set with a different stone. The sun-ring was of gold with diamond or sapphire; the silver moon-ring bore a rock crystal or a moonstone; the ring of Mars was of iron set with an emerald; for Mercury, the ring was of quicksilver and bore a piece of magnetic iron; Jupiter's was of tin, the setting being a carnelian; copper was, of course, the material of the Venus-ring (*cyprium,* copper, being sacred to the Cyprian goddess), and the stone was an amethyst; lastly, the Saturnian ring was of lead and had for setting a turquoise.

Some of the appropriate rings and stones to be worn by those who hope to attract to themselves the favorable influences of Sun, Moon, and planets, are given in the Syro-Arabic work of the eighth or ninth century on the mystic potencies of stones, put forth under the name of Aristotle. For the Sun the stone is rock crystal, which must be set in a gold ring; Mercury's influence is secured by wearing a piece of magnetite in an electrum setting, and for those wishing the help of the Moon, one of the varieties of onyx is recommended, silver being the metal in which it is to be set.[72]

For some reason or other zodiac rings, that is rings bearing zodiacal symbols, seem to be especially favored by the modern goldsmiths of the Portuguese island Madeira. Occasionally a ring of this type from earlier times may be seen there; one of these, of crude workmanship and much the worse for wear, has been attrib-

[72] Julius Ruska, "Das Stienbuch des Aristoteles," Heidelburg, 1912, p. 6.

GOLD ZODIAC RING, PROBABLY MADE ON THE WEST
COAST OF AFRICA IN THE NINETEENTH CENTURY
British Museum

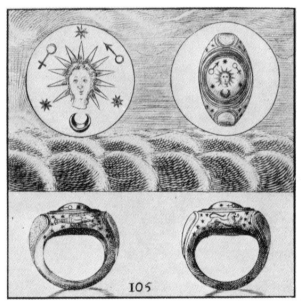

ZODIACAL RING OF SILVER; FOUR VIEWS. SET WITH AN
ENGRAVED ONYX. ON THE SIDES ARE CHASED THE
SIGNS LEO AND CANCER, AND THE SHOULDERS OF THE
HOOP ARE INLAID WITH BRASS AND IRON, RESPECTIVELY
Gorlæus, Dactyliotheca, Delphis Bat., 1601

Amulet ring of Twelfth Century,
engraved with cabalistic characters
Edwards' "History and Poetry of
Finger Rings"

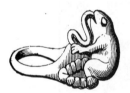

┌─────────────────────────────┐
│ ✠ ZARA·ZAI·DE ZEVEL │
└─────────────────────────────┘
┌─────────────────────────────┐
│ ✠ DEBAL·GVT·GVTTANI │
└─────────────────────────────┘

Talismanic ring, with cabalistic
inscription. Found on coast of Gla-
morganshire, Wales

Rings inscribed with names of Three
Kings, or Magi: Melchior, Jasper and
Balthazar. Worn as talismanic rings

Fairholt's "Rambles of an Artist"

1, toad swallowing a serpent; 2, toadstone with embossed figure of toad; 3, massive thumb-ring set with teeth
of an animal
Londesborough Collection
Fairholt's "Rambles of an Artist"

1, talismanic ring that opens when the stone setting (ruby and amethyst) is pressed down, releasing a
spring. Hoop inscribed with names of spirits and magic signs; 2, ring set with a ruby; 3, gold enameled ring
said to have belonged to Frederick the Great
Fairholt's "Rambles of an Artist"

uted to the time of a twelfth-century duke of Burgundy, whose crusading expedition did not extend much beyond the frontiers of Portugal.[73] More than likely Moorish influence, or that of the Orient at least, was a determining factor, for the study of zodiacal influences was eagerly pursued in Spain in the thirteenth century and earlier, as is witnessed by the curious Lapidario of Alfonso X, the Wise, composed in the latter half of that century. The survivance of this style in Madeira depends quite probably upon one of those rather inexplicable chances that cause the production of a certain class of jewels or ornaments, when a curious or unusual example strikes some tourist's fancy, and he shows it to friends at home; these in their turn will ask for it when they go to the same place, thus creating a demand and a local fashion. Rings of this kind are brought from Madeira by sailors and travelling jewellers, and are found at a number of places, including the west coast of Africa.

Many gold zodiac rings of a simple type are made on the Gold Coast and brought thence to Europe. The hoop is a flat band, on which the conventional symbols of the zodiacal signs are soldered, scroll borders also being applied in the same way.[74] While these rings are totally lacking in artistic quality, their production on the Gold Coast may indicate that long ago some better work of the class was done here, probably under Portuguese influence.

[73] Communicated by Mrs. Isabel Moore, formerly of Woodstock, N. Y., now in the Azores.

[74] O. M. Dalton, " Franks Bequest, Catalogue of the Finger Rings, Early Christian, Byzantine, Teutonic, Mediæval and Later [British Museum]," London, 1912, p. 347, No. 2514, fig.

Rings holding truly "celestial stones," gems from the heavens as they are called, are those in which have been set small, but perfectly cut chrysolites (peridots) from crystals found in meteorites. One of these was of the pallasite type, from Brenham, Kiowa County, Kansas [75] and gems were also cut out of chrysolite from the meteorite of Glorietta Mountain, Santa Fé County, New Mexico.[76]

A most attractive kind of natal ring is that having the birth stone in the centre between the stones of the guardian angel and of the apostle of the month. While this particular arrangement of the settings is followed in the greater number of cases, it sometimes happens that a better artistic effect is obtained, a better harmony of color, by making either the stone of the angel or that of the apostle the central gem. The essential thing is that the three particular stones assigned to the given month shall be grouped together. The following table renders it easy to find the proper combination for each month, or each zodiacal sign:

Month	Zodiacal Sign	Natal Stone	Guardian Angel	Angel's Gem	Apostle of Month	Apostle's Gem	Flower of Month
January	Aquarius	Garnet	Gabriel	Onyx	Peter	Jasper	Snowdrop
February	Pisces	Amethyst	Barchiel	Jasper	Andrew	Carbuncle	Primrose
March	Aries	Bloodstone	Malchediel	Ruby	James and John	Emerald	Violet
April	Taurus	Diamond or Sapphire	Ashmodel	Topaz	Philip	Carnelian	Daisy
May	Gemini	Emerald	Amriel	Carbuncle	Bartholomew	Chrysolite	Hawthorne
June	Cancer	Agate	Muriel	Emerald	Thomas	Beryl	Honeysuckle

[75] George F. Kunz, "On five new American Meteorites," American Journal of Science, 3rd Series, vol. 40, pp. 320-322.

[76] George F. Kunz, "On three masses of meteoric iron from Glorietta Mountain near Canoneito, Santa Fe Co., New Mexico," Amer. Journal of Science, 3rd Series, vol. 30, p. 238; vol. 32, pp. 311-313.

Month	Zodiacal Sign	Natal Stone	Guardian Angel	Angel's Gem	Apostle of Month	Apostle's Gem	Flower of Month
July	Leo	Turquoise	Verchiel	Sapphire	Matthew	Topaz	Water Lily
August	Virgo	Carnelian	Hamatiel	Diamond	James the Less	Sardonyx	Poppy
September	Libra	Chrysolite	Tsuriel	Jacinth	Thaddeus	Chrysoprase	Morning Glory
October	Scorpio	Beryl	Bariel	Agate	Simon	Jacinth	Hops
November	Sagittarius	Topaz	Adnachiel	Amethyst	Matthias	Amethyst	Chrysanthemum
December	Capricornus	Ruby	Humiel	Beryl	Paul	Sapphire	Holly

If, like Apollonius of Tyana,[77] anyone should wish to wear on each week day a ring set with the stones especially appropriate to the day, the following list gives for the successive days the pair of stones whose combination was believed to unite the most favorable planetary and celestial influences:

	Gem of the Day	Talismanic Gem	Astral Control
Sunday	Diamond	Pearl	Sun
Monday	Pearl	Emerald	Moon
Tuesday	Ruby	Topaz	Mars
Wednesday	Amethyst	Turquoise	Mercury
Thursday	Carnelian	Sapphire	Jupiter
Friday	Emerald	Ruby	Venus
Saturday	Turquoise	Tourmaline	Saturn

The use of fraternity rings is often connected with a certain amount of sentiment or even superstition concerning their emblematic value. The most important of this type of rings are those worn by the Free Masons.

The greater number of Masonic rings are intended for those Masons who have attained the two highest degrees, the thirty-second and the thirty-third; some, however, are appropriate to those of the lower degrees. The bezels of the Blue Lodge, or Master Mason rings, frequently have the square compasses and the latter G in gold on a background of blue enamel; occasionally emblems and paraphernalia used in the Lodge are enamelled in blue on the gold hoops of the ring. Sometimes, instead of enamel, the background is formed of sapphire, bloodstone, or some other stone on which the emblems are encrusted in gold. An example of the ring

[77] See p. 296.

of a Past Master bears a raised gold sun-face. In a ring for the Chapter of Royal Arch Masons, the keystone is usually enameled white with a black circle and white centre. Shrine Rings are distinctly Oriental in type, the prevailing design showing a simitar passed between the horns of a crescent moon. In rings of the Knights Templar the design is usually a cross passed through a crown, with the motto of Constantine the Great: In hoc Signo vinces. The cross will be of black enamel (occasionally of red enamel) and the crown is gold. A special ring for this order has a Blue Lodge emblem on one shoulder and the Chapter emblem on the other, and is arranged for a diamond to be set in the centre of the bezel. On a fourteenth degree ring (Lodge of Perfection) appears the initial Hebrew letter (*yod*) of the Tetragrammaton, or Ineffable Name, now approximately sounded Yahweh. Sometimes the symbols of more than one degree appear on the ring, one example bearing those of the fourteenth, sixteenth, eighteenth, thirtieth and thirty-second; this is one of the Consistory rings, as those for thirty-second degree Masons are denominated. These usually have the double eagle on the bezel.

The variety of types of fraternity rings is manifold, most of the orders having a half-dozen or more different ring-designs, although certain distinctive elements run through all, as with the wide-spread Benevolent Protective Order of Elks, for instance, on whose rings the elk-head is always conspicuously present. For rings of the Knights of Columbus, the anvil, sword and battle-axe are never-failing marks. The Brotherhood of Locomotive Engineers, a labor organization of the highest type, has for its device a locomotive running on a railway track, with a telegraph pole at one side. The Loyal Order of Moose has the head of the patron ani-

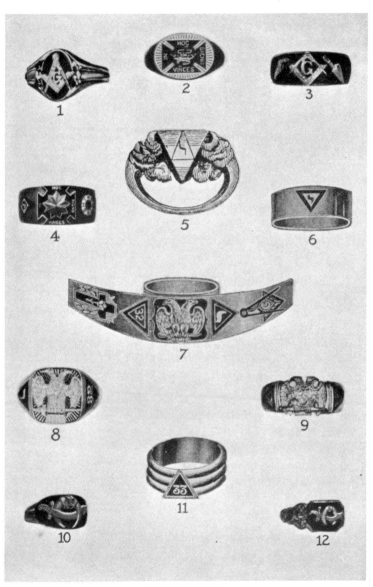

MASONIC RINGS

1, 3, Master Mason or Blue Lodge; 2, 4, Knights Templar; 5, "The Signet of Zerubbabel," adopted as one of the Royal Arch symbols. Explained as the "Signet of Truth." See Haggai, ii, 2-3; 6, 14th Degree, or Lodge of Perfection; 7, Emblem of 14th Degree on one side, of 32d Degree on the other; 8, 9, 32d Degree; 10, 12, Mystic Shrine rings; 11, 33d Degree

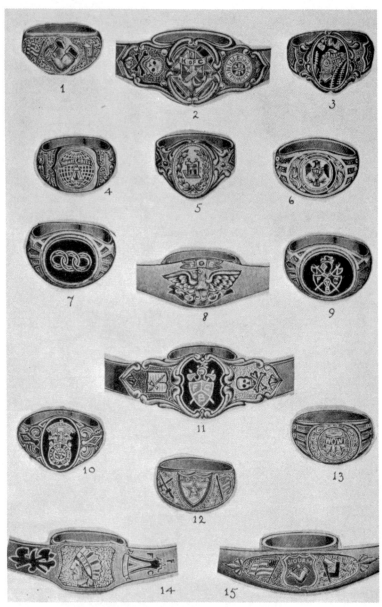

RINGS OF ORDERS AND SOCIETIES

1, Senior Order United American Mechanics; 2, Knights of Columbus. Raised centre emblem on black enamel; 3, Brotherhood of Locomotive Engineers; 4, Knights of the Maccabees; 5, Order of Railroad Telegraphers; 6, Improved Order of Red Men; 7, Independent Order of Odd Fellows (encrusted sardonyx); 8, Fraternal Order of Eagles; 9, Knights of Pythias (encrusted sardonyx); 10, Sons of Veterans; 11, Knights of Pythias (raised centre emblem on black enamel); 12, Patriotic Order Sons of America; 13, Woodmen of the World; 14, Improved Order of Red Men (raised centre); 15, Junior Order United American Mechanics

mal, less graceful than the elk, but better suggesting the aggressive quality of this order. A considerable variety of designs are represented among the rings worn by the Knights of Pythias; in most cases a helmet and battleaxes are combined with a shield. Last, but not least, the Independent Order of Odd Fellows has many rings rich in symbols, the all-seeing eye, the open hand with a heart in it, a death's-head and cross-bones, and everywhere, the three interlinked rings characteristic of the order. These are only a few of the innumerable ingenious designs that American factories have produced to satisfy an overwhelming demand for fraternity rings. For the leading schools also, many special rings have been executed to be used as prizes, or else to meet the wants of school fraternities or sororities. Of course, the numerous college fraternities also frequently use specially designed rings as distinguishing emblems.

The immense number of rings that must have been produced for members of the largest societies becomes apparent when we consider that the Independent Order of Odd Fellows, whose English foundation dates back to about 1745, now has a membership of over 1,500,000, in the United States and more than 160,000 in other countries. To this must be added the membership of the Daughters of Rebekah, a coördinate body of women numbering about 700,000. Another society, the Knights of Pythias, though of comparatively recent organization, having been founded in Washington, D. C., in 1864, has over 700,000 members in the United States and Canada. This order has a branch exclusively for the colored race, denominated the Knights of Pythias of North and South America, Europe, Asia and Africa; its members number 50,000. The Benevolent and Protective Order of Elks counts 410,000 members in 1309 lodges and the Knights of Columbus, a fraternal and

benevolent society founded in New Haven in 1882, had, on July 1, 1914, 326,858 members.

The membership of the Greek-letter fraternities of the universities and colleges in the United States is enormous. In 1914 there were 38 leading fraternities distributed in 1228 active chapters and counting 2,656,-817 members, with 979 fraternity houses. The oldest Greek-letter society, Phi Beta Kappa, was organized at William and Mary College, Virginia, in 1776; Kappa Alpha was founded at Union College, in 1827, this being the first fraternity to be organized according to the system at present prevailing. The first sorority was Kappa Alpha Theta, established at De Pauw in 1870. The sororities now have about 50,000 members in 395 chapters.

A gem representing one of the States is often set in a talismanic ring. The following is a list of the stones of the various States in the United States,—a precious or semi-precious stone having been found in every State:

Alabama	Beryl
Arizona	Turquoise
Arkansas	Diamond
California	Kunzite
Colorado	Aquamarine
Connecticut	Beryl
Delaware	Pearl
Florida	Chalcedony
Georgia	Ruby
Idaho	Opal
Illinois	Pearl
Indiana	Pearl
Iowa	Fossil Coral
Kansas	Chalcedony
Kentucky	Pearl
Louisiana	Chalcedony
Maine	Topaz

Maryland Orthoclase
Massachusetts Beryl
Michigan Agate
Minnesota Chlorastrolite or Agate
Mississippi Pearl
Missouri Pyrite
Montana Sapphire
Nebraska Chalcedony
Nevada Gold Quartz
New Hampshire Garnet
New Jersey Prehnite
New Mexico Garnet or Peridot
New York Beryl
North Carolina Emerald
North Dakota Agate
Ohio Chalcedony
Oklahoma Smoky Quartz
Oregon Agate
Pennsylvania Sunstone or Moonstone
Rhode Island Amethyst
South Carolina Beryl
South Dakota Agate
Tennessee Pearl
Texas Agate
Utah Topaz
Vermont Beryl
Virginia Spessartite
Washington Agate
West Virginia Rock-crystal
Wisconsin Pearl
Wyoming Moss Agate

For fuller information concerning natal stones, stones of the month, stones of the day, stones of the week, stones of sentiment, stones for posy rings, for wedding anniversaries and similar occasions, see George Frederick Kunz, " The Curious Lore of Precious Stones," J. B. Lippincott Company, Philadelphia and London, 1913, xiv + 406 pp., 58 pl. (8 in color), many text cuts (Dover reprint).

VIII

RINGS OF HEALING

CLOSELY allied with the magic rings, so closely indeed that it is often difficult to establish a satisfactory distinction between them, are the rings of healing, those to which were ascribed special and peculiar curative powers. In some instances this was due to a legend connected with a particular ring or with the prototype of a class of rings; at other times the therapeutic virtue was believed to result from the inscription of certain letters or words. In other cases, again, the belief arose from the form given to the ring.

In the course of his eleventh consulate, Augustus was attacked by a serious illness. None of the remedies prescribed for him were of any avail, until finally he was relieved by following the directions of Antonius Musa, who recommended cold baths and cold drinks. As a reward Musa was granted the privilege of wearing gold rings, and also received a large gift of money from the grateful emperor.[1] Although this ring was not in itself a cause of healing it was certainly the memorial of a successful cure.

A strange remedy for sneezing or hiccoughing, recommended by Pliny, was to transfer a ring from one of the fingers of the left hand to the middle finger of the right hand.[2] This prescription is copied from Pliny by the physician Marcellus Empiricus [3] who says, how-

[1] Cassius Dio, lib. liii.

[2] Plinii, " Historia Naturalis," lib. xxviii, cap. 15.

[3] Marcelli Empirici, " De medicamentis," cap. 17.

ever, that a ring should be put on the middle finger of the *left* hand, adding that the cure was immediate. Probably the explanation is to be found in the fact that rings were rarely worn by the Romans on the middle finger, and hence the unusual sensation produced by placing a ring on this finger operated to check the nervous spasm causing the sneezes or hiccoughs. It is well known that any nervous shock, sometimes a very slight one, will suffice to cure such spasms; indeed, Pliny also advises the immersion of the hand in very hot water.

Since lizards were believed to recover their sight by natural means after they had been blinded, this fancy led to the use of a strange method for procuring remedial rings. A blinded lizard was put into a glass vessel, in which iron or gold rings were also placed. When it became apparent that the creature had regained its sight, the rings were taken out and used for the cure of weak and weeping eyes. Something of the natural force that operated to restore the lizard's vision was supposed to communicate itself to the rings.[4]

In a treatise incorrectly attributed to the Roman physician Galen ("De incantatione"), the statement is made that the wearing of a ring set with a sard weighing twenty grains will ensure deep and tranquil sleep and give protection against bad dreams or fearful " visions of the night." For nervous derangement, often a cause of nightmare, Marcellus Empiricus, who practised medicine in the Roman world of the sixth century A.D., recommended a finger ring made out of the hoof of a rhinoceros, asserting that any patient suffering from " obstruction of the nerves " would surely experience relief by wearing such a ring. On the other hand a

[4] Plinii, "Naturalis historia," lib. xxix, cap. 38.

ring turned out of rhinoceros horn was supposed to have efficacy against poison and spasms.[5]

As a cure for bilious or intestinal troubles, the physician, Alexander Trallianus (sixth century A.D.) recommends an iron ring with an octagonal *chaton* on which should be inscribed the words:

Φεῦγε, φεῦγε, ἰον χολή, ἥ κορύδαλος ἐζήτει.

" Fly, fly, wretched bile, the swallow is seeking thee." [6]

This refers to the belief that the flesh of the swallow was a remedy for those suffering from colic.

A gold ring, evidently of Byzantine origin, bears on the face, divided into six segments, an invocation to the saints Cosmas and Damian. According to Catholic legend these saints were brothers, of Arabian birth, who practised medicine in Ægæ in Cilicia at the end of the third century. They were regarded as the patron saints of physicians and were often invoked by those suffering from disease. Hence this ring probably represents a type common in the Eastern Empire and used as a talisman for the cure or prevention of various illnesses. We know that the Byzantines were fervently devoted to three groups of saints, regarded as physicians, whose festival days were July 1, November 1, and October 17.[7]

The initial letters of some magic or religious formula believed to operate as a charm, were engraved on certain rings, as, for example, the four Hebrew letters א ג ל א

[5] Jacobi Wolfii, " Curiosus amuletorum scrutator," Francofurti & Lipsiæ, 1692, pp. 388, 392.

[6] Alexandri Tralliani, " De medicamentis," Basileæ, 1556, p. 593; lib. x, cap. 1.

[7] G. Schlumberger in the Mém. de la Soc. des antiq. de France, 1882, vol. xliii, pp. 135 *sq.*

or their equivalents in Roman characters, sometimes disposed as follows:

$$\frac{a \mid l}{g \mid a}$$

This was called the Shield of David and was believed to afford protection from injury by wounds, fire, etc. The Hebrew letters are the initials of the four words:

את גבור לעולם אלהים

" Thou, God, art mighty for ever."

A gold ring with a Runic (old Scandinavian) inscription was owned by the Earl of Aberdeen in 1827. It had evidently been destined for use as an amulet, the characters reading in translation as follows: " Whether in fever or in leprosy, let the patient be happy and confident in the hope of recovery." On rings for wear as protection from the plague the favorite inscriptions were I E S V S—M A R I A—I O S E P H and I H S N A S A - R E N V S R E X I V D E O R U M.[8] A massive thumb-ring in Mr. Hamper's possession bore an old French legend more in accord with true Christian piety than the inscription we have noted, namely: *Candu plera meleor cera,* or " When God pleases, things will be better."

The curiously learned theologian and natural philosopher, Albertus Magnus (1193–1280), Count of Bollstädt, and Bishop of Ratisbon, affirmed that he had seen a sapphire set in a ring remove impurities from the eyes. He had also witnessed the curative effects of the stone when applied to carbuncles, and declares the common belief that after operating such a cure a sap-

[8] William Hamper, " Observations on a Gold Ring with a Runic Inscription," Archæologia, vol. xxi, London, 1827, pp. 24-30.

phire would lose its virtue, to be entirely false.[9] As
the name carbuncle (or *anthrax* as Albertus puts it)
was given both to a boil and to ruby or garnet, we have
here an instance among many of the cures by antipathy,
the blue stone curing a red, inflamed tumor.

Should we need proof that in the Middle Ages
rings were believed to have remedial powers, this is
offered by a passage in the statutes of the Hôtel Dieu
of Troyes, dated in 1263. Here it is decreed that the
nuns should not be permitted to wear rings set with
precious stones, *except in case of illness*.[10] Probably
in this event the appropriate stone was selected by
those versed in this branch of knowledge, after they had
determined, as well as they were able, the real nature of
the disease.

If the owner of a garnet ring who was not an expert
in precious stones wished to assure himself of the
genuineness of his garnet, the following rather trouble-
some experiment was at his disposal. He was to dis-
robe, still wearing his ring, and then to have his body
smeared with honey. This done, he was to lie down
where flies or wasps were about. If in spite of the
sweet temptation they failed to light on his body, this
was a proof that the garnet was genuine, an added
proof being that when he took off the garnet ring the
insects would hasten to make up for lost time and suck
up the honey.[11]

Jacinth as a ring-setting was said to preserve a
traveller from all perils on his journey and to make

[9] Cited in Johannis de Cuba, "Ortus Sanitatis" (Strass-
burg, ca 1483) ; " De lapidibus," cap. cix.

[10] Havard, " Historie de l'orfévrerie," Paris, 1896, p. 358.

[11] Johannis de Cuba, " Ortus Sanitatis," " De lapidibus,"
cap. lx.

him well received everywhere. Another merit was that he was protected against plague and pestilence, and would enjoy good sleep.[12] Certainly if this were true, the traveller could ask for no better amulet to bear about with him on his trip.

A toadstone set in an open ring, so that the stone could touch the skin, was thought to give notice of the presence of poison by producing a sensation of heat in the skin at the point of contact. A ring made out of narwhal tusk was believed to be an effective antidote to poisons. Apart from these materials, several precious or semi-precious stones, such as emeralds, agates, and also amber and coral, were assumed to be especially sensitive to the approach of poison, so much so that when worn suspended from the neck or set in rings, they would lose their natural color, thus giving timely warning to their wearers.[13]

The earliest notices of cramp rings are from entries made in the reign of Edward II (1307–1327), recording the Good Friday gifts of coins by the sovereign to the altar, the metal of which, or else an equivalent quantity of metal, was to be made up into rings. Although no cramp ring has been preserved—at least none concerning which there is any good evidence—it has been considered probable that it was a simple gold hoop. Its curative power was not connected with any image or inscription, but solely due to the magic effect of the royal blessing. Some old wills contain bequests of cramp rings, or what we may assume to have been such rings. Thus John Baret of Bury St. Edmunds, in his

[12] Johannis de Cuba, "Ortus Sanitatis," (Strassburg, ca. 1483). "De lapidibus," cap. lxv.

[13] Jacobi Wolfii, "Curiosus amuletorum scrutator," Francofurti & Lipsiæ, 1692, pp. 408, 409, 419.

will dated in 1463, left a " rowund ryng of the Kynges silver," that is of the silver coins of the royal offering; another bequest in the same will is that of a " crampe ryng with blak innamel, and a part of silver and gilt." A few years later, in the reign of Henry VIII, Edmund Zee wills to his niece a " gold ryng with a turkes (turquoise) and a crampe ryng of gold." [14]

At his coronation, Edward II of England offered at the high altar of Westminster Abbey a pound weight of gold, fashioned with " the likeness of a king holding a ring in his hand, to this was added a golden image weighing eight ounces ($^2/_3$ pound), representing a pilgrim stretching forth his hand to take the proffered ring. The offering of a pound of gold has persisted down to modern times, although the later offerings have been in the form of plain ingots, while in medieval times the sovereign would have it formed into the saintly figure or figures to which he paid particular devotion, as Edward II did to St. Edward the Confessor.[15]

These so-called " cramp-rings," long regarded in England as specifics for the cure of cramps and convulsions, and even of epileptic attacks, owed their virtue, as has been stated, to the royal blessing. Polydore Vergil, writing in 1534, in the reign of Henry VIII, asserts that the original cramp-ring was brought to Edward the Confessor shortly before his death by some persons who came from Jerusalem. This very ring had been given by Edward, many years before, to a beggar, who had craved alms of the King for the love

[14] Edmund Waterton on Cramp Rings in the " Archæological Journal," vol. xxi, pp. 103-113.

[15] " Ancient and Modern Gold and Silver Smiths' Work in the South Kensington Museum," with introduction by John Hungerford Pollen, London, 1878, p. cxlix.

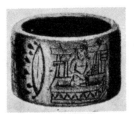

Massive gold ring engraved with the Wounds of Christ A healing talisman; English; Fifteenth Century.
Found at Coventry, 1802
British Museum

Edward the Confessor bestowing his ring upon the beggar. From a tile in
the Chapter House at Westminster. Thirteenth Century
British Museum

Jeweller offering rings
Johannis de Cuba, "Ortus Sanitatis,"
[Strassburg 1483], De Lapidibus,
cap. lxv

Curious test of the genuineness of a
garnet set in a ring. Should the stone
not be an imitation, flies and wasps will
not alight on the wearer's body, even
though it be smeared with oil
Johannis de Cuba, "Ortus Sanitatis",
[Strassburg, 1483], De lapidibus, cap. lx

The sapphire as an eye-stone. The
woman points to her eye, which the
physician is about to relieve by apply-
ing a sapphire ring
Johannis de Cuba, "Ortus Sanitatis,"
[Strassburg, 1483], De lapidibus, cap. cix

he bore St. John the Evangelist. The historian appears to regard the return of the ring as a warning to the King of his approaching death. When Edward was interred in Westminster, this ring was placed in that church,[16] and it became an object of great veneration there, for it cured those suffering from paralysis or epilepsy, if they touched it. From this time, says Polydore Vergil, the kings of England adopted the practice of consecrating, on Good Friday, similar rings, which received the name of " cramp-rings " from their special efficacy.[17] Confirmation of the exercise of this rite of consecration by Henry VIII after the establishment of the English Church is given by Andrew Borde, who writes in 1542 as follows: " The Kynges of Englande doth halowe every yere Crampe rynges the whyche rynges, worne on ones fynger, dothe helpe them the whyche hath the Crampe." [18]

Cramp rings appear to have been consecrated by Henry VIII both before and after his breach with the Roman Church, for in 1529 Anne Boleyn wrote to Bishop Gardiner, then in Rome, that she was sending him cramp rings for himself and certain of his friends.[19] After the death of Henry, Bishop Gardiner wrote to Ridley that he trusted the young king (Edward VI) would not neglect to continue the usage. However, as

[16] See also pp. 174, 175.

[17] Polydori Vergilii, " Historiæ Anglicæ," Lug. Bat., 1651, p. 187.

[18] The fyrst Boke of the Introduction of Knowledge made by Andrew Borde of Physcycke Doctor; ed. by Furnivall, London, 1870. Early English Text Series; Extra Series No. X.

[19] Burton, " History of the Reformation," Oxford, 1829, vol. II, Pt. II (Collection of Records, bk. II, No. 24) pp. 413, 414.

we have no information that such rings were consecrated during Edward's reign (1547–1553), it seems probable that the practice was discontinued.[20] In the early part of Mary's reign (1553–1558), a special Latin service for the consecration of cramp rings was drawn up, some extracts from which are here translated: [21]

The rings lying in one basin or more, this prayer is to be said over them: " O God, the creator of all celestial and terrestrial creations, the restorer of the human race, and the bestower of all blessings, send Thy Holy Spirit, the Paraclete, from heaven upon these rings made by the hand of man, and deign to so purify them by Thy power, that all the corruption of the envious and venomous serpent being expelled, the metal created by Thee in Thy goodness may remain untainted by all the stains of the enemy. Through Christ, our Lord. Amen."

Benediction: O God, who in every disease hast always shown miracles of Thy power, and who hast willed that rings should be a pledge of faith for Judah, a priestly ornament for Aaron, a symbol of a faithful custodian for Darius, and a remedy for various diseases in this reign, graciously vouchsafe to sanctify + and to bless + these rings; that all who wear them may be protected from the wiles of Satan and armed with the virtue of a celestial guardianship; and that they shall neither be menaced by convulsions nor by danger of epilepsy, but shall find by Thy succor, alleviation of all manner of diseases. In the name of the Father + , of the Son +, and of the Holy Spirit +. Amen.

A manuscript owned by the late Cardinal Wiseman described the ceremonies of the service under this head-

[20] *Ibid.*, vol. ii, p. 645.

[21] *Ibid.*, vol. ii, Pt. II (Collection of Records, Bk. II, No. 24) pp. 415, 416.

ing: " Certain prayers to be used by the Quene's Heigh-nes in the Consecration of the Cramp-rynges." There is also an illuminated design showing Queen Mary as she knelt at the ceremony, a dish filled with the rings being set on either side of her. King Philip was also present to take part in the ceremonial, although the Queen's share in the consecration must have been re-garded as the principal one; still Philip's fervent de-votion to the church ritual found expression here as else-where, for on entering the chapel he is said to have crept on his knees along a carpet extending from the entrance to the place where the rings were to be blessed. Here a crucifix had been placed on a cushion, and the King, still in a kneeling attitude, bestowed his royal blessing on the rings. This intensely devout approach to them was then repeated by Queen Mary and the ladies who attended her to the chapel.[22]

A talismanic ring especially valuable for a physician is described by Konrad von Megenberg. This is to be of silver and set with a stone bearing the figure of a man with a bundle of herbs hanging from his neck. The wearer is given the power to diagnose diseases, and he will be able to stanch any hemorrhage, however severe, if he only touch the affected part with the stone. As a natural result, we learn that the physician will gain both reputation and honors, and it is related that Galen, the great Roman medical authority, wore such a ring.[23]

In the " Gesta Romanorum " is a story of a ring endowed with great remedial powers:

[22] William Jones, " Crowns and Coronations," London, 1883, p. 474.

[23] Konrad von Megenberg, " Das Buch der Natur," ed. Pfeiffer, Stuttgart, 1866, p. 470.

A certain king had three sons and one precious stone. When the hour of his death had come, he reflected that his sons would dispute for the possession of the stone. Now he loved one of his three sons better than the others, wherefore he caused three similar rings to be made and two glass imitations resembling the precious stone; he then had the three stones set in their respective rings. Lest his plan should fail, the father called his three sons to him, and gave to each the ring destined for him, giving the best one to the son he most loved. After the father's death each of the sons declared that he had the ring with the precious stone. Hearing this, a sage said: " Let us make a test, for that ring which can cure disease is the most precious." The test was made, and two of the rings had no effect, but that with the precious stone cured the disease; whence it became manifest which of the sons had been best loved by his father." [24]

It was this mediæval tale that suggested to the German dramatic poet and critic, Lessing, the celebrated parable of the three rings, which he puts into the mouth of Nathan the Sage,[25] in answer to Saladin's question as to whether the true religion was Judaism, Christianity' or Mohammedanism. Nathan likens them to the three rings given by the father to his sons, the secret as to which was the genuine magic ring being hidden from them. Pursuing the parable, he makes the sons, after the father's death, bring their dispute before a court of justice. The judge having heard the testimony, at first declares that it is impossible for him to determine which of the rings is the genuine one; then, after a moment's thought, he recalls the statement that the hearts of all will be drawn toward him who has it, and asks which of

[24] " Die Gesta Romanorum," ed. Wilhelm Dick, Erlangen, 1890, pp. 65, 66.

[25] " Nathan der Weise," Act III, sc. 7, 11. 395 sqq.

the brothers is most loved by the other two. They are honest enough to confess in turn that each loves himself the best. Thereupon the judge adjourns the case for a few thousand years, during which the race that has shown the greatest virtues will become the favored one, and thus prove that its ring was the true one.

Mediæval superstition did not shrink from the belief that some magicians had such power over the spirits of evil that they could force a demon to take up his abiding-place in a ring, and rings of this kind were thought to be powerful medical amulets. In classic times also medicine-rings were known and used, one having been given by Augustus to his son-in-iaw Agrippa.[26]

It was not uncommon in the Middle Ages for a pharmacist to make an impression from a signet upon his prescription as a guarantee that it had been prepared by a trustworthy person. A fine specimen of this type of ring is one that belonged to a certain Donobertus.[27] It was found at St. Chamant, dept. Corrèze, in 1867. The material is gold and the ring was set with an antique carnelian around which is engraved on the gold bezel a circular inscription signifying "Donobertus has made this medicine." The supposition is that, as in so many cases, the functions of the physician and pharmacist were here exercised by the same person.[28]

At the trial of Jeanne d'Arc, her judges questioned her closely regarding certain magic rings she was

[26] Jacobi Wolffii, " Curiosus amuletorum scrutator," Francofurti et Lipsiæ, 1692, p. 574.

[27] M. Deloche, Revue archéologique, 2d Ser., 1880, vol. ii, pp. 1 *sqq.*

[28] " Etude historique et archéologique sur les anneaux sigillaires," Paris, 1900, pp. 239–242, fig.

asserted to have worn. From the tenor of the questions we can infer that Jeanne was accused of having used the rings for the cure of diseases and also that they were believed to have been set with charmed stones.

Interrogated as to whether she had any rings, Jeanne replied: "You have one of mine; give it back to me." She added that the Burgundians had taken away another, and requested that if the judges had the first-mentioned ring in their possession they should show it to her. When questioned as to who had given her the ring taken by the Burgundians, Jeanne answered that she had received it in Domremy, either from her father or her mother, and that she believed it was inscribed with the names "Jhesus Maria." She did not know who had made the inscription and did not believe there was any stone in the ring. She strenuously denied ever having cured anyone by means of her rings. It is characteristic of the simple straightforward way in which Jeanne refuted the accusation of witchcraft that she charged her judges to give to the church the ring in their possession.[29]

In 1802 there was found in Coventry Park an ancient gold ring, weighing 1 oz., 13 dwts., 8 grains, and bearing a number of religious designs. In the central division was depicted Christ rising from the tomb, the hammer, ladder, sponge and other emblems of the Passion being shown in the background. In two compartments on either side were graven the five wounds, with the following Old English legends: "the well of everlasting lyffe," "the well of confort," "the well of gracy," "the well of pity," "the well of merci." Still existent traces evidenced that black enamel had

[29] Quicherat, "Procès de condemnation et de réhabilitation de Jeanne d'Arc," vol. i, Paris, 1841, pp. 86, 87.

been used in the figure of Christ, and red enamel to picture the wounds and the drops of blood. Inside the hoop ran the following legend: "Vulnera quinq. dei sunt medicina mei, pia crux et passio xpi sunt medicina mihi. Jaspar, Melchior, Baltasar, ananyzapta tetragrammaton." The whole signifying that the wounds and Passion of Christ were to serve as remedial agents for the wearer, the healing virtue of the ring being strengthened by the names of the Three Kings, by an enigmatic Gnostic epithet, and by the tetragrammaton, or the four Hebrew letters forming the Ineffable Name. A series of sixteen mourning rings "of fyne Gold," bequeathed by Sir Edmond Shaw, Alderman of London, by his will made about 1487, were "to be graven with the well of pitie, the well of mercie, and the well of everlasting life." [30]

It has been conjectured that the names of the Magi, the "Three Kings," Gaspar, Melchior and Balthazar, which nowhere appear in the Scriptures, may have been originally titles or epithets of Mithras, signifying respectively "White One," "King of Light," and "Lord of Treasures." [31] The invocation or inscription of these names was, in early Christian and mediæval times, believed to have great curative effect, more especially against epilepsy, and hence they were often engraved on rings. A number of these may be seen in the British Museum. Cologne Cathedral has been and still is the great centre of attraction for all devotees of the Three Kings, for their remains are said to have been brought

[30] Thomas Sharp, "An account of an ancient gold ring found in Coventry Park in the year 1802," Archæologia, vol. xviii, pp. 306-308. The "Coventry Ring" as it has been called is now in the British Museum.

[31] C. W. King, in *Archæological Journal*, vol. xxvi, p. 234.

there in 1162 from Milan, whither they had been miraculously conveyed long before from Constantinople.

Medicinal rings were often used in the reign of Elizabeth, and one was given to this queen by Lord Chancellor Hatton. Writing to Sir Thomas Smith, under date of September 11, 158–, Hatton says: " I am likewise bold to recommend my most humble duty to our dear mistress [Queen Elizabeth] by this letter and ring, which hath the virtue to expell infectious airs, and is (as it telleth me) to be worn between the sweet duggs, the chaste nest of pure constancy. I trust, sir, when the virtue is known, it shall not be refused for the value." [32] This rather coarse flattery would not offend the Virgin Queen, who habitually indulged in very plain speaking.

A diamond ring said by a faithful courtier to have brought him health and strength when he was at death's door, was one sent by King James I to Thomas Sackvil, Duke of Dorset, High Treasurer both under Elizabeth and James. When, early in June, 1607, news was brought the king that his Treasurer was so dangerously ill that his life was despaired of, he sent him a rich gold ring set with twenty diamonds, five of which were so disposed as to form a cross. With the ring James sent a special message, expressing the hope that Sackvil would recover and might live as long as the diamond in the ring endured. This proof of his sovereign's favor

[32] Pettigrew, " On Superstitions Connected with the History and Practice of Medicine and Surgery," London, 1844, p. 67. This letter is among the Harleian MSS, and was read before the Soc. of Antiquaries, Nov. 12, 1772, according to the Minute Book of the Society.

called the patient back to life, according to his own narration. [33]

Convulsions and fits were believed to be cured by rings made of a silver coin representing the value of a number of smaller pieces of money, sixpences or even pennies, collected at the church door from those who had just been present at a communion service. Should this have taken place on Easter Sunday, the value and efficacy of the talismanic ring made from the offering were much enhanced. A less religious source for a silver ring of this kind has been reported. Five bachelors were to contribute a sixpence apiece, and a bachelor was then to convey the silver to a blacksmith who was also unmarried and who was to make the ring. An absolute requisite, however, was that none of the voluntary contributors should have the slightest idea of the destination of his sixpence.[34]

For the cure of ulcers, Johannes Agricola advises the wearing of rings made from solidified quicksilver, during a conjunction of the moon with the planet Mercury; these rings were to be worn on the side opposite to that afflicted with the ulcer.[35] This might suggest some vague idea of the fact that the right hemisphere of the brain controls the left side of the body, and *vice versa*, although if the effect of the ring was to be transmitted by reflex action of the brain, the stimulus must of course, proceed from the afflicted side. It is said that if a reme-

[33] Arthur Collins, " The English Baronage," London, 1727.

[34] Thomas Joseph Pettigrew, " Superstitions Connected with the History and Practices of Medicine and Surgery." London, 1844. pp. 61, 62.

[35] Jacobi Wolfii, " Curiosus amuletorum scrutator," Francofurti & Lipsiæ, 1692, p. 460.

dial potion were stirred about with the ring finger, the heart would quickly realize the presence of poison, and would thus give warning against drinking it; the fourth finger was therefore sometimes called the "medical finger." [36]

The idea that the ring possessed a mystic restraining power finds expression in the curious custom of the Bagobos of the Philippine Islands, who encircle the wrists and ankles of the dangerously ill with rings of brass wire, in the belief that these serve to keep the soul from taking its flight.[37] An analogous, although apparently contradictory impulse induces the Greek inhabitants of the island of Scarpanto (Carpathus), near Rhodes, to take off all rings from a dead person lest the soul should be bound to the body even after death; the pressure of a ring on the little finger being sufficient to interfere with the freedom of the spirit.[38] Similiar beliefs obtained as to the secret binding power of knots.

A ring made from the hoof of a wild ass was supposed to possess medicinal virtue, and one made from the hoof of a rhinoceros, if placed on the finger, was believed to cure certain nervous disorders. A ring of rhinoceros-horn was a still more powerful remedial agent and its wear was favored in India as an antidote for poisons and to cure convulsions or spasms.[39] A ring made from the hoof of the elk possessed similar

[36] *Ibid.*, p. 570.

[37] Blumentritt, " Das Stromgebiet des Rio Grande de Mindañao," in Petermann's Geographische Mitteilungen, vol. xxxvii, p. 111, 1891.

[38] Blackwood's Magazine for February, 1886, p. 238.

[39] Jacobi Wolfii, " Curiosus amuletorum scrutator," Francofurti et Lipsiæ, 1692, pp. 390, 392.

ASTROLABE RING, OF GOLD
Two views, closed and open
Albert Figdor Collection, Vienna

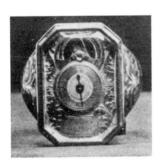

PHYSICIAN'S RING OF GOLD, WITH MINUTE WATCH FOR
COUNTING THE PULSE-BEATS

Beneath the watch is the maker's name, **Kossek in Prague.** The
movement is regulated by a slide at one side; the hole for the watch key
is on the lower side. Enameled leaf-work decoration. Two views

Albert Figdor Collection, Vienna

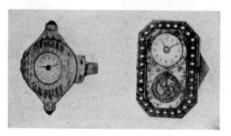

1. WATCH RING, SET WITH DIAMONDS
2. WATCH RING, SET WITH PEARLS
Showing the dial and the movement of the balance staff
Eighteenth Century

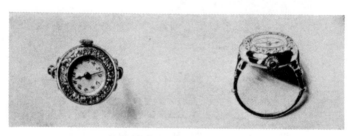

MODERN WATCH RING
Side and front views

virtues, and cramps in the legs would be cured if the afflicted part were merely touched with such a ring.

As to the mode in which the elk-hoof should be used for curative rings for epilepsy, the old authorities differed, Goclenius affirming that a piece of the hoof should be set in a ring, while others believed that the entire ring should be turned out of this material. The proper way of wearing it was to place it on the fourth finger, so that it could come in contact with the palm of the hand. The choice of the particular hoof was also matter for debate, some favoring that of the left hind foot and others that of the right one. Rings set with teeth of the sea-horse were recommended by Johann Michaëles, a famous physician of Leipsic. A ring made of pure silver, of " the moon," as the astrologers said, if set in a piece of elk-hoof, under the zodiacal sign of Pisces and during a favorable conjunction of the planets, would prove a certain cure for epilepsy and all brain diseases.[40]

The Tyrolean hunters have the same superstitious fancy as to the talismanic power of an antelope's tooth set in a ring as is (or was) held in some other parts of the world regarding elks' teeth set in rings. Of the Tyrolean rings, four examples were disposed at the sale in New York in 1913, of the fine collections of Mr. A. W. Drake.[41]

A gold ring specially designed for a physician's use in counting pulse-beats is to be seen in the collection of Dr. Albert Figdor, Vienna. It is set with a watch, below which, on the bezel, is inscribed the name of the watchmaker, Kossek in Prague. The aperture for the

[40] *Ibid.*, p. 32; Sec. I, cap. ii.

[41] " Illustrated Catalogue of Mr. A. W. Drake's famous collections," New York, 1913, Pt. I, Nos. 1757, 1758, 1759, 1760.

insertion of the watch key is on the lower side, and there is a slide for regulating the movement of the little timepiece.[42]

Among healing rings none might be thought to promise better results than the " electric rings," made of an amalgam of copper and some other metal, which are sold to a considerable extent, their curative power being supposedly derived from an electric charge, or a generation of electricity. Whatever good effects may have been observed as a result of the use of such rings, presumably few would be inclined to deny that one of the active agents in the cure was the faith of the wearer, which assuredly would fortify or supplement the beneficial effects of electric emanations, where the mind was firmly impressed with the conviction that a curative power existed in the ring.

[42] Communicated by L. Weininger, of Vienna.

CHAPTER IX

RING MAKING

THE modern methods of ring manufacture in the United States are far different from those of the past, due to an endeavor to keep pace with the growth of the country and with an increase in production. Owing to the introduction of modern systems, great quantities of an article can now be sold, which, though not preserving the character of the finest handiwork, yet cost so much less to produce that they can now be offered at greatly reduced prices.

In the manufacture of the modern ring, there is first prepared a design, or even a model. The initial process consists in cutting this object exactly as it will appear when it is finished,—or such parts of it as are made by measure,—on what is known as a " hub " made of soft steel. When the design is finally completed, it is hardened by heating and then by dipping into water, oil or other solution. When the metal hub has been hardened, it is forced into a mass of soft steel by great pressure, usually hydraulic, producing a die, as it is termed, on which all the ornamentation is the reverse of that on the desired object. This die is then hardened.

The die is placed on the stand of the drop press, the upperweight strikes it and forces the metal into it; this requires from four or five to seven or eight operations. Each time the metal is struck it is annealed, then restruck and again annealed, until the ring is ready for trimming. This trimming removes all the superfluous metal, and the ring is then in condition for the jeweller to bend it into a complete circle.

In the manufacture of many rings, the metal first receives a special form. The gold plates are blanked and rolled to a definite thickness according to the pattern of the ring desired, the width being controlled by screws attached to the rolls themselves. To obtain the exact width, the measure in which it is placed can be adjusted to cut a strip of metal from a millimeter, or thinner, up to several inches in width. It is slid over a roll and two wheels with sharp edges separate the mass of gold into exactly the desired widths. The gauges are so exact as in one instance to provide 16 variations to a millimeter, approximately $1/25$ of an inch. Another screw gauge is so delicate that it can be adjusted to the four-thousandth of an inch.

Each piece is then put in a cutter exactly the outline of the desired piece, which, for a ring, is usually quite flat. The piece of metal then drops into a cutting box and a number can be struck out successively by simply raising the press and allowing the cutter to come down. The metal is now placed in another roll, which, in the case of the signet ring, rolls the sides thinner than the head. When this process is completed the product is put in a gauge measure which measures the length of the ring from 0.4 to size 13, on Allen's standard gauge. The ends of the metal are then cut off so that the ring is approximately the desired size, and the ends are annealed or soldered without any further operation.

In most cases when striking a signet-ring, the top is not cut out entirely. The gold backing of the stone is left, and the head of the ring is struck with a concave space so that when the two sides are brought down the space will remain flat. For transparent stones, the top is cut out of the setting entirely. When the rings are finally completed they are cleaned by what is known as

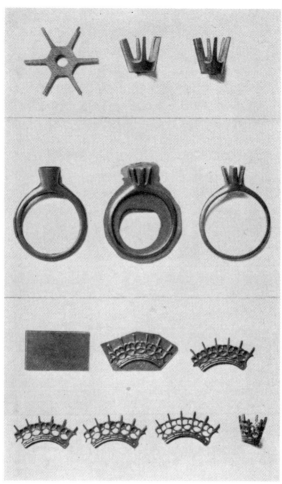

PRODUCTION OF RINGS WITH PRECIOUS STONE SETTINGS BY
MEANS OF MACHINERY

1, original blank struck from plate of metal. 2, same raised, with claws
pointing upward. 3, same reduced. 4, first strike of a one-piece ring.
5, second operation. 6, third operation. 7, 8, 9, 10, 11, 12, 13, successive
stages in the manufacture of a gallery for the ring

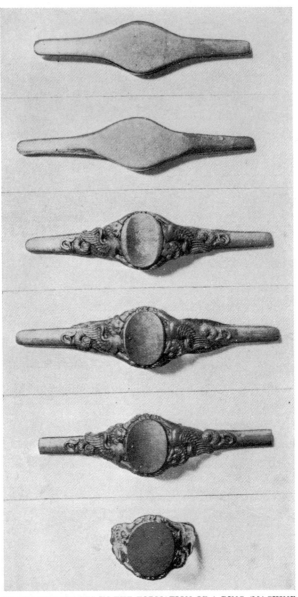

SUCCESSIVE STAGES IN THE FORMATION OF A RING (MACHINE MADE) FROM THE SHAPED, BENT, UNORNAMENTED BAR TO THE FINISHED RING

a stripping wheel, the reverse of a plating wheel, which removes all the fire-markings, and all the other impurities that exist, leaving the metal clean.

The rings are then polished by rapidly revolving wheels of hair,—at times, of other materials. After this, the stones are set. If the rings need engraving, they are then passed to an engraver and are finally polished, leaving the metal entirely finished.

In former times, and now also, by hand methods· one man would frequently make an entire ring. By modern methods, the ring passes through the hands of a number of workers: first, the blank-maker, then in succession the man who operates the drop press, the jeweller, the stone setter, the engraver, and finally, the polisher.

As to the statistics of ring-making, with the great demand throughout the United States a single factory has produced 3,000,000 rings a year, some selling for less than $1.00 each, and on up to $5.00 and $10.00 each; very occasionally for higher prices, up to $50.00 or $60.00. Recently to fill an order for a chain of popular shops, this factory turned out 2,000,000 rings to be sold at ten cents apiece. In the region of Providence, Rhode Island, and the nearby Attleboro, Mass., the total value of the annual ring output, which gives employment to some two thousand persons, is put at $5,000,000. In a factory of the largest kind, frequently the various parts for making up a ring may be kept in small boxes, because a stamper, in making an intricate ring, is able to produce more in one day than a jeweller can finish in a week. In simple rings, however, the jeweller finishes as many rings as the stamper can produce in a day.

There is no piece of jewellery that is more generally worn nor whose possession causes more joy, than a

finger ring. And the proper fitting of a ring for com-
fort in wearing it, or to prevent its loss, which frequently
would be looked upon almost as a calamity, is something
that can be attained by careful adjustment to the proper
size. Many fingers taper forward. In other fingers,
the knuckle is very large and the third joint much
smaller than the knuckle. Where the finger tapers from
the joint at the hand to the tip it is frequently difficult
to make a ring hold properly. But this can be done by
wearing a tiny guard ring. In cases where the finger
is much smaller between the third and fourth joint the
ring will turn around, which is not only uncomfortable
but makes the ornaments fail to show properly. This can
be prevented by having the hoop penannular in shape, or
by the addition of an internal spring.

To prevent the rubbing together of two rings worn
on the same finger, and the resulting attrition, which in
the lapse of years sometimes wears down a gold ring
until the hoop becomes so thin that it may crack, a simple
device has been patented. This is a narrow circlet which
may be made of ivory or any other suitable material. It
has a thin vertical flange just high enough to interpose
between the rings that are to be kept apart, and two
horizontal flanges to pass beneath the hoops of the rings.

To protect two rings from rubbing against each
other, an exceedingly narrow gold circlet is worn be-
tween them. Where there is risk that a hard stone in
one ring will come in contact with a pearl in the other,
or a diamond with any other stone, necessarily softer,
one or more very small beads are welded on that part of
the hoop nearest to the setting. In cases where a treas-
ured ring has worn almost to the thinness of paper, it is
possible to strengthen it by adding gold at either side
of the hoop.

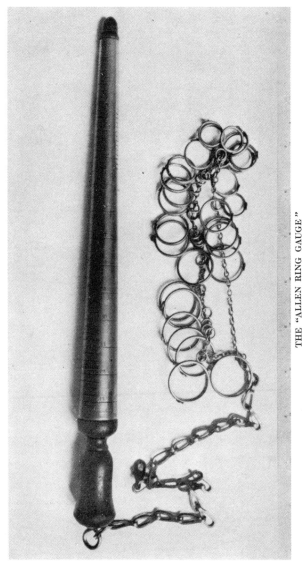

THE "ALLEN RING GAUGE"

Generally used in the United States for measuring accurately the size of the ring required to fit a given finger

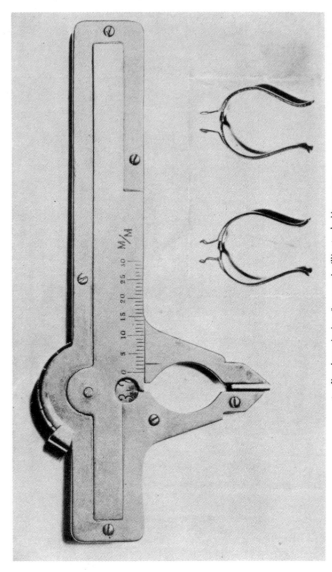

1, Engelmann's ring, finger and millimeter locking gauge.
2, "display rings," in which a succession of precious stones can be set and tried on the fingers

The size of the finger is often recorded by what is known as the Allen gauge, a tapering stick numbered from 1 to size 13 in half sizes. To this stick is attached a chain, and pendant to the chain is a series of rings of graduated sizes. When it is decided which ring of the series best fits the finger, it is slipped on the gauge and its size ascertained. If size 6 is a little tight and $6\frac{1}{2}$ a trifle loose, this indicates that $6\frac{1}{4}$ is the correct size.

In measuring the finger for a ring, by Engelmann's Ring, Finger and Millimeter Locking Gauge, the ring is set *over* the *outside* perpendicular ends of the gauge (see plate). These are then separated to their fullest extent, so that they touch the ring on both sides. The exact size of the ring is thus indicated on the scale over the mark on the movable upper part of the right-hand end.

To measure the size of a finger, the ends should be separated sufficiently to permit the finger to pass through the aperture between them. They are then to be closed so as to touch lightly—not pinch or squeeze—the flesh of the finger. When this has been done the ends are locked, and if the knuckle passes easily through the aperture, the right size has been found. This is recorded on the scale in the same way as in the ring measurement. In measuring the finger of either a child, boy, girl, or woman, who has not a large or high knuckle, a safe rule is to add a $\frac{1}{2}$ *ring-size* to that which has been indicated by the measurement.

The width of the metal ring-shank is ascertained by placing its lower, centre part between the two inside perpendicular ends, and the exact dimensions will be made apparent on the millimeter scale. Where the shank is tapered, the maximum and minimum widths must be taken, and these must both be stated in ordering a ring.

An unset stone is to be measured in the way just described, maximum and minimum widths being taken; for this purpose also, only the extreme pointed ends are to be used; these dimensions should be correctly stated when the ring is ordered.

To alter a ring to any size, place the lower, centre part of the shank *over* the scale and estimate the width of metal to be taken off or added, respectively, by the millimeter-lines.

Where the proper measuring devices are not attainable, resource may be had to various simple expedients. For instance, a bit of copper wire can be used; one end is turned so as to form an eye, and through this the other end is drawn until the circle fits the finger; the free end is then twisted to keep it from slipping back. In this way the exact size of a finger can be obtained. It is also possible to have the wire notched so as to indicate the standard numbers of rings, or better still, to have them stamped on a narrow, flat strip of copper or steel with a slot at one end, through which the other end can be passed and turned down when the band has closely encircled the finger. Of course, these simple methods need only be resorted to when the prospective buyer is ordering a ring by mail or messenger, as jewellers are always provided with instruments for taking the exact measurement of the fingers.

A new and practical invention is that of a " display ring," by means of which the jeweller can enable anyone who desires to order a ring, to judge of the effect of various stones when worn as ring settings. This little device is open at one end, the metal band being flexible enough to yield to slight pressure applied to both sides. In front, on either side, are two claws, which open up and grasp the stone when the pressure is relaxed. Thus

one gem after another can be displayed. Sets of these display-rings are made comprising eighteen different sizes.[1]

When a ring has become painfully and injuriously tight on a finger, a simple method and often efficacious, for its removal, is to take several feet of cotton cord, soak this in soapsuds, glycerine, or oil, and pass one end of it under the ring, leaving about six inches loosely hanging down. The other end of the cord is then to be wound tightly around the finger, beginning close to the ring and continuing over the middle joint up to the end of the finger. If left on for a while, the cord compresses the flesh to such an extent that when it is unwound by pulling at the loose end hanging down from the base of the finger, the ring will be gradually and painlessly forced off. In very serious cases it is safest to file through the hoop and bend it open sufficiently to free the finger. The trifling injury to the ring can easily be repaired, leaving it in all respects in its original condition.

A ring that fits too tightly may become a source of serious injury to the wearer in course of time. This applies especially to engagement or wedding-rings, for many wearers have a sentimental, or even superstitious disinclination to remove such a ring after it has once been placed on the finger by the cherished donor. Slight as the effects appear to be, since the progressive tightening is so very gradual, there have been cases where the increasing plumpness of a hand has caused the pressure of the ring to become so intense as to induce an affection of the arm, rendering it liable to serious trouble in case of an attack of rheumatism or a severe cold. In some

[1] Patent application filed April 3, 1912, by Monroe Engelsman, and serial number 688,244.

cases, when such a tight ring has been cut from the hand, the present writer has seen that the entire finger under the ring was an open wound, occasionally a deep one.[2]

Throughout Europe—England and the Continent—narrow gold rings are generally worn, almost invariably of 22-carat gold; among the poorer classes, the standard falls to 18-carat—never lower. In the United States the correct wedding ring is a 22-carat ring, but away from the large cities and among their less prosperous inhabitants 18-carat rings are worn to a considerable extent. These are often two, three, or four times the weight of the European 22-carat ring, flatter and sharp on the edges, thus cutting the finger. Frequently perspiration under the ring will cause the finger to become sore and infected. The narrow ring is more rounded on the inside and never infects the finger in any way.

Charges of selling illegally stamped wedding-rings have recently been preferred in a New York court. The proceedings were instituted under paragraph 431 of the Penal Law. The marking in one case was "14 Kt. $^1/_{10}$," this having been stated to signify that nine-tenths of the metal was 14-carat gold and one-tenth of some baser metal. The real meaning, however, appears to be that one-tenth is of 14-carat gold, the remaining nine-tenths being alloy. The ring was found to weigh 72 grains, and on being tested at the United States Assay Office, the fineness of the entire metal was determined to be 52/1000, equivalent to a fineness of but $12\frac{1}{2}$ carats for the one-tenth represented to be of 14-carat gold. The utmost variation from standard permitted by the statute is one carat. The quantity of pure gold in such a ring would only be about $3\frac{3}{4}$ grains, worth a fraction over 16 cents. The rings were sold for \$3.75 and \$4.

[2] George Frederick Kunz, " The Etiquette of Gems," the Saturday Evening Post, June 27, 1908, p. 29.

An alarm ring, giving the wearer timely notice if its stone setting should fall out, has recently been invented. Beneath the stone, a needle traversing the ring is so adjusted to a coiled spring that if the stone drops out, the spring is released, and the needle-point gives a slight prick to the wearer's finger. The idea is ingenious enough and the ring may find favor among those who value their ring-stones enough to endure a " sharp reminder " of their loss when this helps their recovery.[3]

A curious and interesting example of inlaying, is a gold ring owned by B. G. Fairchild, Esq., of New York. In the flat bezel have been inserted two winged figures, cut in intaglio on pieces of brown chalcedony. As there is no margin of stone showing about the figures, the effect is very striking, the chalcedony appearing to be naturally embedded in the gold. This is a production of antique art.

In designing a ring the goldsmith must constantly bear in mind that only the upper part, less than half the circle, will be displayed, and he should thus carefully avoid regarding the whole ring as an ornamental object and chasing or adorning the part that will not be shown. To this end he is advised to model the design in wax on the circlet itself, rather than to work from a sketch or drawing. If any plant or other nature form enters into his composition, he should, where possible, have a specimen before him while he works, so that whatever modifications or adaptations he may make will not violate the main lines of the natural type. In making a ring of solid metal, it is either cast in the desired form, or hammered from a cast. After the metal has been annealed, the design is sketched on in black water-color; it is then outlined with a small round-edged tracing-tool and the

[3] U. S. Patent, No. 1,179,025, April 11, 1916.

groundwork is chiselled away. The design can now be finished with chasing tools.[4]

The making of finger rings as well as of everything else has been strongly influenced by machine production. Cloth is machine-made, pictures are lithographed, lace, macaroni, and even small houses are now produced with an exactness that was never before possible. But, unfortunately, with the dominance of the " machine-made " product, the artistic quality is entirely obliterated. Rings are now made in such vast quantities that exactness of reproduction is the great aim. Thus while the initial design may possess a certain measure of originality, the single ring of the type, one out of thousands or tens of thousands stamped out of the same model, necessarily lacks that personal touch which alone can produce a truly artistic object.

NAMES OF THE RING [5] IN VARIOUS FOREIGN LANGUAGES.

Anglo-Saxon	Hringe
Arabic	Khatam, mahbas
Babylonian	Shemiru, lulimtu?
Bohemian, Serbo-Croatian	Kruh, prsten
Bulgarian	Prsten
Chinese	Pan-chih, chih huan [6]
Danish	Ring
Dutch	Ring
French	Anneau, bague
Gaelic (Erse)	Fainne, failbeagh
German	Ring
Greek, ancient	Δακτύλιος, δακτυλίδιον
Greek, modern	Δακτυλίδι
Hebrew	Tabba'ath, hotham

[4] H. Wilson, " Silverware and Jewelry," New York, 1903, pp. 110, 111.

[5] The word " ring " belongs to the Teutonic language group, and etymologically it is what is termed common Teutonic.

[6] Archer's thumb ring.

Hungarian (Magyar)......Gyürü
Italian................Anello
Icelandic...............Hringr
Irish..................Fainne
Japanese...............Yubi no wa
Laos...................Pawp Mü
Latin..................Anulus, anellus
Lithuanian..............Ziedas
PersianAngushtar (halkat)
Polish.................Piercien, krouzek
Portuguese.............Annel
Roumanian.............Inel
RussianKoltsó,[7] pérsten [8]
Ruthenian (Little Russian)..Persten
Sanskrit...............Angulîya, anguli mudra
Serbian.................Prsten
SiameseNew nang (nang pet)
Spanish................Sortija, anillo
Sumerian...............MUR (KHAR)
Swedish................Ring
Syriac.................Tab'â, hathmâ
Turkish (Osmanli).......Yüsük, halqa
Welsh.................Modrwy

The following hints as to the proper pronunciation of some of the rare words in the above list have been kindly furnished by Prof. John Dyneley Prince, of Columbia University, who has also supplied several of the names:

In *prsten* (Bulgarian, Bohemian and Serbo-Croatian), the r has a peculiar rolling sound with an inherent vowel; this cannot be correctly reproduced in English spelling. The ci of Polish *piercien* is pronounced like the Italian ci (chee). Little Russian (Ruthenian) and

[7] Plain ring.
[8] Ring set with a stone.

Russian *persten* means literally " finger-thing." In the Lithuanian *ziedas,* the z is pronounced like French j, or our z and azure. The Hungarian gyürü sounds like dyü-rü; it means something rolled. The t in Hebrew, Arabic and Syriac is an explosive t unknown in English; the letter rendered by the sign is a deep, guttural and faucal exhalation. Irish *fainne* is pronounced fau-in-nye, and the Welsh *bodrwy* is sounded as bod-roo-ee.

The word " ring," *tabba-ath,* appears once in Genesis (xli: 42), the ring given by Pharaoh to Joseph; six times in Esther iii: 10, 12; viii: 2, 8 (bis), 10, the ring of Ahasuerus. In the New Testament the ring is mentioned once in Luke xv: 22, the ring given the Prodigal Son; and once in the Epistle of James, ii: 2. The word " rings," as finger-rings, occurs in Exodus xxxv: 22, of the offerings of the people of Israel in the desert; in Numbers xxxi: 50; in Canticles v: 14 (this is probably to be rendered " rods "),[9] and in Isaiah iii: 21. That rings should be so rarely alluded to in the Old Testament might seem to prove that they were not as extensively worn in the land of Israel as some have assumed. The finest ancient Hebrew signet is said to be one of the time of Jeroboam II, King of Israel (790-749 ? B.C.), found at Megiddo. This is the seal of Shemai, the King's Minister of State. It is of jasper and bears the finely engraved figure of a lion. The form is oval and the seal measures 3.7 by 2.7 cm.[10]

[9] The word used here and also in Num. xxxi: 50 is *glilim.* ḥotham means a seal-ring in Jeremiah xxii: 24.

[10] Mitteilungen and Nachrichten des deutschen Palästina-Vereins, 1904, pp. 1 sqq.

INDEX

367